THE
WORLD ATLAS
OF STREET
PHOTOGRAPHY

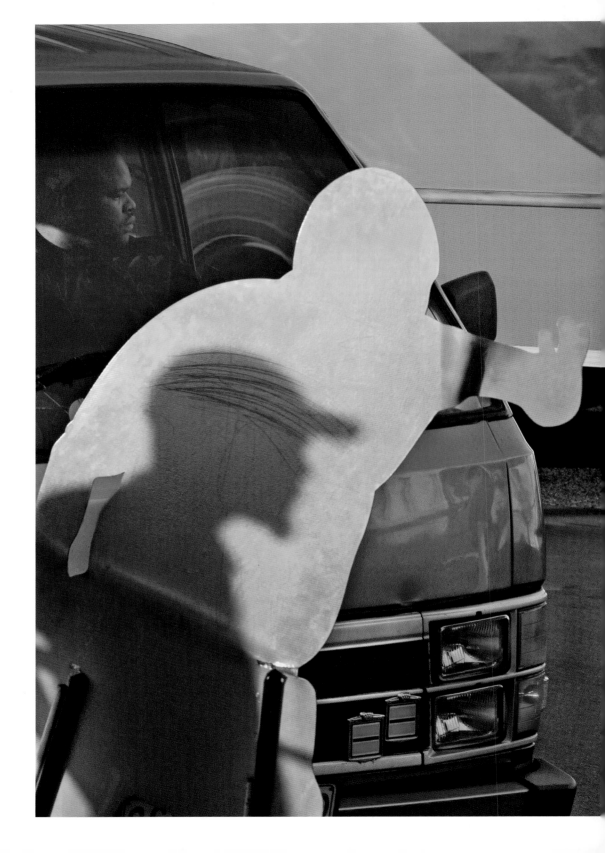

1 From 'A City Refracted',
Graeme Williams,
Johannesburg,
South Africa, 2012–14

THE WORLD ATLAS OF STREET PHOTOGRAPHY

JACKIE HIGGINS

FOREWORD BY
MAX KOZLOFF

YALE UNIVERSITY PRESS, NEW HAVEN AND LONDON

NORTH AMERICA

LATIN AMERICA

EUROPE

CONTENTS

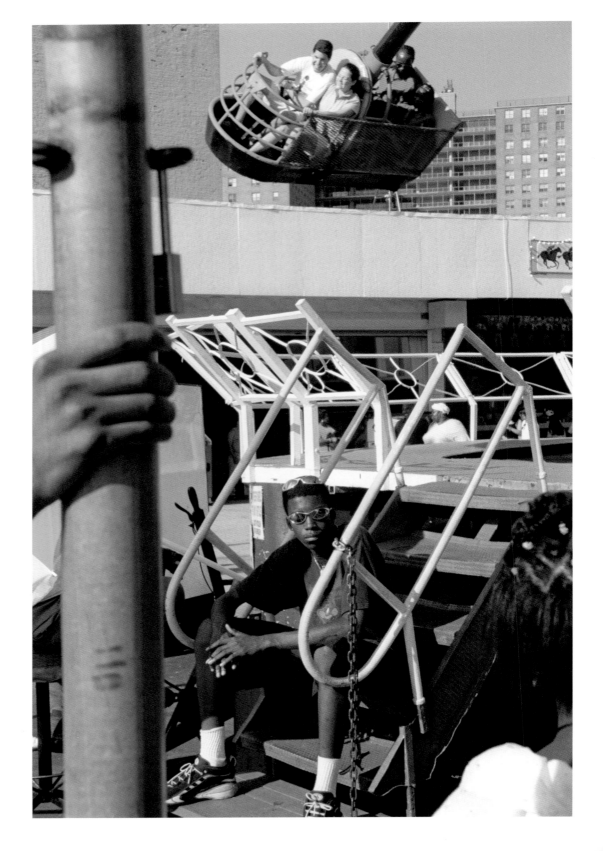

1

1 *Young Man with Sunglasses,*
Coney Island, Max Kozloff,
New York, USA, 1997

FOREWORD

BY MAX KOZLOFF

How uncommon, but fitting, to find the word "atlas" used in the title of this groundbreaking book of photographs. To thumb through its pages is to encounter widespread images of cities, arranged by continent and region. Many of these places are captured by impassioned visitors, as well as by locals. Whatever their origins, they take into account cosmopolitan trends promoted by global cultures. That fact makes for convergences in styles and ideas, even though the look of things is naturally differentiated by the particulars of geography. The images chosen for inclusion in *The World Atlas of Street Photography* have been filtered through the traditional obligations of the street genre itself, which is valued for its credibility as urban witness. They have been selected because they are arresting or thought-provoking images of our urban landscapes.

Traditionally, street photography acts as a portmanteau term that covers a range of idioms centered on the built environment and the experience of those who perceive the human traffic around it by means of the camera. They have usually served civic, political, editorial, and journalistic functions. We encounter these channels in such projects as David Goldblatt's portraits in South Africa, Joel Meyerowitz's documentation of the 9/11 ruins in New York, and the Magnum photographer Alex Webb's evocation of Istanbul. Guided by more personal and artistic motives, much of the work featured here ventures into equivocal terrain; it retains the imagery of the streets but blurs the question of how they're peopled. The Essop Twins, devout Muslims in Cape Town, stage a didactic theater about cultural clashes, using themselves—surreptitiously—as models. Nikki S. Lee, a South Korean formerly based in New York, pretends to be a habitué of cliques with which she was on only professional terms. From one practitioner to the next, the old rule that observation should be faithful to an external reality has itself become debatable. Instead of remaining opportunistic spectators of passing scenes, they have become agents involved in posing situations, with the hope of kindling meanings otherwise in short, random supply.

The still image grips some previously undefined instant that may often go nowhere, aesthetically, and may leave the social impact of the picture uncertain and hard to explain. For the last twenty years or so, street photography has been transformed by four environmental conditions: media markets have dwindled; digital photography has virtually replaced film; postmodernist scepticism toward documentary forms has increased in the academic world; and the division between public and private spaces has been confounded. Faced with these challenging circumstances, photographers have reacted with a discursive strategy of their own. We often find in their statements a desire to tell a story, as if to compensate for the prevailing reticence of unscripted actions to speak for themselves in single images. No wonder so many photographers work in series or have resorted to video in order to reiterate points of view and to gain narrative momentum. They have switched from being members of hunter-gatherer societies to a more organized stage as pictorial agriculturalists. Instead of foraging for content, they grow it in crops.

The images in this book offer a harvest of new ambiguities. Photoshop manipulation instigates, often without acknowledging, the metamorphoses of bodies. Models or stand-ins replace those who might be thought the original actors in a scene. One no longer knows whether a tableau represents an occasion or a re-enactment born from a photographer's mind. Here, street photography becomes a subspecies of performance art, activated by proxies engaged in apparently self-generated activities. Yet these tactics do not prohibit gestures that are genuinely empathetic, or references to historic injustices or adversities that must be taken seriously. What is at stake is not the integrity of the act of witness, which has been sidestepped, but a mode of feeling, even if it is built on a conceptual artifice.

People pose for portraits out in the street. People walk past or into a camera snare without being aware of it. They are spied on, for purposes they might object to. Yet each of them becomes a creature momentarily active in the imaginative world of someone else. None of them are any longer in that world, which lives on only as an image. Yet it makes a difference whether that image is the result of an intervention into a flow, decided by impulse, or given out as an occurrence discovered, while in fact it has been prearranged. The difference is manifested in the behavior of bodies and minds, interpreted by viewers. In either case, the street is still that zone rightly viewed as the site of where things happen. If there ever appears any sour proclamation about the death of the street, it should be taken with a grain of sugar. In the end, street photography, as always, radiates a polymorphous openness to life.

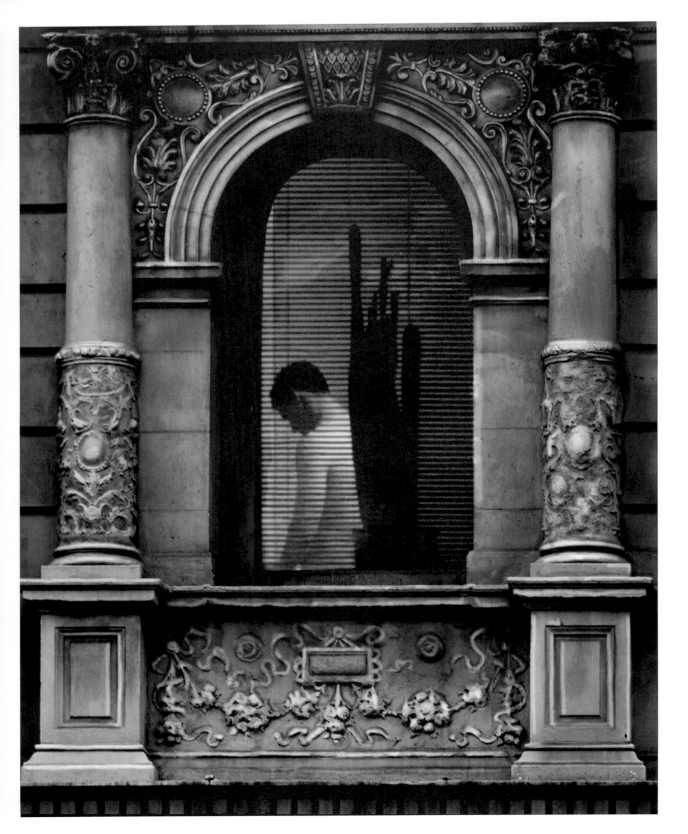

1 *Guy with Cactus (Lower East Side, Sunday 9:52 pm),*
Yasmine Chatila, New York, USA, 2008

1

INTRODUCTION

More people than ever before reside in cities. According to a United Nations report in 2008, for the first time in human history over half of the global population is now urban; a figure that is set to rise to 70 per cent by 2050. In both the developed and developing world, the city has either become or is fast becoming a fact of life. Cities have been hailed as the "greatest artifacts" made by humankind. Architectural critic Jonathan Glancey describes them as "zoolike, forestlike places planted with trees and alive with animals." The city's ever-changing, energetic pace draws and entices us. Critic and writer Susan Sontag views it as "a landscape of voluptuous extremes." "Synonymous with movement, dynamic, and vitality, it is the place where nothing is permanent and everything is possible," claims curator Marcel Feil. "The city is a magnet to fortune hunters, the underprivileged and ambitious." It is also an irresistible lure to artists.

The World Atlas of Street Photography showcases the work of 100 established and emerging contemporary artists. From Brazil to Beijing, Sydney to Seoul, New York to Delhi, the book journeys across five continents, to over fifty diverse and disparate cities, with the purpose of searching out the world's best urban photographic art. The list of artists is not comprehensive; instead it has been compiled to create illuminating juxtapositions and to illustrate the range of ideas, approaches, and techniques that are being explored in current street photography. The book reveals how artists across the globe are pushing, pulling, and radically redefining the tradition of street photography with the result that the practice is being taken into new realms.

The book looks at those who practice classic candid street photography: people interested in freezing the theater of life being played out on the pavements. Tokyoite Daido Moriyama (see p.348) muses, "For me cities are enormous bodies of people's desires and I search for my own desires within them, I slice into time, seeing the moment." Other photographers are intent on extracting the extraordinary from the ordinary. "You can walk 5th Avenue all day and it's never the same," claims New Yorker Joel Meyerowitz (see p.18). "You get a different selection of the animal life in that canyon and it never ceases to amaze." The urban carnival draws artists for all manner of reasons. Dutch photographer Hans Eijkelboom surveys pedestrians as a quasi-anthropologist on a quest for evidence (see p.192). JH Engström's series in Paris (see p.152) and Alisa Resnik's in Berlin (see p.184) reflect a more personal, almost diaristic approach, depicting encounters on the streets with both friends and strangers. For others the drive is perhaps to document ways of life beyond their own; Danish photographer Trine Søndergaard trains her lens on women working the red-light district of Copenhagen (see p.200), whereas South African Pieter Hugo focuses on an unusual group of Nigerian street performers in "The Hyena and Other Men" (see p.270).

The book also considers artists working with urban portraiture: people who effectively turn the streets into makeshift studios. The work of Americans Katy Grannan (see p.64), Michael Itkoff (see p.390), and Dawoud Bey (see p.74), at home and abroad, creates an intriguing dynamic between what photographer and critic Max Kozloff calls "the roving spirit" of street photography and the "deliberate encounters" of portraiture. Elsewhere, artists introduce textual elements into portraiture, lending the usually mute photograph and its subject a voice. On the street corners of London, Gillian Wearing frames her

subjects holding a board on which they have inscribed their thoughts and feelings (see p.124), whereas in Berlin, Sue Williamson gathers groups to express themselves similarly (see p.186). The theme is once more varied with David Goldblatt's work in Cape Town that exhibits written testimony from subjects alongside their photographs (see p.258).

These alternative uses of image and text ultimately explore the performance inherent in a portrait, but for other artists performance is their central concern and many employ the city as a stage. Some take on the role of director while others star in their own dramas. Canadian Jeff Wall (see p.86), Parisian Mohamed Bourouissa (see p.160), and Londoner Hannah Starkey (see p.136) fall into the first category; they each meticulously mastermind actors, lights, and props to create single-frame plays. Sophie Calle in the cramped, winding alleys of Venice (see p.164) and Nikki S. Lee in the regimented grid of New York (see p.42) take the second tack. They artfully disguise and stage themselves; Calle turns private detective and Lee, Zelig-like, changes her weight, mannerisms, and language to infiltrate an array of subcultures, from hip-hop gangs to yuppie clans. Unlike Calle, she then steps in front of the camera to immortalize these urban theatrics, recalling the work of the Essop Twins in Cape Town (see p.254), who not only appear in their staged images, but also digitally clone themselves, so that they appear over and over.

Finally the book reflects on the endless and diverse appeal of the urban landscape to artists. Olivo Barbieri's epic project "site specific" (see p.208) has so far taken him to forty cities across the world. It started in the wake of 9/11 when he expressed a desire "to look at the city again." He frames skylines in vast aerial vistas using helicopters, and experiments with focus and perspective to render them uncanny. Massimo Vitali (see p.168) and Alexey Titarenko (see p.226) focus on how crowds move within landscapes, but whereas the former uses overexposure to ghost out cityscapes, the latter uses long exposures to recast St. Petersburg into a city of shadows. Meanwhile, Uta Barth deliberately moves the camera while the shutter is open in order to dematerialize the street corners of Los Angeles and transform them into color field abstractions (see p.56).

Through myriad urban explorations an international cast of artists are fracturing, shifting, and diversifying the traditional interpretation of street photography. "I can't photograph anything without a city," claims Daido Moriyama—a sentiment echoed by many of the artists within this book. *The World Atlas of Street Photography* shows how the city and its streets are stimulating and inspiring the current generation of artists; and with the city as their muse, we now face a new dawn for street photography.

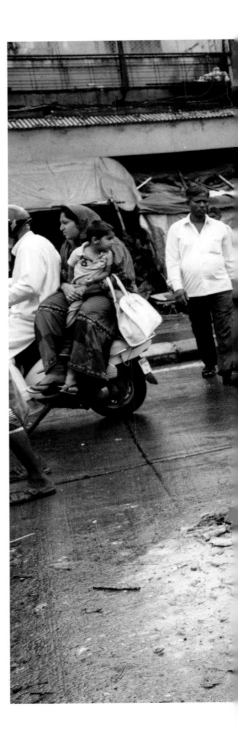

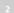

2 Maciej Dakowicz, Mumbai, India, 2007–13

NORTH AMERICA

NEW YORK LOS ANGELES CHICAGO
DETROIT HOUSTON VANCOUVER

JOEL MEYEROWITZ YASMINE CHATILA GUS POWELL VERA LUTTER MATTHEW BAUM
PETER FUNCH NIKKI S. LEE PHILIP-LORCA DICORCIA BRUCE GILDEN MIRKO MARTIN
UTA BARTH ANDREW BUSH KATY GRANNAN MICHAEL WOLF DAWOUD BEY
DOUG RICKARD PAUL GRAHAM WIM WENDERS JEFF WALL

From the late 1950s to the mid 1970s, New York City was widely
seen as the urban center for street photography. Legendary names
from Garry Winogrand and Tod Papageorge to Lee Friedlander and
Joel Meyerowitz (see p.18) would pound 5th Avenue, cameras at the
ready. Today the tradition continues to thrive; photographers such
as Bruce Gilden (see p.48) and Gus Powell (see p.24) have finessed
various approaches to progress the New York School legacy into
new territory. Elsewhere across North America, others use their
practices to push, pull, and interrogate the genre of street
photography with often intriguing results.

The Canadian artist Jeff Wall uses the term "near documentary"
to describe his approach (see p.86). He starts with memories of
scenes that he has witnessed on the streets of his hometown of
Vancouver and then meticulously recreates them with actors in front
of his tripod-mounted, large-format camera. Other artists stage
scenes, notably Gregory Crewdson (see p.170) and his cinema-inspired
mise en scènes, but Wall's point of departure is street photography. In
an interview with art historian and critic David Shapiro, Wall said,
"I think in 1945 or 1955, it was clear that if you wanted to come into
relation with reportage, you had to go out in the field and function
like a photojournalist or documentary photographer in some way . . .
I think that's what people in the 70s and 80s really worked on: not to
deny the validity of documentary photography, but to investigate
potentials that were blocked before." With the "near documentary"
imagery, which feels like it depicts events in the real world, Wall
furthers the conversation by asking whether it can "make a claim
to truth via photography."

The computer desktop revolution has introduced another tool
with which to interrogate street photography. Both Yasmine Chatila's
series "Stolen Moments" (see p.20) and Peter Funch's "Babel Tales"
(see p.38), which at first sight appear as candid street shots, are in
fact digitally altered tableaux. Tod Papageorge asserts, "Now ideas
are paramount, and the computer and Photoshop are seen as
the engines to stage and digitally coax these ideas into a physical
form—typically a very large form. This process is synthetic, and the
results, for me, are often emotionally synthetic too." Nick Turpin,

British street photographer and founder of the online street
photography collective In-Public, adds, "I consider these images
easy to make compared to the process of creating a genuinely
extraordinary moment from the street, they are as much a tribute to
the engineers at Adobe as they are to the skills of the photographer."
By digitally tampering with an image, there is the sense that it loses
its authenticity. However, Funch counters these critiques by claiming
he is not interested in truth, "I don't see 'Babel Tales' as necessarily
'true or untrue.' I find this binary way of thinking quite boring. We
need other ways of conceptualizing truth."

A growing group of North American artists are focused on
exploring the contested area between classical and (choreographed
or digitally) constructed street photography. On the east coast,
Philip-Lorca diCorcia (see p.46) captures candid street shots but uses
a large-format camera and an extensive lighting apparatus to add a
veneer of theatricality to the ebb and flow of everyday life. Matthew
Baum (see p.34) endeavors (in his words) to "flip the vogue for
'constructed' photography upside down" by making "observational
pictures in the 'real' world that look as if they have been staged." He
further complicates the work by turning to the digital process and
using Photoshop. On the west coast, Mirko Martin (see p.52) trains
his lens on the movie shoots that take place on the streets of
downtown Hollywood. His series "LA Crash" mixes cinematic and
real-life snapshots to leave the viewer guessing which portrays
"fiction" and which "fact."

Paul Graham's recent body of work, created when he moved to
the United States in 2002, offers an apposite end thought (see p.80).
His groundbreaking "American Trilogy"—consisting of "American
Night," "a shimmer of possibility" and "The Present"—examines
different aspects of the urban documentary photograph. Graham
expresses concern that the genre is stagnating; he elaborates, "It was
wonderful when it was invented. But it has to be alive, to grow, and
develop, just like the spoken word." It seems as if artists across North
America have already responded to Graham's challenge. This chapter
reveals the myriad inventive ways in which they are confronting and
taking the street photograph into the twenty-first century.

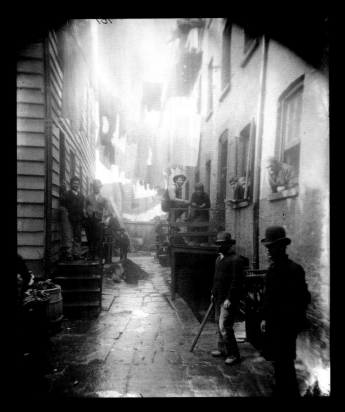

1		3	4
2			

1 *Bandit's Roost, 59½ Mulberry Street*, Jacob Riis, 1888 2 *Tempo of the City I*, Berenice Abbott, 1938 3 *Four Heads*, William Klein, 1955 4 *World's Fair, New York*, Garry Winogrand, 1964

NEW YORK

The streets of New York City have lured photographers from throughout the world for more than a century. Each borough, neighborhood and corner offers an opportunity to see something new through the lens, yielding images as varied as the city's street life. New York's built environment provides a dramatic backdrop: Manhattan, Coney Island, Central Park, and the subway system are just a few examples. Over the years, many renowned image-makers have immortalized this ever-changing urban center, each creating a distinctive vision of the city that provides a window onto a vast and complex metropolis teaming with an extremely diverse population. It is, after all, the people who are most often the subjects of the street photographer, and because of the often-assumed sense of anonymity provided by the city, photographers can catch people deep in thought and unaware of their surroundings. While photographic technology has evolved, so too have the ways photographers interact with the city and its people. From working with cumbersome equipment to using easily concealed portable cameras that allow working on the move, photographers have continued in their quest to create highly crafted expressions of the city.

Early on, photography in New York City took place in formal settings; portrait studios littered the city. It was not until the late 1880s—when technology enabled photographers to take to the streets and truly capture the spontaneity of their surroundings—that picture makers began producing a surfeit of cityscapes and street views. Among the first to pursue work on the streets were documentarians and professional photographers seeking to provide imagery for newspapers and newly emerging print media. Jacob Riis, a police reporter for the *New York Tribune*, was a social reformer who enlisted photographers Richard Hoe Lawrence and Henry G. Piffard to operate the camera. The trio photographed throughout Mulberry Bend, a slum notorious for its cellar beer dives and local toughs (see image 1). With the aid of newly developed magnesium flash powder, Riis drew attention to the crime, poverty, and deplorable housing conditions during the height of European immigration to New York City. At nearly the same time, commercial photographers created street imagery of a very different sort. Firms such as the Byron Company, a family business founded in 1892, took to the streets, photographing architectural views, interiors, street scenes, and

outdoor events for newspapers and any client with the means to pay for their services. Despite their different incentives, both Riis and the Byron Company were creating documentary photographs intended to describe the city—its flaws and its wonders.

At the turn of the twentieth century, a group of serious amateurs strove to elevate photography from mere description to the realm of art. Led by the impresario Alfred Stieglitz, a group of photographers—including Alvin Langdon Coburn, Edward Steichen, and Karl Struss—created impressionistic images in technically challenging environmental conditions including rain, snow, and even darkness. Many also photographed subjects of contemporary city life previously considered unworthy of an artist's attention.

The next generation of photographers went one step further. Paul Strand, Walker Evans, Berenice Abbott, and others created "straight" photographs that utilized the camera's ability to record "fact" while embracing new perspectives, camera angles, and subjects that directly confronted issues of modern life. Strand created a series of street portraits and scenes that formally addressed composition, light and shadow, and picture planes in new ways. Abbott returned to New York in 1929, deeply affected by the work of French photographer Eugène Atget, and created a series titled "Changing New York" that highlighted the city's state of flux. Largely working from street level, Abbott's large-format photographs juxtaposed eighteenth-century tenement houses with gleaming modern skyscrapers, as pedestrians navigated horse carts, trolleys, taxis, and buses (see image 2).

Meanwhile, a cohort of photographers working from the 1930s through the 1950s for New York–based magazines such as *Fortune*, *Esquire*, *Vogue*, and *Harper's Bazaar*, came to be known as the "New York School." This circle included such luminaries as Bruce Davidson, Roy DeCarava, Robert Frank, Saul Leiter, Helen Levitt, Louis Stettner, and Weegee. Often employing a film noir sensibility, they translated the crush of urbanity, freezing New York's spontaneity into an art of precision and wit. The quintessential photographer of postwar New York associated with this group is William Klein. By experimenting with blurring, abstractions, close-ups (see image 3), harsh printing, and aggressive picture-making techniques, Klein produced a tense and claustrophobic vision of urban life. By the 1960s, photographers such as Garry Winogrand, Lee Friedlander, and Joel Meyerowitz (see p.18) embodied the contemporary *flâneur*—one who strolls through the city's streets, collecting images that reflect the feel of the modern urban experience. Winogrand photographed obsessively and exercised a keen intuition. Considered by many to be the consummate street photographer, he desired to see how the world looked when captured on film (see image 4).

The city continues to attract photographers of diverse styles, including Philip-Lorca diCorcia (see p.46), Jeff Mermelstein, Sylvia Plachy, and Gus Powell (see p.24), looking for the perfect moment to press the shutter release. Some things remain the same; New York is still dominated by the street grid, which dictates pedestrian patterns and forces a type of choreography that is unlike any other city. The mixture of towers and low-rise tenements create unique lighting situations—notably the sharp and angular shafts of light slipping through skyscrapers. This, along with the extraordinary diversity of people and personalities, continues to provide photographers with limitless possibilities. In the city that never sleeps, the next great photograph is less than 1/30th of a second away. **SC**

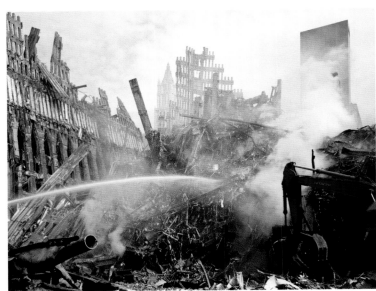
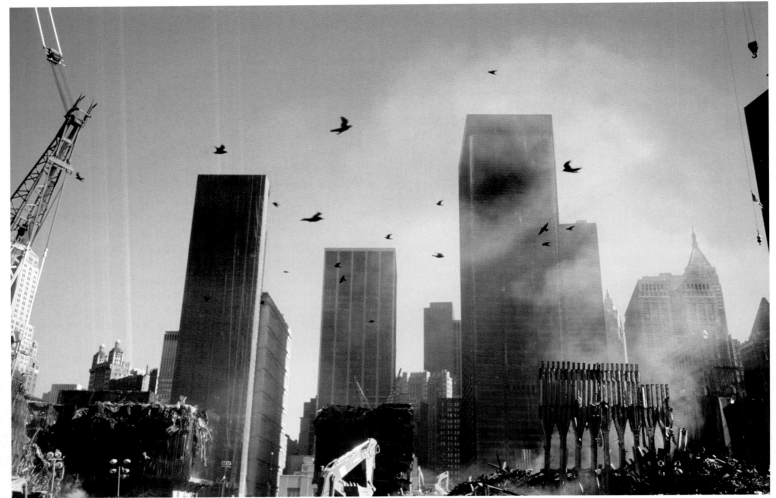

NEW YORK
BORN 1938, New York, USA LIVES New York STUDIED Ohio State University,
Columbus SERIES "Out of the Ordinary," 1970–80; "Aftermath: The World Trade
Center Archive," 2001–02 OTHER GENRES Portraits, landscape

JOEL MEYEROWITZ

Joel Meyerowitz is one of the most renowned street photographers around today. In the late 1960s and early 1970s, he would pound 5th Avenue with Garry Winogrand, their Leicas at the ready. "We just walked all day long," he recalls, "It was as if we were fishermen in the stream of 5th Avenue and we were just looking at all the specimens that came up." He framed these specimens in the aesthetic of the New York School, but with one crucial difference, he did so in color. At the time, color photography was only just becoming accepted as an art form; William Eggleston was yet to have his legendary show at the Museum of Modern Art (1976). However, many of the pictures Meyerowitz made during this period are now considered iconic.

Meyerowitz believes his home city is due some of the credit: "New York is really different from most cities," he claims, "the grid design allows streets to run for miles straight ahead and so the energy on these streets is funnelled. . . . When you participate in that . . . you flow with it and you feel that dynamic. . . . It's a modern experience." So when his much-cherished city was attacked on September 11, 2001, and he learned that police were not allowing photographers in, he recalls, "Sometimes life just gives you the push you need. No photographs meant no visual record of one of the most profound things ever to happen here. . . . As I walked past the press corps, penned in and waiting, my fury gave way to a sense of elation. I was going to get in there and make an archive of everything that happened at Ground Zero."

Within a few days of the attacks and with no small amount of cunning and determination, he gained access and began taking photographs on site. Day after day, while still waiting for permission from City Hall, he returned, becoming expert at forging workers' passes and wearing the right uniform, adding "You also had to look the part: backwards hard hat, respirator round the neck, duct-taped pants' legs, so that the jagged pieces of steel couldn't catch in them and pull you down." In the end he managed to work Ground Zero for nine months: from September 23, 2001 to June 21, 2002. Looking back, he was the only photographer with unimpeded access and the images he made (nearly 8,000 in total) are gathered together under the title "Aftermath: The World Trade Center Archive."

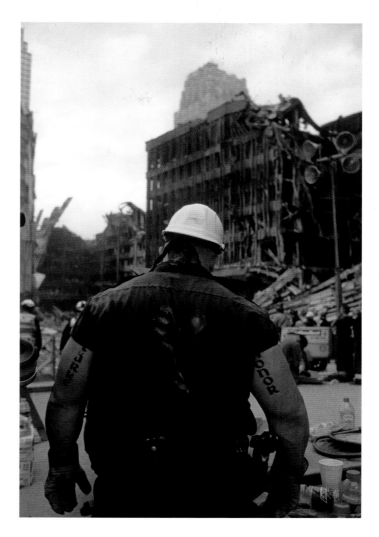

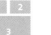

1 *Workers with the Thousand-ton Crane, Lifting Columns on the North Tower Debris Pile*, New York, USA, 2001
2 *The Base of the North Tower*, New York, USA, 2001
3 *Looking East, Smoke and Birds*, New York, USA, 2001
4 *An NYPD Rescue Worker*, New York, USA, 2001

For this project Meyerowitz used three cameras: a 35mm Leica, a 6x7 Mamiya, and a wooden Deardorff 4x5 view camera. The frames are mainly devoid of people so he was able to use long exposures. Consequently, the imagery is dense with detail, color, and depth. He says, "I wanted to communicate what it felt like to be there as well as what it looked like." These dystopic cityscapes ultimately provide much more than Meyerowitz's initial hope of creating a record; they also read as a celebration of those who worked at the Twin Towers site after September 11 and a eulogy to those who worked there before.

NEW YORK

BORN 1974, Cairo, Egypt LIVES New York, USA STUDIED Atelier Berino, Paris;
Parsons School of Design, Paris and New York; Columbia University School of the Arts,
New York SERIES "Stolen Moments," 2008–present

YASMINE CHATILA

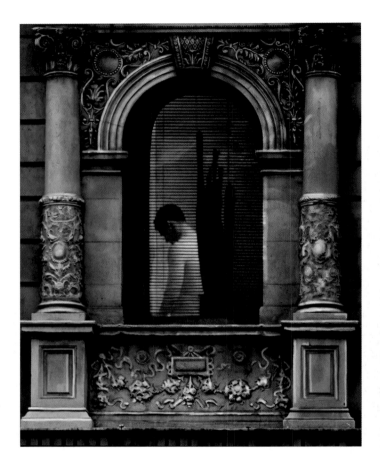

"A person who gains sexual pleasure from watching others when they are naked or engaged in sexual activity," is how the *Oxford English Dictionary* defines the word "voyeur." The Cairo-born, New York–based photographer Yasmine Chatila says of her work, "It is not sexual and that is the difference between the stigma associated with the word 'voyeur,' and what I feel I am doing." For eight months Chatila photographed her fellow New Yorkers through their windows, without their knowledge. Her series "Stolen Moments" exposes the whole gamut of human behavior that goes on behind closed doors around the hour of midnight: *The Kiss (Lower East Side, Sunday 11:37 p.m.)* reveals two men in a passionate clinch; *Naked Girl with Pills (West Village, Sunday 12:56 p.m.)* is as the title says; *The Bathroom Girl (City Hall, Wednesday 5:36 p.m.)* depicts a girl naked in the shower and the image that was the first to sell out, *The Bachelor (Wall Street, Friday 11:34 p.m.)*, portrays a couple having sex against a kitchen counter. "If your window is open and you're having sex in front of it, you must know people may be watching," Chatila suggests. "Of course, you don't expect the person watching to have a camera." Some critics have asked "Didn't you ever run into trouble? Didn't you ever get caught?" whereas others have alluded to the famous quote by famed New York photographer Diane Arbus, "I always thought of photography as a naughty thing to do." The series certainly explores notions of voyeurism and scopophilia—the pleasure of watching others—yet it also casts a light on deeper questions.

Chatila first conceived of the idea for the series on a winter's night in 2006 when a snowstorm struck the city. People were forced indoors and she took refuge with her neighbor, a film-maker. They started watching movies together to bide the time when she noticed a pair of binoculars on his windowsill. When she asked him about them, she recalls, "He told me he was spying on the neighborhood. I went home kind of creeped out." That same evening, the curtains in her front room fell down. She became so self-conscious that other people could see what she was doing that she returned next door and asked if she could borrow the binoculars. "I wanted to look at the people who were now spying on me in my imagination," she says. The watched turned watcher and once she started, she became

hooked, describing what she saw as "the theater of life . . . a gold mine for exploring human nature." It was then just a small step to start documenting what she was witnessing and the ongoing series "Stolen Moments" began.

She developed her own photographic system that enabled her better vision into people's rooms, by adapting a telescope to a camera that was fixed on top of a tripod. She took the first photographs in her own front room, but soon began asking friends and colleagues if they had, or knew of, rooms with expansive views over residential buildings. In this way, she traveled the length and breadth of Manhattan, setting up her photographic vigil sometimes for a few hours and at other times night after night, for weeks on end. She was endlessly surprised by people's behavior and by the rituals involved in their routine lives. For example, she soon

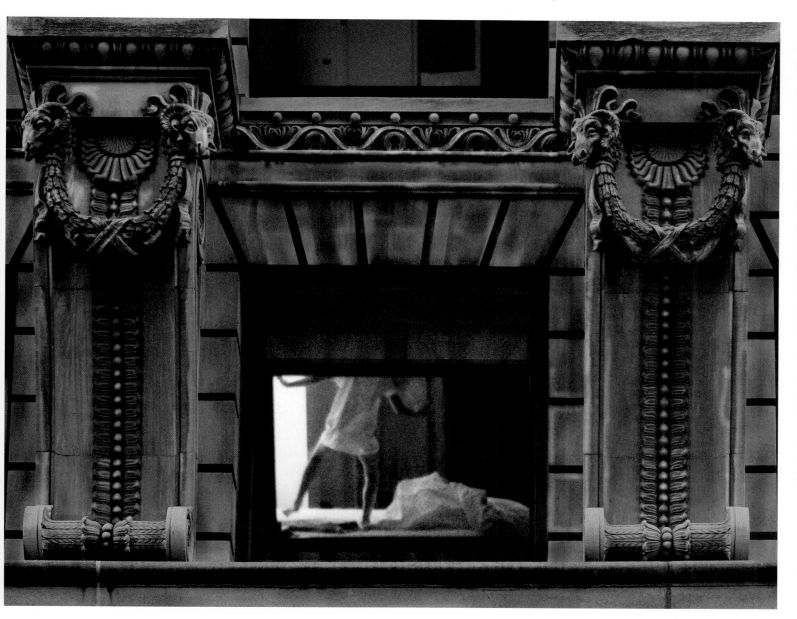

1 *Guy with Cactus (Lower East Side, Sunday 9:52 p.m.),* New York, USA, 2008
2 *Girl Bouncing on Bed (West Village, Tuesday 7:12 p.m.),* New York, USA, 2008

discovered how the woman portrayed in *The Bathroom Girl (City Hall, Wednesday 5:36 p.m.),* "took a shower every day at the same time with no curtain between herself and the window" despite the presence of the office building opposite teeming with workers. Chatila adds, "I think she actually found pleasure in the idea that entire floors filled with people could witness her."

"Stolen Moments" has been compared to "The Jazz Loft Project" by the famous U.S. photojournalist W. Eugene Smith. Between 1957 and 1965, Smith exposed 1,447 rolls of film from his fourth-floor apartment in New York's flower district, taking photographs of people in the streets below without their knowledge or consent. In a similar vein, one could argue similarities with Walker Evans's

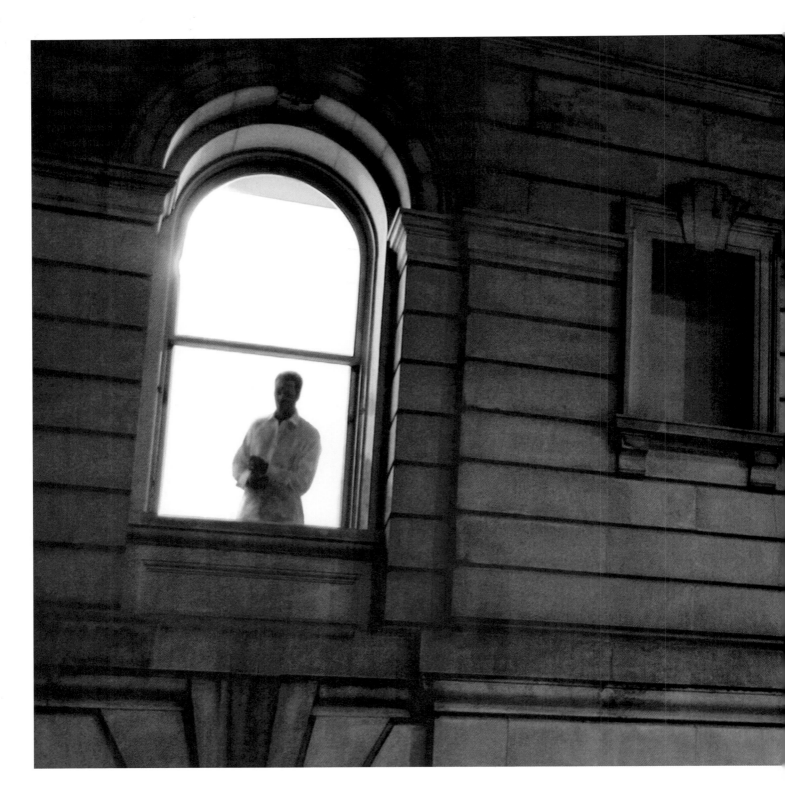

3 *The Wall Street Guy (Wall Street, Monday 9:34 p.m.),* New York, USA, 2008

celebrated series from the early 1930s to 1940s, "Subway Passengers, New York City," and French photographer Luc Delahaye's more recent series "L'Autre" (1995–97; see p.156), which captured unsuspecting commuters on the New York City Subway and Paris Metro respectively. Both series of photographs set out to reveal what people looked like when they did not know they were being watched. However, although Evans, Delahaye, and Smith, like Chatila, photographed people without their knowledge, they did so in public places. In contrast, Chatila trained her lens on individuals when they were in private places, where they assumed they were shielded from prying eyes. "I was always very surprised at how different people looked from when they were on the street," she observes: "Something so tender and raw comes out of people when their social masks are left at the door. It's as if they are naked unto themselves."

Despite their similarities, however, far more fundamental differences are at play between these various bodies of work. Most importantly, before anyone ever saw her images from the series, Chatila heavily manipulated them in Photoshop. She disguised the façades of the buildings and reframed the interior "dramas" with completely different windows. "I don't think people realize how much these pictures are altered," she states, "All the objects in the house are also changed.... Faces, noses, eyes, and hair are either obscured, blurred or transformed altogether." For ethical and legal reasons, she did not want people to recognize themselves or their friends and family. Influenced by the aesthetics of film noir and French New Wave cinema she created imagery with deep black shadows, grainy textures, and mysterious atmospheres. In her mind, Photoshop "became a kind of canvas for storytelling"; the individual windows within the series became screens on which the viewers could project their own voyeuristic fantasies.

Throughout the period she has worked on the "Stolen Moments" series, Chatila has been endlessly fascinated by the people who seem to go about their lives without ever covering their windows. "It seems to me that the lonelier ones don't close their curtains. Maybe they have an imaginary witness to their lives and it keeps them from feeling lonely," she wonders, "the anonymous voyeur eye." Ultimately, she discovered she was as intrigued by the mundane, lonely moments she encountered as the titillating scenes, and she feels that the experience has changed her. "Spending time with strangers has brought me closer to humanity. When I walk the street I no longer feel surrounded by anonymous drones. I see people with their insecurities and their vulnerabilities. It has inspired a feeling of being connected to others."

NEW YORK
BORN 1974, New York, USA LIVES New York SERIES "Lunch Pictures," 1999–2003;
"Mise en Scène," 2010–present INFLUENCES Joel Meyerowitz, Garry Winogrand,
Paul Graham, Joel Sternfeld, Sophie Calle OTHER CITIES WORKED Amsterdam

GUS POWELL

"So how do we make street photographs after Winogrand?" asked
the U.S. photographer Tim Davis. "The postmoderns knew. You don't."
However, he goes on to claim that his fellow New Yorker Gus Powell
has managed. He hails him as "a Metamodern, a post-Postmodern
artist for whom the arch arguments of high-concept photography
have lost their savvy anguished punch," saying quite rightly that
Powell's street work "is as much a measure of his New York as
Winogrand's was." Powell has produced two bodies of work in
Manhattan—the "Lunch Pictures" and "Mise en Scène"—both of which
present a way of framing the city that is quintessentially his own.

In the mid 1990s, Powell worked as a photo editor at *The New
Yorker* magazine. Much as he loved his job, he felt unable to devote
time to what he was most passionate about: not editing but making
his own photographs. Then a friend sent him a copy of *Lunch Poems*
(1964) by the U.S. writer, Frank O'Hara. The story goes that in
Manhattan in the 1950s and 1960s, at noon on weekdays, O'Hara
would leave the Museum of Modern Art (MoMA), where he worked
as a curator, wander along 5th Avenue to the Olivetti typewriter
showroom where he would sit down and punch out poems during
his lunch hour. "This pocket-sized book of poems was a catalyst for
me. I realized what could be achieved in the space of an hour," recalls
Powell, "It was the licence I needed to pursue photography." The *New
Yorker* offices are not far from MoMA, so Powell found himself
retracing O'Hara's half-a-century-old footsteps through midtown
during his lunch breaks. In place of a pen or typewriter, Powell had
a 35mm film camera, which he used to capture the slices of real life
poetry unfolding in the Manhattan streets around him. The result
was the "Lunch Pictures."

The time limitations implicit within the lunch hour framework
focused Powell's mind. He discovered that moments of drama or
wit would happen naturally, but they were sadly rare. Instead his
camera quickly became attuned to the seemingly insignificant
moments that busy New Yorkers usually overlook, such as how
light plays across the city's surfaces or how shadows shift, and
he soon started to learn how to maximize his chances of success.
"One thing I think about is how generous the sidewalks of New
York are," he confides. "If you have an idea for what you might
like to see . . . and if you are ready for it . . . it often comes." For
example, with *Four Heads* (see image 1)—his homage to legendary

| 1 | 3 |
| 2 | 4 |

1 *Four Heads*, from "Lunch Pictures," New York, USA, 1999–2003
2 *Blue Frieze*, from "Lunch Pictures," New York, USA, 1999–2003
3 *Regrets*, from "Mise en Scène," New York, USA, 2010–present
4 *Heaven and Hell*, from "Mise en Scène," New York, USA, 2010–present

U.S. street photographer William Klein and his piece *Four Heads* (see p.17) from 1955—he waited for the picture to develop. He remembers, "First I took pleasure in the light on that corner, then I took pleasure in how the two heads that are inside the cafe are faux reflections of the faces of the two men on the sidewalk."

Yet he also learned how to more proactively take control of his surroundings; more specifically, how to realize the inherent order beneath the seeming chaos of the streets. He discovered how something as simple as shifting a trash can into the flow of oncoming pedestrians enabled him to redirect their movement to his advantage. He points out how "corners are fantastic because they give you two opportunities," two possible frames through the simple act of

pivoting. He discovered how the continuous rush of people exiting a subway, or perhaps a department store, provides a whole new set of circumstances and therefore possibilities. He argues for staying rooted to one spot and slowly understanding its rhythms of light and movement, "You get to really become a student of the pedestrian theater and then in turn you get to become the director of it, because through photography you do get to control it and find that one moment when these things that seem like they're out of control, actually have an order."

In 2004 when Powell left *The New Yorker* and concentrated on photography full-time, he broke away from his home town, traveled and tried out new projects. He also worked alongside his wife Arielle

5 *Busy Busy Busy*, from "Mise en Scène,"
New York, USA, 2010–present
6 *Tributary*, from "Mise en Scène," New York,
USA, 2010–present

Javitch as the art director on the movie she was making, called *Look, Stranger* (2010). During these years, a notion slowly gestated in his mind: he started to see the city as a stage set on which he could direct its inhabitants much as a theater or film director constructs a scene. Therefore when he set about his second, still ongoing street photography project in 2010, he already knew where he was headed and gave the series the cinematic title "Mise en Scène."

The resulting images portray Powell's predilection for distance, yet they have become even more complex. As usual, he frames his characters head to toe, but he also quite often includes more than a few within his viewfinder. Through the simple act of framing, he implicates these people as characters, as protagonists in his dramas.

The images also appear more formal. He often takes advantage of the blank canvases the city has to offer, in particular, the solid panels of blue that are used to hide construction sites. There is a sense that Powell has somehow controlled every element, and that when set against these theatrical backdrops they seem to assume a new significance and connote meaning. "I aim to make hard-to-get, well-earned pictures where great care is given to the edges," he asserts, "they do not read simply as straight street photographs, but they tell a story." Powell's images capture the day-to-day dramas on New York's streets that other people miss, that even the people present within the frames miss; like a movie director, he steps in and seems to alter reality to create a slice of fiction.

1 *545 Eighth Avenue, New York I: February 6, 1994.* Unique silver gelatin print. Dimensions 66 ½ x 42 ⅛ in. 2 *Grace Building, IV: March 4, 2005.* Unique silver gelatin print. Dimensions 66 ½ x 42 ⅛ in. 3 *Times Square, New York, VIII: September 5, 2007.* Unique silver gelatin print. Dimensions 66 ½ x 42 ⅛ in.

BORN 1960, Kaiserslautern, Germany LIVES New York, USA STUDIED Akademie der Bildenden Künste, Munich; School of Visual Arts, New York SERIES "Urban Landscapes," 1994–2010 OTHER CITIES WORKED Vienna, Basel, Venice

VERA LUTTER

At first glance these landscapes of New York City appear to have been taken at night; inky black skies and skyscrapers bathed in eerie lunar light, with occasional illuminated windows hinting at their residents' nocturnal activities. Yet, all these images were actually exposed during broad daylight. In fact, they are monumental negatives that render sunshine black and shadows white, their subjects fixed in reverse. Moreover, they are created without the use of a camera. The artist instead transforms whole rooms in warehouses, factories, office blocks, and apartments, into a type of "camera" that was invented centuries before the advent of photography.

In 1993 Vera Lutter left her German homeland and moved to New York. She is so enamored with the city that she remains there 20 years later. When she first arrived, she had recently graduated from the Akademie der Bildenden Künste in Munich; trained in conceptual art and sculpture, she had reached an impasse. "I had come to a point where I didn't really quite know how to continue," she recalls: "It was actually rather a serious crisis." However, the city of New York soon provided welcome inspiration. She found a loft space on the 27th floor, in the Garment District of Manhattan. It was an illegal sublet in a commercial building. "I was overwhelmed and incredibly impressed by the city, the light, the sound, the busyness of the streets." She recollects her loft in particular: "through the windows, the outside world flooded the space inside and penetrated my body. It was really an impressive experience on all levels and I decided to turn it into an art piece."

She conceived of the notion of transforming her room into an enormous pinhole camera. This involved blacking out the windows, but leaving a tiny hole through which a beam of light from outside could enter the darkened room. In effect, she had created a camera obscura — an apparatus that projects a moving image of the outside world inside. It was most likely developed in Europe during the thirteenth or fourteenth centuries, although it was not until the Renaissance that it was perfected as an instrument of vision. In 1544 it was used to demonstrate a solar eclipse, and in 1558 Giovanni Battista Della Porta suggested using it in combat to view battle scenes unfolding. It also attracted artists; academics have suggested that Vermeer may well have taken advantage of the camera obscura to paint his *View of Delft* (c. 1660–61) and so too did Canaletto for his celebrated views of Venice. However, Lutter added photosensitive paper in order to record the views cast by her camera obscura.

Lutter chose to hang a vast piece of photographic paper on the far wall of the room opposite the pinhole. "The scale was a given, as the space I was working with was architectural and the wall onto which I projected was the wall of the room," she explains. As her eyes adjusted to the dark, she began to witness the images from her urban neighborhood flood in, and play out in real time, reversed and inverted, across the room of her loft. These ephemeral, ghostlike apparitions made a strong impression on Lutter. "The first time I created a camera obscura," she describes, "I thought I'd seen God. When I saw the first projection, it was an epiphany. It was probably one of the most overwhelming moments of my life."

Using the New York skyline as her muse, she set about patient but keen experimentation, perfecting in particular the exposure times. These turned out far longer than she had first anticipated in order for the traces of light to imprint on the paper. However, eventually she hit upon the method she still uses to this day using exposures that can last hours, days, weeks, and sometimes even months. Consequently, her frozen images record the ebb and flow of the city, the passing of time. She elaborates, "I think of Andy Warhol's films, like *Sleep* or *Empire* where he points the camera in one direction and the camera records. What goes into many frames in his film would go into one frame in my image."

Given that Lutter likes to remain present in her camera obscura projects — most recently she has swapped rooms in buildings for rented shipping containers — she is able to see a real-time project like a movie and observe how it accretes on the photographic paper. "I see the cars driving through the image, I see . . . birds and airplanes flying through," she explains, but because fast movements do not register, her urban landscapes appear strangely depopulated. Her presence within the camera enables her to choreograph how the light falls on the paper and how the image gradually accumulates. Indeed, she will cover up areas that have received the most light, enabling less exposed areas to catch up. However, there is also a conceptual, perhaps performative, reason for her presence; it harks back to her first, defining experience when "the outside world flooded" into her loft and "penetrated" her body.

Crucially, Lutter wants her imagery to remain as direct and immediate as possible. For this reason, she knew from the start that the negative would form the actual artwork. In the typical photographic process, a negative undergoes re-exposure with a flash to create a direct positive: subsequently repeated to create multiple positive prints. By contrast, Lutter's image dispenses with this step. Her method echoes an idea the French philosopher Roland Barthes toyed with in his seminal treatise on photography, *Camera Lucida* (1980): "From a real body, which was there, proceed radiations which ultimately touch me, who am here. . . . A sort of umbilical cord links the body of the photographed thing to my gaze." He may have been talking about portraiture, but the idea applies equally to Lutter's urban landscapes. The light that bounced off the streets and thoroughfares of Manhattan is the same that meets the viewer's gaze when looking at these images in a gallery. As Barthes might have said, the city and the viewer are joined by an umbilical cord of photons, and as Susan Sontag might have added, through Lutter's pictures the New York skyline touches us "like the delayed rays of a star."

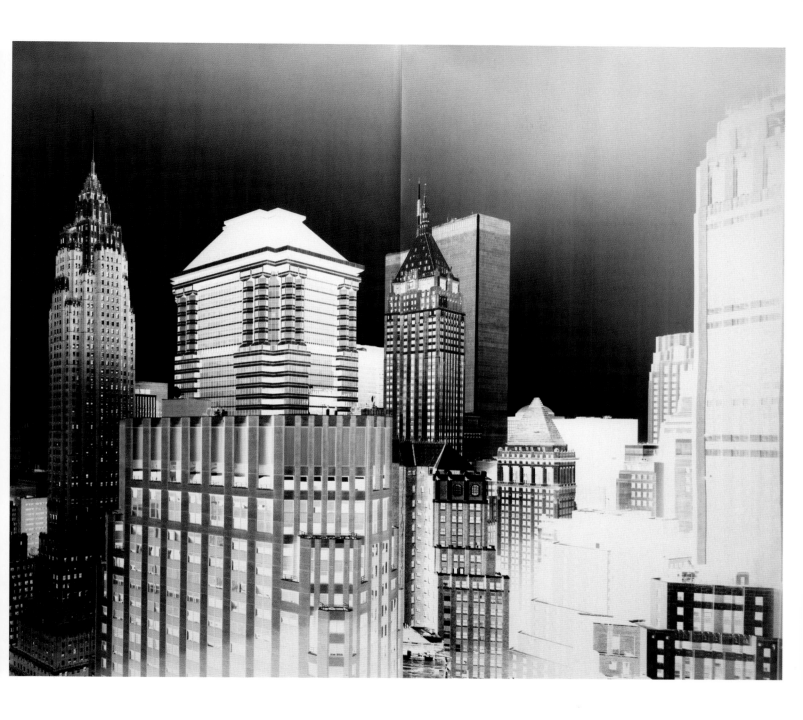

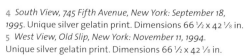

4 *South View, 745 Fifth Avenue, New York: September 18,*
1995. Unique silver gelatin print. Dimensions 66 ½ x 42 ⅛ in.
5 *West View, Old Slip, New York: November 11, 1994.*
Unique silver gelatin print. Dimensions 66 ½ x 42 ⅛ in.

1 *Self-Portrait*, New York, USA, 2012.
HDR ultra chrome archival pigment print.
40 x 60 in.

NEW YORK

BY AHN JUN

During the six years that I lived in New York City, I felt like I was in the middle of someone else's dream or fantasy. So many people's exciting experiences took place there, on the streets near to me. By contrast, my room was so quiet. Everyone seemed to enjoy partying, except me, working alone in my small studio. These three pictures show the boundary between the private and public space. In each, my body is located in exactly the same space, but what is seen looks so different. My body on the window ledge symbolizes the psychological boundary we face every day; the vulnerability of ultimate humanity. I think everyone is living somewhere on the edge. We are all living somewhere between birth and death, normal and abnormal, private and public, ideal and reality. Nobody completely belongs to any place; we are all in between. Therefore, for me, the present is a void between the past and the future, like my feet hanging between the void of the building and the street.

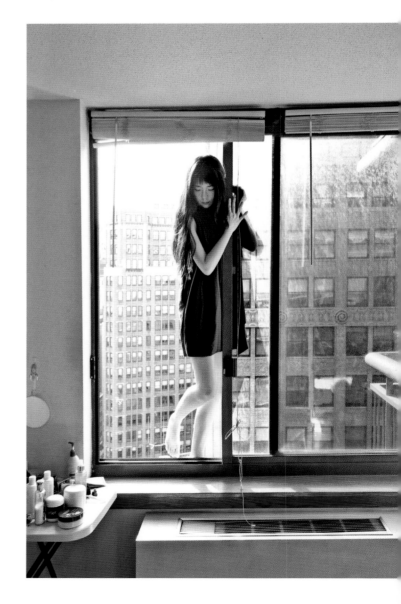

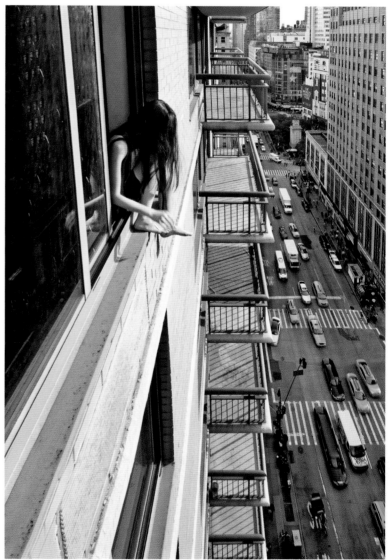

BORN 1973, Princeton, New Jersey, USA LIVES Brooklyn, New York, USA
STUDIED School of Visual Arts, New York SERIES "Eighteen," 2006–12; "Civil War,"
2011–present OTHER GENRES Landscape OTHER CITIES WORKED Gettysburg

MATTHEW BAUM

Matthew Baum is not the first to view New York as a photographic hunting ground: a place to prowl and track down unexpected moments of drama. The image of the suited man on his cell phone, *Untitled, New York* (see image 1), was shot on 5th Avenue, the favorite haunt of the famed street photographer, Garry Winogrand. When Baum recounts how he captured the image, his words echo the tried and tested formula for the genre: "I was wandering around midtown with my camera. The light was extraordinary. I was at 53rd Street and 5th Avenue, when I saw him," he recalls. "I was instantly focused and thrust into that primal space that happens when you lock in to make a picture on the street." However, unlike Winogrand and other past masters, whose cameras seem to snatch moments from the flow of time, Baum's lens extracts an uncanny stillness from the streets, as if they are somehow released from the moment, or from time itself.

Baum very nearly did not become a photographer. Having graduated from Brown University with a degree in history, he started studying architecture at Harvard University's Graduate School of Design but dropped out. "I knew it wasn't the right path for me, but I didn't know what I was going to do next," he remembers. He ended up taking a 32,000 kilometre trip around the United States with only a camera for company—"a beautiful old Nikon F that my uncle had bought in Japan in 1968." This decision changed his life. On returning, he enrolled in a photography Master's degree at the School of Visual Arts in New York and committed himself to a career of making "pictures spontaneously in the 'real' world, letting the camera guide me."

Untitled, New York, is from the series "Eighteen" that Baum worked on throughout graduate school. The title of the series denotes the number of images in the portfolio, but also the Hebrew word "chai" that translates numerically as "18" and linguistically as "living" or "alive." This image holds particular significance for Baum; it was the image that began the series. He had been exploring ideas and recalls, "I was probably primed for some sort of breakthrough. Fortunately I happened on this guy [and took the shot]." What piqued his interest, however, was how his fellow students reacted to the picture; they asked whether the man was a model, whether he had been choreographed into position, whether the scene had been entirely set up.

1 *Untitled,* New York, USA, 2007

The students had mistakenly classed Baum's work as part of a movement in contemporary art known as "constructed photography" in which artists, including Jeff Wall (see p.86) and Gregory Crewdson (see p.170), have enjoyed considerable success staging scenarios that mimic reality. "At first, the response and questions were a surprise to me," Baum recalls, "but it got me thinking." He realized that the strange stillness evident in *Untitled* lends it a degree of theatricality; it appears almost as a moment frozen from a play. The episode enabled Baum to formulate the concept that eventually led to "Eighteen"; he decided that he would create a series that would, as he says, "flip the vogue for 'constructed' photography upside down" by making "observational pictures in the 'real' world that look as if they have been staged."

Baum's tutor, street photographer Philip Perkis, had always warned: "You can't shoot and think at the same time," so Baum set about carefully analyzing the image after it had been shot in order to understand what he had been doing intuitively. At the time, he had been researching certain painters, particularly those who used light and set up their canvases in a theatrical way. In terms of influence, he cites various names from Caravaggio to Courbet, but raises one above all others: that of the U.S. realist painter, Edward Hopper. In fact, when he was about to press the shutter on *Untitled* he recalls thinking that it was like "witnessing a live-action, twenty-first-century Hopper painting." On closer examination, two aspects of this exposure especially resonated with Hopper's tableaux—the lighting and the framing.

Untitled was shot in the late afternoon, when Baum believes the light in New York is at its most dramatic, "when it is low, and chopped and filtered by skyscrapers, and only hits certain corners." The effect is one of chiaroscuro—bright highlights contrast against velvety dark shadows. Indeed, it is so theatrical that the man could be an actor standing on a stage illuminated by floodlights. Furthermore, the

framing feels expansive, the composition very much self-contained, and one even sees the subject's full body; all these factors insinuate the sense of seeing a performance on a stage. On realizing which lighting and framing options he had instinctively favored, Baum decided to hunt for similar situations when next out on the streets, explaining, "I began to look for certain types of lighting and to consistently frame the pictures in a way that suggested a stage, almost always showing people as full-figures."

Gradually the series began to take shape but there was one final turning point: Baum switched from film to digital photography. "When I started shooting digitally, things really broke open," he says, "there was something new about the quality of the images." He discovered that with the digital process, unlike film, he could use

Photoshop and printing processes to give the photograph what he describes as "a certain hyper-reality." Baum's post-production techniques lend his imagery a distinctive aesthetic; they are crisp, almost hard-edged and depict an almost unreal perfection. However, this intervention has received a fair amount of criticism from more traditional street photographers. Nick Turpin says of *Untitled*, "The picture and Baum move across a border, they cross my 'red line' into a new region of photography, a region that I respect less because it is easier to do." Baum counters, "Over the last few years, it has been my goal to push the boundaries of what a street photograph is. . . . Any genre of art is only alive so far as its rules are being challenged." Ultimately, Baum's work throws up a multitude of questions, about the nature of street photography and the nature of photography itself.

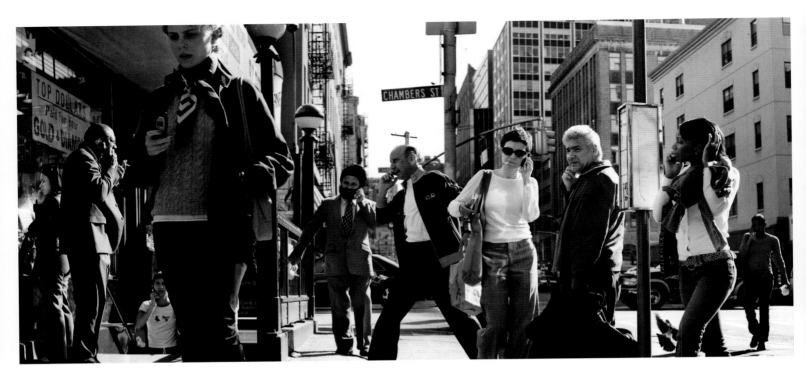

NEW YORK

BORN 1974, Denmark **LIVES** New York, USA **STUDIED** Danish School of Media and Journalism **SERIES** "Babel Tales," 2006–10 **OTHER GENRES** Documentary, fine art **OTHER CITIES WORKED** Copenhagen, Amsterdam

1 *Communicating Community*, New York, USA, 2007
2 *Memory Lane*, New York, USA, 2008
3 *Informing Informers*, New York, USA, 2010

PETER FUNCH

"It's my corner after all. I mean its just one little part of the world but things take place here too, just like everywhere else." This is how Auggie Wren (played by Harvey Keitel), the central character in Paul Auster's movie *Smoke* (1995), explains his obsessive project of photographing the same New York street corner outside his shop, every day for more than a decade. As Paul Benjamin (William Hurt) flicks through the resulting stack of albums, Auggie continues, "You'll never get it if you don't slow down. . . . They're all the same but each one is different." This scene similarly inspired the Danish artist Peter Funch when he first arrived in Manhattan. Like Auster, Funch was captivated by the infinite possibility of how the lives of the city's inhabitants unknowingly intersect as they go about their daily business; he adds, "It's an island with so many stories, references, history and mystery."

In the summer of 2006, Funch took to the avenues of New York to capture life in a radically different way from street photographers of the past. The resulting series "Babel Tales" (2006–10) portrays the typical city hustle and bustle, yet with uncanny repetitions and coincidences. In the early works, he focused on people performing similar behaviors: holding manila envelopes (see image 3) or mobile phones (see image 1). His fascination with the repeated recurrence of certain human behaviors calls to mind urban anthropology; he admits, "I am very interested in how we function as people in a large city; where does the individual end and the group begin." Over time, he started to picture more complex, yet subtle patterns. He captured people posing for and taking photographs (see image 2). He hunted out the various ways pedestrians entertain themselves as they walk the streets: some with heads in books, newspapers, or magazines; others typing, tweeting, or texting on their phones. He recalls, "In *Two to Tango* [see image 5, p.41] I documented pairs of various types." There are twins, people out with their dogs, pregnant women, a mother and child, even couples seemingly reflecting their partners behavior. In all of Funch's street panoramas, the echoes within the frame seem endless, so much so that one begins to question what one is looking at and for good reason; these are not your everyday street photographs.

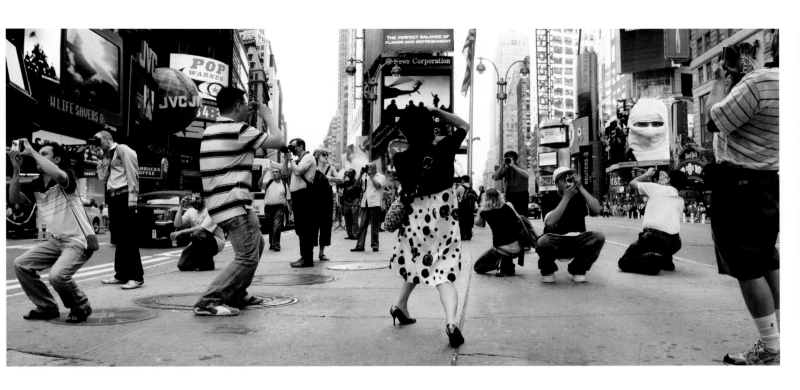

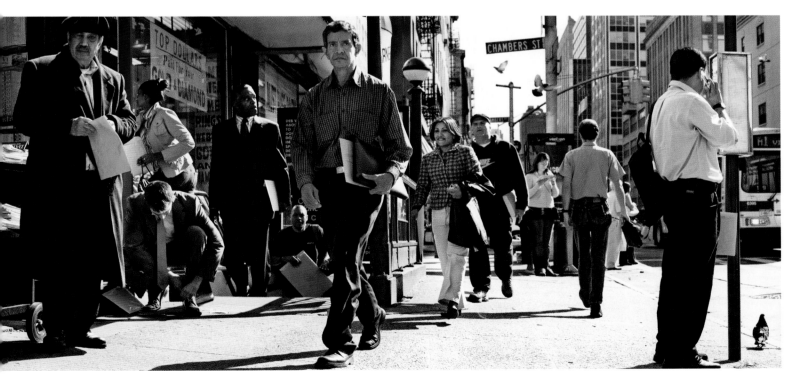

When making an image, Funch starts out a little like Auggie Wren. "I find the place with the right flow and the right types of people," and every day "I come to the same spot, at the same time and shoot there." Unlike Auggie, however, he only stays in one spot until he has what he needs, which will generally take between ten to fifteen days. Back at his studio, Funch painstakingly reviews the thousands of exposures he has made of one street corner, each identically framed but captured at different times, on different days or even weeks. He begins by hunting out recurring behaviors, repetitive patterns, and other odd confluences within the crowd, and then digitally superimposes and stitches them together. The end result is a composite of several hundred frames, where split seconds have been plucked from the flow of time to create one moment. Funch calls it the "perfect moment . . . the moment where all these tracks are crossing." Henri Cartier-Bresson's decisive moment becomes multiplied, multilayered and transformed into an extraordinary constructed moment.

Such overt manipulation might seem an unusual choice for one who first trained as a photojournalist. He elaborates, "I used to be interested in the true story, but I guess I've now become fascinated by how you understand the story . . . and compelled to tell my own stories, to bend images to my will." He is clearly influenced by cinema history, and talks of how certain movie narratives other than *Smoke* have provided inspiration, citing Robert Altman's *Short Cuts* (1993) and Paul Thomas Anderson's *Magnolia* (1999). These scripts deal in Funch's fascination with what he phrases as "the almost magical and serendipitous interconnectivity of different lives." However, by framing every picture in "Babel Tales" with cinema's widescreen aspect ration, he also emulates the movie aesthetic and experience.

The effect is certainly more immersive as it takes up most of the viewer's visual range. Moreover, this play between the photograph (a medium associated with reality) and cinema (a medium that deals in make-believe) sets up an interesting tension. Themes of truth and fiction run throughout "Babel Tales." Funch frames the discussion by claiming that the images are neither completely real nor completely fiction, then adds, "Everything depicted in 'Babel Tales' is true to life." He likens his process to an iconic shot taken by the Italian Futurist Anton Bragaglia a century ago, *The Cellist* (1913). By making repeated exposures of the musician playing, Bragaglia froze and sliced their movement across a single frame. "'Babel Tales' isn't any different," argues Funch, "The technologies and techniques are just more advanced." To accusations that his pictures are "mere fiction," he asks whether adding the element of time makes his work any less real.

Perhaps it is more apt to say that "Babel Tales" exists somewhere between truth and reality. The viewer looks to each image and the same questions recur: what aspect is authentic and what is staged; is any of it real and does it matter? The series was conceived to invite speculation and Funch welcomes the discussion. "I don't see 'Babel Tales' as necessarily 'true or untrue.' I find this binary way of thinking quite boring. We need other ways of conceptualizing truth." He looks forward to a time when digital photography and other ways of tampering with the photograph proliferate. He argues that it will lead to an improved understanding of photography. His work begins to challenge our notion of the photograph, any photograph—even one that has not been digitally manipulated—as a "truthful" depiction of a moment in time. Ultimately, Funch's "Babel Tales" calls into question our understanding of the entire photographic medium.

NEW YORK
BORN 1970, Kye-Chang, South Korea LIVES Seoul, South Korea STUDIED
University of Korea, Seoul; New York University, USA SERIES "Projects," 1997–2001
OTHER GENRES Performance OTHER CITIES WORKED Seoul

NIKKI S. LEE

Nikki S. Lee is hardly a street photographer of the traditional mold.
Indeed, her work is as much performance art as it is photography.
However, her pictures are rooted to the city; their material is gleaned
from its streets. Lee is drawn to the kaleidoscopic diversity of urban
subcultures. In her first series "Projects," Lee shape-shifts like Woody
Allen's hero, Zelig; image after image reveals her posed in multiple
guises hanging out within all sorts of gangs. Although she has
traveled the length and breadth of the United States, she finds
most inspiration in New York. There, she has insinuated herself into
a variety of communities across its colorful neighborhoods—from
the lesbians of Greenwich Village to the yuppies of 5th Avenue, from
the Hispanics of Spanish Harlem to the Japanese fashionistas of the
East Village. Each project, each infiltration, is recorded on celluloid.

 Lee was born Lee Seung-Hee in a small village in South Korea
called Kye-Chang. When she arrived in New York in 1994, having
recently graduated with a photography degree from the Chung-Ang
College of the Arts at the University of Korea, she soon enrolled
in a photography Master's program at New York University. However,
before doing this, she decided to change her name. A friend sent
her a list of American-sounding options and Lee Seung-Hee became
Nikki S. Lee. The story hints at Lee's compulsion for new identities;
ironically, she later discovered that all the names on the list had been
plucked from a recent edition of *Vogue* and that she had chosen the
name of someone who dresses up and assumes disguises on a daily
basis: the fashion model Niki Taylor.

 The "Projects" series was conceived for her Master's degree. She
embarked on her first "project" in 1997 when, donning blonde wig,
killer heels, and layer upon layer of make-up she dressed as a male
transvestite and infiltrated the drag queen community at infamous
nightclub, Mother, in Chelsea, Manhattan. Bitten by the dressing-up
bug, she tried out different masquerades. That same year *The Drag
Queen Project* was joined by *The Punk Project*, *The Young Japanese
Project*, *The Lesbian Project*, and *The Tourist Project* (see image 2, p.44).
The following year came *The Hispanic Project* (see image 1), *The Yuppie
Project*, and *The Swingers Project*. The resulting imagery caught the
attention of a New York gallery and Lee was immediately offered
a solo show. Lee recalls, "It was 1999; I was still a student," and
her first instinct was to refuse. However, on getting to know the
gallery owner, she went ahead. That single show launched her

1

1 *The Hispanic Project (1)*,
New York, USA, 1998. C-print

career, and more successful projects have since followed; the last was *The Hip-Hop Project* in 2001 (see image 3).

Each "project" was meticulously researched. On targeting a group, Lee would spend as much as three months observing them. Like a method actor, she practiced their speech patterns and gestures. She studied their style; going on shopping trips to perfect the look. Like a consummate professional, her disguise knew no bounds; she dyed her hair, adopted dreadlocks, gained and lost weight, aged her face, and even changed the color of her skin. When gaining access to her chosen group, she would never disguise the fact that she is an artist and was always open about her intentions. For example, when she acquired her "fake girlfriend" for *The Lesbian Project* by hanging out in community discussions in Greenwich Village, Lee recalls, "She knew

what I was doing, so she really participated in the work. . . . We were both performing." Each project reveals a similar collaboration: everyone is in on the act.

As further evidence of collaboration, Lee chooses one of the gang members to take the photograph. She purposefully uses a small snapshot camera, because she says, "People are familiar with it. They don't get nervous." The critic Russell Ferguson observes how this decision creates images that are "authentically amateur snapshots"; they reveal an "artlessness" that registers "as 'real' for the viewers." Quite often, they are even branded with the date stamp typically found with inexpensive cameras, which as Ferguson adds, acts to provide "the mark of the real, of the specificity of a time and place, the evidence of a precise moment when a group of people were

2 3

2 *The Tourist Project (10)*, New York, USA, 1997. C-print
3 *The Hip-Hop Project (2)*, New York, USA, 2001. C-print

together." The overall process becomes a balancing act between where she retains and where she releases control. So although she hands over the camera to someone else, she masterminds the place, the time, the pose, the performance, the moment.

Lee has been accused of being an egomaniac. "I am interested in myself," she admits. "Changing myself is part of my identity. That's never changed. I'm just playing with forms of changing." However, her self-interrogation and her many faces have broader implications for how we view identity. The single, authentic notion of self—the individual—is very much a Western concept. Lee is more interested in the Asian notion of how people identify themselves in relation to their community. The art critic Carly Berwick discusses how Lee's work reveals that "Identity is not fundamental or innate but malleable,

created through interactions, in which who 'I' am depends to a large extent on who 'you' are." Her work has drawn comparisons with artist Cindy Sherman, however, while they both turn the camera on themselves, they perform very different roles. Sherman's Hollywood screen sirens are worlds apart from Lee's everyday settings. Lee herself says, "I want my pictures to look real and easy to believe, which is why I use a documentary snapshot style rather than theatrical, structured photography." "People compare her to Cindy Sherman," says Nancy Spector, curator of contemporary art at New York's Solomon R. Guggenheim Museum, "but Nikki's work is more a performance piece about how identities are consumed and used and fabricated. It ends in a photograph, but it's so much about the reality of it, that she's out there living it."

BORN 1951, Hartford, Connecticut, USA LIVES New York, USA STUDIED School of the Museum of Fine Arts, Boston; Yale University, New Haven OTHER GENRES Staged OTHER CITIES WORKED Tokyo, Los Angeles, Rome, Berlin, Calcutta

PHILIP-LORCA DICORCIA

Philip-Lorca diCorcia has traveled the four corners of the Earth in search of teeming, bustling streets. However, his current hometown of New York (more specifically its busiest intersection, Times Square) provided the setting for his best-known series, "Heads" (2000–01). Like the city's street photographers of the past, from Robert Frank to Garry Winogrand, diCorcia captures pedestrians unaware. Yet he goes to such lengths that his approach can hardly be described as traditional. He discards a hand-held 35mm in favor of a large-format camera; he mounts it on a tripod and frames passers-by through a telephoto lens from about 20 feet away. He also rigs up a complex lighting apparatus on street signs to lift it out of sight. Whenever someone interesting walks by, he presses the shutter and a radio signal trips the lights to flash.

Head #24 (see image 1) was created this way. Along with every other image in the series, it can be seen as an archetype of the street documentary genre; yet, it is also indisputably staged. Critic David Campany observes how people step "unwittingly into a pre-planned theater of flashlights" producing an image that oscillates between seeming reality and "cinematic spectacle and celebrity portraiture." The elaborate lighting contraption generates such a strong directional beam that it not only illuminates the subject's face but also throws those nearby into darkness. Such chiaroscuro picks out and spotlights the subject within the crowd, creating a portrait with a tangible sense of drama. DiCorcia describes it as "a cinematic gloss to a commonplace event"; indeed the woman in *Head #24* seems straight out of a movie. As with many of diCorcia's subjects, the woman's eyes are elsewhere; her face is slack, revealing an unposed expression. He suggests, "They become less aware of their surroundings, seemingly lost in themselves." Ultimately, they remind us that each one was oblivious to being photographed. To a degree, "Heads" recalls the famed series by Walker Evans, who from 1938 to 1941 rode the New York subway with a camera hidden beneath his overcoat to sneak shots of commuters. Like Evans, diCorcia "steals" images from the unsuspecting public, but, unlike Evans, he does not conceal his camera. "I never ask their permission. . . . I'm not sure I would like it to happen to me, but I maintain my right to do it," he declares. In a world saturated by surveillance cameras, it seems privacy in a public space, if it ever existed, is now a long-lost privilege.

1 *Head #24*, New York, USA, 2001

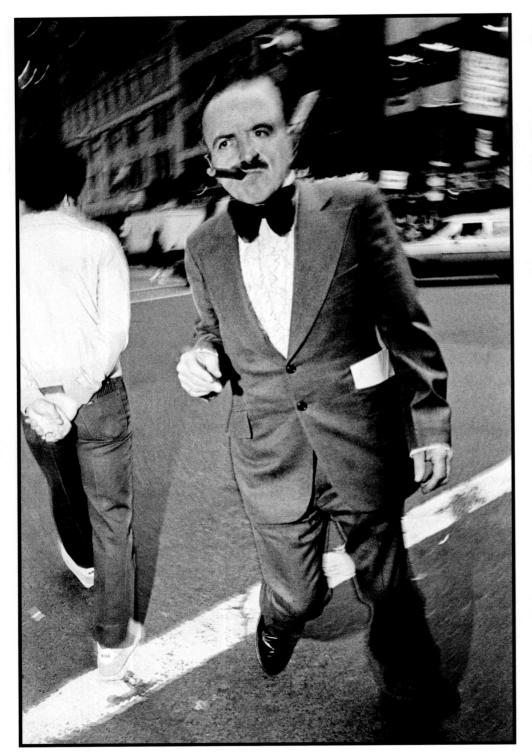

NEW YORK
BORN 1946, New York, USA LIVES New York STUDIED Self-taught in
photography OTHER GENRES Portraits, documentary OTHER CITIES
WORKED Tokyo, Port-au-Prince, New Orleans, Bogota, London, Moscow

BRUCE GILDEN

"I find it horrifying how everyone wanders around with their faces buried in cell phones," claims born and bred New Yorker Bruce Gilden. "Walker Evans said it better than me . . . 'Stare. It is the way to educate your eye, and more. Stare, pry, listen, eavesdrop.'" Gilden has developed a signature style that does just that and he exercises it to great effect on the people he meets on the streets of his home city. Yet, he believes there is an ethical stance to this staring; one has license as long as the person knows you are watching. "If someone was to take my picture, I'd like to know about it," he explains, "photographing people on a long lens from across the street feels like sneaking." By contrast, he opts for the close encounter, or rather the closer than close encounter. He walks right up to his subjects, who face his lens, and he frames them so tightly that the viewer is thrust into the center of the image. Like Gilden, the viewer becomes involved; he adds, "You're no longer an outsider, you become part of the theater." Moreover, you are no longer able not to stare, but crucially feel you have permission to do so.

Gilden may easily not have become a photographer. Growing up in Brooklyn with what he describes as a "tough guy" of a father, he drove a taxi and trucks, but being tall and with a naturally athletic frame, he dreamed of becoming a professional basketball player. However, he says he was not good enough and besides he was naturally drawn to the streets. He recalls they became like a "second home," saying, "I would look out of my second-storey window at the vigorous street activity below and I was hooked." He had recently read about Robert Capa, and was struck by his famous dictum: "If your photographs aren't good enough, you're not close enough." In the mid 1970s he tried putting this into practice at Brooklyn's famous beach where New Yorkers flock in the summer to escape the city heat, Coney Island. He would roam its famous boardwalk, Leica in hand, on the hunt for characters; then jump out and frame them between the cross hairs of his viewfinder. The resulting vertical, head-to-toe portraits were striking for their powerful expressions and eye contact. They launched his photographic career and in 1998 he was invited to join the legendary agency that Capa had co-founded, Magnum.

Over the years, Gilden's signature photographic style has remained true to its roots but it has also evolved. He explains, "I am trying to say more with less. My palette is becoming smaller and smaller." His framing has certainly got tighter; whereas he left space around the

 1–4 New York, USA, 1986–92

Coney Islanders, with the Manhattanites he condenses it to such an extent they appear cropped. "The older I get, the closer I get," he quips. Moreover, he now walks the city streets with camera in one hand and a flashgun in the other, saying, "The flash allows me to visualize the speed, the stress, the anxiety and the energy of the streets." The combined result of these tactics creates portraits that seem to pulse with energy and brood with psychological intensity. With the skill of a big game hunter, Gilden homes in on the shifting panoply of New York society, from its polished socialites to its sharp-suited hoods, and under his gaze their individuality is both celebrated and preserved.

LOS ANGELES

The first picture ever taken of Los Angeles was made by a photographer who climbed to the top of Fort Moore Hill and turned his camera southeast toward the Los Angeles Plaza. Likely shot between 1858 and 1862, the image shows whitewashed adobe houses around the main square with vineyards and orchards in the distance. The identity of the photographer is unknown, but experts suggest that the image is likely to be the handiwork of the city's first professional artist, Frenchman Henri Pénelon, who had a studio on Calle de Eterninad, where he painted portraits of the city's most prominent residents. The photograph's depiction of a semi-rural environment is slightly misleading, given it does not show the sectors to the north and south of the plaza, with their hotels, homes, and shops. Already, Los Angeles was a booming melting pot.

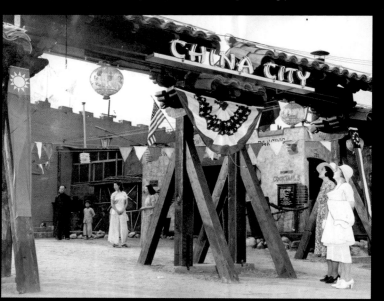

Californian photographer Edwin H. Husher took what are likely the first aerial pictures of the City of Angels on June 26, 1887 from a hot-air balloon. Taken for a publicity stunt orchestrated by publisher William Randolph Hearst for his newspaper the *San Francisco Examiner*, Husher's 13 images capture Los Angeles in its formative years, showing the outlines of the future urban behemoth.

One of the earliest practitioners of photography in Los Angeles was Charles Chester Pierce, who arrived in the city from Chicago in 1886 and remained until his death in 1946. A prolific photographer, he charted the changes in the city through the early 1920s, from muddy streets and horse-drawn trollies, to turreted mansions and streetcars. Aside from making his own photographs, Pierce acquired the negatives and prints of other regional photographers such as Emil Ellis, Herve Friend, and George P. Thresher. Pierce erased the signatures on their photographs, stamped on his name and organized the images into subject files, making it hard to establish the links between the photographs and their creators. However, Pierce's collection has become an invaluable archive documenting the people and architecture of the area.

As Los Angeles grew, so different areas like Chinatown took on distinct identities. A trawl through the archives of the *Los Angeles Times* reveals how the city took shape via imagery of openings, galas and so on. In the late 1930s, a mock Chinese village, China City (see image 1), flourished. Located near Olvera Street across from Union Station in Downtown Los Angeles, China City featured a Chinese-style temple, shopping arcade, lotus ponds, and rickshaw rides. The tourist development was destroyed by fire in 1948 and was not rebuilt.

Kansas-born photographer William Reagh landed in Los Angeles in the 1930s. Reagh walked the city taking black and white photographs until the 1990s. He returned to some neighborhoods year after year

charting their evolution: Pershing Square, The Pike, Pacific Ocean Park, Bunker Hill, Long Beach, and Terminal Island. If not for Reagh, much of Los Angeles's intimate sidewalk stories would have been lost, and his 40,000 photographs earned him the accolade of an "Ansel Adams of the Angels."

Julius Shulman photographed southern California's most iconic buildings from the 1930s through the 1980s, helping promote the modern architecture that swept the region after World War II and the idea of the California dream. He made portraits of homes by architects such as Richard Neutra, John Lautner, and R. M. Schindler.

As a young photographer in 1949, Don Normark became fascinated by Chávez Ravine, home to a Mexican-American community on a hill overlooking downtown Los Angeles. He spent a year taking soulful, intimate pictures of life in the neighborhood, unaware that it was to be wiped off the map. A year later, 300 families were evicted to make way for Dodger Stadium, the new home of the former Brooklyn Dodgers baseball team. Homes, churches, and schools were bulldozed, but Normark's imagery documents the peaceful Latino community's lost way of life.

Artist Ed Ruscha is known for the revolutionary photobooks that he began publishing in 1963. He used the format to publish his documentation of Los Angeles streets, including Melrose Avenue and Pacific Coast Highway, which started in 1965. His accordion-folded

7.6 meter-long book *Every Building on the Sunset Strip* (1966) consists of two continuous views of a landmark stretch of the Strip, one for each side of the street. Ruscha's series "The Streets of Los Angeles" contains more than a million exposures taken over more than 40 years, focusing on the city's billboards and signage. Likewise, the landscapes that Stephen Shore photographed in the 1970s, mostly in color, are not idealized panoramas of the city (see image 3). His documentary style focuses on the outer fringes of city life – parking lots, silent streets, and the bric-a-brac of culture and advertising – while systematically cataloguing facts and surfaces.

Lee Friedlander photographed Los Angeles street life for decades. He played with shadows, angles, and obstacles that he used to frame elements and structure his compositions (see image 2). His own shadow or reflection can be found in many of his images that depict urban life and the feel of modern society. Joseph Rodriguez has also attempted to depict the city's social aspects, photographing the gangs of East Los Angeles for his book *East Side Stories* (1998) in an effort "to get to the core of . . . the quiet violence of letting families fall apart, the violence of segregation and isolation."

Although the city has become urban sprawl, for some it still has rural charm. Bruce Davidson photographs nature in unlikely places, including under Los Angeles's highways in 2008. He says: "Even under concrete, nature is there, surrounding the grid of the city itself." **CN**

LOS ANGELES

BORN 1976, Sigmaringen, Germany LIVES Berlin, Germany STUDIED
Braunschweig University of Art, Germany; California Institute of the Arts, Los
Angeles SERIES "LA Crash," 2006–11 OTHER CITIES WORKED Marrakech, Lemgo

MIRKO MARTIN

"Once upon a time there was an enchanted hotel. . .
. . . built many, many years ago,
at the beginning of the last century
on the corner of 5th Street and Main,
in the heart of downtown Los Angeles.
For a while it was the tallest and most splendid building
in the city.
And it carried the euphemistic name
The Rosslyn Million Dollar Hotel."

The Heart is a Sleeping Beauty by Wim Wenders and Donata Wenders,
Schirmer/Mosel Verlag GMBH, 2001

The hotel Wim Wenders (see p.84) refers to—featured in his movie
The Million Dollar Hotel (2000)—forms the backdrop to one of Mirko
Martin's photographs (see image 1). In the early 1900s, when
Downtown Los Angeles (LA) was the heart of the U.S. entertainment
industry, the rich and famous flocked to this hotel. Today it is the
landmark of LA's most run-down neighborhood; its façade is faded,
its neon lights are broken and it faces the city's skid row. Yet this area
intrigued German artist Martin when he arrived in LA for the first
time in 2005, luring him back in 2008 and again in 2010, and its
streets became the subject of his series "LA Crash."

"Downtown LA is one of the most fascinating places I know,"
explains Martin. "The streets often look strangely familiar because
I know their aesthetics from films." In fact, it has arguably become
LA's most filmed district; on one day up to 100 shoots can be taking
place in its 2.5-mile radius. Martin describes it as a "parallel world"; his
"LA Crash" series juxtaposes photographs of helicopters circling
between its high-rises, police arrests on its dimly lit street corners
and car accidents blocking its thoroughfares. (Crashes are such a
recurrent motif that they—and Paul Haggis's 2004 movie *Crash*,
which was marketed in Germany as "LA Crash"—lend the series its
title.) All these images combine to fulfill our expectations of how we
imagine the movie capital of the world to look, but Martin ensures
that nothing he shows us is as it first appears.

Martin uses photography and film to explore the difference
between reality and fiction. He asks what makes human behavior
appear authentic, and how do we know if a scene is staged? When
he first began to explore Downtown LA, by chance he came across
a Hollywood movie being shot on a small backstreet. Fascinated, he
watched the scene unfold and found himself framing its drama with
his own camera lens. Looking through the resulting images back in his
studio, he began to wonder whether he could develop the idea into a
coherent series; "I thought it would be interesting to photograph the
scenes in such a way that the viewer can't tell that they were taken
on movie sets." He returned to the streets, this time with the hope
of searching out more film sets. Like Weegee, the New York
photojournalist who tuned into the police radio so he could be the
first at the crime scene in the 1930s, Martin became expert in tracking
down movie sets in Downtown LA. He started to notice the coded
signs put up by production companies to direct film crews to
locations, and gradually learned the movie-makers' favorite haunts.

As the project took shape, he was struck by something else.
"I realized that some of the staged scenes were actually mirrored by
real-life incidents there," he recalls. It "was bizarre." Simply by turning

1–2 From "LA Crash," Los Angeles, California, USA, 2006–11

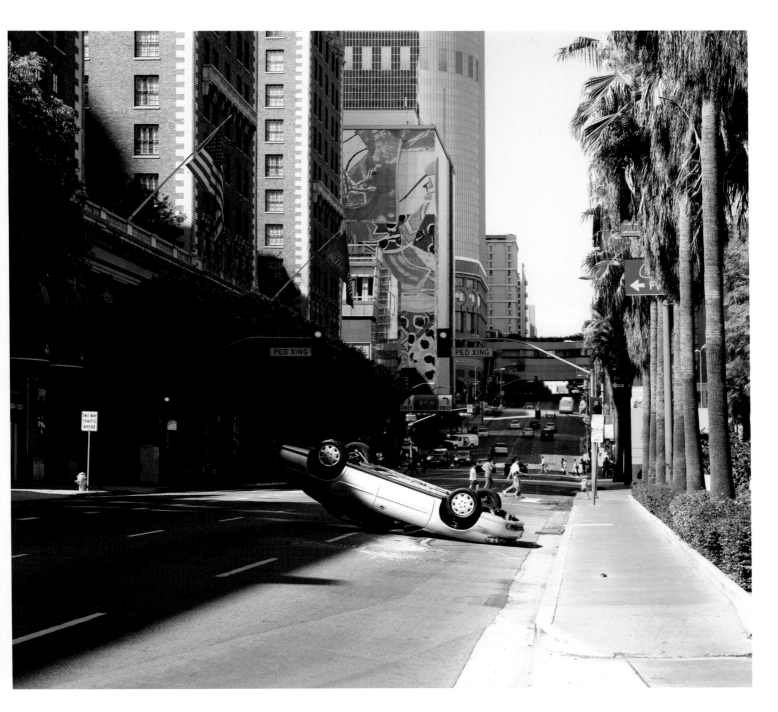

his camera and homing in on the actual street life unspooling around the movie sets, he could create another body of imagery that would act as a counterpoint to his portrayals of Hollywood fabrications. The combination of these ideas resulted in the "LA Crash" series. The question of which photographs portray either a real event or a Hollywood staging is left open. Reality and fiction are played off against one another creating what Martin describes as "a kind of charade" between the two.

Throughout, Martin worked much like a traditional street photographer, who pounds the pavements in search of the right moment. He seldom intervened in a situation and he used a 35mm camera to maintain a low profile. However, the work was not simply objective documentary. He would employ tactics to make the Hollywood imagery look quotidian and the street photographs look dramatic. With the authentic street scenes, he elaborates, "I usually try for a perspective or a moment, in which the theatrical aspect of the situation comes to the fore so that the image might convey the impression of being staged." Moreover, although he resisted resorting to extra lighting, he was very careful about when to shoot. He learned how the quality of the Los Angeles light changes through the day, saying, "At times it appears almost too evident to be believable, like an exaggerated reality [that] triggers cinematic memories." He

would choose the brightly lit hours to shoot the real street scenes so they are cast in a cinematic luster, and the slightly duller hours to shoot the movie scenes so that they appear banal. He also noted and made use of another lighting trick. Occasionally the film crews would swivel the big floodlights off the set. Martin would wait for people passing by to chance through their dramatic beam of light. "Sometimes a theatrical expression flickers across a person's face," he says. "I try to capture this moment."

In the "LA Crash" series, Martin frames everyday Los Angeles street scenes to appear more theatrical than Hollywood's richest imaginings. In doing so, he heightens the sense of fluidity between reality and fabrication. The project recalls the words of the French philosopher, Jean Baudrillard, in his travelogue *America* (1986): "When I speak of the American way of life, I do so in order to emphasize its utopian character, its mythical banality, its dreamlike quality. . . . Fiction is not imaginary. It anticipates the imaginary by realizing it." Baudrillard suggests that fiction is already reality in the United States; it is the only country in the world where actors perform for a movie on the streets and nobody notices. However, Martin's series reveals that of all American cities, Los Angeles—the world's movie Mecca attracting famed directors from Altman to Wenders—is where this blurring of fact and fiction is an everyday "reality."

UTA BARTH

The streets of Los Angeles enjoy a radically different representation
in the work of the Berlin-born, California-based artist, Uta Barth. Her
series "Fields," which she started in 1995, depicts everyday, mundane
urban scenes cast at various times and in various lights. Yet, whether
dawn or dusk, dappled with sun or soaked with rain, all the images
are unanimously blurred. They appear like seductive color washes
in which the details float out of focus and the content remains out
of reach and elusive. Moreover, they portray the "non-event" or the
"non-place." Barth admits that a "certain kind of detachment" runs
through her thinking and her work. "I am interested in the margins,"
she says, "in everything that is peripheral rather than central."

Barth has been making out-of-focus imagery since the early 1990s.
In the "Fields" series, she created this aesthetic by moving the camera
as she took the exposure; the urban landscape therefore disintegrates
as a motion blur. In a previous series, "Grounds," which began in 1992,
she used a collaborator to stand in the foreground of the composition
and provide a point on which to focus her camera. Once that person
had exited the frame, she would then trip the shutter on the softly
focused and empty background. In his influential treatise on
photography, *Camera Lucida* (1980), the French philosopher Roland
Barthes recognized the medium's reliance on subjects, "Photography
is never anything but an antiphon of 'Look,' 'See,' 'Here it is'; it . . .
cannot escape this pure deictic language." Yet, in "Grounds," "Fields,"
and indeed beyond, Barth has repeatedly attempted to do just that.
"Most photographs are tied up with pointing at things in the world
and thereby ascribing significance to them," she says. "So while I do
have a great interest in and respect for historical photographic
practice, it has never been the point of departure for my own work."

Some critics have suggested that Barth's choice of titles clearly
alludes to painting, in particular to ideas espoused by Clement
Greenberg, legendary critic of the American Modernist movement
and promoter of Abstract Expressionism. In this argument, "Fields"
refers to color field painting and "Grounds" to the figure/ground
relationship. However, perhaps more accurately Barth's work can be
situated within the movements of Minimalism and Conceptualism.
After all, in the 1970s she studied art as an undergraduate at the
University of California, Davis, and then moved to Los Angeles to
enroll in a Master's degree program at the University of California
(where she still occasionally teaches). Moreover, when asked about

1 *Field #20*, Los Angeles, California,
USA, 1997. Acrylic lacquer on canvas.
131 7/8 x 204 in.

2 *Field #21*, Los Angeles, California, USA, 1997.
Acrylic lacquer on canvas. 131 ⅞ x 204 in.
Tate Collection

key influences, she states, "If I have to think about the artists whose work is important to me, I end up going back to people like Robert Irwin."

Living in Los Angeles, Barth could hardly avoid being influenced by the film industry and this is particularly evident in "Fields." Whereas the indoor settings of "Grounds" explore the pictorial conventions of still photography and painting, the LA street scenes of "Fields" mimic cinematic conventions. Barth admits that although most images in the series do not literally re-create scenes from particular movies, she does have "certain styles of film-making in mind." As art scholar Pamela M. Lee observes, "She is typically ambiguous about identifying those films through narrative, a point in keeping with her general modus operandi: concerned as she is with evoking the ambience of cinematic space and time rather than actual movies." Barth also likens the process of her image-making to that quintessential Los Angeles exercise of "location scouting": "I end up driving around various neighborhoods of the city looking for a place that is general, neutral enough to not interfere or visually compete with what might take place in the foreground," she says. She continues: it must be "a place that has very particular, 'atmospheric' characteristics." Consequently her hazily rendered street scenes tend to feel familiar. Occasionally, the scale of the works also emulates the cinema experience. *Field #20* (see image 1, pp.56–7), for example, is monumental in reality; at over 13 feet long and almost 11.5 feet high, it relates directly to a movie theater screen. This size also combines with the defocused aesthetic to create a disorientating effect. Barth adds, "One has a sense of being made aware of one's peripheral vision, of what you see when you turn your head toward something, of what you might see while in motion."

Overall Barth's work reveals a preoccupation with perception; "Fields," like "Grounds" previously and various series since, interrogates how we view the world. She throws the focus of her camera and plays with motion blur in order to release her imagery from the need to depict subjects. Initially this tactic serves to confuse or frustrate the viewer. Barth elaborates, "Certain expectations are unfulfilled; expectations of what a photograph normally depicts, of how we are supposed to read the space of the image." The viewer therefore needs to invest time in deciphering the image. Curator Camilla Brown suggests Barth's work "encapsulates a particular moment, when we are unconsciously ignorant of the fact that we are looking." Barth explains, "Instead of losing your attention to thoughts about what it is that you are looking at . . . the question for me is how can I make you aware of your own activity of looking." Indeed, as we look and ponder, the work promotes a near meditative experience; thoughts turn inward and one becomes gradually conscious of one's activity, one's self.

1 *site specific_Los Angeles 12*, 2012.
Inkjet print on archival paper.
63 ¼ x 84 ¾ in.

LOS
ANGELES
BY OLIVO BARBIERI

The tower of the Academy Theater in Inglewood, southwest of
Downtown Los Angeles, was apparently inspired by a spool of film
unwinding. The movie theater opened in 1939 and that same year
it was immortalized in an image by the renowned architectural
photographer, Julius Shulman. Its creators hoped that it would
host the Oscar awards ceremony, but it never did; it stopped
showing movies in 1976 and instead became a church—the Academy
Cathedral. To my mind, a disappearing spool of film and God housed
in a former movie theater in the post-analogue landscape of the
world's movie capital are strong metaphors for our time.

LOS ANGELES

BORN 1956, St. Louis, Missouri, USA **LIVES** Los Angeles, California, USA **STUDIED** Yale University, New Haven; Pomona College, Claremont **SERIES** "Vector Portraits," 1989–97 **OTHER GENRES** Portraits

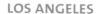

1–8 From "Vector Portraits," Los Angeles, California, USA, 1989–97. Digital C-prints

ANDREW BUSH

At first glance these portraits seem to portray drivers snapped waiting in traffic jams, at junctions, or parked stock-still. On closer examination, however, one begins to notice various hints of motion: backgrounds passing so fast they have been smeared across the frame, wheels spinning at such a rate they have blurred. In fact, each of the images from the "Vector Portraits" series were captured at high velocities, with subject and photographer driving up to 60 mph. They picture people speeding through the streets and freeways of the sprawling, urban landscape of Los Angeles. "The idea for the series came easily," claims Missouri-born Andrew Bush. "Living in Los Angeles, you're surrounded by cars and very few pedestrians." Bush mounted his medium-format film camera to the exterior passenger door of his car and set off scouring LA's neighborhoods in search of subjects for his drive-by shootings. "It didn't matter where I went, I drove until there was no light left in the day," he recalls. "I felt like I had tapped into a vein that would allow me to document something fundamental about the way we live in the world today."

Various cues would make him home in on and pursue a car: bright paint, particular models, erratic motion and also, as he points out, the times 'when it was clear that the driver was just an extraordinary character study, and I would do whatever I could to manoeuver my car so that I could make a picture." In order to capture exposures that were imbued with stillness, he realized he had to pull alongside his targeted vehicle and mimic their motion and speed. He remembers,

"I became fascinated with the idea of moving in parallel with the person next to me, as a way of coming into their world."

In all the images the drivers are frozen with a deadpan aesthetic: all facing west, mostly in profile. The framing remains constant, tending to cut off the car's hood and tail. The constant repetition evokes a scientific approach that highlights the differences between the details. Bush even ascribes the images with titles that note the speed, location and time of capture, framing the imagery as data points within the real world, such as *Man traveling southbound at 67 mph on U.S. Route 101 near Montecito, California, at 6:31 p.m. on or around Sunday, August 28, 1994* (see image 4). Bush, however, refers to his technique as "sloppily objective" and other titles read more like poetic riffs, as with *Person driving somewhere in the last decade of the previous millennium (whereabouts unknown)*. Moreover, when the images are assembled en masse, their repetitive style conjures a syncopated, rhythmic pattern that verges on abstraction.

Ultimately, the series comments on issues of privacy within public space. We tend to feel cocooned, almost invisible, in the air-conditioned seclusion of our cars and so perhaps we let our guard down. Indeed, Bush caught the Los Angeles commuters performing all sorts of habits one might hesitate to perform in public, from singing to dancing to kissing; he adds "anything under the sun takes place, especially if there is more than one person in the car." Yet each person remained oblivious to Bush's prying lens; the few that turned their heads (see image 6) had no time to compose themselves. By triggering the flash as he makes the exposure, Bush creates imagery that highlights our intrusion; like a voyeur, he watches unseen from the sidelines, skewering subjects unaware.

LOS ANGELES

BORN 1969, Arlington, Massachusetts, USA LIVES Berkeley, California,
USA STUDIED Yale University School of Art, New Haven SERIES "Boulevard,"
2008–10 OTHER GENRES Portraits OTHER CITIES WORKED San Francisco

KATY GRANNAN

"Everybody's a dreamer and everybody's a star
And everyone's in show biz, it doesn't matter who you are
And those who are successful
Be always on your guard
Success walks hand in hand with failure
Along Hollywood Boulevard."

© Sony/ATV Music Publishing LLC

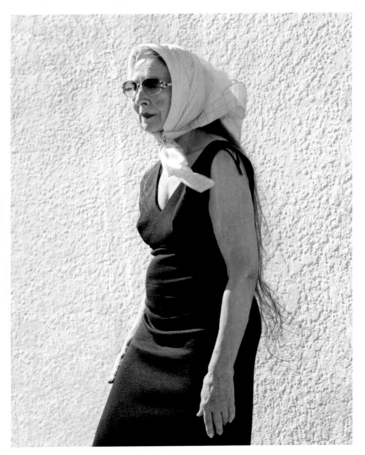

Katy Grannan chose the lyrics of the song "Celluloid Heroes" by The
Kinks to accompany the first exhibition of "Boulevard"—a series of
portraits of people that she mostly met on the infamous Hollywood
Boulevard of Los Angeles between 2008 and 2010. The series portrays
the street's faded beauty queens, its hustlers, strutters, drag queens,
and addicts. "Prisoners of the streets, celebrity impersonators . . .
born-again Christians, outcasts," continues critic Jerry Saltz. Each one
appearing "restless and worn yet often possessed of a fierce pride,"
adds curator William A. Ewing; "resigned to the next throw of the dice
while not holding out much hope that it will go their way." In fact,
a sense of fragility and fantasy permeates the pictures, as Grannan
concurs in the introduction to her book *Boulevard* (2011), "Yesterday
I found Malaysia. I'd seen her several times before, on a lonely stretch
of La Brea. There are many here like her: boulevard phantoms . . .
people with nothing but aspiration and delusion."

Grannan was born and brought up on the east coast of the United
States. Her first break came in 1999 when she was included in the
somewhat notorious show "Another Girl, Another Planet" in New
York. The exhibition was co-curated by her tutor from Yale University,
artist Gregory Crewdson (see p.170). Throughout most of her career
she has worked in much the same way. For all her portrait series—
from "Poughkeepsie Journal" (1998), "Dream America" (2000),
"Morning Call" (2001–04), and "Sugar Camp Road" (2002–03) to
"Mystic Lake" (2004)—she found subjects by placing a classified
advertisement in local newspapers: "Art Models: Artist/Photographer
(female) seeks people for portraits. No experience necessary. Leave
msg." Interested strangers would approach Grannan. "Posing for a
portrait is quite a common thing, but it is another thing entirely to
meet up with a stranger," she explains. This transaction would set the
tone for the ensuing portrait session. Moreover, Grannan ensured that
these charged encounters were collaborative; she would make the
exposure but subjects might choose where to be photographed, what
pose to strike, and what to wear. All these elements—the ad, the
one-time-only meeting, the "give and take" in the staging—combine
to lend the images a certain dynamic. Ultimately, as Grannan says
"They represent the desire to be seen and be paid attention to."

In 2006 Grannan moved from New York to Berkeley, California,
and her modus operandi changed. One suspects it was prompted by
something she discovered in Los Angeles and in Hollywood Boulevard
in particular. Recall the "dreamers" of The Kinks song and Grannan's
"boulevard phantoms," and suddenly the streets are thronged with
potential: people she wanted to photograph and people who wanted
to be photographed. Grannan no longer needed to advertise for

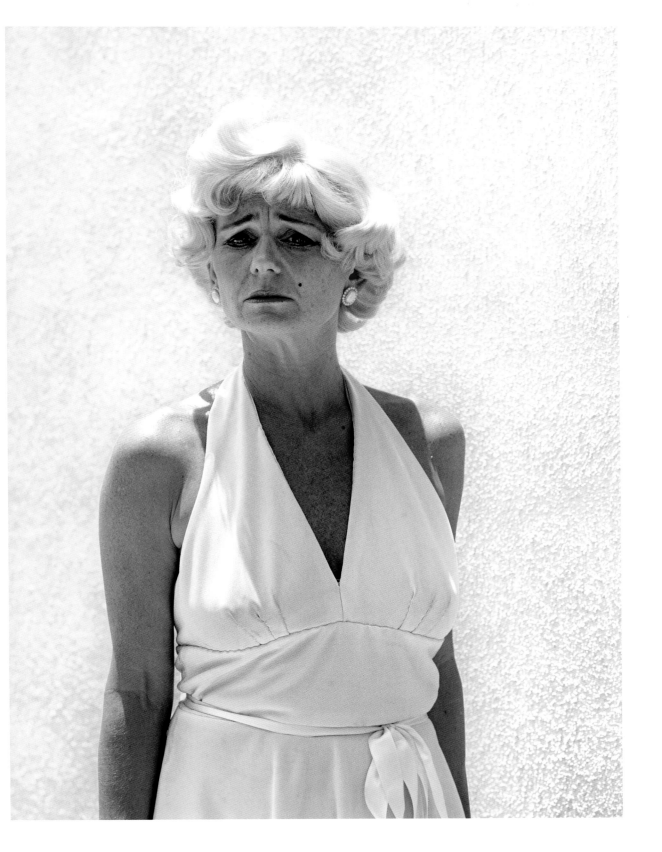

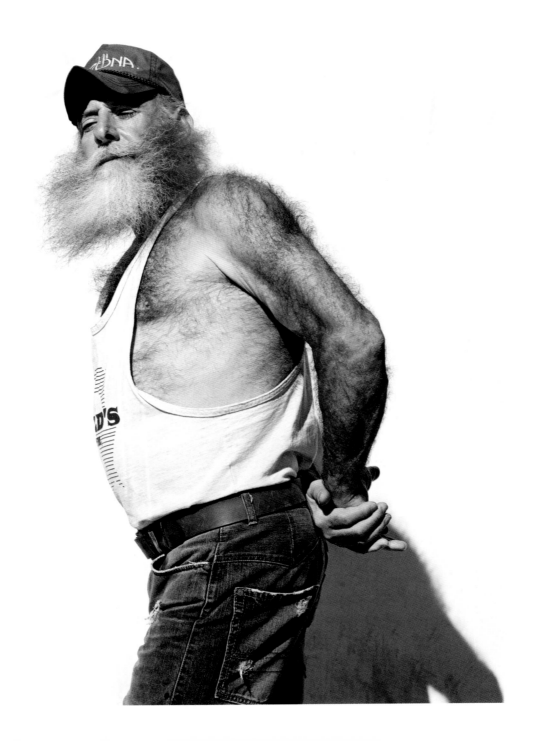

subjects; she simply had to ask. She would walk up to strangers and tell them about the project. If they were interested in participating, she would set up her medium-format camera and suggested they try to ignore her. "As you can see in the pictures, many of them really perform while others seem to remain lost in their thoughts," observes curator Britt Salvesen. "Katy has a remarkable ability to recede and make people feel like they are participating on their own terms, even though her camera is not hidden." By framing her characters against white stucco walls, she transformed the city into a portrait studio. Salvesen adds, "In a way she was letting go of the California landscape or cityscape and getting closer to people," and the blank backdrop, the void, acts to focus the viewer's attention onto the subjects. She never used more than the ambient light. She explains: the light "was the first thing I observed when I moved to California . . . so seductive and comforting, and at the same time . . . relentless and indiscriminate. It illuminates everything, everyone." Her subjects appear under the glare of the penetrating Californian sun, like specimens pickled in aspic.

As with her earlier series, the subjects reveal the same desire to be seen and noticed. As before, the aesthetic speaks not of detachment but of involvement, collaboration and complicity. Yet the process of approaching subjects (as opposed to being approached) charges the images differently; as Salvesen says, "It creates a different 'transaction' and narrative implication." Gone is the private, somewhat illicit intimacy of "Mystic Lake" et al., where subjects seem to offer themselves up to Grannan's camera. Instead, the people in "Boulevard" perform, preen, and pose. "The dynamic is different every time," she declares. "People really get into it, and it requires a generosity and openness to be part of this process, to dance on the sidewalk in front of traffic, to wave at strangers honking." Sometimes the ever-present public is reflected in a subject's body language, in a hint of coyness within their demeanor, and those portraits that expose a fragility beneath a flamboyance are arguably the most gripping. Grannan's work has often been likened to that of New York portrait photographer Diane Arbus. Saltz has called herself Arbus's "legitimate heir." Arbus famously once remarked, "Our whole guise is like giving a sign to the world to think of us in a certain way, but there's a point between what you want people to know about you and what you can't help people knowing about you. And that has to do with what I've always called the gap between intention and effect." Grannan mines this gap with great results: readily revealed by the portraits of the procession of dreamers and fantasists that she encountered on Hollywood Boulevard.

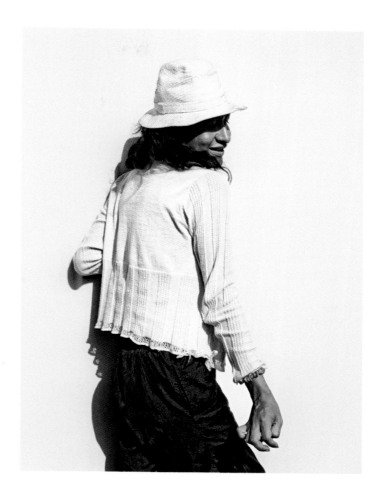

 3–4 From "Boulevard," Los Angeles, California, USA, 2008–10

CHICAGO

By the late 1850s, only two decades after photography's invention, there were already 13 daguerreotype studios in Chicago. These early photographers made portraits of locals, street scenes, and full-scale panoramic views of the city. At that time, photography could not freeze motion and photographers worked outdoors in the early morning when it was light and there were few pedestrians, placing their cameras up high or in wide public streets. If people were included, they were posed in specific situations. Makers of postcards and views wanted to sell to a mass audience, and made images that were upbeat; a set of city views might include an ethnic shopping district but avoided slums or sweatshops employing children.

In the late 1880s, an inexpensive method of printing photographs in books, magazines, and newspapers was developed. Along with the availability of fast films and portable cameras, it made modern news photography possible. The *Chicago Daily News* was one of the first newspapers in the country to feature black and white photography of subjects including labor strikes, boxing matches, and crime scenes. Photographs from the newspaper's collection include candid shots of the SS *Eastland* disaster, when hundreds drowned after a steamer sank in the Chicago River on July 24, 1915, or the aftermath of the St. Valentine's Day Massacre orchestrated by gangster Al Capone on February 14, 1929.

In April 1941, Farm Security Administration photographers Russell Lee and Edwin Rosskam traveled the streets of Chicago's South Side and Bronzeville, recording the life of the city's African Americans. A few months later, John Vachon and Jack Delano followed. Lee's photographs are the strongest. His view of poverty and struggle is balanced by joyful images of bowling, roller skating, cabaret scenes, and church going.

Wayne F. Miller received two consecutive Guggenheim grants to fund his project on Chicago's South Side titled "The Way of Life of the Northern Negro" (see image 2). Working in his hometown from 1946 to 1948, he took photographs of storefront church services, industrial workers, slaughterhouse workers in the taverns at night, fish peddlers, gospel preachers, drunks, drag queens, and street toughs—images of ordinary people with a sense of the emotions that animate their lives.

	2	3
1		

1 *Chicago*, Harry Callahan, 1950
2 *A Makeshift Pushcart*, Wayne F. Miller, 1947 3 *Untitled*, Ray K. Metzker, c. 1960

Vivian Maier moved to Chicago in 1956, where she worked for about forty years as a nanny for families in the North Shore suburbs. On her days off, she wandered the streets with a Rolleiflex twin-lens reflex camera around her neck, making pictures in the spirit of Lisette Model. An outsider, Maier related particularly well to those on the fringes of 1950s and 1960s American society, including children, African-Americans of all ages, and the poor of any color. In her photographs there is compassion but also playfulness. She captures passing moments, but her pictures also possess an underlying gravity and emotion.

In 1937 László Moholy-Nagy, a Hungarian Jew who fled Nazi Germany, had established a school in Chicago modeled after the original Bauhaus in Weimar Germany. The New Bauhaus then became the Chicago School of Design and, in 1944, the Institute of Design, where generations of photographers would be educated. Moholy-Nagy's images are mostly controlled studio experiments, more concerned with form and materials than with documenting the world. But Moholy did some documentary work that was "straight" in the technical sense, using extreme perspectives to distort the subjects.

In the 1940s, New York-born photographer Aaron Siskind moved to Chicago to teach photography at the school. Siskind made a shift from a documentary to a metaphorical approach, creating more formal, poetic, conceptual images. His photographs of Chicago's wall surfaces and their textures of splashed paint, layers of posters, graffiti marks, and crumbling materials, explore ideas of decay, fragmentation, and regeneration.

Moholy-Nagy invited Harry Callahan to teach at the school in 1946. Callahan used a variety of cameras and materials that, with his strong sense of design and composition, allowed him to produce meticulously crafted and elegant images of the everyday world. One of his most famous series shows the faces of female pedestrians (see image 1) caught unaware in downtown Chicago.

Ray K. Metzker studied at the Institute of Design from 1956 to 1959, where he made his first sustained body of personal work—images of Chicago's business district. Often he shot from unusual perspectives (see image 3); close to the ground with tiny silhouettes of passers-by in the background, or focused on light silhouettes of passers-by against a rich dark background that erased the details of their environment. Multiple exposures, superimposition of negatives, juxtapositions of two images, solarization, and other such formal strategies were part of his vocabulary.

Ken Josephson studied photography under Siskind and Callahan. Some of the photographs Josephson made in Chicago are abstracted views of poles, wires, or trees, but he also produced street views of the city, some in panoramic format, shop windows, or darkened silhouettes of passers-by at night. Later, he turned to more conceptual work that comments photographic truth and illusion. **CN**

1 *Transparent City 41*, Chicago, Illinois, USA, 2007

CHICAGO

BORN 1954, Munich, Germany LIVES Hong Kong, China STUDIED University of California, Berkeley; Folkwang School, Essen SERIES "Transparent City," 2007 OTHER GENRES Photojournalism OTHER CITIES WORKED Hong Kong, Tokyo, Shenzhen, Paris

MICHAEL WOLF

When Michael Wolf first came to Chicago in the autumn of 2005, little did he know that he was about to embark on an artistic endeavor that would result in the transformation of the famous "Windy City" into the "Transparent City." The Munich-born photographer had been living and working in Hong Kong for more than a decade. He had moved there in 1994, a few years before the former colony transferred its sovereignty from the United Kingdom to the People's Republic of China. He witnessed the island's rapid growth into one of the most densely populated areas in the world and became so fascinated by what he saw, that he began the 'Architecture of Density' project that was to earn him recognition.

The project is comprised of various series of large-format images, many of which reconceptualize Hong Kong's claustrophobic architectural skylines as abstractions. By scaling buildings, Wolf gained vantage points that enabled him to frame the façades of high-rises face on. Crucially, he eliminated skies and streets, indeed any horizon or feature that might give the image a sense of perspective. The resulting deadpan imagery portrays a flattened aesthetic in which the city's three-dimensional maze collapses into two-dimensional repetitive, mesmerizing, and shifting patterns. Under Wolf's watchful lens Hong Kong's extraordinary expansion has been recast as vast, abstracted photographic canvases.

Chicago, however, presented Wolf with an entirely different urban experience. Pioneering architects, such as Daniel Burnham and Louis Henry Sullivan, created Chicago's landmarks. Then later, after World War II, the city became a world capital of modern architecture, attracting innovators from Ludwig Mies van der Rohe to Frank Lloyd Wright. Wolf was struck by the city's architectural diversity from the moment he arrived. "When I got to Chicago I came in on the elevated train," he recalls; "The buildings were all individual" and he remembers how the mix, particularly in height, enabled "different views through vacant lots in between." The possibility of vistas opening up through and between buildings was in stark contrast to his experience of Hong Kong. Moreover, much of the modernist and contemporary architecture was constructed out of glass and Chicago seemed almost transparent. Wolf realized that as well as being able to peer through and between buildings, he could also catch glimpses of the human life contained within the city's fabric, beneath its architectural skin. These ideas later took shape as the "Transparent City" series (2007).

2–3 *Transparent City 20 & 39*, Chicago, Illinois, USA, 2007
4 *Transparent City Details (TCD) 27*, 2007 5 *TCD 1*, 2007
6 *TCD 6*, 2007 7 *TCD 9*, 2007 8 *TCD 24*, 2007 9 *TCD 4*,
2007 10 *TCD 29*, 2007 11 *TCD 3*, 2007 12 *TCD 7*, 2007

The desire to see into Chicago's buildings prompted a shift in focus in Wolf's practice. He discovered that interiors were most clearly visible when they were illuminated and it was dark outside, so he became a nocturnal *flâneur*. With office blocks he observed, "In September, it would only get dark around seven or eight, and the office buildings by then were deserted . . . In December, of course, the nights got longer and longer, and the days got shorter and shorter and so the lights in the buildings were already on at three-thirty or four in the afternoon. That was ideal for me." Images such as *Transparent City 20* (see image 2) were captured in the dead of winter. Wolf would wait in the dark for hours on frozen, windswept rooftops with his camera on tripod at the ready. It resulted in work that took on a fascinating new angle: like the protagonist of Alfred Hitchcock's 1954 film *Rear Window*, Wolf found himself turning into a voyeur.

The voyeuristic sense was heightened as the series progressed. Staying late in his studio one night, he was scanning photographs to check them for flaws and as he zoomed in on one image, he saw a figure he had not previously noticed, staring back and giving him the finger. Again, the similarities to Hitchcock's thriller are startling; the spy had been spied, the observer implicated. Intrigued by the potential of other overlooked moments, Wolf began to scour each image, window by window and row by row. "One of the fantasies that I had was that I would get up onto these rooftops every night—for four or five or six hours—and I would look into hundreds of windows, and I would see thrilling things going on," Wolf recalls. However, Wolf's particular brand of photographic voyeurism proved that the reality did not quite live up to the fantasy: "What I found was how boring everyday life is," and he admits to feeling disillusioned on finding that "Night after night, in all these buildings, [I saw] single people between the ages of twenty-five and forty, tired after work, sitting on the sofa watching TV." Indeed, as he continued, Wolf realized that the work was permeated by a loneliness that reminded him of Edward Hopper's paintings.

There were, however, moments of surprise and Wolf amassed these into the "Transparent City Details" series. *Transparent City Detail 24* (see image 8) depicts the man whose angry gesticulation first inspired him, and *Transparent City Detail 27* (see image 4) seemingly reveals a woman stripping that, under closer scrutiny, turns out to be a cardboard cutout. These images position the viewer in the role of "peeping tom," interrogating the fascination and perhaps pleasure derived from such spying. However, by dramatically zooming in on the original overall photograph and enlarging them into vast canvases, Wolf creates heavily pixellated, hazy compositions that are difficult to read, enabling him to frustrate and thereby expose the hidden voyeur in us all.

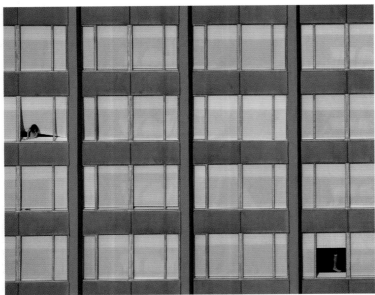

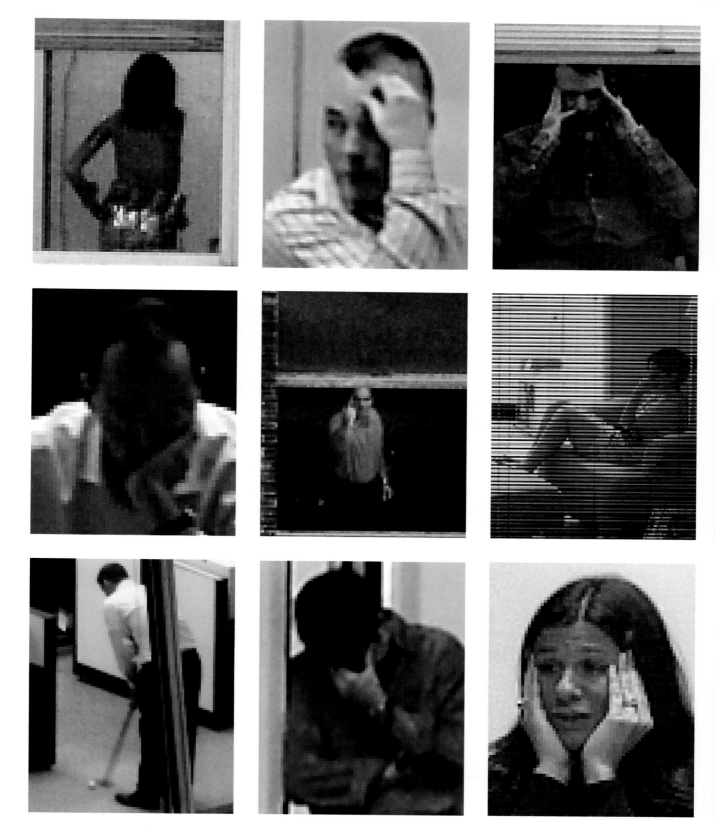

1 *Jovanni*, 2009 2 *Elizabeth*, 2009 3 *Aaron*, 2009 4 *Tiffany*, 2009
5 *Lauren*, 2009 6 *Ed*, 2009 7 *Nikolas*, 2009 8 *Aoife*, 2009
9 *Elisiana*, 2009

DAWOUD BEY

In 2008 Dawoud Bey, along with ten other U.S. photographers, received an invitation from USA Network and Aperture Foundation to undertake the task of picturing the "American Character." The final catalogue offered Abraham Lincoln as its "patron saint," stating: "not a man renowned for his beauty, Lincoln indeed embodies 'character' in multiple senses, with a face Americans love to look at in photos despite its flaws." Bey, however, decided to train his lens on students, in particular those who attend Columbia College in Chicago, where he teaches. "My interest in young people has to do with the fact that they are the arbiters of style," he explains, "Their appearance speaks most strongly of how a community of people defines themselves at a particular historical moment." He set up a makeshift studio on Chicago's main downtown thoroughfare, the bustling Michigan Avenue, where students spend many hours walking to and from lectures.

Bey used the kind of equipment one might find in a photographic portrait studio: an old Busch Pressman 4x5 large-format film camera mounted on a tripod. "I did not use any lights," he claims, "Instead I found a location that was in the open shade the entire day. This meant that there was beautiful even light, with no direct sunlight. It's the kind of light I create when I do use a studio." He set himself up alongside the slightly distressed side of a construction shed that afforded him a quiet space in the busy environment, as well as a relatively uniform backdrop against which he could isolate his subjects, again as he does in the studio, to "emphasize their individual gestures and psychology." However, by doing all this on the street, he effectively opened up his work to the element of chance encounters as the city spontaneously provided his subjects. "Character Project" (2008) fuses the informality of street photography with the formality of studio portraiture. As writer Max Kozloff suggests, "he keeps the roving spirit of the first but blends it with the deliberate encounters of the second." Bey describes his approach as "hybrid studio/street photography," yet when he started out he clearly favored one over the other.

Bey's career began on a day in 1969, when a sixteen-year-old high school student from Queens, New York, named David Smikle decided to visit the Metropolitan Museum of Art; he wanted to see the much-talked about photography show "Harlem on My Mind." The experience prompted him to pick up a camera: a decision that would change his life. Ten years later, having changed his name to Dawoud Bey, he had his first solo exhibition, "Harlem, USA" (1975–79), at the Studio Museum in Harlem. For this series, Bey had roamed Harlem day after day, month after month, with his 35mm camera in his hand, hunting for people to picture and moments to freeze. "I wanted to show people living their lives," he says. "But first I had to learn how to insert myself into their social space." He felt his first success came with the image of a middle-aged man, *A Man in a Bowler Hat* (1976). To get this image, he had asked the man's permission and requested that he resume what he had been doing. As the subject leaned back against the railing, he cupped his hand; to Bey, this quirky gesture, this "grace note" as he calls it, created 'a momentary connection that would leave viewers feeling they knew this person'.

Today, Bey always asks for permission from and he always directs his subjects. This conversation between artist and sitter creates a different dynamic to the casually snapped street photograph; the sustained engagement is reflected in the images of "Character Project." Bey hopes it "results in a photograph with a heightened sense of physical presence and participation." He thinks of the portrait as a kind of performance, one that is directed at the photographer. "I try to get them to relax so that some of their own idiosyncratic gestural behavior begins to emerge. I then shape that to the frame of the photographic space." Effectively, "I try to direct the person that I am photographing to a more sustained 'performance' of themselves."

The question is how much can a portrait reveal of the person it depicts. David Travis, former curator of the Art Institute of Chicago, says that "Bey wants to discover things about people, not stop at the surface but really get under the skin." U.S. photographer Richard Avedon famously said, "The point is you can't get at the thing itself, the real nature of the sitter, by stripping away the surface. The surface is all you've got. You can only get beyond the surface by working with the surface." In other words, Avedon manipulates surface, gesture, and costume to hint at his sitter's inner psyche. However, Bey responds, "He's right that you only have the surface . . . but the surface is full of rich information if you can create a space in which the person is comfortable enough for some of themselves to actually emerge." Bey's aim is to coax a revealing performance from his sitter. Fundamental differences exist between Avedon and Bey's approach, however. Avedon was notorious for catching his subjects off guard, whereas, as Travis explains, Bey is "very considerate about never really taking a face the sitter didn't mean to give up. He's not a trespasser." Bey himself adds, "A successful portrait to me is one in which we come to feel that we know something about a stranger. We cease to think about the experience as being one of looking at a photograph and it becomes one of experiencing another human being."

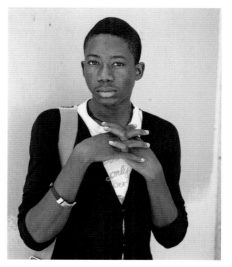
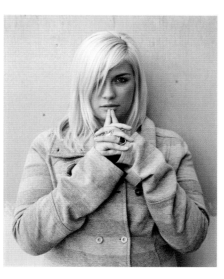

DETROIT
BORN 1968, San Jose, California, USA LIVES Sacramento, California STUDIED
University of California, San Diego SERIES "A New American Picture," 2006–11;
American Suburb X and *These Americans* websites OTHER GENRES Documentary

DOUG RICKARD

In 2011, when Doug Rickard exhibited his first series, "A New American Picture," it caused quite a stir. Some critics were troubled by the fact that Rickard had neither visited the places, nor encountered the people portrayed in his street photographs. Indeed, while making this series, not only did he not travel to Detroit, Michigan—or for that matter, other towns featured, from Baltimore, Maryland to Baton Rouge, Louisiana—but also, he did not even need to leave the leafy suburbs of Sacramento, California, where he lives. He created the series solely on images sourced from the internet, on Google Street View. In other words, an eyeball-like robot, automated to shoot without thought or intent, had captured the people and places depicted.

"I wanted to do something that paralleled Robert Frank, Walker Evans, and others who have turned their eye on the American experience," claims Rickard, and it is clear that he is guided by the same impulse that drove legendary photographers, such as Walker Evans or Dorothea Lange. Like them, he hopes to use his work to highlight the plight of people living at the margins of U.S. society. In this respect his work recalls that of another artist working in Detroit, Paul Graham; indeed, Rickard cites Graham's "American Night" series (see p.80) as an early influence. Rickard was born in San Jose, California, to a family of Christian missionaries and preachers. His father was a televangelist with a very conservative outlook, whom Rickard claims, believed "our Christian nation had been specifically blessed by God to lead the world." It was not until he left home to study American history at the University of California, San Diego, that he began to question his father's outlook and see his country in a radically different light. However, as Rickard admits, it was this collision of world views that informed and inspired "A New American Picture" and, in 2008, set him on a virtual road trip across the United States, courtesy of Google Street View, in search of those people for whom the American dream remains a myth.

Boarded up and dilapidated buildings, shuttered windows, derelict lots, boardwalks with weeds growing between the cracks, peeling paint, graffiti, broken-down cars, liquor stores; Rickard's series portrays segregated neighborhoods devastated by unemployment, poverty, crime, and drugs. The streets are striking

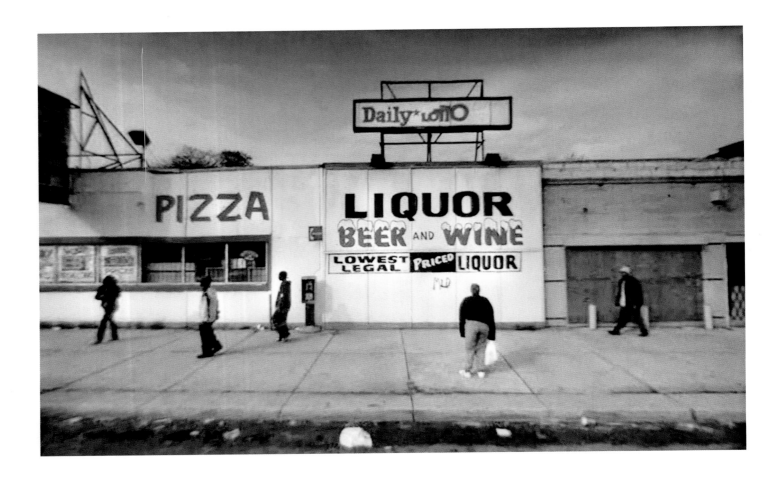

for their lack of people and occasional figures seem in a state of torpor, of apparent aimless wandering. "The work kept me in a dark room behind a computer for a thousand hours or more, over three years." He searched online databases for neighborhoods with high crime rates and low employment. He logged onto housing and travel advisor websites noting the areas to avoid. He even plugged "Martin Luther King, Jr." into Google Street View's engine to find the streets, avenues, and roads named in his honor. "These areas were typically the most devastated," he discovered. "It was incredibly sad that a beacon of hope for our nation now served as a symbol for blight."

Although Rickard shoots his computer screen with a 35mm camera—the tool of choice for many street photographers—his series seems the antithesis of street photography. Unlike a typical street shooter, whose instinct leads them to the right place at the right time, to capture that much-lauded "decisive moment," Rickard can take all the time he likes; his subjects don't move. As critic Erin O'Toole points out, "He can leave off working on a picture in the morning, and return later in the day to find the scene exactly as he left it." Alien to conventional street photography's hand-held, instant nature, he uses a tripod and combines this with slow shutter speeds. However, despite these differences, Rickard's approach has more in common with street photography than one might initially suppose.

Google Street View takes nine images every thirty feet and stitches them together to create a continuous stream that re-creates reality. This online frozen terrain is so seamless that Rickard was able to roam and prowl its streets like a postmodern-day *flâneur*. By using Google's four cardinally pointed arrows, he could adjust his gaze within this landscape relatively freely: looking up, down, and around 360°. Although there is not quite as much freedom as

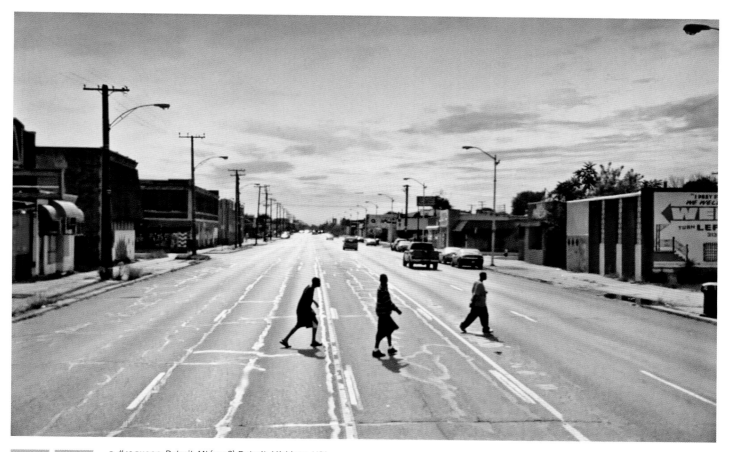

2 *#42.511900, Detroit, MI (2008)*, Detroit, Michigan, USA,
2010. Archival pigment print
3 *#82.948842, Detroit, MI (2009)*, Detroit, Michigan, USA,
2010. Archival pigment print

afforded by a camera in the real world, he claims there is enough to allow him "to get the same feeling that I would get out in the world doing photography on the street." In effect, he became a "virtual street photographer."

This work can be seen as taking street photography into the next generation. Although grounded in the tradition, it simultaneously subverts, questions and redefines the genre. Like the renowned street photographers of old, Rickard offers insight into how people experience the world. It is just that the world is now a very different place. "I could go from the inner city of Camden, New Jersey, to the borderlands of New Mexico in the same evening," he observes. "This constant ability to explore new areas was a thrill and a pull." The series comments on the way most people in the digital age have started to experience reality—through the interface of a computer. The idea seems far-fetched and futuristic, yet Rickard believes it is

happening, now. He suggests that "people may be experiencing 'real life' less and relying on the representation of life on the screen at home and in their hands as a substitute for life."

"A New American Picture" also remolds how we see art. As critic Robert Shuster observes, there is a strong current of irony that high art can be created by "an unfeeling contraption designed by a multibillion-dollar company that takes drive-by pictures of poverty as part of a project to help us 'plan a summer vacation.'" Yet Rickard has effectively taken Richard Prince's postmodern tactic of appropriation, which in the 1970s sent shockwaves through the art world, to a new level. Whereas Prince re-photographed, stole, or (in his words) "re-presented" advertising images photographed by someone else and published in print media, Rickard "steals" photographs taken by a robot and existing on the internet, in the ether, in some alternative reality, which if we listen to him, is fast becoming our reality.

DETROIT

BORN 1956, Stafford, UK LIVES New York, USA STUDIED Bristol University, UK;
self-taught in photography SERIES "American Night," 1998–2002 OTHER
GENRES Fine art OTHER CITIES WORKED Los Angeles, New York, Memphis, Atlanta

PAUL GRAHAM

"The photography I most respect pulls something out of the ether of nothingness . . . you can't sum up the results in a single line," claims Paul Graham. In his series "American Night," much of the imagery appears so bleached out that it seems to verge on the edge of nothingness. One struggles to make out overall composition, let alone details. Urban landscapes as in *Plate #52, Man at crossroads, Detroit* (see image 1) are rendered abstract. Indeed, reportedly when the book was first released, some critics returned it to the publishers assuming there had been a mishap during the printing process. Graham always intended the images to appear this way. At the point of making them, he deliberately opened up his aperture so that light could flood in and overexpose the negatives. He hoped to create a final image that would mimic what he describes as "the sense of disorientation and drama" one experiences on exiting a cinema into the searing, blinding light of day. As with stepping into the sunshine, these washed out, near-white images force the viewer to search their landscapes for information, for clues.

A quote at the outset of the *American Night* book reaffirms Graham's call to visually interrogate the images. It is taken from Herman Melville's novel *Moby-Dick* (1851): "anyone's experience will teach him, that though he can take in an undiscriminating sweep of things at one glance, it is quite impossible for him, attentively and completely, to examine any two things . . . at one and the same instant of time." We often fail to question our powers of perception, yet we undeniably see the world in a predetermined way that is guided by how our eyes and brains have evolved over time. In order to grasp the full picture, we all too easily glide over detail. This quote echoes the effect of presenting underexposed pictures; it too encourages an active engagement and a closer look. Many of the images in "American Night" focus on the poor and deprived section of the U.S. urban population. Although both of the photographs shown here were taken in Detroit, Graham traveled across the country to places such as San Antonio, Atlanta, and Memphis, and discovered social fracture nationwide. He rejected the photographic tradition of using darkness and shadow to depict poverty, and instead chose to "white out" non-whites in order to comment on how these people seem not to be noticed by society. Curator Alanna Heiss describes them as inhabiting "the no-man's land of suburbia: walking, waiting, sitting, or staggering across the terrain of America, their presence so ubiquitous that they have achieved near-invisibility."

1 *Plate #52: Man at crossroads, Detroit*, 2001

2 *Plate #46: Man in wheelchair waiting for traffic, Detroit* 2001

In 2002 Graham emigrated from Britain to New York and embarked on two further series that are also set in his adopted country: "a shimmer of possibility" (2004–06) and "The Present" (2009–11). Together these series form his "American Trilogy"—a body of work that interrogates how one can articulate the medium of photography, and what Graham calls the "uniquely photographic act." "I have dissatisfaction with classic documentary language," he reveals. "It was wonderful when it was invented. But it has to be alive, to grow, and develop, just like the spoken word. We don't speak the same way we spoke in 1938 or 1956, so why should we make pictures the same way?" "American Trilogy" works to create a contemporary formal treatise on the ontology of photography. Each series in the trilogy investigates the three main controls of the camera. "American Night" considers how adjusting the aperture can overexpose frames. In "a shimmer of possibility" Graham experiments with the shutter to create staggered, flickering, almost filmic scenes in which images are grouped in sequence to create what he describes as "filmic haiku." As he said in a 2007 interview: "Just slow down and look at this ordinary moment of life. See how beautiful it is, see how life flows around us, how everything shimmers with possibility." Finally, in "The Present" he examines how focus leaves its mark on the negative, and by doing so he calls into question documentary's "decisive moment." As critic Gerry Badger says, "Not for him the fake theatricality of the perfect street shot."

Graham's work has often sought to challenge the status quo. As a self-taught photographer who became interested in the medium after picking up a copy of the British magazine *Creative Camera*, he never went to art college but instead graduated from Bristol University with a degree in microbiology. Graham actively set out to work in color photography from the start and he was influenced by the work of William Eggleston. The series that arguably propelled him into public awareness, "Troubled Land" (1984–86), about the troubles in Northern Ireland, was shot in color. He now admits that it "transgressed two genres, mixing up landscape and war photography . . . but I think that it was in part a reflection of my distance, and a way of approaching something big and beyond ordinary rational comprehension, starting at arm's length, as it were." As he says, these images are the reverse of the press photographs in which photojournalists tend to abide by Robert Capa's dictum: "If your pictures aren't good enough, you aren't close enough." In "American Night," Graham continues to blur the lines between the genres of landscape and social documentary. "I am interested in more elusive and nebulous subject matter," he concludes. "Art isn't about providing answers. . . . Its more about questions—asking thought-provoking, unexpected, unarticulated questions."

WIM WENDERS

Wim Wenders is best known as a film-maker and an influential architect of the New German Cinema movement. However, he is also a photographer and when he is traveling for his movies, he is rarely without his old 6x7 medium-format camera. He shot to stardom in 1984 with the film *Paris, Texas*, which won him several awards, including the highly prized Palme d'Or at Cannes. However, the previous year, while scouting for locations for this production, he took a series of photographs that deserve similar celebration. Embarking on a road trip from Arizona to New Mexico, he eventually arrived in Texas, where he created an unusual and evocative portrait of a place. He writes, "You can never really own a place. Even the camera can't. And if we take its picture, we're only borrowing the place's appearance for a little while, nothing but its outer skin, its surface."

Wenders's photography reveals a deep understanding of some of the medium's legendary names. *Safeway* (see image 2) recalls the stark, frontal, pared-down style of Walker Evans. The shop sign also echoes Evans's fascination with lettering and words, and how they appear within the U.S. landscape as vernacular advertising. *Joshua and John (Behind)* (see image 3) evokes William Eggleston's simple yet striking studies in color. However, Wenders's pictures also reference painting, and in particular the work of U.S. realist painter Edward Hopper. Alluding to Hopper's *Early Sunday Morning* (1930), Wenders remarks, "There's that famous picture of a street in New York, with the barber's shop in the middle. I believe that is a highly exciting picture in the way it references photography and film. . . . It's a picture where you expect that the very next moment something will happen and it will change — perhaps the lighting. It is a picture waiting to pounce." Much of Wenders's imagery creates the same sense of anticipation and the same suggestion of narrative.

Although his lens has immortalized many places beyond Texas, from Havana to Tokyo, he says, "I must say that I now almost just as much like empty landscapes, such as deserts." Indeed, apart from the odd frame such as *Entrance* (see image 1), Wenders's urban landscapes are nearly all as devoid of people as the desert. Wherever he is, he hunts down empty street scenes and corners. These desolate cities or urban deserts appear hauntingly apocryphal. In fact, art historian and curator Peter-Klaus Schuster suggests they foresee a time when "humans have more or less retreated" and "signs of civilization that have been left behind . . . tell of the people who were once here."

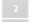

1 *Entrance*, Houston, Texas, USA, 1983
2 *Safeway*, Corpus Christi, Texas, USA, 1983
3 *Joshua and John (Behind)*, Odessa, Texas, USA, 1983

VANCOUVER
BORN 1946, Vancouver, British Columbia, Canada LIVES Vancouver
STUDIED University of British Columbia; Courtauld Institute of Art, London
OTHER GENRES Staged, fine art

JEFF WALL

One of the most inventive and influential contemporary artists, Jeff Wall was born and raised in Vancouver, where he has set many of his "street pictures," including *Overpass* (see image 1). These images explore the documentary style of street photography practiced by icons, such as Robert Frank and Garry Winogrand, yet with a twist. Wall explains, "I have a strong relationship to the tradition of reportage, but it's reportage flipped over. I don't photograph and I don't file my report on time." The seed was sown for *Overpass* when, gazing from his studio window, he saw a very similar scene unfold in downtown Vancouver.

The philosophy behind Wall's street pictures began two decades earlier with *Mimic* (1982). "I wanted to find a way to deal with real events," he recalls, "To get away from my own imagination . . . out of the studio, but not to relinquish certain advantages, which I felt I'd gained there." He saw an incident that could have formed a classic reportage photograph, but he had not recorded it. He frames the decision not to photograph the scene as a breakthrough, adding how this meant "that my work as an artist, at least my work outside, would have one of its points of origin in the act of renouncing the opportunity to photograph events as they happen." This gesture of refusal enabled Wall to approach these everyday moments in a radically different way; he decided to stage them using actors and large-format cameras. *Mimic* reveals what he saw in Vancouver all those years ago: a white man caught in a moment of racial hatred, pulling "slant eyes" at an Asian man. Yet, as the image feels like it depicts a real event, as Wall hoped, it "therefore could make a claim to truth . . . even though it was not documentary photography but a contemplation of documentary photography." He calls this challenge to photographic authenticity "near documentary."

Wall still favors the signature presentation he set with *Mimic*— large format, backlit in a metal-edged light box and mounted on a gallery wall—but the more recent work is bigger still, approximating the scale of classical painting. *Overpass* refrains from the overt theatricality of *Mimic* and its quieter atmosphere makes it more difficult to interpret. By turning their backs to the camera, all four figures frustrate the viewer's voyeuristic desire to read their faces. We know that the scene created is slightly different from the one Wall originally spotted because he changed the setting in favor of one with a dipping view. By framing this preferred location, he was able to picture figures walking along an overpass that stretches off into the distance, thereby evoking notions of pilgrimage, or perhaps, as the stormy skies portend, exile.

1

1 *Overpass*, Vancouver, Canada, 2001.
Transparency in light box.
84 ¼ x 107 ½ in.

LATIN AMERICA

MEXICO CITY MONTERREY LIMA
RIO DE JANEIRO SÃO PAULO CARACAS

FRANCIS ALŸS OSCAR FERNANDO GÓMEZ EDI HIROSE CLAUDIA JAGUARIBE JULIO BITTENCOURT
ANA CAROLINA FERNANDES CÁSSIO VASCONCELLOS LUIS MOLINA-PANTIN

"To photograph is to appropriate the thing photographed. It means putting oneself into a certain relation to the world that feels like knowledge." Furthermore, "to collect photographs is to collect the world." These words from U.S. writer Susan Sontag's landmark treatise *On Photography* (1977) can be used to frame much of the street photography currently emerging out of Latin America. Many of the artists in this chapter might be called "collectors"; their practice tends toward painstakingly and at times compulsively gathering impressions of the people, places, and things that they encounter in the city.

Antwerp-born artist Francis Alÿs is one such collector, who even adopted the term as a title for one of his conceptual pieces ("The Collector," 1991–2006). Over a decade ago Alÿs started to notice homeless people and stray dogs bedding down on the pavements and park benches of his adopted home, Mexico City. He started to photograph them on his daily walkabouts: a practice he continues to this day that is slowly amassing into the series "Sleepers" (see p.94). He also trains his camera on all manner of urban characters as seen in two other series, "Ambulantes" and "Beggars." The first portrays street hawkers pushing overfilled carts around the capital; the latter reveals the range of people found begging at subway entrances.

There is an element of objectivity to Alÿs's various celluloid compilations. He clarifies, "My method of shooting is always systematic and tries to respond technically to the encountered situations. 'Sleepers' will always have the camera at ground level. 'Beggars' (2002–04) takes a quasi-hypocritical high viewpoint. 'Ambulantes' (1992–06) is always shot perpendicularly to the passing subject at a distance of fifteen feet or so. In that sense it is as neutral a register as can be, and it is that which might give it its archival value over time." His words echo Sontag's suggestion that photography can frame the world in a way that feels like gathering knowledge. Ultimately, the alternate methodical approaches to his subjects give the work a quasi-scientific veneer; the faces photographed recall the pinned exotic specimens brought back from a naturalist's field trip.

Two other Latin American artists further evolve the notion of the collector. Both have standardized their practices in much the same way; they have independently arrived at the idea of fixing their subjects through different types of windows. Mexican Oscar Fernando Gómez is a taxi driver who photographs people through the passenger window of his Nissan Tsuru so they appear framed by the inside of the car door, windshield, and wing mirror (the street sellers and beggars uncannily parallel Alÿs's work, see p.94). Meanwhile, Brazilian Julio Bittencourt pictured each of the inhabitants of a condemned apartment block in São Paulo within its many windows. The residents of the 22-storey, 911 Prestes Maia Building had learned in March 2006 that they were facing eviction. Bittencourt set about creating an artwork that today serves as a photographic elegy to the diverse community that once lived in this now-demolished tower (see p.112). The rigorously repetitive framing used by Gómez and Bittencourt lends the two respective series, like those by Alÿs, a semblance of objectivity. However, both artists accentuate this by presenting the imagery in a regular, gridlike pattern (Bittencourt digitally collages the windows to reconstruct the building's façade). Effectively, such systematic arrangements encourage a compare-and-contrast approach to the photographed subjects, creating a simple typology and heightening the sense that one is looking at a form of anthropological collection.

Similar terminology is invoked to describe the work of Venezuelan Luis Molina-Pantin; hailed as a cultural ethnographer and urban archaeologist, he is certainly a collector and yet his quarry is different. Molina-Pantin walks the city streets not in search of people or places, but urban objects. His hunt through Caracas for signs that bear his name culminated in the series shown in this chapter (see p.116). His roving eye is attuned to objects that highlight readily overlooked cultural idiosyncrasies. "Eight Failed Attempts Looking for the First Edition of *One Hundred Years of Solitude* in Caracas" (2013) not only reads as a tribute to Latin America's much-loved author Gabriel García Márquez, but also shows how ubiquitous the book that earned him international acclaim (and its subsequent editions) has become. Like many of the artists on the following pages, Molina-Pantin's approach speaks of detachment and discipline; in his hands, the camera becomes a recording device with which to collect the world.

MEXICO CITY

Mexico's historical, social, political, and aesthetic forces have influenced the work of both Mexican and international photographers over the years. Drawn by what U.S. photographer and curator Wendy Watriss calls the "dissonance and consonance inherent in cosmopolitan industrial economies that function alongside pre-Columbian Amerindian cultures and the vestiges of nineteenth-century colonial institutions," photographers have captured this richness through a prism of realism, surrealism, modernity, and poetry. In this context, Mexico City's urban setting encapsulates the motherland's contrasts and contradictions, serving as a site for what French novelist Pierre Mac Orlan called "the fantastic sociality of the street."

In the works of photographers such as Manuel Alvarez Bravo, Nacho López, Graciela Iturbide, Pedro Meyer, and Pablo Ortiz Monasterio, the gaze bestowed on Mexico City's diversity and translated photographically is primarily through the daily lives of the people on the streets. They record a "Mexicanity" derived from a mixture of pre-Hispanic and modern culture, Catholicism and indigenous religions, and the struggles of a peasant population in a growing capitalist society. Intent on rejecting a folkloric, picturesque, and national aesthetic, the Mexican photographic tradition is rooted in social documentary and journalism. Combining the concerns of the photojournalist, the artist, and the social critic, photographers distinguish themselves with anti-picturesque images that represent a people not only defined by a rich, complex culture but by their daily struggles, traditions, and rites. They attempt to make visible what would otherwise remain anonymous; the "literalness" of a committed photography interrogates the city and records events in all their richness through "the discontinuities of fragmented urban lifestyles."

In the nineteenth century, in order to attract foreign capital under President Porfirio Díaz's regime, photography played an important

role in documenting a country in expansion. Artist Frida Kahlo's father, Guillermo, was commissioned to photograph the economic development and modernization of its metropolis. He did so with detailed, astringent clarity, depicting the city's elaborate and luxurious architecture, such as colonial churches, the Central Post Office, and the new Legislative Palace. Foreign photographers, such as French archaeologist Claude-Joseph Désiré Charnay, were sent by their governments to document the Americas, and were enticed by the panoramic cityscapes, picturesque locales, and colonial buildings.

In the early twentieth century, during the political reconstruction after the Mexican Revolution, photography witnessed and recorded social, political, and economic concerns. Shaped by the post-revolution values contextualized in the work of muralists Diego Rivera and José

1 *How Small the World Is*, Manuel Alvarez Bravo, 1942 2 *1968 Student Movement*, Pedro Meyer, 1968
3 *It is Gold, Cement and Silver*, Pablo Ortiz Monasterio, 1990
4 *Sonoran Market*, Graciela Iturbide, 1978

Clemente Orozco, seminal photographer Alvarez Bravo was drawn to the ordinary men and women in the streets of Mexico City (see image 1). His work is firmly anchored in the indigenous roots of the nation and the traditions of the common people. Alvarez Bravo endlessly walked the streets of the city "La Merced, La Candelaria de los Patos . . . surreal neighborhoods, dark, quiet, out-of-the-way places"; he once said that he was born in Mexico City "behind the Cathedral, in the place where the temples of the ancient Aztec gods once stood."

The most notable figures in Mexican photography of the next generation were socially committed photojournalists who made visible the conflicts of a class of people in post-revolutionary Mexico. Documenting protests, labor strikes, assassinations, and other forms of political unrest, García Cobo and Nacho López fused "social commitment with searing imagery to dramatize the plight of the helpless, the poor, and the marginalized," and questioned the effects of change in society. Their images provided rich subject matter for a developing press that served an eager audience in the 1940s and 1960s. López, one of the most famous photojournalists in Mexico, crafted many photo-essays of a city grappling with its new wealth. He documented the flip side of affluence and how the process of modernization did not bring about the government's homogeneous vision.

In 1968, a group of student and civilian protesters were killed by government forces in what became known as the "Tlatelolco massacre." The tragedy impacted a generation of photographers who began their careers in the 1960s and 1970s, and redefined a documentary photography that would advance new social and political ideas. Among them is Spanish-born photographer Meyer (see image 2). A liberal humanist influenced by Henri Cartier-Bresson's formalist photography, Meyer's ongoing theme is urban life. Overtly unsympathetic to Mexico's middle and upper classes, Meyer investigates a fragmented society and, with great sensibility, portrays how people in the lower strata maintain a "balance between the old traditions and new influences, as well as between the spiritual and the secular in their daily lives." Mexico city's social fragmentation is also the matrix for the work of documentary photographer Pablo Ortiz Monasterio. In *It is Gold, Cement and Silver* (see image 3), Monasterio's unsettling eye unveils the way of life of a marginalized population that goes largely unnoticed amid the complexities of Mexican society. Photographing Indians without resorting to the "picturesque" is difficult, yet Graciela Iturbide's gaze enters into the world of the "other," the indigenous communities, and reflects on lives rooted in tradition and lived in spite of mainstream norms that foster indifference and prejudice (see image 4).

The visual stimuli of Mexico City stand for the spirit of Mexican culture. Through their images, photographers attempt to uncover the heart of a complex and multilayered culture as embodied in the individuals who form its base. **CF**

1–5 *Sleepers IV, Mexico City*, 1999–present.
80 35mm slide carousel projection

MEXICO CITY

BORN 1959, Antwerp, Belgium **LIVES** Mexico City, Mexico **STUDIED** Institute of Architecture, Tournai; Institute of Architecture, Venice **OTHER GENRES** Performance **OTHER CITIES WORKED** London, São Paulo, Lima, Paris, New York

FRANCIS ALŸS

Belgian-born conceptual artist Francis Alÿs revels in the unconventional. In the name of art, he has let loose a fox in London's National Gallery at night (*The Nightwatch*, 2004), persuaded 500 Peruvian students to move a giant sand dune by shovel (*When Faith Moves Mountains*, 2002) and pushed a block of ice around the steaming streets of Mexico City until it melted (*Paradox of Praxis 1, Sometimes Doing Something Leads to Nothing*, 1997). He uses painting, drawing, video projection, animation, and photography to tell stories. "If the story is right, if it hits a nerve, it can propagate like a rumor," he advocates. "Stories can pass through a place without the need to settle. They have a life of their own." His words recall the notion of the "meme," the term coined by evolutionary biologist Richard Dawkins in his book *The Selfish Gene* (1976) to refer to an idea that travels from person to person through culture. Art critic Lynne Cooke writes how Alÿs is thinking of creating a work "which takes the form of a rumor." The artwork can be seen as a meme traveling through Cooke's essay, the words on this page and indeed any written or spoken subsequently by someone passing on the story.

However, the majority of Alÿs's projects are set on the terra firma of his adopted home: the vast, sprawling, crowded Mexico City. To the Chilean poet Pablo Neruda this city was "the touchstone of America"; to Alÿs it teems with tales and each of its inhabitants takes on the role of muse. "All these people who live around my studio in the historical center of Mexico City remain the principal inspiration for many of my projects," he admits. "They are a constant reminder of the crude reality of the metropolis." This fascination with the living, breathing reality of the city is mirrored in his ongoing photographic series "Sleepers." In 1999, Alÿs started taking photographs of the sleeping stray dogs and homeless street dwellers that he encountered on his daily wanderings through his neighborhood. Ascribing no difference between man and beast, he set about picturing them taking naps in doorways, sprawled on pavements and lying prone on park benches.

The series has its vocal critics who variously accuse Alÿs of being paternalistic, naive, sentimental, or judgmental. However, he steadfastly believes that the role of artists is to bear witness to the society in which they find themselves. They have a responsibility to look without bias and represent all spheres of society including its marginalized populations. To sideline these inevitable accusations, he frames the work in other, more conceptual concerns. "With 'Sleepers,' what interested me was the use of public space in such a private way," he explains, adding "there are few activities as private as sleeping." However, when art historian Anna Dezeuze directly asked him if he is interested in whether these people have a choice in where they sleep and how they live, he countered, "I'm interested, of course, but I don't think it's something I could translate in the work. If I did I would fall precisely into a more patronizing reading."

Alÿs frames every single sleeper—human or canine—the same way. Each subject is photographed from a distance and at ground level. This style has been mindfully chosen to instill dignity; it succeeds by avoiding not only the voyeuristic close up, but also the condescending downward aspect. As Jörg Heiser, co-editor of the magazine *frieze*, recognizes, "The protagonists become strangely

noble, sleeping the sleep of the just." However, Alÿs made great efforts to ensure the photographic approach remained constant for another reason. He claims inspiration from a legendary twentieth-century German photographer whose name has been cited as an influence by artists from Bernd and Hilla Becher to Andreas Gursky: August Sander and his practically lifelong yet unfinished project *People of the Twentieth Century* (Menschen des 20 Jahrhunderts).

In 1910, Sander opened a photographic studio in Cologne and set about creating a collective, comprehensive portrait of German society. He dedicated over five decades to the idea, but at the time of his death the project remained unfinished. He chose to categorize his subjects by their profession and class: as farmers, lawyers, bankers, merchants, musicians, artists, poets, as well as gypsies, beggars, and the insane. Consequently, the portraits have since been interpreted as representations of types, rather than individuals. In this respect, although Alÿs's series "Sleepers" frames a certain section of Mexican society, all sharing the same activity, it does so for very different reasons. The project seems more akin to social reportage than scientific classification; indeed, Alÿs has also linked it to Francis

Wheatley's *Cries of London*, an eighteenth-century series of oil paintings that celebrates the London street hawkers of the time. Sander's series is also renowned for its standardized approach that lends the work a sense of objectivity, and in this way, Alÿs's series continues the tradition. He adds, "My method of shooting is always systematic and in that sense it is as neutral a register as can be, and it is that which might give it its archival value over time."

Mexico City has clearly been a great influence on Alÿs, however, he might easily have never stepped foot on the continent. During the 1980s he was studying engineering and architecture in Belgium when, on September 19, 1986, Mexico City was struck by a series of massive earthquakes that killed at least 10,000 people and destroyed much of the city's infrastructure. Later that year the young Alÿs set out to Mexico City as part of an assistance team to help rebuild areas that had been devastated. Ultimately, this city turned out to be not simply the inspiration behind his art, but also the reason why he became an artist. "I always had an interest in the arts, but without any real intention of getting involved as a main activity. It is probably the encounter with Mexico that made me just give it a try."

6–8 *Sleepers IV, Mexico City*, 1999–present.
80 35mm slide carousel projection

MEXICO CITY

BY ALEX WEBB

"Our festivals are explosions," wrote Mexican poet and essayist Octavio Paz. "There is nothing so joyous as a Mexican fiesta, but there is also nothing so sorrowful. Life and death, joy and sorrow, music and mere noise are united," he added. Mexico City may be a chaotic, smog-choked, over-populated modern metropolis, but during its long Christmas holiday season, it reveals an essential Mexicanness, as the center of the city bursts into weeks of celebration.

MONTERREY

BORN 1970, Monterrey, Mexico LIVES Monterrey STUDIED Self-taught in photography SERIES "Windows" (La Mirada del Taxista), 2008–10
OTHER GENRES Portraits

1–12 From "Windows," Monterrey, Mexico, 2009

OSCAR FERNANDO GÓMEZ

For fifteen years Oscar Fernando Gómez photographed weddings and *quinceañeras* (the celebration of a girl's fifteenth birthday) in the city of Monterrey in northeastern Mexico. In 2005, in an effort to supplement his income, he decided to rent a green Nissan Tsuru and become a taxi driver. A few years later, when his wife was expecting their first baby, he set about creating a photographic album of his daily encounters to show their future child. The result was the series "La Mirada del Taxista," now known simply as "Windows."

Gómez never received any formal training. He claims, "I bought a photography magazine that had a two-page crash course in it that taught me all the essentials, like how to click the shutter. That was all I needed." Photographer Martin Parr (see p.384) included Gómez in a show he curated for the Brighton Photo Biennial in 2010; it was the first time Gómez's images were exhibited outside Mexico. "Thank God Gómez did not attend photography school, and is not involved with contemporary photographic practice," he wryly notes. If he had, or if he were, it is unlikely "Windows" would exist; there is an appealing naivety running through the images. Parr suggests, "It reminds me of that excitement of arriving in a new country, where everything is so fresh and so intense . . . just like that first ride from the airport in a taxi."

The Nissan passenger window frames every one of the photographs in the series. One can easily make out the inside of the door, a corner of the front windshield, and often the wing mirror depicting another reflected scene: a picture within a picture. The act of making a photograph is a case of framing a vignette from the world within a viewfinder, however, the visibility of the vehicle's window serves to underscore and remind us of this process. As a result, the images seem somehow activated and animated; as Parr observes, it is "as if reality becomes more intense when it is framed so perfectly," and moreover, so overtly.

"Windows" calls to mind Andrew Bush's series "Vector Portraits," which depicts people driving in their cars in Los Angeles (see p.62). Both artists arrange their individual images in a grid format. This style creates simple typologies and the viewer's eye roams through the almost rhythmically repetitive imagery searching for differences. Yet, there is a subtle but intriguing disparity at play between the two bodies of work. Whereas Gómez repeatedly photographs people through *his* car window, Bush repeatedly photographs people through *their* car window; when Gómez gazes out, Bush gazes in.

Consequently, "Windows" does not display the voyeuristic sensibility of "Vector Portraits"; instead it seems to chronicle Gómez's world. It was, after all, conceived as an album to show his first child how he spent his days, and for this reason, it reads as a kind of visual diary.

Tragically Gómez's baby died at birth. "From one day to the next, everything was over," he recalls. Despite this, he continued his project and in many ways the resulting series is colored by his misfortune. "I was drawn to people's tragedies and problems," he explains. "Through my pictures, I took the people very much to my heart and soul, the pictures reflecting the depth of feeling, the energy." Among the images of walls emblazoned with colorful grafitti, Gómez's eye is constantly drawn to certain local figures: street sellers hawking their wares, men pushing wheelbarrows brimful with junk, and homeless people asleep in doorways. "Windows" is undoubtedly tinged with a sense of melancholy. However, the death of his firstborn was not the only event that instilled in him an empathy for those less well off. When Gómez turned twenty, long before he became a wedding photographer, he left Monterrey to look for work in Mazatlán, a city twelve hours away on the Mexican seaboard. On his journey there he ran out of money. "I ended up sleeping rough, on street corners, eating whatever I could find," he recalls, "eating little birds and the remains of soft drinks that people had chucked away outside cinemas. I thought my life was about to end." Luckily an aunt who lived nearby came to his rescue, but these memories are etched deep in his pysche and they tend to resurface whenever he sees people in a similar situation.

There is one image in this collection with a particular resonance for him (see image 6). "I saw this man while I was out driving one day. He reminded me of what I'd been through," says Gómez. "He had loaded his wheelbarrow with industrial waste—wood, metal, plastic—to sell to recycling companies for about three pesos a kilo. I, too, did this. As I drove past him, I noticed he had stopped to comb his hair very carefully. I asked if I could take his photograph because I wanted to show that even people who can't find work, people who have nothing, can maintain their dignity. Often, it is all they have." "Windows" is an homage to these people.

Oscar Fernando Gómez is currently supported by a grant from CONACULTA, the Consejo Nacional para la Cultura y las Artes in Mexico, and he is hoping to one day have earned enough money through his photographs to be able to buy his own taxi.

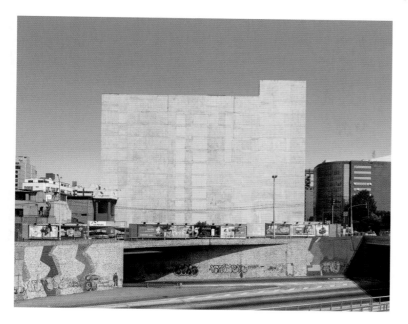

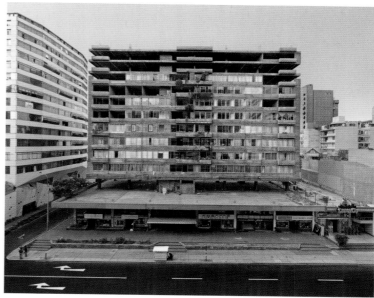

1–3 From "Expansión 1," Lima, Peru, 2008–13

LIMA

BORN 1975, Lima, Peru LIVES Lima STUDIED Instituto de Educación Superior Antonio Gaudí, Lima SERIES "Pozuzu," 2000–03; "Expansión 1," 2008–13 OTHER GENRES Documentary OTHER CITIES WORKED Pasco, Cajamarca

EDI HIROSE

Lima, the capital of Peru, is one of the world's fast emerging megacities. With a population approaching nine million, it is home to a third of all Peruvians and ranks as the fifth largest city in the Americas. Yet it is growing at an accelerated rate and this relentless expansion sprawls both outward and skyward. Edi Hirose has never lived anywhere other than Lima and he watched how his neighborhood of Miraflores transformed as the real estate boom took hold in 2008. "The place I live in was the fastest district to change," he recalls. "There was a vast amount of new construction occurring in a very short time." Every day would bring new surprises; he saw old edifices being knocked down and rapidly replaced by taller, modern façades. As the city grew and changed shape, he began to realize that he was witnessing something unprecedented. "I decided to start photographing my immediate neighborhood in 2008 and I am still working on the project," he explains. "I had no idea how big it would become."

The resulting series, "Expansión 1," documents Lima's skyline in the process of formation and transformation. Hirose used a distant and deadpan gaze to create an aesthetic that seems to privilege surface over content. This acts to enable the viewer to forget that these façades hide offices and homes—an effect heightened by Hirose's decision to explicitly exclude any evidence of people within the frame.

Instead the imagery presents buildings as perpendicular, blocklike patterns of colors, tones, and textures that look more akin to sculptural installments. "The work points to the façade as a notion of limit; a surface that defines the private from the public," he asserts. Yet, he is swift to point out the social implications of the photographed façade: "It is also associated with a zone of conflict. It effectively represents the social tension that exists between the adjacent property borders." Throughout the construction boom, Hirose notes how it was common for developers to start building without proper planning and that they would press ahead with whatever suited them. "In Lima," he concludes, "this individualistic thinking has led to a city with 'blind' walls, where no one seems to care about their neighbors."

As the project took shape, Hirose found himself traveling beyond Lima and he noticed that the construction boom had spread. He started to photograph other cities for the series, such as Cajamarca and Pasco. He became fascinated by what was happening at the city borders, where the artificial and natural landscapes collide; thus began the second volume of the project. "Now I'm working on 'Expansión 2,'" says Hirose. "This next stage focuses on the transformation of the natural landscape as a result of our progress. I don't know what 'Expansión 3' is about yet, time will tell." Inevitably perhaps, Hirose's ongoing "Expansión" project will continue to expand, mirroring its subject, but even in these early stages, this body of work enables us to look at the city from a distance, as a phenomenon that seems to pulse, grow, and consume: a living creature with its own mind and will.

RIO DE JANEIRO
BORN 1955, Rio de Janeiro, Brazil **LIVES** São Paulo, Brazil **SERIES** "Rio: Entre Morros" (Rio: Between Hills), 2010 **OTHER GENRES** Landscape, video
OTHER CITIES WORKED São Paulo

CLAUDIA JAGUARIBE

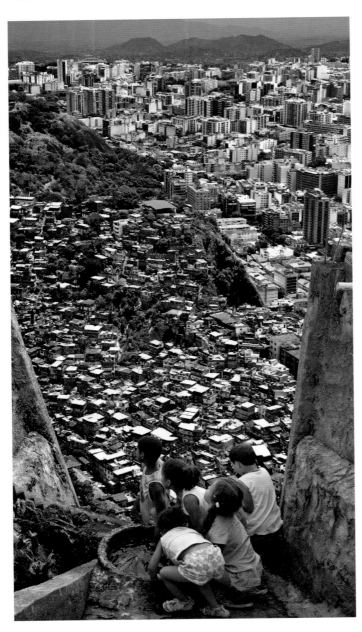

Rio de Janeiro is often described as being between mountain and sea: an axis that resonates in these towering, vertical cityscapes. Jewel-bright colors and hyper-real details combine to create a seductive aesthetic. Yet there is something uncanny about these urban panoramas; they emanate unease and precariousness. On closer inspection, one realizes that the perspective in every composition is oddly skewed. In fact, each is a collage of many individual images. In "Rio: Entre Morros" Claudia Jaguaribe skillfully frames, angles, and layers imagery to create views of the city that are not quite correct. The effect has met with various interpretations. Some have read it as a critique on the uncontrolled growth of Rio's shanty towns. Antonio Gonçalves Filho writes, "Claudia Jaguaribe shows in Entre Morros how the landscape transformed itself to the point of becoming unrecognizable . . . turned into the purgatory of real estate speculation, of ecological destruction." Jaguaribe offers an alternative view: "My Rio—a combination of real and created images—seems to me more coherent with how we inhabit and understand the city." She hopes her images convey the experience of city life. Her disjointed scenes are certainly immersive; they invite the viewer to invest time deciphering their portrayed landscapes.

Jaguaribe was born and bred in Rio, but she left the city before she envisioned "Entre Morros." In 1989, for professional and personal reasons related to her work, she decided to move to São Paulo. However, she has since commuted back and forth to see her family. "I always fly," she says, "and this has influenced my view of the city and the way I photograph it. Only from the air can we fully see and understand this extraordinary place." She began to wonder if she could create a picture both within and above the landscape, and the idea for the series was conceived. With a guide, she headed off to the hills, into the violent and lawless terrain of the *favelas*. Despite the tense atmosphere of *favelas* such as Rocinha, Rio's largest, they were warmly received by the local children and so Jaguaribe photographed them. After, covering the same ground but from the air in a helicopter, she combined the bird's-eye and ground views of the same scenes. "There was a lot of trial and error. It takes a while to figure out the compositions and how the separate pieces relate to one another: not unlike a jigsaw puzzle." The final artworks are arguably brought to life through the children clambering, climbing, and playing, but they also crucially provide foreground interest, thereby accentuating the giddy perspectives of these city panoramas.

1

2 3

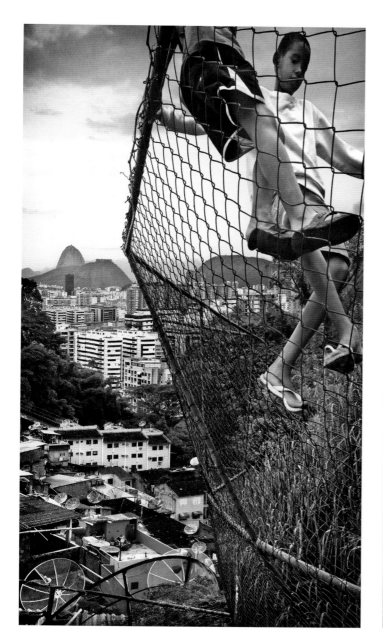

JULIO BITTENCOURT

Rio de Janeiro is world famous not so much for its street life as its beach life; throngs of thonged or microkini-clad bodies flock to its shorelines, to strut, swagger, and worship the sun. Yet the beach these pictures portray is seen by few, if any, tourists. Noisy, polluted, crowded, and, moreover, like some of the flesh on display, somewhat artificial. It was created from scratch in 2000 to surround a vast lake constructed across 10 square miles and filled with 8 million gallons of seawater. It is known locally as Piscinão de Ramos (Ramos Swimming Pool) and is located on the outskirts of Rio in Complexo da Maré, an area notorious for its *favelas* (shanty towns). The *favelas* that back onto Ramos are run by warring factions of drug-trafficking gangs and are plagued by violence; in fact, they log some of the highest crime statistics in the country. As Joaquim Ferreira dos Santos, columnist for Rio's *O Globo* newspaper, rightly points out, "The Princess of the Sea doesn't come to this beach, nor does the Girl from Ipanema. Those who go to Ramos beach are of a different sort."

São Paulo–born photographer Julio Bittencourt first heard of Ramos when it opened for business on December 16, 2001 and amid much pomp was inaugurated by the city's governor. It was instantly popular, attracting as many as six million people in one weekend and Bittencourt was instantly intrigued. "Since starting out as a photographer, I always wanted to do a project related to a beach in Brazil," he recalls. Ramos seemed ideal because it was such a far cry from people's expectations and Rio's rich, renowned, south-side beaches. He made a pact with himself to visit the beach at the earliest opportunity. He had to wait seven years.

First, Bittencourt had to find someone who lived in the area, who could introduce him to the locals and act as a guide; otherwise, the project could be potentially dangerous. Through various friends and contacts, he eventually met up with the right man, a musician by the name of Bhega. "Without him I could not have done this project," says Bittencourt. "He let people know who I was and as long as he was with me, I was safe." Bhega suggested Bittencourt first get to know Ramos and its visitors before bringing along his camera. Despite this, however, there was drama on their first day. "I was wearing a red T-shirt and was told as soon as I got on the main street

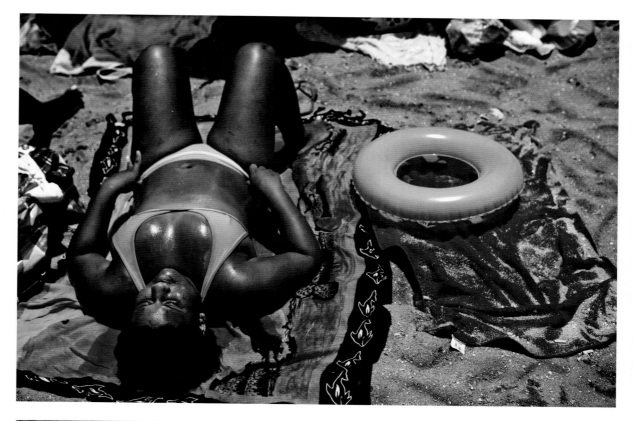

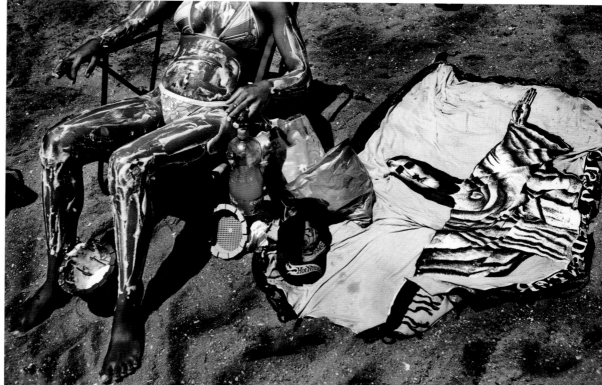

1–5 From "Ramos," Rio de
Janeiro, Brazil, 2009–12

right outside the swimming pool to take it off," Bittencourt recounts. It turned out that of all the T-shirts he could have put on that day, he chose the wrong color. "A drug gang called Comando Vermelho (Red Command) had recently been thrown out by another gang and red was Comando Vermelho's color." Bittencourt had unknowingly been wearing the gang's uniform and made himself an obvious target.

From the beginning, Bittencourt was excited. "It was clear there was something there." After a few months of visiting as a tourist, he and Bhega agreed that it was finally time to bring the camera along. Bittencourt clearly remembers it. "The day was hot, about 104°F, very crowded as usual." As he started to walk around, he cannot even recall putting the camera up to his eyes, but within minutes he had taken an image that turned out to be the one that defines the

series and ended up on the cover of his book (see image 7): "The first photo I made was of a little kid playing with a small Labrador dog in the water." It all came together without him thinking. "It is hard to describe the feelings. Those moments are what I live for. Just seeing so many lives and moments pass one after the other in front of you and you there, trying to let them in somehow."

In the summer of 2008, he spent all his spare days at Ramos. When he returned the following summer he decided to rent a room inside the community, on a tiny backstreet, within three minutes walk to the pool. "I went there almost every weekend and depending on how hot it was, sometimes during the week as well. It was then that everything started to click more." Summer after summer he returned. He got to know the neighbors, and soon they would spend

afternoons together; "[they] used to sit with me on the floor right outside their homes on that tiny street, looking at and sometimes even editing my photos together. It was a great experience. Intense and lots of fun." Eventually in 2012, he felt that the series was complete.

The year he first visited Ramos was memorable for another reason. It was also the year he shot to prominence with his first artistic project, a series on São Paulo's poorest housing development titled "In a Window of Prestes Maia 911 Building" (see p.112). Stylistically, however, the two series could not be more different; they reflect antithetical modes of working. "Windows" required Bittencourt to set up shoots by posing people framed by their windows. He then stitched these individual windows together like a digital patchwork blanket to create a building. "The concept from day one was to try to create the building in an aleatory way as you saw it from outside. . . . The windows weren't necessarily next to each other, or even on the same floor." By contrast in "Ramos," Bittencourt uses classic street photography. "The idea was the opposite from 'Windows,'" he states: "For this particular project, I wanted to control less. To let things come into the camera without me having to direct. . . . Being invisible was more important than anything else." He wanders and observes, like a latter-day *flâneur* who has switched streets for sand, boulevards for beach, creating a portrait of an unknown tranche of Rio beach life. At Ramos, as Joaquim Ferreira dos Santos observes, "What matters is not looking good for the camera, but rather feeling the sun on one's skin, getting drunk on cachaca (Brazilian rum) and splashing the time away."

RIO DE JANEIRO
BORN Rio de Janeiro, Brazil **LIVES** Rio de Janeiro **STUDIED** Escola de Artes Visuais do Parque Lage, Rio de Janeiro **SERIES** "Mem de Sá 100," 2011–13 **OTHER GENRES** Photojournalism **OTHER CITIES WORKED** Brasilia, São Paulo

ANA CAROLINA FERNANDES

The title of the photographic series "Mem de Sá 100" is an address in Lapa, a neighborhood of Rio de Janeiro that is renowned for its nightlife. It leads to the home of Luana Muniz, a transvestite who works in the local clubs and is a strong influence in the surrounding community. She rents out rooms in her beautiful, large, rambling house to her colleagues and friends. One such friend is the Brazilian photographer Ana Carolina Fernandes, whom she invited into Mem de Sá 100. For two years they co-existed and through her lens Fernandes framed the comings and goings and various dramas that took place at the house. The resulting series reveals a world that is

rarely seen and lends a voice to a group of people who are rarely heard. It explores the beauty and sensuality of bodies that reflect both genders, and ultimately reveals the malleability of sexuality. "The ambiguity of two bodies, both female and male within the same person, has always fascinated me." says Fernandes. "This series would not have been possible without Luana's permission. She was the key."

Fernandes initially trained as a photojournalist and for two decades she worked for many of Brazil's foremost magazines and newspapers, including its biggest broadsheet, *Folha de S. Paulo*. However, in 2008, she quit. "Photojournalism just did not satisfy

1–5 From "Mem de Sá 100," Rio de Janeiro, Brazil, 2011–13

me anymore," she recalls. "I wanted to be able to tell stories in a more indepth, more detailed way." By chance she met Muniz. They had known each other years before and when they came across each other on this occasion, Fernandes was looking for subjects to photograph. Muniz invited her over one Friday night when all the girls were getting dressed up for their evening shifts at the clubs. Fernandes remembers, "I took my camera of course but kept it in my bag." She felt she first had to gain her subjects trust. "It was casual . . . various girls drifted in and out of the house while I sat on the floor and watched, completely relaxed." However, even before the evening was finished, she had managed to take her first photograph. "April 22nd, 2011; this was the first day of the project."

Nearly all the photographs are exposed at dusk. '6:19 p.m., 7:45 p.m., 5:17 p.m., 5:41 p.m., 6:00 p.m.; these are when some of the pictures were taken. I found that it was the time when the girls were most relaxed: waking up, taking a shower, and making themselves up." Fernandes's decision to avoid flash and to restrict herself to the fading ambient light created a very distinct aesthetic. The frames seem to pulse with vitality and color. Yet the edges are softly, almost incoherently blurred and details seem smeared across the page. The overall feeling is one of fluidity; a notion that mirrors how one's sense of sexuality, and indeed identity, are constructed, performed, and shifting.

When the series "Mem de Sá 100" was eventually finished in 2013, it was exhibited at a local Rio art gallery. Fernandes remembers the opening night fondly, "All the girls came along and they were so proud of themselves and the work we had done together. What I find most rewarding about this project is that they trusted me and they still do."

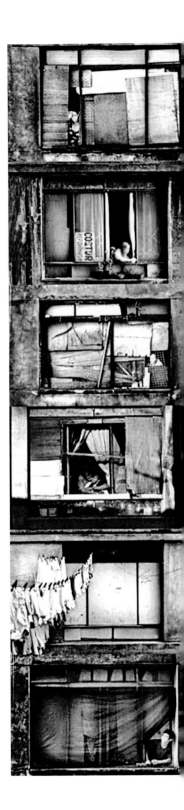

1 From "In a Window of Prestes Maia 911 Building," São Paulo, Brazil, 2006–08

SÃO PAULO

BY JULIO BITTENCOURT

For the series "In a Window of Prestes Maia 911 Building" (2006–08), the concept from day one was to try to re-create an occupied building in an aleatory way as you saw it from the outside. The final piece is presented as a collage of the entire building; however, the windows weren't necessarily next to each other or even on the same floor. These works represent a narrative formed by my experience of growing up in São Paulo and they witness the ways in which the city constantly evolves. The city continually and rapidly expands, always generating crisis. In its housing, it builds, destroys, reconstructs, and redefines its spaces over and over again.

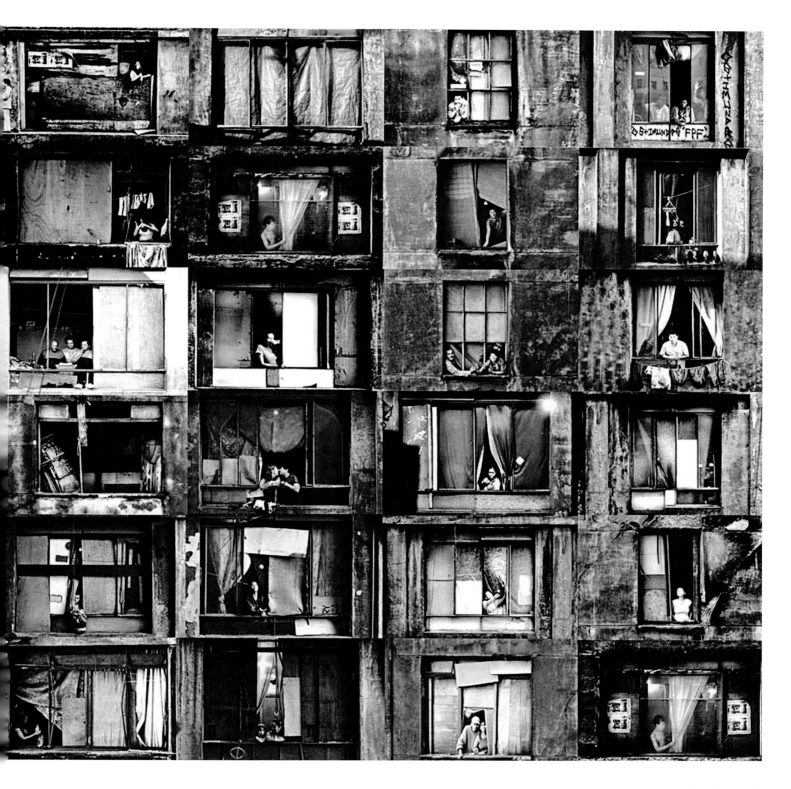

SÃO PAULO

BORN 1965, São Paulo, Brazil LIVES São Paulo SERIES "Nocturnes," 1998–2002 OTHER GENRES Aerial, fine art OTHER CITIES WORKED Rio de Janeiro, Paris, New York

1–12 From "Nocturnes," São Paulo, Brazil, 1998–2002

CÁSSIO VASCONCELLOS

Cássio Vasconcellos is a born and bred *Paulistano* who describes himself as an urban being with an obsessive love-hate relationship of his city. His series "Nocturnes" portrays a highly subjective vision of São Paulo: indeed, almost an apparition. For four years, he wandered its twisting backstreets and open parks, its airports and avenues, its highways and abandoned parking lots. He did so always when the rest of the city slept, often on foot and alone—unless visiting deserted, dangerous neighborhoods where he claims "the presence of watchmen became necessary." "The fact that the work was accomplished at night was not accidental," states Vasconcellos. "I was involved by the lyricism of night, when dreams are made." Under his gaze, São Paulo is transformed into an ethereal, otherworld. It appears empty of people and phantasmagorically lit, like fragments of a dream. In fact, as a whole, the series "Nocturnes" conjures up strange somnambulistic forays; as philosopher and director of Brazil's Arte/Cidade project Nelson Brissac observes; it "allows you to walk through the city as if you had your eyes tight shut."

Photography draws Vasconcellos because of its contested connection to the world and to reality. He says, "As a registered mark, I seek the singularity, the limit between real and imaginary." After studying the medium at São Paulo's Escola de Fotografia Imagem-Ação, he worked as a photojournalist, first for the magazine *IstoÉ* and then for the broadsheet *Folha de S. Paulo*. However, the documentary approach held limited appeal for him and he soon set about exploring how the camera could create parallel worlds. In 1988, the same year he joined *Folha de S. Paulo*, he also embarked on his crepuscular photographic perambulations of the city, and the idea for "Nocturnes" was born.

Vasconcellos shot the series using an old Polaroid SX-70 that his father had bought in the 1970s. He talks of the camera's instantaneous results in terms of wonder and magic, saying; "A glance, a click, a mechanical sound, and a few seconds later the image appears in my hands, without manipulations or interference." Perhaps more than any other camera, the forthrightness of the Polaroid, enhances the illusion of photography's ability to capture reality. However, he then pushes the images further into the realms of the imaginary with the use of vivid lighting. At first he experimented with the headlights of his car to starkly illuminate scenes, he then tried spotlights with batteries so heavy that he had to push them along in a supermarket trolley. He throws these powerful lights through filters to create an intense and vivid palette, in which primary yellows, reds, and blues combine in various hues. The resulting images of São Paulo are endlessly and kaleidoscopically disorientating. "I had never before made such an extensive series on a theme, but São Paulo is like that: gigantic, immeasurable, a metropolis that never stops," concludes Vasconcellos. "It is the city that keeps seducing me, and although I try, its constant mutation does not allow me to decipher it."

CARACAS
BORN 1969, Geneva, Switzerland LIVES Caracas, Venezuela
STUDIED Concordia University, Montreal, Canada; San Francisco Art Institute,
California, USA OTHER GENRES Conceptual

LUIS MOLINA-PANTIN

American intellectual, film-maker and writer Susan Sontag
wrote in her landmark series of essays *On Photography* (1977):
"To collect photographs is to collect the world. . . . Photographs
really are experience captured, and the camera is the ideal arm
of consciousness in its acquisitive mood." Venezuelan artist
Luis Molina-Pantin collects the world through taking photographs.
He has also been described as an urban archaeologist, as well
as a passionate ethnographer and cultural archivist. However,
he does not capture events or experiences, so much as objects.
As he wanders around his home city of Caracas, he uses his
camera to gather images of the various "specimens" that attract
his attention.

Molina-Pantin employs the camera as an objective device
to record what he finds. Like the early American Conceptual
artists, such as Dan Graham and Ed Ruscha, Molina-Pantin
uses photography in a perfunctory manner to place ideas center
stage. As Venezuelan curator and art historian Luis Pérez-Oramas
has pointed out, "The photographs are neutral. They are
indifferent. They reveal the imperfection of things, the
marks that neglect has left on them, the patina of use." It is
what the images portray that offers insight—the everyday
and frequently overlooked objects on which Molina-Pantin's
eye alights that reveal and chronicle some of the strange
idiosyncrasies of our age.

1–4 From "Luis Molina-Pantin," Caracas, Venezuela, 2007–08

The series "A Study for Color Bars" (2013) involved a hunt around the city in search of rainbow-hued arrangements. He encountered and then photographed them in a surprising number of places; as well as arrayed across the façades of tower blocks and as flags, he found them running up stairwells, as museum installations, and in shops hanging on clothes rails or on shelves bearing goods ranging from culinary instruments to sneakers. The next project followed a similar quest, as explained by its title: "Eight Failed Attempts Looking for the First Edition of *One Hundred Years of Solitude* in Caracas" (2013). For "Auto-censorship" (2013), Molina-Pantin set himself the task of photographing parked cars draped by protective covers. He recalls how he first decided on the idea: "I was simply out walking around my neighborhood in Caracas, as I do quite often, when I noticed the first one. After that, your eye becomes attuned and I began to see them everywhere. The series came together very quickly." The meaning of the title is twofold.

Firstly, "auto-censorship" is a bit of a buzzword in contemporary Venezuelan politics, but there is also the literal and more playful translation that suggests these cars are covering up or censoring themselves. He adds, "I was shocked [at] how easy these covered cars were to find. Ultimately this series hints at the exodus of the upper and middle classes from our city."

The series "Luis Molina-Pantin" (2007–08) is somewhat different to those discussed so far. As previously, Molina-Pantin embarked on a citywide search: this time for specific words in the vernacular signage that adorns walls, doorways, and shopfronts on the streets. As before, he used the camera to collect the objects and as before, the photographs are rendered with a deadpan aesthetic. However, on this occasion he was concerned with discovering something personal, something that was unique to him. The resulting series reveals the individual words that make up his name (see images 1–4) and it reads as an unusual and original form of self-portrait.

EUROPE

LONDON BELFAST PARIS VENICE ROME NAPLES XINZO DE LIMIA VALENCIA BERLIN DÜSSELDORF AMSTERDAM ROTTERDAM COPENHAGEN ISTANBUL MOSCOW ST. PETERSBURG KHARKOV

GILLIAN WEARING SLINKACHU RICHARD WENTWORTH SHIZUKA YOKOMIZO HANNAH STARKEY WOLFGANG TILLMANS POLLY BRADEN MATT STUART NILS JORGENSEN ADAM BROOMBERG & OLIVER CHANARIN JH ENGSTRÖM LUC DELAHAYE MOHAMED BOUROUISSA SOPHIE CALLE MASSIMO VITALI GREGORY CREWDSON JOHNNIE SHAND KYDD CRISTÓBAL HARA TXEMA SALVANS ALISA RESNIK SUE WILLIAMSON THOMAS RUFF HANS EIJKELBOOM OTTO SNOEK TRINE SØNDERGAARD ALEX WEBB OLIVO BARBIERI BORIS SAVELEV MELANIE MANCHOT SERGEY BRATKOV ALEXEY TITARENKO BORIS MIKHAILOV

The anonymity gained from living among the urban crowd enables every one of us to watch our fellow citizens unseen, and the camera, since its invention, has been the tool of choice to preserve such voyeuristic acts. Technological advances have made surreptitious image capture easy: pictures can be taken on camera phones and relayed globally through various social networking sites. "We all take pictures now, that's just what we do," says Gus Powell; doubtless, he finds the sheer ubiquity of cameras a challenge to his practice: "It's harder and harder to take a picture without somebody in the picture who's also taking a picture." Moreover the streets are increasingly under surveillance by automatic forms of image-capture: police cameras, closed-circuit cameras, and, of course, the ambitious but controversial Google Street View project. These issues have not gone unnoticed; a recurring theme within work emerging across Europe's disparate and diverse cities is that of the camera's voyeuristic drive.

"Stare. It is the way to educate your eye, and more. Stare, pry, listen, eavesdrop. Die knowing something. You are not here long." These words, advocated in the 1960s by U.S. photographer Walker Evans, could read as a mantra to contemporary street photographers worldwide. In Europe the tradition continues to thrive: Otto Snoek in Rotterdam (see p.196), Nils Jorgensen (see p.146) and Matt Stuart in London (see p.144) to name but a few. All of these practitioners disappear into the city crowd, eyes and ears primed for that unguarded split second unfolding in the dramas of passers-by. The genre is at its core voyeuristic. However, some artists take this impulse further; they go beyond blending into the background to deliberate concealment.

Luc Delahaye pictures unsuspecting commuters on the Paris Metro with a camera hidden beneath his jacket for his series "L'Autre" (see p.156). Txema Salvans opts for disguise—or as he says "camouflage"—to photograph prostitutes on the Spanish highways (see p.178). He explains, "In my observation I avoid humor and anecdote and seek neutrality"; he wants his subjects to behave as if he were not present. For "The Waiting Game," he donned hard helmet, high-visibility jacket, and yellow tripod: the uniform of a surveyor or topographer. By contrast, French artist Sophie Calle takes the concept into the realms of masquerade for her project "Suite Vénitienne" (see p.164). She not only dresses as a private investigator, but also wholeheartedly performs the role. She recalls packing her suitcase with "a make-up kit so I can disguise myself; a blonde, bobbed wig; hats; veils; gloves; sunglasses; a Leica and a Squintar (a lens attachment equipped with a set of mirrors so I can take photos without aiming at the subject)." Thus equipped, she spends two weeks furtively following a man around Venice.

Around the world, artists exploring the Peeping Tom approach to photography. In the United States, Yasmine Chatila and Michael Wolf conduct peering-through-window vigils in New York and Chicago respectively, to create "Stolen Moments" (see p.20) and "Transparent City" (see p.70). However, a London-based artist pushes the practice into further fascinating territory. Shizuka Yokomizo's "Stranger" series (see p.134) evolves the notion of what it means to be a voyeur. Like the others, she photographs her subjects through windows at night. Like the others, she remains cloaked in darkness so that those photographed never glimpse her. Yet in stark contrast, Yokomizo has permission from her participants and this creates a radically different tension within the imagery.

Elsewhere in this chapter, artists broaden the scope of surveillance. Some explore the technologies that are being invented to watch us. Thomas Ruff frames his hometown of Düsseldorf through the lens of a military surveillance camera for the "Nacht Bilde" series (see p.190), whereas from the comfort of his study, Michael Wolf uses Google Street View to create a revisionist take on street photography called "Paris Street View." By contrast Adam Broomberg and Oliver Chanarin delve into the archives (see p.148). Allan Sekula warns of the use of photographs in archives: "Every proper portrait has its lurking, objectifying inverse in the files of the police." What interests Broomberg and Chanarin about the Belfast Exposed Archives are where people have tried to scratch out or obliterate faces. Their series "People in Trouble Laughing Pushed to the Ground" reveals the all too real repercussions of what it can mean to live in a state that is monitored and to lose one's anonymity.

LONDON

the British class system. He would sometimes stage his friends in street scenes under bright lights or down dark alleys, and back in the darkroom, he knew every trick for exaggerating the atmospheric effects of the city's infamous smog. London captivated him, not for its beauty, but for its unfathomability. He was drawn by its endless supply of contradictions and ambiguities: "There is very little generally acknowledged beauty in London. It has no great avenue like the Champs-Elysées in Paris and no overpowering skyline like New York . . . [but] the extreme social contrast during those years before the war was, visually, very inspiring for me."

Brandt was not the first photographer to become preoccupied by London's social inequalities. Victorian London was the world's largest metropolis—a city of great wealth and even greater poverty. Many of those with inherited money found it easy to make more because the expansion of the British Empire opened up countless new trading routes, but millions of Londoners lived a precarious hand-to-mouth existence in overcrowded and heavily polluted slums.

In the 1870s, the photographer John Thomson and journalist Adolphe Smith made one of the earliest known attempts to use photography to record the lives of the poor. Their monthly magazine, *Street Life in London*, included photographs and brief written portraits of chimney sweeps, shoeshiners, chair menders, fruit sellers, musicians, and dustmen whose daily struggles they described as "bitter and intense." Street characters had been written about by social reformers such as Henry Mayhew and novelists including Charles Dickens, and had often been the subject of popular prints,

Bill Brandt wrote in the introduction to his book *Camera in London* (1948): "I wonder if anyone could ever succeed in photographing London? There are the well-known views bought by the hundreds—Trafalgar Square and Piccadilly Circus, the British Museum and Buckingham Palace, Whitehall and Regent Street. But these are not London any more than a casserole is the same thing as the smells and savors of the dish within. London is something too complex to be caught within a set of views or by any one photographer."

Brandt arrived at this conclusion after spending the best part of twenty years photographing the British capital. He documented elaborate cocktail parties and wartime shelters (see image 1), family dinners and pub gatherings, railroad arches and church spires, often setting scenes showing the aristocracy and the poor side by side in book and magazine spreads to draw attention to the divisiveness of

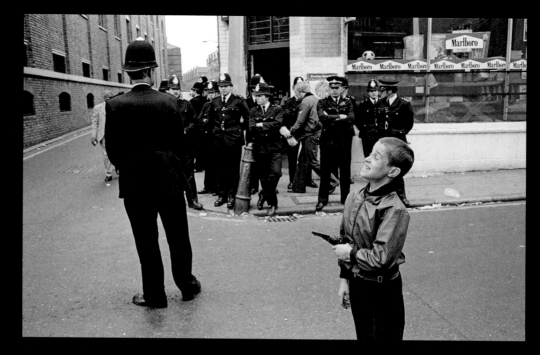

1 *People Sheltering in the Tube, Elephant and Castle Underground Station*, Bill Brandt, 1940 2 *People around a Fire, Spitalfields*, Markéta Luskačová, 1976 3 *Brick Lane, London E1*, Paul Trevor, 1978

but Thomson and Smith felt that photography could lend a new urgency to the public's awareness of the plight of the poor. Inequality, they argued, was a subject that could never be exhausted "nor, as our national wealth increases, can we be too frequently reminded of the poverty that nevertheless still exists in our midst."

Brandt was only one of an extraordinary cast of international photographers who either passed through or settled permanently in London during the twentieth century. Others included Henri Cartier-Bresson, Robert Frank, Eve Arnold, Wolfgang Suschitzky, Sergio Larrain, Dorothy Bohm, and Elliott Erwitt. All quickly became aware of the city's deep-rooted social stratifications, and many sought to comment on them by photographing the uniformed nannies and top-hatted schoolboys of the upper classes, or the Pearly Kings and Queens and market traders of the working classes. One of the most iconic documents of class was made by the Swiss-born photographer Frank in the early 1950s. His image of a bowler-hatted gentleman striding confidently down a pavement apparently oblivious to the worker who hoists coal from a truck less than a meter away, speaks volumes about the simultaneous interdependence and indifference between rich and poor in the capital. In many ways, little has changed in the years since the photograph was taken: London could not function as a world center of commerce without an invisible army of night workers cleaning the offices of bankers for minimal pay.

In the second half of the twentieth century, legislation allowed all those from Empire and Commonwealth countries unhindered rights to settle in Britain. A period of mass immigration began, and racial tensions were soon competing with class tensions as a source of

conflict in the city. Charlie Phillips and Neil Kenlock made powerful photographs about the lives of Afro-Caribbean settlers in Notting Hill and Brixton, while Paul Trevor and Markéta Luskačová documented the Jewish, Bangladeshi, and white British populations living in the East End (see image 2). In 1978, when Trevor took his photograph of a young boy pointing a toy gun at a police officer on Brick Lane (see image 3), the area was notorious for regular outbreaks of race-related violence, and the police presence was heavier than anywhere else in mainland Britain.

The parts of London that Phillips, Kenlock, Trevor and Luskačová documented have become gentrified almost beyond recognition. However, the poor still live cheek by jowl with the rich: in the London Borough of Tower Hamlets, which butts up against the City of London (sometimes called "the wealthiest square mile on Earth"), more than fifty percent of children live below the poverty line. For better or worse, inequality continues to provide rich visual material for London's photographers. On Brick Lane, where fashion students rub shoulders with curry merchants and city traders drink coffee alongside celebrity artists, almost everyone seems to be trying to capture a fragment of street life with an iPhone or Leica. Anonymous blogger The Gentle Author is a much-loved contemporary chronicler of the area and explains its enduring allure: "How can I ever describe the exuberant richness and multiplicity of culture in this place to you . . . I do not think there will be any shortage of material, though it may be difficult to choose what to write of because the possibilities are infinite." Clearly, like so many photographers, The Gentle Author has been bewitched by London's immensity and complexity. **SH**

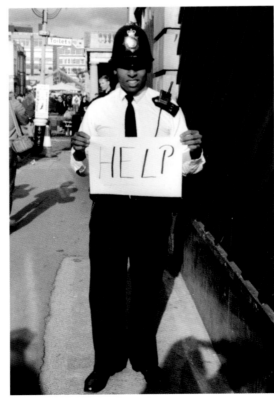

LONDON
BORN 1963, Birmingham, UK LIVES London, UK
STUDIED Goldsmiths, University of London; Chelsea College of Art, London
SERIES "Signs," 1992–93

GILLIAN WEARING

British artist Gillian Wearing is renowned for her practice documenting the confessions of ordinary people. The fascination started when Wearing graduated from Goldsmiths, University of London, and took to the capital's streets with a camera. The result was "Signs that Say What You Want Them to Say and not Signs that Say What Someone Else Wants You to Say"—an iconic series that launched Wearing's career and contributed to her winning the Turner Prize in 1997.

The "Signs" series portrays people of varying age and gender from many different walks of life. Yet each one is framed in the same manner; they are all photographed holding up a sheet of paper on which (at the artist's request) they have written something that they felt was important for them to say in that moment. Wearing's simple tactic transforms the documentary tradition; it lends people a voice in an otherwise mute medium. Art historian Bernhart Schwenk goes as far as to suggest that consequently "each picture is not only a portrait, it is also a self-portrait." These handwritten revelations give the works their titles, from *I Really Love Regent's Park* (see image 3) to the appeal of the couple in *Work Towards World Peace* (see image 2) or the city policeman's cry for *Help* (see image 4). However, the most powerful pieces are those, as Wearing admits, "when you do sense someone confessing something."

The "confession" of the businessman in *I'm Desperate* (see image 5) is all the more poignant and seemingly authentic because it stands in direct contrast to his suited, suave, and sophisticated exterior. Wearing recalls how he stormed off after she took his photograph, encouraging speculation about whether he was ultimately concerned about having revealed too much. *I'm Desperate* (as well as the series more broadly) mines the disparity between the faces that we reveal in public and our private thoughts. "What people project as the human mask they are," states Wearing, "is obviously very different to what is going on inside." The man perhaps found his public confession a discomfiting experience; it certainly makes for surprising, indeed almost uneasy, viewing. Nonetheless, that encounter also provided Wearing with a revelation that has continued to guide, inspire and intrigue her to this day; it "set me on the path to thinking about interior monologues and finding that everyone's got a story; everyone's either got a secret or everyone's got something that you can't perceive by just meeting them briefly."

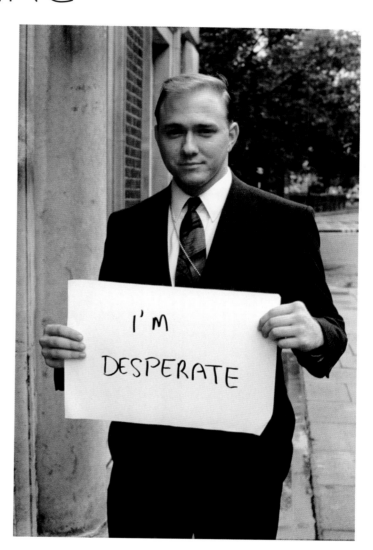

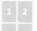 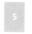

1–5 From "Signs that Say What You Want Them to Say and not Signs that Say What Someone Else Wants You to Say," London, UK, 1992–93

LONDON

BORN 1979, Devon, UK LIVES London, UK STUDIED Self-taught in photography SERIES "The Little People Project," 2006–present OTHER CITIES WORKED Moscow, Beijing, New York, Hong Kong, Cape Town, Athens

SLINKACHU

"The world is going to the dogs. You read about it in the papers every day. . . . The good old days are long gone and the only thing to look forward to is a steady decline, leading to the inevitable apocalypse. . . . But there are more immediate concerns for us, because the train is late and it's already 8:45 a.m. The baby was awake all night and the kids are bunking off school. Letters from the bank are stacking up, unopened." These are the words of London-based artist Slinkachu: the mind behind "The Little People Project." "These are the real dramas, this is the real news. . . . Despite all our differences, this is what unites us, the 'Little People.'"

"The Little People Project" is an ongoing street art campaign that started in 2006 to create a fantasy world beneath our feet; it promulgates the idea that our day-to-day dramas are re-enacted by a thriving community, indeed, a vast society of Lilliputians. For Slinkachu, London offers the main stage on which to play out these theatrics. "There is something inherently absurd about the dramas and problems of city living," the artist claims. Consequently, there is much of the absurd in the miniature installations. Slinkachu takes model train set figures and meticulously customizes them with baggy jeans or hoodies, painstakingly repositions them into lifelike poses, then finally sticks them in place with a dab of superglue. The mise en scènes are constructed in order to be photographed. "I think of it a bit like reportage and that I am just capturing a small incident." However, at the end of the endeavor, the Little People are abandoned and left to fend for themselves. From Liverpool Street to Ladbroke Grove, Paddington to Primrose Hill, Embankment to Edgware Road: the streets and sidewalks of the capital are peppered with tiny tableaux that only the most observant passer-by might spot.

Slinkachu is not his real name. Like Banksy, this artist prefers to remain anonymous and we are only given snippets of biographical information: "born in 1979, in Devon, moved to London in 2002 to work as an art director for an advertising firm." Yet the parallels with the world-renowned, pseudonymous graffiti artist continue. Slinkachu's street art similarly offers social comment. The work explores what it means to live in a modern metropolis. It conjures up themes of urban estrangement, alienation, as the artist points out, the gamut of "feelings that city life can create: of being lost, alone, dwarfed by the environment or threatened by others." "But underneath this," Slinkachu adds, "there is always humor.

I want people to be able to empathize with the Little People."
In this way the practice once more references Banksy's tendency
to irony, even subversion. Titles play a key role; images such as
Last Kiss, Embankment, London, 2008 (see image 1) and *Tundra,
Liverpool Street Area, London, 2008* (see image 3) wryly evoke a
sense of loneliness and isolation that is then echoed in the titles.
That humor turns seditious when you learn of the title to *Company
Car, Ladbroke Grove, London, 2008* (see image 5, p.128), and then
darkens further in images, such as *Sugar High, Kings Cross, London,
2011* (see image 6, p.129), where the lives of the Little People hang in
the balance. In a large swathe of the images, as exemplified by *Bad
First Date, Paddington, London, 2007* (see image 2), the humor is
thrillingly bleak, even black.

"Some ideas for the installations come very naturally, others
evolve over time," explains Slinkachu. The artist keeps a box full of
unpainted train set figures and continually collects miniature props
or oddities that at some point might end their day in an inventive
reinterpretation. A pair of aerodynamic, winglike feathers creates a
modern-day Icarus; an old tennis ball is transformed into a floating
island; bottle tops become boats; green shoelaces metamorphose
into a Lilliput Loch Ness Monster and a bubble-gum wrapper takes
to the skies as a makeshift kite. With a scene in mind, the next step
is to comb London for appropriate locations. The artist notes, "I may
have a specific location in mind. In these cases I usually get on the
train or cycle to a part of a city and walk around for a few hours to
find a good location to set up the installations." It might be a

featureless flat surface that can be framed against a distant, dynamic skyline (as with *Last Kiss*), a puddle that will translate as an ocean expanse (as in *Fantastic Voyage*) or simply a blank architectural space that evokes the desolation implied by the title *Tundra*.

When it comes to the camerawork, Slinkachu is entirely self-taught. However, the act of photographing the installation is done as simply as possible. The idea is to render the subject objectively, with a deadpan gaze. Consequently, one's attention is drawn to the content of what is portrayed, not the style. This approach recalls that of a documentary photographer, lending a hint of reality to the result. Each shoot follows much the same format: the Little People are framed through the same standard 24–105mm lens and illuminated by the natural, ambient light. They are all photographed at a similar distance. It is a balancing act; too far from the scene and the drama is lost, but too close and the illusion is lost. Slinkachu errs on the side of remoteness, so although the background appears scaled to the figures it also

almost swamps, indeed, dwarfs them, heightening the sense of urban alienation. The artist explains, "In all the images, I am trying to find the simplest way to make the models and locations combine to tell a story or create a location . . . to provoke emotions in the people seeing the photographs." However, having created the illusion, Slinkachu's next step exposes it. A much wider shot is taken from the same viewpoint. "This is a very simple image, almost boring in a way," explains Slinkachu. Yet this single gesture, not only enables the viewer to situate the Little People within a recognizable context but it also exposes them for what they really are: miniature simulacra of their larger, real counterparts.

Slinkachu's project is fast becoming a global phenomenon. The Little People are now appearing in metropolises as far-flung as New York and Moscow (see p.216), Hong Kong and Cape Town, Beijing and Bridgetown, reminding us that certain experiences of life within a city are much the same, no matter where it is.

5 Company Car, Ladbroke
Grove, London, 2008
6 Sugar High, Kings Cross,
London, 2011

1 *West Hampstead, London, UK, 1979*
2 *Hackney Wick, London, UK, 2013*
3 *West End, London, UK, 2008*
4 *Caledonian Road, London, UK, 2011*

RICHARD WENTWORTH

Richard Wentworth is perhaps best known as a sculptor and is a leading light within New British Sculpture. However, in 1971, while still a student, he picked up a camera and started a photographic project that became known as "Making Do and Getting By." This series, ongoing over forty years later, has since become widely celebrated. Wentworth walks the streets of London in search of curious and ingenious uses of the detritus of everyday life. Scenes that have attracted his eye include: a wellington boot used to prop open a door, shoes strung by their laces over telephone pylons, and a lost glove skewered on a railing. By framing such human acts or interventions, the individual images amass into a series that celebrates the seemingly insignificant and the often overlooked. Not surprisingly perhaps, critics have compared Wentworth's project to the poetry of William Carlos Williams; writer Michael Bracewell observes that as with Williams where "so much depends" on "the red wheelbarrow" likewise with Wentworth "you feel that everything and nothing are fused within the poise and high refinement of his abutted objects and precarious mises en scène." In this way, "Making Do and Getting By" reconfigures the banal fabric of the modern world rendering "its reconstituted, rearranged presence electrifyingly energized, and mesmeric."

Wentworth first exhibited the series in 1978 in the journal *Artscribe*. He wrote, "I began seven years ago to make casual notes with the camera, of situations, which attracted me. Indeed only as personal reminders." Over time he realized, "they were photographs of how people place things." Certain themes and patterns clearly emerge within the overall scheme. His gaze is repeatedly caught by evidence of "enduring individual resourcefulness" and "high material intelligence"; for example, *Camberwell, London* reveals how someone has inventively silenced a door bell by wedging a chocolate bar between the bell and the clapper. He also focuses on what he describes as "the alignments—laying, leaning, propping, wedging, chocking, jamming" in the arrangements encountered on the street and their inherent sculptural qualities. *West Hampstead, London* (see image 1), for example, portrays a stairwell repeatedly, almost rhythmically, barred with wooden boards. Another theme is his patent interest in what he calls

"low level messages," whether a polite signal, a gentle invitation, or a strident instruction, such as that in *London* (1999) demanding that visitors press the bell "for a long time." The result is a vast series with recurring patterns and cross-references that Wentworth likens to "an elaborate mycelium of criss-crossed fibers."

When Wentworth published the series in *Artscribe*, he felt the need to identify himself as a sculptor, not a photographer. He claimed "limited competence" and said that his photographs were "not technically good." His words recall those used by U.S. artist Ed Ruscha when he said of his own practice: "The photographs I use are not 'arty.' . . . They are nothing more than snapshots." As art historian Anna Dezeuze points out, the decision to first reveal the series in *Artscribe* could align it "to the use of conceptual photography in magazine spreads by artists such as Dan Graham and Robert Smithson or in artists' books such as Ed Ruscha's or Sol LeWitt's." Wentworth's work is therefore often discussed within the framework of the photo-conceptual work of the late 1960s and early 1970s that deliberately used photography in a perfunctory, matter-of-fact way and fostered an amateur aesthetic.

However, Wentworth has also affiliated himself with a luminary figure from the annals of photographic history. "A lot of photographs I was taking I didn't understand. Walker Evans's work helped confirm what they were," he claims. Evans is renowned for a style that has been described as straight, economical, frontal, and unemotional; curator John Szarkowski poetically labelled Evans's photographs "bare faced facts." Indeed, Szarkowski continued, at first they seem "more appropriate to a bookkeeper's ledger than to art" but closer analysis reveals them to be "immensely rich in expressive content." Likewise, Wentworth's images are not amateur so much as deliberately and elegantly pared down, measured, and minimal, following in the same tradition of Evans's "bare faced facts."

When Wentworth first started taking the photographs in 1971, little did he know that the project would last so long. Over time the act of observing and photographing has become compulsive. Dezeuze noted how Wentworth has repeatedly linked the process to bodily needs and functions, describing it as his "diet." Wentworth has explored the biological connection further in conversation with the brain scientist Mark Lythgoe. Observing how some images from the series give him a buzz, Lythgoe explains this is how "our brain rewards certain thoughts or events" important for our survival as a species. He continues, "This is what makes great art: someone who can see something that we all can relate to, that universally lights up the same area of our brain. That's what your photographs do for me."

1 *Walkie Talkie Melted My Golden Calf*, London, UK, 2013

LONDON
BY RUT BLEES LUXEMBURG

In this work, from my latest series "London Dust," I am looking at how photography is used in the representation of urban space. I focused on the vast computer-generated landscapes that developers and architects plaster over city walls to sell their vision of how the city could look in the future. For the image, I deliberately spilled some water in front of a hoarding, on the top of an electric box (perfectly safe!), to emphasize the actual city itself—its puddles, its dust, and joyous filth, which speak of time and entropy, in contrast to the shiny promise of the computer-generated dream.

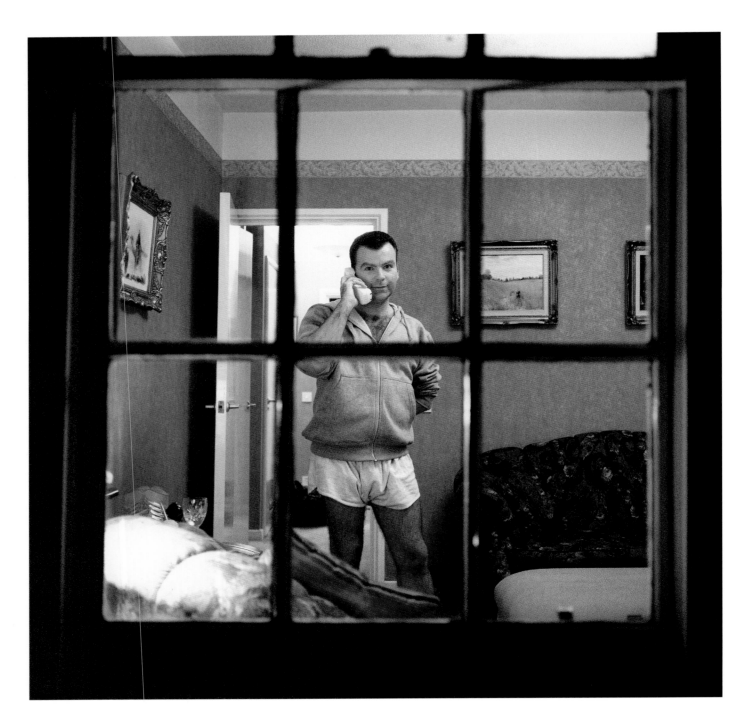

LONDON
BORN 1966, Tokyo, Japan **LIVES** London, UK **STUDIED** Chelsea College
of Art and Design, London; Goldsmiths, University of London **SERIES** "Stranger,"
1998–2000; "I Can Feel It (But I Can't See It)," 2008 **OTHER GENRES** Portraits

SHIZUKA YOKOMIZO

"Dear Stranger, I am an artist working on a photographic project which involves people I do not know. . . . I would like to take a photograph of you standing in your front room from the street in the evening. A camera will be set outside the window on the street. If you do not mind being photographed, please stand in the room and look into the camera through the window for ten minutes on __-__-__ [date and time] . . . I will take your picture and then leave . . . we will remain strangers to each other. . . . If you do not want to get involved, please simply draw your curtains to show your refusal."

Shizuka Yokomizo wrote these words and posted them through the letterboxes of first-floor apartments on various streets in the capital. She always specified a time in the evening when the light was low, so should a subject appear at their window to be photographed, they would only see their image reflected in its glass. Yokomizo would set up her camera and tripod, take the exposure and leave, remaining throughout, cloaked in darkness and anonymous.

The Tokyo-born artist moved to London in 1992 and at the time of making the "Stranger" series had relatively recently completed her Master's degree in fine art at Goldsmiths. "My motivation for 'Stranger' came from running around London in a car with a ridiculously huge telephoto lens, trying to glimpse unsuspecting people through the windows of their apartments," she recalls. "I felt absurd and increasingly frustrated by the one-sidedness of the activity." Gradually she realized she was searching for a different kind of encounter: an exchange of sorts and one that implicated the "watched" as well as the "watcher." "It was important for me that the subject, a stranger, made eye contact with me," she explains. "I needed these people to look back and recognize me equally as a stranger." Yet Yokomizo's inspired idea of the letter furthermore enabled a pact between strangers: if someone appeared at the window, they were tacitly consenting to be photographed.

The consent creates a body of work with a radically different dynamic to the more traditional, opportunistic style of street photography. Even though all the subjects stare directly into the camera with an open posture (some perhaps a little more guarded than others), it is their consent that invites intimacy; it gives the

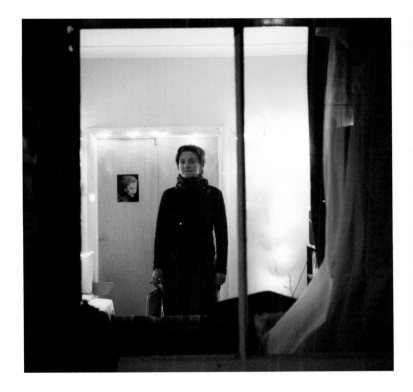

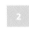

1 *Stranger No. 1*, London, UK, 1998
2 *Stranger No. 2*, London, UK, 1999

photographer, and by dint, the viewer permission to look. Yet Yokomizo is also careful to frame the building façade or the window moldings within the picture, so we feel furtive like voyeurs in the dark. The curtains and security gates act to add layers of distance, reminding us of the tactics usually employed to keep us out.

Critic Thomas Boutoux wonders whether Yokomizo's work is informed by living in a foreign land. He argues, "This exiled condition has, consciously or not, framed her photographic explorations of intimacy, solitude and individual vulnerability in the contemporary megalopolis." Whether true or not, ultimately, the "Stranger" series steals into a world of consenting adults usually hidden behind closed doors. It interrogates the meaning of the term "stranger" in vast cities where people live cheek by jowl, yet don't know one another's names.

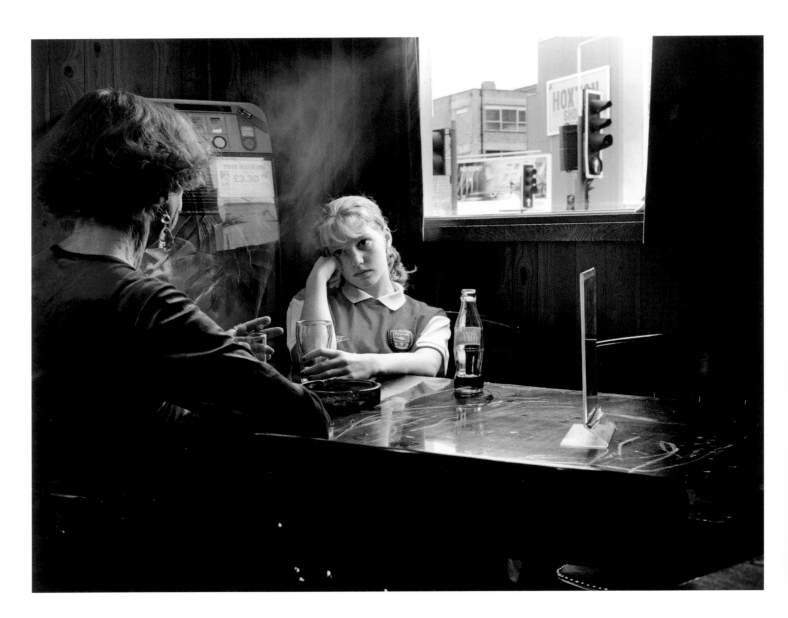

LONDON

BORN 1971, Belfast, Northern Ireland, UK LIVES London, UK
STUDIED Napier University, Edinburgh, Scotland; Royal College of Art,
London OTHER GENRES Staged

HANNAH STARKEY

The city of London has a strong presence in Hannah Starkey's imagery. Whether the gold foyer of the UBS office in Liverpool Street in *Untitled, August 2006* (see image 2), the brick façade of BBC Television Centre in *Untitled, November 2009* (see image 4), the glimpse of the Hoxton sign in *Untitled, October 1998* (see image 1) or the red blur of the ubiquitous London bus in *Untitled, May 1997* (see image 6, p.138). Starkey's lens seems to search out women and girls in the capital and document their everyday experiences. Yet, each of these large-scale scenes is a complete fabrication, staged entirely by the artist. She uses large-format cameras, lights, actors and mise en scène to construct still images, much as a director shapes moving sequences. Time is frozen, yet split seconds appear to linger. Starkey's photographs are not vignettes cropped from the flow of real street scenes; they are meticulously crafted creations that suggest stories.

The narratives implicit in Starkey's work have often led her work to be viewed in relation to cinema and situated within the so-called "directorial mode" of contemporary photography. Yet unlike some of the genre's renowned practitioners, such as Gregory Crewdson (see p.170) or Cindy Sherman, she does not build elaborate tableaux that stage or mimic the fantasy of Hollywood. Instead, her narratives are more ambiguous, elusive, and far more quotidian. Arguably, Jeff Wall (see p.86) is a more apt comparison. Wall uses the term "near documentary" to describe his approach: "They are pictures whose subjects were suggested by my direct experience, and ones in which I tried to recollect that experience as precisely as I could and to reconstruct and represent precisely and accurately." Whether the work can be labeled "near narrative" or "near documentary," art historian Margaret Iversen adds, "What seems clear is that both artists want their pictures to have some purchase on the real of everyday life."

Like Wall, Starkey turns to experience in search of inspiration. She walks the streets of London on the lookout for little details to build into her imagery. One such observation made it into her piece *Untitled, August 2006*. "Corporations have these big bouquets of flowers in their reception area," she explains. In "Broadgate, at the end of the week, I've noticed that you will see the odd secretary or receptionist with these massive bunches of flowers, just in a plastic

bag." She believes each of these real references is crucial to how one encounters her work. "It pulls in all the other elements of the picture. . . . Maybe the flowers are that detail in the picture that in some way catches your eye and validates everything else in the picture." She also refers to French philosopher Roland Barthes's notion of the "punctum" in a photograph; those marginal details within the frame that are especially touching, those details that he describes as "denotations" and she views as moments of recognition. She wonders whether the bouquet is the punctum, and of *Untitled, October 1998* (see image 1, p.136), suggests: "The punctum there would be the older woman's crystal earring."

Starkey uses various tactics to create complexity in her images. For example, the faces of her protagonists are often turned away. The woman in *Untitled, November 2007* (see image 5) holds her head at such an angle that the viewer is hard-pressed to read her expression. Alternatively, faces are veiled: by hair, smoke, or shadow. The curtain of glass prisms that falls in front of the woman at the bar in *Untitled, September 2008* (see image 7) means that she is barely glimpsed; the composition is further fractured by street scenes reflected in windows, so much so that one's eye is challenged to find purchase. However, if Starkey chooses to reveal her protagonists' faces, she ensures they appear blank, as if absorbed in thought. She observes, "When we are in repose we're not animated. I find this more interesting; it's more contemplative, meditative even. It's introspective." Philosopher Diarmuid Costello adds, "In different ways they are all folded in on themselves, marooned in their own world. It's almost as if, through their day-dreaming, their internal world is externally projected, their mental life figured in the space around them."

Mirrors, windows, and other reflective surfaces repeatedly recur through the imagery. Starkey enjoys how mirrors add dimension to a flat photograph; how "mirrors can become depth within an image . . . allow you out of the confines of two-dimensional representation." She often reflects her subject in them, such as in *Untitled, November 2009*. Indeed, this is how she chose to portray herself in *Self Portrait, September 2008*. She also uses them to introduce secondary characters. For example, in *Untitled, May 1997* (see image 6) a young woman presses a moth against a mirror. The scene pictures the back of her head and shoulders, but the mirror, while reflecting her face, also introduces the figure of an older woman, who is only present in the image within the mirror. She is transfixed by the younger girl and the moth—thereby setting up an intricate relay of glances. However, Starkey also deftly wields mirrored surfaces as focal points to encourage reverie, both for her photographed subjects but also for the viewer. "A window or a mirror is a route of escape—I mean for the subconscious traveling through the picture," she says. "It's where you move into projecting your own ideas or thoughts of the image or the situation." Mirrored surfaces are continually used to fragment, reflect, layer, and multiply meaning in myriad ways.

Starkey's work delights in purposefully creating complexity and ambiguity. If a viewer looks to the titles of her works for clarification, they will be disappointed. The titles serve to open up, rather than close down, further possible interpretations. Starkey has adopted a simple formula, recording first the month, then the year. In one sense this sparse recording of facts is objective, however, it can also be regarded as promoting subjectivity. One can read the titles as framing devices that replace the clichéd story opener "Once upon a time" Each photograph demands a new emotional and intellectual engagement. In Starkey's images of London, the act of looking becomes curious, open-ended and, as she says, "The more you look, the more you see."

LONDON
BORN 1968, Remscheid, Germany LIVES London, UK, and Berlin, Germany
STUDIED Bournemouth and Poole College of Art, UK SERIES "London Underground,"
2000 OTHER CITIES WORKED Hamburg, New York

WOLFGANG TILLMANS

It is relatively well known that in the winter of 2000, the German-born Londoner Wolfgang Tillmans became the first photographer and the first non-English artist to be awarded the prestigious Turner Prize. Perhaps what is less known is that a few months earlier, he had been given the unusual honor of guest editing and contributing images to the capital's street magazine sold by the homeless, *The Big Issue*. In search of inspiration, he had headed camera in hand, down into the labyrinthine network of the city's subterranean train system, the London Underground.

In some sense Tillmans was retracing the footsteps of other artists, including Walker Evans and Luc Delahaye (see p.156). Evans created the now legendary series "Subway Passengers, New York City" between 1938 and 1941 and, more recently, from 1995 to 1997, Delahaye photographed commuters on the Parisian Metro for his series "L'Autre"; both make use of the traditional portrait—depicting anonymous faces lost in thought—to examine the notion of privacy in public spaces. By contrast, the images Tillmans took of Londoners on the Tube that appeared in *The Big Issue*'s edition of August 28, 2000 called "The View From Here" interrogate the same concept, but in a markedly different way.

At the time, Tillmans was known for his politically charged, anti-hierarchical, anti-hegemonic photographs depicting the capital's youth culture and club scenes. Images of his friends, such as *Lutz & Alex sitting in the trees* (1992) and *Suzanne & Lutz, white dress, army skirt* (1993) came to define a generation. The "London Underground" series (2000) signals a departure from his usual style; it frames people as abstractions. As Tillmans remarks, "You could argue that these works are documentary, on the other hand you could say that they are mere studies of surface textures." Tube passengers are reduced to exquisitely rendered sculptural patterns of shape, shadow, and color. However, Tillmans contends that despite their obvious abstraction, these images remain charged with meaning: form intertwines with content.

The London Underground had long drawn Tillmans. "I was fascinated by what I saw," he recalls and for a very specific reason. "I have always associated [it] with incredible intimacy among people,

without them wanting to be intimate with each other." His images show how the hands of strangers are tantalizingly close, how thighs press against thighs, backs against bottoms, cheeks are pushed into biceps and yet throughout eyes always remain averted. He observes, "It's a weird phenomenon, whereby men and women [stand] incredibly close to each other," yet "we've all decided not to think of it as a sensual experience, because a taboo is at work." Tillmans's lens, which throughout his career has made a point of seeking out taboos, here reveals the sensuousness and illicitness of rush hour on the London Underground. Tillmans pictures our enforced intimacy as a tangled mass of arms and legs, lips and armpits, that leave the viewer struggling to decipher which limb belongs to whom.

LONDON
BORN 1974, Perthshire, Scotland LIVES London, UK STUDIED London College
of Communication SERIES "London's Square Mile," 2006–13 OTHER
GENRES Documentary OTHER CITIES WORKED Shanghai, Shenzhen, Kunming

POLLY BRADEN

The series "London's Square Mile" by Polly Braden refers to a specific
part of the capital just over 1 square mile in area known as the City of
London. Home to the London Stock Exchange, Lloyd's of London, and
the Bank of England, this major financial center is often called "the
wealthiest square mile on Earth." It is in fact a self-contained kingdom
with borders marked by cast-iron dragons, its own mayor, and its own
police force. When Braden learned about this city within her city, she
was so intrigued that she embarked on a photographic project that
would preoccupy her for the next eight years.

The imagery delights in the City's eclectic mix of ultra-modern
architecture: hard-edged, textured concrete juxtaposes with polished
metal façades; form and pattern are reflected in vast glass walls;
shadows and light play across surfaces. People feature in each
frame, but often as solitary souls that are isolated and dwarfed by
their monochrome habitat. Curator and photographer David Campany
writes, "There is something salutary in the way Londoners fail to live
up, or down, to the cosmetic glass of their surroundings. Whether or
not we wish to, we just don't mirror these façades." Braden adds, "To
a newcomer the city looks impenetrable, like an oiled machine with
a hidden logic. Look again and many of them seem out of their element,
as if caught between one air-conditioned sanctuary and the next."
Indeed, her images are infused with a sense of urban alienation.

Braden's blend of street photography is not quite traditional. Her
approach is more considered, more deliberate than the classic roaming
street shooter, yet she too relies on the chance split second. Many of
the images are taken in the early hours of the morning; she trains her
lens on an interesting corner and bides her time until the workers
clock in. She admits to a certain discomfort having to single out figures
from the crowd. "The city teems with people, but selecting just one can
feel unbearably intimate," she admits. The viewer is clearly drawn to the
imagery for its voyeuristic impulse, but to be a voyeur is not necessarily
anti-social. Braden's gaze is tender and empathetic. Campany views
her as more guardian angel than opportunistic miscreant, concluding,
"Closed-circuit cameras catch every second of every day in the high
security Square Mile but they miss the things that really matter.'

1	2
3	4

1 *Fenchurch Street, 11 a.m.* 2 *Appold Street, 6 p.m.*
3 *Threadneedle Street, 6 a.m.* 4 *Paternoster Square, 11 a.m.*
From "London's Square Mile," London, UK, 2006–13

LONDON
BORN 1974, London, UK LIVES London STUDIED No formal photographic study;
worked as a photographer's assistant for three years INFLUENCES Robert Frank,
Garry Winogrand, Joel Meyerowitz, Lee Friedlander, Tony Ray-Jones

MATT STUART

Matt Stuart, a Londoner born and bred, is a street photographer
of the traditional ilk. He roams his city, Leica and 35mm lens at
the ready, alert to those rare moments where serendipity and
circumstance seem to magically collide. "If there is a photographer
working today who seems to have eyes in the back of his head, it is
Matt Stuart," quips curator Sophie Howarth. He abides by a strict
code: a simple set of unbreakable rules. He never moves, alters, or
stages anything once it is within his viewfinder, and he never uses
Photoshop. "I think we're living in a world where everything is

Photoshopped or faked," he claims. "Reality is very important to me
[and] showing reality is far more interesting. The lovely thing about
street photography is that with the best stuff, there is no way you
can stage or even think it up."

Stuart's first preoccupation was skateboarding on the street.
From the age of twelve, "I did that for about seven years and that was
my education," he recalls. He came to street photography through his
father, who showed him two books by genre legends Henri Cartier-
Bresson and Robert Frank. At the time, Stuart was working for a cell
phone company answering customer complaints and was in need of
inspiration. The books provided not only welcome relief, but also
revelation. He recalls, "I spent about a year sitting at my desk,
answering telephone calls and looking through these two books

| | 2 | 3 |
|1| 4 | 5 |

1 *Moorgate Station*, London, UK, 2005
2 *High Holborn*, London, UK, 2006
3 *Trafalgar Square (Somersault)*, London, UK, 2009

4 *Trafalgar Square (Pigeon)*, London, UK, 2004
5 *Covent Garden*, London, UK, 2008

and I became obsessed." In the same way that he had enjoyed the skateboarding process of spending the day trying to master a "trick," he realized he could head out into the streets to find a new sort of "trick," but this time with something physical to bring back home and show for his efforts. Eighteen years later, the thrill has yet to wear off.

Many talents are involved in the way Stuart works—instinct is one of them. For image 4, he had been lying at curb level for about half an hour; "It all happened so quickly that I wasn't exactly sure what I had got but something felt right. When I received my contact sheets back I was delighted to have found the legs within the legs and the way that the coats mimicked the pigeon's tail." Another is a sort of hyper-alertness. He only managed to capture image 3 by snatching the tail end of a distant conversation; "Had I been wearing my iPod

(something that I occasionally do to get inspired and feel invisible)," he adds, I "would probably have missed the moment." However, the skill most evident in Stuart's work is his uncanny ability to home in on the humor in what to everyone else would appear a mundane sight. New York street photographer Joel Meyerowitz (see p.18) wrote in his renowned book *Bystander: A History of Street Photography* (1994) that the best street photos are "tough to like, tough to see, tough to make, tough to understand." Stuart adds, "One of my mentors is Joel Meyerowitz," and his words on "tough" pictures "I kind of always have in the back of my mind." Yet oddly, Stuart's work only ticks the "tough to see, tough to make" boxes: his photographs are readily understandable, effortless to like, and they sparkle with a dry, ironic wit.

NILS JORGENSEN

"Photography can be a mirror and reflect life as it is, but I also think that perhaps it is possible to walk, like Alice, through a looking glass, and find another world with a camera." These are the words that English photographer Tony Ray-Jones used to describe street photography; they memorably introduce his first book, published after his untimely death in 1972. They are also an apt description of the practice of London photographer Nils Jorgensen. Curator Sophie Howarth notes how Jorgensen "spots unlikely patterns and picks out exquisite collisions of line and form in the most ordinary places." He has an almost uncanny ability to find beauty within mundane, everyday scenes and to notice fleeting moments that pass by the rest of us. In Jorgensen's expert hands the camera lens, much like Alice's looking glass, seems able to reveal other, surprising worlds hidden within our own.

Jorgensen was born and spent his early childhood in Denmark. His mother was a painter and his father, although he worked as a doctor, was an avid photographer. Jorgensen took his first photograph at the age of six; by his mid teens photography had become an obsession and he was printing his work during school lunch breaks. Jorgensen remembers the day his father first took him seriously: "He gave me his old Leica IIIg which I still have today . . . and told me to master technique first." Jorgensen senior also shared his photography books with his son. "One book above all other was my favorite," he recalls, "the Time Life Photography book from 1973. [It] has outstanding images by the world's greatest street photographers." It was the year before Ray-Jones's posthumous book, *A Day Off*, was published, but it still featured his work. "The photographs by Tony Ray-Jones hit me more than any of the others," recalls Jorgensen. "He became an inspiration to me." He adds, "Little did I know then, at the age of fourteen, that I was to dedicate the rest of my life to this great art form."

Over four decades later, street photography remains Jorgensen's passion but he makes his living as a press photographer. "Working full time covering news, celebrities, meeting deadlines, and so forth can make it hard to switch back to taking photographs of small random moments which have no obvious news or commercial significance," he admits. In the press realm, he chases obvious subjects and wires the image off immediately, whereas in the private realm he

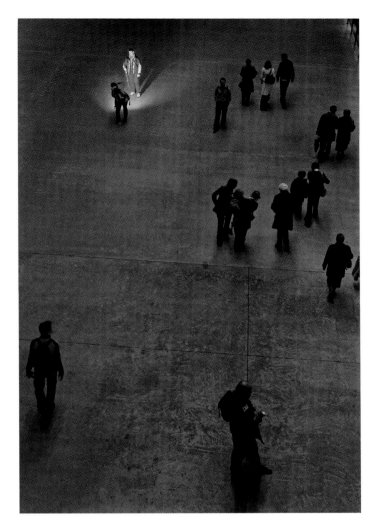

1	2	
3	4	7
5	6	

1 *Dreaming of Red*, c. 2003
2 *Two Red Figures*, 2009
3 *Tree*, c. 2007
4 *White Dog Fever*, c. 2003
5 *What Dreams May Come*, 2011
6 *Playing With Her Hair Well Regularly*, 2009
7 *Flash of Light*, 2005

deliberately slows the process down. He talks about being drawn to simple scenes that become strange when photographed and remains fascinated by the power of the medium to transform random, meaningless events into ones with new meaning. The overriding impression one has with Jorgensen's photography is its unusual way of seeing the world. Because he is more interested in a shadow on the wall than a fight, he will always be the lone observer looking the other way to the crowd. He lets subjects emerge, saying, "I tend to wait for the picture to come to me. For me street photography is what happens as a result of just living."

BELFAST
BORN 1970, Johannesburg, South Africa (Broomberg); 1971, London, UK
(Chanarin) LIVES London SERIES "People in Trouble Laughing Pushed
to the Ground," 2010 OTHER CITIES WORKED Baghdad

ADAM BROOMBERG
& OLIVER CHANARIN

These photographs chronicle the street protests, press conferences, violent confrontations, and ensuing funerals that took place in Belfast during the troubles in Northern Ireland. However, the artists Adam Broomberg and Oliver Chanarin did not take these photographs nor did they even visit Northern Ireland during these fraught times. They actually went to Belfast in 2011 at the invitation of the Belfast Exposed photographic archive; a repository in a small room on the first floor of 23 Donegall Street that houses over 14,000 black and white contact sheets of photographs taken by journalists and civilians. Chanarin recalls, "It struck us immediately as a completely fascinating collection of images." The archive had been open to the public and the contact sheets not only bore the markings and small circular stickers of the successive archivists as a result of their ordering and cataloguing, but also the gestures of people who wanted to scrub an image from public record. Broomberg and Chanarin photographed these purposefully defaced street photographs and lifted the dot stickers to reveal what lay beneath. "That area under the dot was rendered invisible, almost censored. And that's what we've blown up and printed," adds Chanarin. They called the resulting series "People in Trouble Laughing Pushed to the Ground."

1 *Untitled (Man Handcuffed to Drainpipe)*, Belfast, UK, 2010
2 *Untitled (Boy Running with Barrel)*, Belfast, UK, 2011
3 *Untitled (Girl Looking)*, Belfast, UK, 2010
4 *Untitled*, Belfast, UK, 2011

Broomberg and Chanarin currently live in London but they grew up in South Africa, where they trained as photojournalists. Throughout the past decade, they have traveled the world to photograph various conflict zones. One of their early series came about while they were embedded with the British forces in Helmand Province in Afghanistan. In "The Day Nobody Died" (2008) they refrained from the act of snapping the scenes they saw through a camera and chose instead to simply expose long strips of photographic paper to the sun allowing the light and chemicals to form abstract images; they explain: "The title of the project refers to the fifth day of our embed, the only day in which nobody was reported to have been killed."

"The Day Nobody Died" and "People in Trouble Laughing Pushed to the Ground" share similar concerns. Firstly, they both deal with issues of authorship. "In Afghanistan, the composition was determined entirely by the sunlight," explains Chanarin. Whereas the images from "People in Trouble" were either shot by amateurs then further altered by interfering visitors or created by exposing only what lay beneath a randomly placed dot sticker, they again forfeit authorship in what the artists have called "a game of chance." However, both series also share the same fundamental purpose: to explore and expose how photographs are used within society. While "The Day Nobody Died" can be read as an act of subversion that questions the genre of war reportage, "People in Trouble" looks at how the photographic archive impacts on those living in a society at war. Chanarin explains that the series reveals "this whole history of engagement. So this idea of the photograph as one moment becomes undone, it becomes this extension of moments." Ultimately, what Broomberg and Chanarin uncovered in the Belfast Exposed archive brings to mind the words from Allan Sekula's famous essay "The Body and the Archive" (1986): Every "portrait has its lurking, objectifying inverse in the files of the police." In Northern Ireland, people resorted to erasing or scratching out faces on photographs because they were fearful of the possible repercussions of being seen.

PARIS

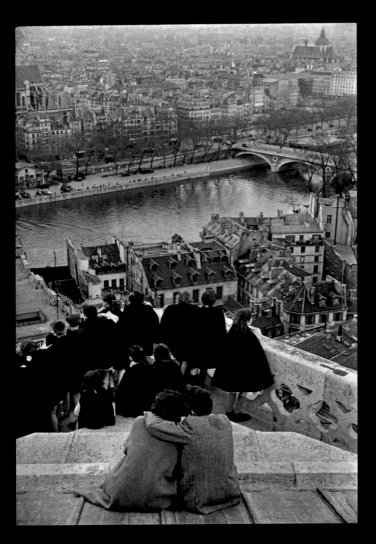

Throughout time, Paris has been immortalized through numerous artistic lenses. For many years, more than any other city in the world, it could arguably claim the title as the capital of street photography. Its architecture and sweeping, urban boulevards, much unchanged since Baron Georges-Eugène Haussmann's nineteenth-century renovation, have provided the backdrop to many of the medium's iconic artworks. As far back as the turn of the twentieth century, Eugène Atget photographed the French capital over a period of thirty years. Critic Susan Sontag hailed him as one of the medium's preeminent practitioners, adding, "Like language, [photography] is a medium in which works of art are made. Out of language one can make . . . Balzac's Paris. Out of photography one can make . . . Atget's Paris." He created a diverse body of work that extensively documented the city, from its shop fronts to its doorways, its streets to its parks, yet as John Szarkowski, the New York Museum of Modern Art's renowned photography curator noted, "Atget rarely made a photograph that directly described a human presence." Although occasionally, perhaps accidentally, he would frame his own reflection in the city's windows.

Photography's illustrious connection to Paris dates back to the dawn of the medium. On January 6, 1839, the city's newspaper *La Gazette de France* ran an article about an invention by Parisian Louis-Jacques-Mandé Daguerre. The piece described what would turn out to be one of the first photographic processes, the daguerreotype: "We have seen on copper several views of boulevards, the Pont Marie . . . and a lot of other places rendered with a truth which nature alone can give to her works." Daguerreotypes required lengthy exposures and rarely registered moving figures. However, *Boulevard du Temple* (1838–39) reveals a man having his boots polished by a bootblack—the two men remained motionless long enough for Daguerre's camera to capture them—in one of the earliest photographs portraying people.

Just over a decade after Daguerre announced his revolutionary technique, Charles Nègre, pupil of the painters Delaroche and later Ingres, took an image on the Quai Bourbon, on the Île Saint-Louis, that has since earned him the accolade as one of the first street photographers. He was also one of the first painters to turn to photography; Delaroche had encouraged him to use the daguerreotype to prepare compositions, but by the late 1840s he started using paper photography. *Chimney Sweeps Walking* (1851) freezes three figures in the act of moving and appears to seize an instant from the flow of time.

Nearly a century later, such instant photography became synonymous with the name of Henri Cartier-Bresson. He is perhaps best remembered for his phrase the "decisive moment," often exemplified in his images of Parisian streets (see image 1). Cartier-

1	2
	3

1 *View from Notre Dame*, Henri Cartier-Bresson, 1953 2 *A Kiss by the Hôtel de Ville*, Robert Doisneau, 1950 3 *Paris Street View 28*, Michael Wolf, 2010

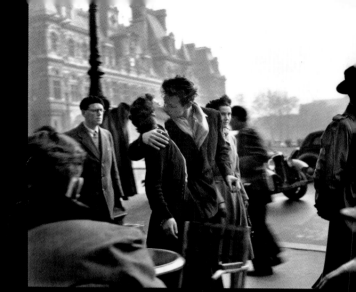

Bresson practiced during the decades after the 1920s, the golden age of street photography. At the time, the Parisian photographic scene was perhaps the most vibrant in the world. Artists such as Brassaï and Robert Doisneau likely walked the same thoroughfares and back alleys as Cartier-Bresson. Brassaï focused on a tawdry group of characters, prostitutes, pimps, madams, and transvestites, in one of the most celebrated photobooks of all time, *Paris de Nuit* (1933). Moreover, Doisneau created a photograph so iconic that it almost came to define the capital. *A Kiss by the Hôtel de Ville* (see image 2) appears as a quintessential "decisive moment," yet Doisneau admitted it was a set-up: "I would have never dared to photograph people like that. Lovers kissing in the street, those couples are rarely legitimate."

Today, the challenge to artists working in Paris is to recognize its uniquely important photographic legacy. For a while, photographers encountered a city that, as curator Sophie Howarth observes, was so "weighed down by photographic history that it seemed almost impossible to make original images there." Contemporary artists, however, have employed myriad inventive methods that have enabled them to visually reinvent the capital. JH Engström's portrayal is a far cry from the traditional, much-mythologized scenes. "Sketch of Paris" 1991–2012; see p.152) is a raw, gritty, and intensely intimate tour cataloguing his various encounters via deserted backstreets to its late night cafes and bars. Luc Delahaye (see p.156) also opted for the shadows but by descending underground beneath Paris's streets. For "L'Autre" (1995–97) he photographed the faces of commuters on the Metro train system. Meanwhile, other artists approach the cityscape as a theater in which to stage performances. For his series *Périphérique* 2005–08), Mohamed Bourouissa (see p.160) chose subway stations and apartment building rooftops to direct actors in meticulously composed tableaux. By contrast, in the series "The Shadow" (1981), Sophie Calle (see p.164) appears as herself. She explains, "I asked my mother to hire a private detective to follow me, without him knowing that I had arranged it." The result reveals the detective's voyeuristic snapshots and notes of Calle's daily movements; the aim, she hopes, "to provide photographic evidence of my existence." A recent project by Michael Wolf (see p.70), "Paris Street View" (2010), relies on another type of voyeur, whose prying eyes few escape. The series is entirely generated from images collected by the Google Street View system. Critic Marc Feustel comments, "Wolf may have become the first street photographer of the online world." His approach displays such a radical aesthetic that with *Paris Street View 28* (see image 3) he is even able to create a novel re-interpretation of Doisneau's legendary *Kiss by the Hôtel de Ville*. **JH**

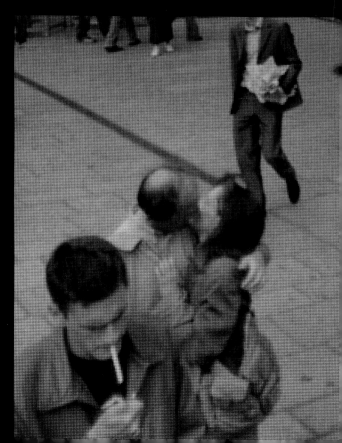

JH ENGSTRÖM

PARIS
BORN 1969, Karlstad, Sweden LIVES Ostra Amtervik, Sweden, and Paris, France
STUDIED University of Gothenburg SERIES "Sketch of Paris," 1991–2012
OTHER CITIES WORKED New York

Few cities have been more photographed than Paris. Daguerre looked up Boulevard du Temple, Doisneau framed a kiss in front of the Hôtel de Ville, Cartier-Bresson snatched a moment behind the Gare St. Lazare, and Willy Ronis scaled the heights of the iconic Tour Eiffel: just a few highlights from a vast bank of imagery that has become part of our shared cultural heritage, our celluloid picture of the French capital. However, JH Engström's photographic series "Sketch of Paris" casts the city in a radically different light. The work pictures dimly lit bars, late night haunts, colorful street life, crepuscular encounters on the Metro, naked figures, and loft apartments in the cold light of morning. For over twenty years, from 1991 to 2012, Engström was rarely without his camera as he documented his life, loves, and adventures in Paris in thousands of photographs. To Engström photography has been a compulsion since he first picked up a camera at the age of five: "It's an urge and a necessity to photograph what I experience and what surrounds me."

Engström was born in Karlstad, Sweden, in 1969 but moved with his family to Paris when he was ten years old. Much of his subsequent childhood was split between the two countries and between two very different experiences: bucolic Scandinavian countryside and European urbanity. Growing up he noticed a stark contrast between the two. "Paris has such an extreme variety of cultures and classes," he observes, "It's freed from the Swedish correctness. Roughness is mixed with tenderness, beauty with ugliness. There's this necessary, vibrant balance." When Engström turned twenty-two, he settled in Paris. The decision would kick-start his photographic career and he "realized you could actually make a living out of it." He then fortuitously landed a job assisting fashion photography maestro Mario Testino. Six years later, with a photography degree to his name, he produced his first photography book, *Shelter* (1997), and despite a move to New York, he did not stop. *Trying to Dance* (2004) followed, then *Haunts* (2006) and four more books; *Sketch of Paris* (2013) is his latest and eighth publication in a mere sixteen years.

From the outset, Engström was drawn to display his imagery in books; in effect they are his medium of choice. He wryly notes, "It's pretty hip now but back in the nineties when I released my first book, there was almost a general contempt toward the format." In contrast to the constancy of this format, however, Engström's

1	3
2	

1–3 From "Sketch of Paris," Paris, France, 1999–2012

photographic approach throughout all his books is frenetically inconstant. He uses a range of cameras, including the same Nikon FM he was given as a child. He deliberately frames compositions on his 4x5 large-format camera mounted on a tripod but he also speedily snaps away on throwaway cameras, asks a friend to snap him, or sometimes does not even have to ask; "these pictures just happen, as part of everything." He shoots with different angles, depths of field, crops, and at different times of day. He mixes types of film, exposing black and white as well as color, saying "I want to be thrown between two energies," and "to be in all these different worlds'. Within this maelstrom of variety he claims that there is no

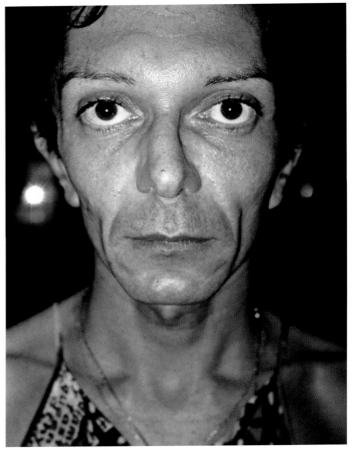

4–7 From "Sketch of Paris," Paris, France,
1999–2012

hierarchy: "as long as the result speaks to me. The work is driven
by my own life and my strong belief in the truth of what my eyes
witness daily." Page by page, the images in the "Sketch of Paris"
series are artfully juxtaposed and sequenced. They come at you
like a stream of consciousness, like memories from a family album
and Paris is portrayed in bewildering motion: as an excitable and
capricious cityscape.

Critic Martin Jaeggi notes, "Whereas most photographers use
their camera merely as a tool to convey their deeply held convictions
about the ways of the world to their viewers, Engström uses the
camera and darkroom to pursue his doubts." He renders photography

unstable, as curator Alfredo Cramerotti points out: "Its solidness,
the materiality of 'the photographic,' so to speak, is always slipping
away, always one step in front of me—just far enough ahead to
be ungraspable." Engström's work revels in slippage, in uncertainty,
and displacement. The photographs often render their subjects
softly focused or smeared across the page in a motion blur; their
faces are often obscured from the viewer by shadows or their backs
are turned. Moreover, the emulsion is marked by smudge and dust,
or appears washed out, fueling the sense that time has passed
and we are looking at old, much-treasured snapshots. These
imperfections combine together to create distance between

the subject and the viewer. "If there is a word for my work," he once declared, "it's loneliness, mine and other's."

"Sketch of Paris" feels highly autobiographical. Engström's reflections appear in cracked and grimy mirrors, obliterated by the burst of his flash or staring out in repetitive formation from a contact sheet. The images are of his haunts, his encounters, his friends: sometimes pulling back an arm to frame himself in his crowd. Yet he points out that although his books and his work are personal, they are not directly revealing. He adds, "I don't think anyone can tell anything about who I am and how I live from looking at my work." Instead, his concerns seem more oblique, indeed existential. Engström admits to

being fascinated by where he came from and what shaped him, conceding, "Those early years in Paris affected me a lot, on [a] deep level. There were so many new impressions and I had no one to share them with or talk to about them." He quotes French novelist Marcel Proust when he wrote, "The real voyage of discovery consists not in seeking new landscapes but in having new eyes," and confesses a greater interest in returning to known places than seeking new ones. "Sketch of Paris" returns to the Paris of his twenties, thirties, and early forties; the images read like memories, the pages sift through them and one senses that in the book Engström has embarked on some form of search: a search, through others, for the self.

PARIS
BORN 1962, Tours, France LIVES Paris, France SERIES "L'Autre," 1995–97;
"Memo," 1996; "Portraits/1," 1996; "Winterreise," 2000; "Une ville," 2003
OTHER GENRES Documentary, portraits

LUC DELAHAYE

In Michael Haneke's movie *Code inconnu* (*Code Unknown*) the lover
of Anna Laurent (Juliette Binoche) is a war photographer readjusting
to life in Paris after returning from Kosovo. In one scene he hangs his
camera around his neck and threads the shutter release cord beneath
his jacket to where he can reach it, hidden in his pocket. Heading
off into the Paris Metro, he rides the trains in search of people to
photograph. Although he is unable to look through his viewfinder
to frame the image, he hazards a guess and to disguise the click of his
camera, he fires only as the doors slide shut. In this way, he captures
the faces of unsuspecting commuters on film. The sequence of black
and white images that follow are, in fact, part of a real series,
photographed in the same way over two years (from 1995 to 1997)
by the French photographer Luc Delahaye: it is called "L'Autre" (The
Other). Today Delahaye is renowned for large-scale, color images
that bring world events, conflicts and social issues to the museum.
Like the character in Haneke's film, Delahaye was once a war
photographer. His career began when he was sent to Beirut by the
French press agency, Sipa. After that, he photographed conflicts
in Romania, Haiti, Kuwait, Afghanistan, Yugoslavia, and eventually
Rwanda. However, he soon began to question the purpose of his
chosen medium of photography and these concerns would culminate
in the series "L'Autre."

Delahaye began to wander through the dark confines of the
city's Metro. He wanted to find out what would happen when the
photographer is removed from the act of photography: when just the
camera and the subject remain. He set about asking the homeless
people who he encountered whether they would pose for him in the
Metro's photo booths. His only act as the photographer was to feed
a coin into the slot. He remembers, "They sat in this cramped booth
while I was looking away. I was confident in the machine, I knew its
power of revelation." The results of this series, "Portraits/1," spawned

1	2	3	4	5	6
7	8	9	10	11	12
13	14	15	16	17	18

1–18 From "L'Autre," Paris, France, 1995–97

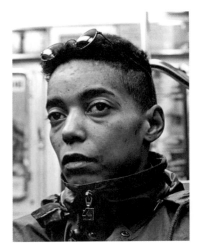

the idea behind "L'Autre." Delahaye, by effectively setting himself up as a walking photo booth, not only relinquished control within these images, but also crucially he was able to capture his next targeted subject while they remained unaware that they were being photographed.

"L'Autre" recalls the famous series by Walker Evans: "Subway Passengers, New York City." In the late 1930s and early 1940s, Evans also photographed New York's underground commuters with a camera concealed beneath his overcoat. He too had wanted to discover whether the camera sees something differently if people do not know they are being photographed. However, the two series differ in one important respect; whereas Evans printed the whole frame of the image, revealing groups of people in context, Delahaye

cropped his to leave only faces. One after another, throughout "L'Autre," they stare back—no smiles, no frowns, no hint of animation—completely blank. The series reads like a mug shot parade, an exercise in physiognomy or perhaps an anthropological study that considers how the human animal copes in crowds, an investigation of what the experts call "civil inattention." Delahaye calls it "that non-aggression pact we all subscribe to: the prohibition against looking at others [where] apart from the odd illicit glance, you keep staring at the wall." Sociologist Erving Goffman described it as "the most basic type of facework" and "subtle employment of bodily posture and positioning" that humans cultivate to give off "the message 'you may trust me to be without hostile intent.'" However we appear when we think others aren't watching, what struck Delahaye

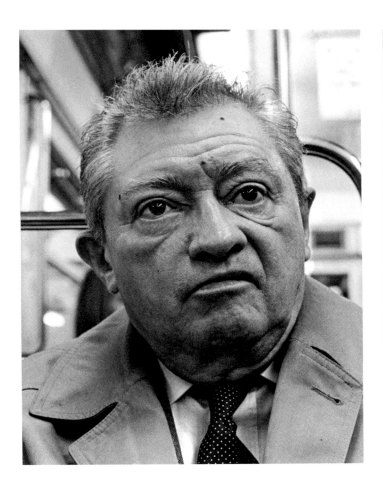

the most was our isolation: "We are very much alone in these public places and there's violence in this calm acceptance of a closed world."

Soon after Phaidon published *L'Autre* in 1999, one of the commuters took Phaidon, Haneke's production company, Delahaye, and his agency Magnum to court invoking his right to control his own image. On June 2, 2004, the Tribunal de Grande Instance in Paris dismissed the case in a groundbreaking judgment for the French courts defending an artist's freedom of expression. Susan Sontag once likened photography to a violation, claiming it sees its subjects "as they never see themselves, by having knowledge of them that they can never have." These words have new resonance with Delahaye's series in which many of its subjects may still not know they have even been "seen."

| 19 | 20 | 21 | 22 |

19–22 From "L'Autre," Paris, France, 1995–97

PARIS
BORN 1978, Algeria LIVES Paris, France STUDIED Ecole Nationale Supérieure des
Arts Décoratifs de Paris; Université Paris 1 Panthéon-Sorbonne; Le Fresnoy, Studio
National des Arts Contemporains, Paris SERIES "Périphérique," 2005–08

MOHAMED BOUROUISSA

The series "Périphérique" by Mohamed Bourouissa portrays a very
different image of Paris from the sweeping boulevards by Haussmann
or the cobbled, winding lanes of the Marais. It depicts life on the
other side of the city's ring road (the périphérique of the title)
amid the high-rise concrete housing projects of suburbs, such as
Sarcelles, La Courneuve, and Pantin. At first sight it reads as classic
photojournalism, documenting the riots that set these suburbs ablaze
in 2005, when, on October 27, two French youths of Malian and
Tunisian descent tried to flee the police by hiding in a power station
in the suburb Clichy-sous-Bois and were electrocuted. Their deaths
sparked nearly three weeks of rioting that raced through the suburbs
and across France leaving in its wake the burned-out wreckage of
torched cars, buildings, and schools. The spectacle played out to
the world through news programs and papers. As it happens, *La
République* (see image 1) was taken where the riots first ignited, in
Clichy-sous-Bois, however, not until 2006, long after law and order
had been restored. In fact every image in "Périphérique' is a highly
polished, artful construction, composed by the artist entirely for the
camera. By all too readily believing what is presented, what is staged,
Bourouissa succeeds in exposing society's prejudices.

Bourouissa has first-hand experience of the people and places he
pictures. "I'm always asked about Algeria, about being Algerian," he
says, "but although I was born in Algeria to Muslim Algerian parents,
I grew up in the suburbs of Paris, and I think of myself as French." On
turning twenty, he left the suburbs for the city. He first studied art
history at the Université Paris 1 Panthéon-Sorbonne, graduating in
visual arts in 2004. He then specialized in photography at the École
Nationale Supérieure des Arts Décoratifs de Paris and completed his
training at the acclaimed Le Fresnoy, Studio National des Arts
Contemporains. However, throughout these years he stayed in touch
with his roots through his childhood friends and slowly the idea for
the series "Périphérique" evolved. "I myself come from a suburb" he
says, "but that is not the only reason I chose this topic. Many of the
people around me come from these suburbs. These are places where
immigrants' identity problems and political conflicts become crystal
clear." He adds, and "by the way I think that we will have new riots in

the next three to four years if things don't improve." His connections
made the series pertinent but also possible; he has a relationship
with nearly every person portrayed, "My first contact usually comes
by way of a friend, and through that person I meet other people and
spend time with them so they will accept me. I show them my pictures.
But the intensity of the encounter is what means the most to me."

Bourouissa works within the tradition of staged photography. Like
a movie director he creates mise en scènes, not for the cinema, but
for celluloid tableaux. He intensely prepares each image, preconceiving
the scene before drafting or sketching it out. He talks of constructing
the picture in a space within his mind; "I was inside the images," he
recalls, "experiencing a place." He uses actors, controlled lighting, and

4 *Périphérique*, Paris, France, 2007 5 *L'impasse*, Paris, France, 2007 6 *Le couloir*, Paris, France, 2007 7 *Carré rouge*, Paris, France, 2005

large-format cameras but the scenes that he builds are meticulously composed to appear natural—like moments snatched from real life. In this way, his practice approaches what artist Jeff Wall (see p.86) describes as "near documentary," generating imagery that occupies and explores a middle ground between fiction and documentary.

There are other echoes of Wall within Bourouissa's work. Both artists are influenced by art history. Like Wall, Bourouissa carefully constructs his tableaux to reference legendary painters. Various compositional elements visible in "Périphérique" evoke masterpieces by artists, such as Delacroix, Goya, and Géricault. An example can be seen in *La République*, where the man wearing the red armband staring up at the French tricolor seems to echo an element in Géricault's *The Raft of the Medusa* (1818–19). As critic Daniel Baird notes, with Géricault "the ragged flag is a symbol of hope, possibility of redemption amid shipwreck and cannibalism and gruesome death; in Bourouissa's image it is draped over division and confusion." Moreover, the drama that plays out within Bourouissa's frames and between his figures also recalls these great paintings. He says, "I use a form of art known as 'emotional geometry.'" He stages emotion, in particular tension, in

the way that individuals interact and interplay; by using body language and eye contact, he hints at the simmering power struggles.

The final shoot involves a degree of collaboration between himself and his actors. After he has composed the scene in his mind and on paper, he practices it with his chosen actors at a random location. This enables the actors to rehearse their roles, and for him to make adjustments, while keeping the actual location fresh. On the day of the shoot, the actors already know their positions and what is expected of them. Bourouissa then allows them to play the scene out for him, which introduces an element of naturalism, but also serendipity. He says, "I am interested in chance and how that can be a prism [by] which we can go deeper and deeper into the reality of things." However, he carefully watches the unfolding drama throughout, looking out for that gesture or expression that speaks to him. If one had to define the series "Périphérique" with one word, it would be tension. Throughout Bourouissa works like a conjurer to render this invisible quality visible. He concludes, "What I'm after is that fleeing tenth of a second when the tension is at its most extreme . . . that extreme moment where anything could happen, or nothing."

VENICE
BORN 1953, Paris, France LIVES Paris SERIES "Suite Vénitienne," 1980
OTHER GENRES Conceptual, performance, video, film OTHER CITIES
WORKED Paris

SOPHIE CALLE

"At the end of January 1980, on the streets of Paris, I followed a man whom I lost sight of a few minutes later in the crowd. That very evening, quite by chance, he was introduced to me at an opening. During the course of our conversation, he told me he was planning an imminent trip to Venice. I decided to follow him." This chance encounter led to one of Sophie Calle's best-known works, "Suite Vénitienne." Like a private investigator, armed with notebook and camera, Calle immediately set off for Venice where she spent two weeks first tracing, then secretly photographing this virtual stranger around its labyrinthine streets.

Photography is just one tool Calle uses to present her life, ideas and psychology through her art; she also employs text, film, and performances. "Suite Vénitienne" is a conceptual piece, and its accompanying text is as vital as its black and white photographs. "Monday. February 11, 1980," one reads, "10:00 p.m. Gare de Lyon. Platform H. Venice boarding area. My father accompanies me to the platform. He waves his hand. In my suitcase: a make-up kit so I can disguise myself; a blonde, bobbed wig; hats; veils; gloves; sunglasses; a Leica and a Squintar (a lens attachment equipped with a set of mirrors so I can take photos without aiming at the subject). I photograph the occupants of the other berths and then go to sleep. Tomorrow I will see Venice for the first time." Her diary-style reports not only give the facts, they also convey her thoughts and emotions as she stalks her subject. She follows Henri B., as she calls him, and his companion around the city for days, taking photographs all the while, sometimes of the couple and sometimes of the things that they photograph. She uses a map to chart the routes they take and makes a note of their behavior. Although she hardly knows him, her desire for him becomes apparent, as does the thrill of the chase.

Although Calle's reportage style is straightforward, banal even, her images portray Venice and its people in a highly intimate, often melancholy way. As she walks relentlessly around the city, she takes snapshots of the streets, squares, alleyways, and canals; as they were taken in winter, they are remarkably empty and lacking in life. When she captures images of the Venetians themselves, these are taken

1–3 From "Suite Vénitienne" (detail), Venice, Italy, 1980

without the subjects' knowledge, sometimes at awkward angles; we see a group of men eating and drinking in a restaurant, a little boy holding a knife with his back to the camera in St. Mark's Square, and, as the work progresses, we see Henry B. and his companion as they are secretly pursued around the city.

The genesis of "Suite Vénitienne" began in Paris where Calle was born. She is the daughter of renowned oncologist Robert Calle and it was partly the result of his interest in art (he was a keen collector who was friends with artists, including Martial Raysse and Christian Boltanski) that inspired Sophie Calle to become an artist herself. After finishing school, Calle traveled for seven years and first developed an interest in photography while living in northern California. On her return to Paris in 1979, Calle felt alienated by her native city and it was this feeling of being isolated that led her to begin a series of projects

in which she rediscovered the city, its people and, to some degree, herself. In her first work, "The Sleepers" (1979), she investigates the lives of the people around her by inviting forty-five friends, neighbors, and strangers to sleep in her bed. Like "Suite Vénitienne," these encounters are documented through text and photography. The images are offered as documentary proofs to help construct identities.

Calle's work is not simply about the photographs themselves but about the feelings these images, in conjunction with the text, evoke. She explains: "In my work, it is the text that has counted most. And yet the image was the beginning of everything." Calle had virtually no training in photography. When she returned to Paris to begin her life as an artist she enrolled on a photography course. She was taken to the first level of the Eiffel Tower and from there she photographed gardeners laying turf for a lawn. She found this deeply uninspiring

and her first day's photography training swiftly became her last. "In 1991, the writer/photographer Hervé Guibert wrote, at my request, the preface to the catalogue for my first retrospective in France at the Musée d'Art Moderne de la Ville de Paris: 'She calls herself a photographer, but Sophie Calle can't even manage to take a proper photograph (although she is making progress)' . . . He was right, I had found my own method. If the work to be done was more in the performance domain, and entailed relationships with other people, I would take the photos myself. In such cases, their quality wasn't crucial. If—but this was rarer—no relationship with others was involved, and graves or stolen pictures or lifeless objects were the subject, I would take a bad Polaroid, decide on the format and the angle, and ask a more technically proficient photographer to take the same picture, but better." When Calle won the renowned Hasselblad Award in 2010 (for "questioning and challenging the relationship

between text and photography, private and public personae, truth and fiction, in a groundbreaking, utterly original way" and depicting "human vulnerability and examining the interrelationship between identity and intimacy"), she quipped, "What a victory for somebody who had spent twenty-five years denying she was a photographer, and who had finally just given into the notion."

In "Suite Vénitienne" once she finds Henri B., she is confused emotionally. "I must not forget that I don't have any amorous feelings toward Henri B.," she tries to convince herself. Finally, one day the man senses that he is being followed and confronts her. He photographs her and tells her that he recognized her by the one thing she should have hidden, her eyes. He refuses to let her photograph him at this point and they part on polite terms (although she follows him back to Paris and takes one final photograph at the Gare de Lyon) and so Sophie Calle's strange but compelling urban odyssey comes to an end.

4 5

4–5 From "Suite
Vénitienne" (detail),
Venice, Italy, 1980

VENICE
BORN 1944, Como, Italy LIVES Lucca, Italy, and Berlin, Germany
STUDIED London College of Communication SERIES "Beach Series," 1995–present
OTHER GENRES Fine art

MASSIMO VITALI

The Como-born, Italian photographer Massimo Vitali is renowned for
his emblematic imagery of throngs of sun worshippers lying and lolling,
preening and posing on various beaches across Europe. He always works
in much the same way and creates pictures with an instantly recognizable
style: a rather overexposed, bleached, candy-colored palette. He uses a
vintage 1950s wooden camera—a large-format, 11x14 Deardorff—that
produces vast canvases of exceptional detail. Perched on top of
custom-made platforms, 20 to 30 feet high and with his camera
mounted on a tripod, his wide-angle lens captures expansive panoramas
from an elevated perspective. He bides his time until people have forgotten
he is there; indeed, he describes the process as a "waiting game."

At first glance, this image of Venice's principal public square and
most famous church, Piazzo San Marco and Basilica di San Marco,
appears a radical departure for Vitali. He used the same tools to capture
them but where is the natural landscape, the sand, the surf? In fact,
Vitali has a far wider repertoire; he has also photographed snowy
mountainsides strewn with skiers, city parks, swimming pools, even
densely packed nightclubs. The backdrops might switch, but there is one
unchangeable constant—the solitary individual does not interest him,
he always frames crowds. Vitali is fascinated by how we spend our leisure
time, what we do on holiday, where we go to relax, and how we occupy
and move through these landscapes. The images might appear as aesthetic
confections, but he surveys the scene with the rigor of a scientist and
frames the human animal through a distant, yet objective lens.

Vitali's practice has been referred to as "photographic zoology." Art
historian Whitney Davis suggests its aim is to reveal "a human ecology"
and "to clarify what kind of society we are, or perhaps could be." Vitali
focuses on where people gather and freezes our tendency to assemble
into groups, driven by an animal instinct to form human herds, packs or
swarms. This image depicts how visitors move around and inhabit Venice's
main tourist attraction. "This magnificent photograph definitely asserts
Vitali's subject matter is the human creature adjusted to the world,"
claims Whitney, "in its own partly self-made historical habitat." Looking
closely, one notices how the crowd behavior of humans is echoed by the
flocks of pigeons. More closely still, one can just make out a man with his
back to us at the center of the image; Vitali has photographed someone
taking a picture of the Basilica. In doing so, as Whitney notes, he not only
reveals our innate habit to cluster and couple, but also to "look at itself
looking at its world, recording what it sees."

1 *Piazza San Marco*, Venice,
Italy, 2005

ROME

BORN 1962, New York, USA LIVES New York STUDIED Yale University, New Haven SERIES "Sanctuary," 2009 OTHER GENRES Staged, fine art, landscape OTHER CITIES WORKED New York

GREGORY CREWDSON

Wooden doorways open onto paved and cobbled alleyways. Dilapidated domed temples, pillared and pilastered façades, classical statuary all hint at antiquity. One has the sense of walking around the streets of Rome, yet centuries ago. The city seems utterly devoid of people. One wonders whether they might have fled under the shadow of some catastrophe. What else would cause the rubble and debris that litter the floor? Much about these urban topographies is familiar, and yet strange. They led the film critic, A. O. Scott to write, "You know this landscape, where it is found on the map, but that particular knowledge lies just beyond the borders of this particular dream." Occasional clues are offered: glimpses of scaffold and building fronts with nothing behind them. In fact, we are in Rome; but we are also on a movie set. The photographic series "Sanctuary" by New York artist Gregory Crewdson portrays the thoroughfares and street corners of the legendary Cinecittà (Cinema City) Studios.

Cinecittà has a colorful history. Founded by Benito Mussolini under the slogan "Il cinema è l'arma più forte" (Cinema is the most powerful weapon), it opened for business on April 21, 1937. Mussolini hoped, along with Luigi Freddi, the studio's first administrator, that it would be used to manufacture propaganda movies to serve the fascist state. Their dreams were short-lived and after the war, Cinecittà not only survived Il Duce's dictatorship but also thrived. By the 1950s it had earned the moniker "Hollywood on the Tiber," having provided the city backdrop to movies from *Roman Holiday* (1953) and *Helen of Troy* (1956) to William Wyler's epic *Ben-Hur* (1959). Even the much-blighted production *Cleopatra* (1963), which reputedly near bankrupted its studio, was moved from London to Cinecittà after problems with bad weather, budgeting, and actress Elizabeth Taylor's health. However, it is best remembered as the setting for many iconic films directed by Federico Fellini, such as *La Dolce Vita* (1960), *Satyricon* (1969), and *Casanova* (1976). Then in 2009, Cinecittà experienced yet another reversal of fortune: a promotion, through Crewdson's lens, from being the stage to starring center stage as the subject.

Crewdson is internationally renowned for "Twilight" (2001–02) and "Beneath the Roses" (2003–07), two series that perhaps more than any other in contemporary art come closest to mimicking the

scale and concept of cinema. Orchestrating directors of photography, camera operators, grips, gaffers, actors, even casting agents, he works like an auteur director to construct a single still photograph that he describes as "single frame movie." Every prop, every shadow, every expression is artfully constructed as a meaningful mise en scène and the final, vast tableaux recall the technicolored, immersive experience of the big screen. "After doing 'Beneath the Roses,' which was this enormous, almost epic project that was seven years in the making and eight productions and many hundreds of people involved, I knew that I wanted to do something very different," recalls Crewdson. "I didn't know what it was, but I knew it would be something more organic and smaller scale." His friend Wes Anderson told him about Cinecittà, having been there to film *The Life Aquatic*

4 *Untitled (4)*, Rome, Italy, 2009
5 *Untitled (2)*, Rome, Italy, 2009

with Steve Zissou (2004) there. When Crewdson visited Rome, he asked for a private tour and his reaction was instantaneous: "When I went onto the back lot, it was one of those moments that come few and far between, where I saw the whole project." Yet his vision could not have been more different from his previous work.

"Sanctuary" marks such a bold departure for Crewdson that critic Francis Hodgson quipped, "One might discern something approaching a mid-life crisis in so radical an upheaval, but I think not. I think," he continues, it shows "a new level of mastery." For a start, Crewdson had never worked outside the United States before. Moreover, he returned to Cinecittà with an uncharacteristically compact crew and, in a single month, created the whole series in less time than he would usually devote to one image. He observes, "I was almost doing the opposite of what my usual job was. Typically I would take ordinary lives and I would heighten it through cinematic production. Here, I was taking cinematic life and trying to make it ordinary. I did everything I could to neutralize the subject matter." He opted for black and white imagery, to reference the history and tradition of documentary practice. He decided not to interfere with what was already there. Indeed, Scott jokes that apparently "offers from the studio administration to trim weeds and clear out trash were politely declined." He refrained from using any artificial illumination and

restricted himself to the soft ambient light of dawn and dusk. Essentially, throughout the project, he cast aside his previous highly subjective visions in favor of a far more objective viewpoint.

"Sanctuary" is the aesthetic antithesis of his previous series "Twilight" and "Beneath the Roses," yet it still manages to convey a compelling sense of incipient drama and narrative ambiguity. The subject matter that Crewdson discovered in the abandoned movie sets of Cinecittà naturally offers multiple levels of reality and artifice, fiction and fantasy. He claims, "I aimed to draw upon the inherent quietness and uncanny aspect of the empty sets." By dispassionately rendering the empty desolation and the beautiful decay of the city scenes, he perfectly captures this strangely familiar, surreal world. Interestingly, for the first time he chose a digital camera over his 8x10 film camera. "Shooting with a large-format camera dictates a certain sort of stance," he notes: more specifically a distance. With "a smaller camera, I can get into locations. I can get closer." He also opted for smaller prints than usual. The combination heightens one's sense of intimacy with the subject. Consequently, more than anything these images conjure up notions of dreams. "A literal question—what is left behind when the movie has wrapped and the cast and crew have departed?—produces a symbolic analogue." Scott asks another, "What is left of the world we dreamed up after we awaken?"

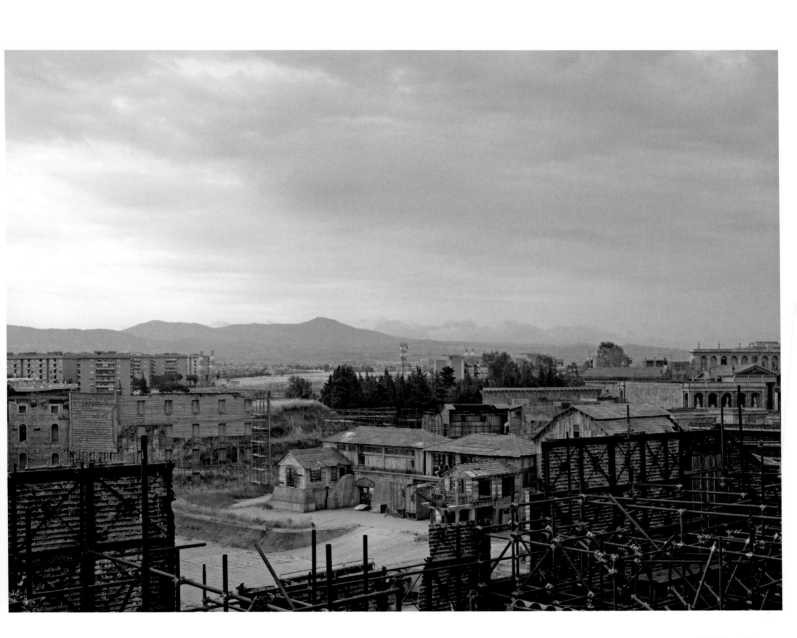

NAPLES
BORN 1959, London, UK LIVES London STUDIED Exeter University,
UK; self-taught in photography SERIES "Siren City," 2000–08 OTHER
GENRES Portraits OTHER CITIES WORKED London, Calcutta

JOHNNIE SHAND KYDD

"Failing to seduce Ulysses with the beauty of her song, the siren Parthenope threw herself from her lair to perish in the waves below. Her corpse washed ashore on the southern Italian coast at a place that in time would become the city of Naples." Johnnie Shand Kydd refers to the origins of the city within Greek mythology to introduce his photographic portrait of Naples and in Parthenope's honor he gives it the title "Siren City." He refers to the city as a woman: "When I'm talking about Naples, I don't feel like I'm talking about a city. It's more like an organism or a human being. She's like a fantastically beautiful lover who has severe mental health issues." His imagery paints a picture of a slightly schizophrenic city.

Shand Kydd did not take up photography until he was thirty-seven. Having worked for the Fine Art Society for thirteen years, he quit. At the time, he was hanging out with a group of artist friends who were soon to become household names, Damien Hirst and Tracey Emin among them. "I was aware that something was happening in London, but I didn't know what," he recalls: "I thought it was worth recording the events, however, crappy the pictures were. So I always used to travel with a camera in my back pocket to the parties and private views." In 1997 the resulting images, shot on an Instamatic camera, were published in the book *Spitfire* and the same year Charles Saatchi hired him to photograph the artists featured in the "Sensation" exhibition at London's Royal Academy. Yet Shand Kydd maintains he has never opened a camera manual and that it was not until he went to Naples in 2000 that he taught himself.

There he learned on a Mamiya twin-lens reflex camera from the 1960s. He shuns digital photography and avoids trying to make technically perfect images; his camerawork delights in the happy accident of "incorrect" over or under exposures. His images pulse with light and energy. Moreover, he feels involved or implicated. This was candidly the case with *Spitfire*, yet it also seems the case with Naples. The "city as seductress" rhetoric hints at this, but he also comments that it "can drive you mad . . . like a drug addiction." At first Shand Kydd presents youthful, sun-drenched optimism, but as he probes deeper into the city's core, the images shift from portraying faded grandeur to squalor; the moods his images convey get darker. Parthenope's madness and her ghost reawaken to haunt the streets.

1–6 From "Siren City," Naples, Italy, 2000–08

| 1 | | 3 | 4 |
| 2 | | 5 | 6 |

XINZO DE LIMIA

BORN 1946, Madrid, Spain LIVES Cuenca, Spain STUDIED Law and business
administration in Madrid, Hamburg, and Munich OTHER GENRES Documentary
OTHER CITIES WORKED London

CRISTÓBAL HARA

Two ladies sport identical black wigs, Chinese cheongsam dresses, and
long black gloves; they look oddly overdressed for an abandoned street
corner in broad daylight, whereas a man barefoot and naked apart
from a tightly fitting woven basket appears peculiarly underdressed.
Meanwhile an inflated zebra seems to tug at its line in an effort to
gallop free across the rooftops. Every year in Galicia, in northwest

Spain, the town of Xinzo de Limia hosts one of the country's wildest
carnivals in which famously nearly everyone dresses up. The carnival's
central character, the "Pantalla," roams the streets searching for people
not in costume. If someone is found, they are marched to a nearby bar
to pay the fine—a glass of wine. The festivities begin three Sundays
before the actual carnival on parade Tuesday. Renowned photographer
Cristóbal Hara goes to Xinzo every year, but never for the main event
and always the day before. "I am not interested in documenting the
celebrations per se," he says. "On the Monday morning there are things
happening in a less organized manner, and there are no crowds. In
these places I find images that I can take out of context." The figures
portrayed in all these photographs would make sense in a carnival
setting and yet taken on Xinzo's deserted streets, they appear strangely

| 1 | 2 | 3 | 4 |

1–2 Xinzo de Limia, Galicia, Spain, 2000
3 Xinzo de Limia, Galicia, Spain, 2003
4 Xinzo de Limia, Galicia, Spain, 2005

marooned. Hara's lens has the seemingly magical ability to turn fact into fiction; he is a maestro at seeking out the surreal in the real.

Various artistic movements resonate within his work. He talks of wanting to find a visual language within his photography that references Spanish culture. "Fortunately I could lean on a very rich tradition," he adds, listing painters such as Diego Velázquez, Francisco de Goya, José de Ribera, and José Gutiérrez Solana. However, as he wryly acknowledges, "one doesn't live in the seventeenth century" and he draws on many other artistic sources. In the 1960s, he was impressed by Abstract Impressionism: "It is really fun to try to mix in what you can steal from that modern period, with what you can use of the Baroque." He also finds inspiration in music, as well as literature, saying, "I sometimes try to look at the world through the eyes of Don Quixote."

These myriad influences combine within Hara's work, echoing within the rhythms, textures, atmospheres, and structures of his photographs.

Hara is widely published; perhaps best known are the first and second volume in his ongoing trilogy, *An Imaginary Spaniard* (2004) and *Autobiography* (2007). Although, he was born in Madrid to a German mother, he spent much of his childhood abroad, mainly in Germany, the Philippines, and the United States. He studied law and business in Madrid, Hamburg, and Munich before deciding to become a photographer in 1969 and then moved to London for a brief spell. He only returned to Spain to live full-time in 1980. Perhaps after all those years away he was able to see his country with fresh eyes and renewed enthusiasm. Since then, his fascination with the fast disappearing, traditional *pueblo* life and its pageantry remains undimmed.

VALENCIA

BORN 1971, Barcelona, Spain LIVES Barcelona STUDIED University of Barcelona;
International Center of Photography, New York SERIES "The Waiting Game," 2005–13
OTHER GENRES Documentary, landscape OTHER CITIES WORKED Barcelona

TXEMA SALVANS

"The outer fringe of the city gives the exact measure of the price we
pay for concentrating the satisfaction of our needs and our desires.
At its boundaries the city reveals itself," asserts Barcelona-based
Spanish photographer Txema Salvans. For the last eight years, he has
toured various city outskirts along the Spanish Mediterranean coast:
from Barcelona in the north and the Costa Brava, via Valencia and the
Costa Blanca, to Algerciras in the south and the Costa del Sol. Of
these places that we fleetingly glimpse as we pass through in our
cars—the shoulders, junctions, rotaries, the industrial dead ends—
Salvans says, they reveal landscapes "where both the city and the
country disappear" and contain "beings that are unable or unwilling
to escape the [city's] field of attraction, yet are not entirely within it."

Salvans focused his lens on one group of people in particular,
which plies its trade in broad daylight on the Spanish highways: the
prostitutes. These women come from Russia, Romania, Latin America,
and Africa, drawn to places like Barcelona by the warm winters that
enable them to work year round and by the heavy and constant
traffic of trucks carrying goods from Andalusia into France. At the
beginning, Salvans tried to take pictures of these vehicles pulling up,
the opening discussion and the moment of transaction, but he soon
changed his approach. He says, "I realized that what was interesting
was to photograph that moment of waiting, of expectancy that was
99 percent of their time." His efforts culminated with the frank and
hauntingly bleak series "The Waiting Game."

Salvans considers himself, first and foremost, a scientist. "My
passion since I was very young has always been science," he notes,
and "as a child, my heroes were Carl Sagan and Darwin." He trained
as a biologist and did not come to photography until later in life,
when in Barcelona just before university, he enrolled in a
photography workshop. Quite quickly he became ensnared by this
new medium but he approached it as an anthropologist or a biologist
might. He suggests, "I see myself as a naturalist, like one of those
guys who traveled in the nineteenth century, who went exploring
other territories and who documented in a very objective and formal
style what they saw." The photographic style that he developed evokes
a scientific approach.

1–4 From "The Waiting Game," Valencia, Spain, 2005–13

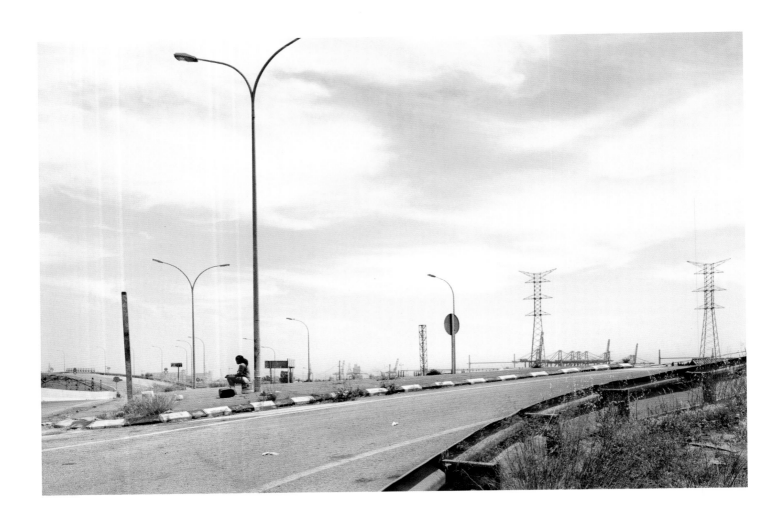

When he started "The Waiting Game" series, he deliberated about how to photograph the women. He wondered whether he should pay them but rapidly concluded: "I would then have to orchestrate the photograph, telling them to sit like this or like that, sit by the chair, or make this gesture" and, to his biologist's mind, this altering of their natural behavior somehow felt like tampering with results or modifying proof. "All of a sudden I came up with the idea of disguising myself," he recalls. "This is once again an idea taken from the world of biology: the idea of camouflage." He concealed himself as a topographer: someone whose profession is to photographically survey the lay of the land. He bought the typical yellow topographer's tripod and installed a mount to which he could fix his large-format camera. He even dressed the part: sporting a hard helmet and a high-visibility jacket. "Then, simply what I did was to approach the girls to say 'Look, I'll be around here for a while near my van.'" The deception worked; the women ignored him and continued as if he were not there, as if he were invisible.

All of Salvans's images of these solitary waiting women picture unremarkable moments frozen in unremarkable landscapes; they are all framed roughly the same size. This repetitive style seeks objectivity and neutrality. The images are uniformly bright. Pepe Baeza, an editor at the Spanish newspaper *La Vanguardia* suggests Salvans slightly overexposes the compositions, saying that these "almost white images" become "an expression of the light blindness that occurs when we throw light on something that has been in the shadows." Moreover, Salvans's lens is distant. He describes it as "an average distance that is shocking and sometimes even tragic." Rarely does it reveal faces; indeed, he claims that within the one hundred

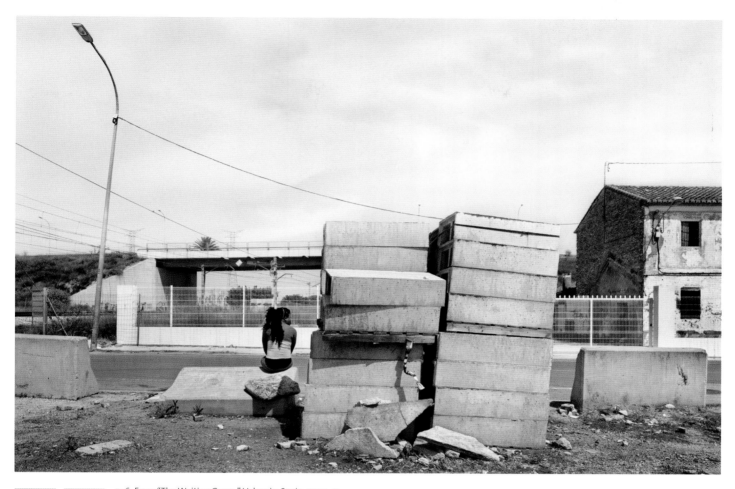

5–6 From "The Waiting Game," Valencia, Spain, 2005–13

images in the series, only six or seven women are recognizable. "The faces of these women weren't useful to me at all," he insists, "it's not a work of portraiture." Consequently, writer and fellow photographer Stanley Wolukau-Wanambwa observes, "Txema's pictures, which depict these desperate people with an almost unilaterally ruthless impersonality, illustrate precisely the way in which they are as disposable and instantly forgettable.... They are perishable parts of a much bigger and far more savage machine."

Unable to access individual psychology, the viewer turns to the landscape for meaning. Salvans situates the series within the genre of landscape; it is the utter isolation of these women within their surroundings that provides the context and the story. He talks of how these girls "are absolutely unprotected," how they are often robbed or worse beaten, even killed. He adds, "I can assure you that these girls

...don't have a strategic plan for the future: they don't have anything." They are plucked from their homes, their villages, their countries by various mafia gangs, often at young ages. "And why doesn't this girl go to the police?" he asks. "The pimp calls his contact in Romania, and they beat the little brother," the mother or someone else close to the girl. "So for me the scale of the tragedy is in the environment." The bleak urban edges portrayed in Salvans's series "The Waiting Game" hint at the utter precariousness of these girls' lives. As Wolukau-Wanambwa puts it, "The longer I spend imagining my way into the spaces of expectation in which Txema has photographed these girls and these waiting women, the more desolate and acute their predicament appears. There is undeniably a game at work, but the pictures make plain that we could never hope to photograph the winners."

1	3
2	4

BERLIN

When German film director Walter Ruttmann set out to make his experimental documentary *Berlin: Die Sinfonie der Grosstadt* (*Berlin: Symphony of a Great City*) in 1927, he aimed to create a "symphonic film out of the millions of energies that comprise the life of a big city." Ruttmann recorded the life and rhythm of a late spring day in Berlin, and thus managed to capture the atmosphere of the Golden Twenties, when the city was the cultural center of Europe. Among the artists and intellectuals drawn to Berlin was a young German photographer Otto Umbehr, better known as "Umbo," who produced photomontages for Ruttmann's film. Born in Düsseldorf, Umbo studied at the Weimar Bauhuas and then moved to Berlin, where he soon became celebrated as the originator of a new photographic aesthetic for his visionary portraits of the city's bohemians. He was also one of the first photographers to systematically photograph Berlin at night. A *flâneur*, and at times unemployed vagabond, his images capture the metropolis and its citizens at play in a poetic, impressionistic fashion. His *Unheimliche Strasse* (*Eerie Street*, see image 1) from 1928 is an outstanding example of the so-called *Neues Sehen* (New Vision) approach to photography. Between the austerity of the *Neue Sachlichkeit* (New Objectivity) and the radical disassociation of Constructivism, Umbo found his own visual language that focused on the miracle and mystery of everyday life.

However, Berlin has also been also shaped by its gloomy periods: economic crises, two World Wars, and times of upswing and reconstruction were captured by photographers, who walked the city streets and documented history while it happened. Early photo chroniclers of the late nineteenth century, including Leopold Ahrendts and F. Albert Schwartz, were followed by photographers such as Heinrich Zille, who recorded Berlin in often out of focus yet atmospheric images of backyards, distilleries, and socially deprived areas, which were the basis for his illustrations.

The carefree moments of daily life in the metropolis also attracted Friedrich Seidenstücker. Every day he wandered through Berlin, looking for unspectacular but characteristic moments that captured the spirit of the times. Besides his closely observed and humorous pictures of animals and people at Berlin's zoo, some of his most

famous photographs are of women jumping over puddles (see image 3). With the wit, optimism and lightness that is inherent in nearly all of his photographs, Seidenstücker records the self-confident woman of the 1920s. A few years later, in 1934, the motif of the woman jumping the puddle was revived by the Hungarian news and fashion photographer Martin Munkácsi, and then again by U.S. fashion and portrait photographer Richard Avedon in 1954. Munkácsi was one of many young Hungarian artists—including László Moholy-Nagy, Eva Besnyö, and Robert Capa—who lived in Berlin during the late 1920s and early 1930s, until the cultural climate changed drastically when the National Socialists assumed power in 1933. Numerous artists and photographers went into exile, were economically ruined, or drafted for military service. The ones who returned to Berlin after 1945, such as Capa, Seidenstücker, Willy Römer, or the Jewish photographer Henry Ries, found a city in ruins and a population ravaged by hunger. Once more eyeball to eyeball with the events of the time was Umbo, whose archive was destroyed during an air raid on Berlin.

The division of Germany by the Allies and the Berlin Wall era were covered in photobooks such as Janos Frecot's *Die Jahre mit der Kamera: Fotografien aus Berlin 1964–1966* (The Years with the Camera: Photographs from Berlin 1964–1966, 2013), John Gossage's *Berlin in the Time of the Wall* (2004), Michael Schmidt's *Waffenruhe* (Ceasefire, 1988), or Rudi Meisel's observations of everyday life from both sides of the wall. The different perspectives on the social systems in the East and West also interested Arno Fischer, who documented his experiences during the years before the wall's construction. In symbolic images with complex compositions, he captured moments where state and individual, political aspirations and everyday reality collide (see image 2). Fischer was a precursor of a lively photographic scene that developed in East Germany at the end of the 1970s. Photographers such as his future wife Sibylle Bergemann, Harald Hauswald, Ute Mahler, and Werner Mahler revealed life in East Germany unvarnished, exposing social contradictions and witnessing the experiences of a generation.

Precise observation and enhancing dialogue also characterizes contemporary photographers who turn their eyes on Berlin. Since 2010, Göran Gnaudschun has visited the historically charged Alexanderplatz once a week to portray the dropouts and runaways, punks and tramps living there (see image 4). His sensitive portraits give the marginalized a face. South African Sue Williamson (see p.186) asks residents about the essence of their city in her series "Other Voices, Other Cities" (2009–present). Both artists add timely voices to the symphony that is Berlin. **SG**

BERLIN
BORN 1976, St. Petersburg, Russia **LIVES** Berlin, Germany **STUDIED** Humboldt
Universität Berlin; Università di Bologna, Italy **SERIES** "One Another," 2008–
present **OTHER CITIES WORKED** St. Petersburg, Odessa, Phnom Penh

ALISA RESNIK

"Encountering a human being means being kept awake by an enigma."
These words by philosopher Emmanuel Lévinas introduce Alisa Resnik's
ongoing series. "One Another" portrays her various after-hours
encounters in Berlin's dimly lit bars, cafes, and streets. The images
shift between deserted, anonymous street scenes and snatched,
often awkward, moments of intimacy with friends and strangers.
Shadows predominate, details blur and the frames seem drained
of color. The aesthetic evokes echoes of the past, of vague memories
or even dreams. Mostly, the people and places appear suffused with
a melancholic and lonely air. Her friend the author, Jeremy Mercer,
writes, "Alisa Resnik's photography inspires such an unsettling
combination of awe and ache. The portraits evoke a startling and
complex human beauty. Yet, there is also a vague sadness."

Until Resnik was fourteen she lived in St. Petersburg; it was only in
1990 that she and her family fled the collapsing Soviet Union in search
of better lives in Berlin. Initially, she felt like an outsider. She recalls,
"I didn't know anything about the city when I moved here. It felt hostile
and rather unappealing compared to the place I came from." She
started to take photographs as a way to stake a claim on the people
and places that she encountered. Yet even today, twenty-four years
later, these feelings have not quite subsided. Resnik admits, "I am part
of Berlin and Berlin is part of me, but I still feel like an alien element
that could be rejected every moment. It's a constant struggle."

For the past two decades she has worked as a waitress in bars
and restaurants. There is an element of this work that satisfies a kind
of voyeuristic impulse; it enables her to watch without being noticed.
Yet simply watching is not enough. She also talks of the "painful
dichotomy between the subject and the object": the gulf between
one's self and others. Furthermore, a "craving for a single moment
of sincerity . . . to break through the glass of loneliness." This is where
her camera fits in; it becomes a tool for existential exploration. The
image of a girl in an empty bar, naked except for black boots and a fox
pelt, tenderly held (see image 1), was taken one evening after everyone
had left and the doors were closed. She and her subject drank and
talked into the night. An instant, long since dissolved, was captured;
it depicts a moment of recognition and connection. "I know my work
might seem quite dark, but it's more about finding love and closeness."
In Resnik's hands, photography becomes a means to break through the
glass that divides us: a way to seek out and establish human contact.

1–4 From "One Another," Berlin, Germany, 2008–present

BERLIN

BORN 1941, Lichfield, UK **LIVES** Cape Town, South Africa **STUDIED** Art Students League of New York; Michaelis School of Fine Arts, Cape Town **OTHER CITIES WORKED** Johannesburg, Havana, Harare, Bern, London, New York, Istanbul

SUE WILLIAMSON

A group of Berliners stand on the steps of the Reichstag holding up letters that spell the words: "It's a bit . . . if you have . . ." The title of the piece fills in the gaps: *It's a Bit Suspicious if You Have Too Much Money*. According to Sue Williamson, who orchestrated this performance in 2010, the security police stepped in. She recalls: "They forbade us to continue as planned on the grounds that this action would be 'against the dignity of the Reichstag.' . . . Participants could only stand there, miming the action of holding up the letters." The image is part of the ongoing series "Other Voices, Other Cities" (2009–present) in which Williamson visits world capitals, asks their inhabitants what it means to live there, and distills their responses into one sentence. This

becomes the basis for her fleeting sculptural statements. In Berlin, she was told that people prefer to avoid ostentatious behavior in favor of anti-riche, uber-cool understatement; thus the Berlin title. As to the police interference, Williamson adds, "I liked it even better than if we had been allowed to hold up the letters."

Although born in England, Williamson has lived in South Africa since she was seven. She shot to prominence when the country was in the grip of apartheid with the series "A Few South Africans" (1983–87), which celebrated the unsung women who were active in the struggle for freedom. Since then, she has used film, found objects, and photography to create work that speaks on behalf of marginalized people. "I am an artist first, but I am interested in the way art can change and influence things," she states. The idea for "Other Voices, Other Cities" began in 2009 when she participated in the 10th Havana Biennale in Cuba. She was showing "What About El Max?" (2004–05), a series taken in the fishing village of El Max in Alexandria, Egypt, and was asked if she could do something similar with the Cuban village of Cojimar. In El Max she had been struck by the fact that the locals kept

1 *It's a Bit Suspicious if You Have Too Much Money*, Berlin, Germany, 2010. Pigment inks on archival paper. Photographer: Abrie Fourie

asking what she thought of their home. She knew that a nearby military base and petrochemical company wanted to move the community inland and she came up with the idea of giving the villagers the chance to have their voices heard. She asked them to paint their thoughts on their homes; she inscribed the English translation next to them and then photographed the statements. She says, "The one that reads 'We are like fish. We cannot live away from the sea' can be read from cars driving past on the main highway from Alexandria." Yet her images have since carried the messages much farther afield, globally.

Photographs are renowned for rendering their subjects mute. Frustrated with this, Williamson has turned to text in her art to turn up the volume control. El Max was not the first time she empowered people to speak through her photographs; "From the Inside" (2000–02) gave voice to HIV-positive people. A former crack cocaine user, Benjamin Borrageiro, painted on the underside of the Buitenkant Street flyover in Gardens, Cape Town: "I'm sick and tired of Mbeki saying HIV doesn't cause AIDS." The sign was soon defaced and the name of South Africa's AIDS-sceptic president Thabo Mbeki was

covered up. Consequently, unlike El Max, the statement now only exists as a photograph. Similarly, the Berliners' thought and the performance that realized it, only lasted for the moment that it was immortalized through Williamson's vision.

The Cojimar project never materialized; instead the concept for "Other Voices, Other Cities" was born. In each city the artist arranges people holding up letters, takes multiple photographs and then stitches together the panoramas, which is why they appear disjointed and the participants recur. During the performance, her attention is focused on directing each person to be in the right place, so she enlists a photographer to trip the shutter (in Berlin this was Abrie Fourie). She has since traveled the world searching out new voices in new cities. In Johannesburg they ask "Who is Johannes?" (see p.244) while New Yorkers wonder "I mean where else are you gonna go?" and Londoners state "You're free once you know the rules." "It is essentially also about creating a dialogue between cities," adds Williamson. The messages from each city are local, but they have a universal resonance. They add to the global conversation in our increasingly global world.

BERLIN
BY VERA LUTTER

1 *Holzmarktstrasse, Berlin, III: August 26, 2003.*
Unique silver gelatin print. 87 x 224 in.

My photograph of Berlin shows the River Spree and a central
power station on the opposite shore. Taken from Max Hetzler's
former gallery location on Holzmarktstrasse, the photograph
connects a cultural site and a site of industry, both of which
have served to fuel the city's rebirth.

DÜSSELDORF
BORN 1958, Zell am Harmersbach, Germany LIVES New York, USA
STUDIED Kunstakademie Düsseldorf, Germany SERIES "Night Pictures,"
1992–96 OTHER GENRES Fine art, portraits

THOMAS RUFF

These hazy, indistinct photographs were captured on the streets of Düsseldorf at night. The various hues of green are created through the use of a highly specialized technology that was invented by the military: a camera designed to boost low light levels to such a degree to grant vision in near pitch blackness. We are now familiar with the aesthetic of night vision cameras from watching news footage broadcast out of war zones and crime movies. However, in 1992, when work on this series began, the technology was only just becoming mainstream. The Gulf War (1990–91) remained fresh in people's minds and as the first conflict to be televised so comprehensively it had brought the spectacle of war directly into living rooms all around the world. The German contemporary artist Thomas Ruff recalls being both fascinated and offended by the imagery: "Technically fascinated with the visual appearance of what they showed and emotionally offended by what it means to view a war happening someplace else, broadcast in real time." For the series "Night Pictures" he decided to turn the camera on his hometown, designating Düsseldorf as the new theater of war.

Ruff is one of contemporary photography's leading practitioners: he belongs to the renowned Düsseldorf School together with Andreas Gursky and Thomas Struth; of the three he has perhaps the most diverse practice. He has always treated photography with scepticism and his work has systematically scrutinized the range of ways in which it is encountered within culture. He has used consecutive series to explore a variety of genres; he looked at portraiture in "Portraits" (1981–85), newspaper snapshots in "Newspaper Photographs" (1981–91), architectural photography in "Houses" (1987–91), astronomy in "Stars" (1989–92), nocturnal military surveillance in "Night Pictures,"and pornography in "Nudes" (1999–present). He likens himself to "a scientist carrying out a series of experiments" in a relentless interrogation in which he tests the limits of the photographic medium. "My predecessors . . . believed to have captured reality [whereas] I believe to have created a picture." He continues, "My images are not images of reality but show a kind of second reality, the image of the image."

Ruff views the photographic surface as a veneer that serves to trick the viewer with its illusion of extreme realism. He uses his various series of photographs to foreground this surface in different ways. With his first acclaimed series, "Portraits," he made enormous

and hyper-real pictures of people that drew viewers to the detail in the images. The face is lost in the minutiae; the image appears more like a topographical survey than a portrait. By contrast, for his series "jpgs," by downloading images off the internet and enlarging them to such monumental sizes in order to emphasize their pixelation, he exposed the building blocks that make up these pictures. In "Night Pictures" he reveals how even the most mundane, the sleepiest of suburban scenes can metamorphose through the lens of a military surveillance camera into what Ruff calls potential crime scenes. He warns, "The illiterate of the future is not the person who cannot read, but the person who cannot read photographs."

1 *Nacht 20 I*, Düsseldorf, Germany, 1995. C-print
2 *Nacht 11 II*, Düsseldorf, Germany, 1992. C-print

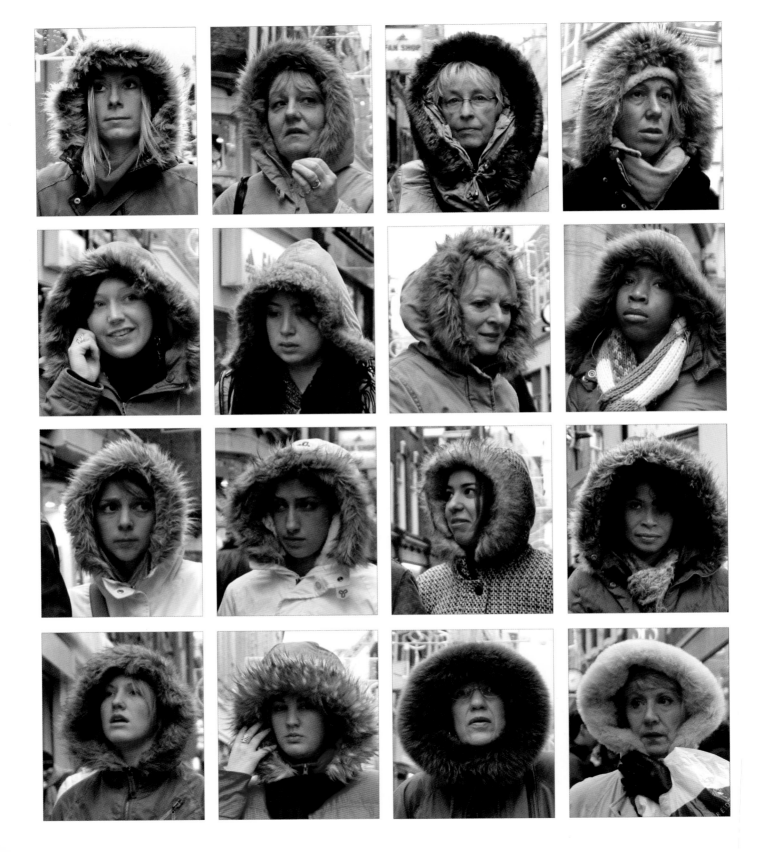

AMSTERDAM

BORN 1949, The Netherlands LIVES Amsterdam, The Netherlands STUDIED
Academy for Visual Arts, Den Bosch; Arnhem Academy for Visual Arts; Ateliers '63,
Haarlem OTHER CITIES WORKED New York, Shanghai, Paris

HANS EIJKELBOOM

On November 8, 1992, the Dutch artist Hans Eijkelboom started what
would turn out to be the most ambitious project of his career. Around
the same time practically every day of the week, for twelve months
of the year, he would head out onto the streets of whatever city he
was in: most often Amsterdam, his home since 2003. Armed with a
camera, he would daily bring home between one and eighty images,
and over the years he amassed an archive of many tens of thousands.
The aim was to materially visualize the development of his world
view. He states; it "is a slow and continuing process: drop by drop,
through daily repeated experiences and observations it shapes itself
like stalagmites and stalactites in a cave . . . I can only guard my eyes,
the entrance gate, and fixate with my camera a few images that
enter this gate." He took his last photograph of the series on
November 8, 2007. The epic endeavor—which he simply titled
"Photo Notes" (1992–2007)—had lasted precisely a decade and a half.

 In contrast to classical street photographers, Eijkelboom adheres
to a strict methodology that has been likened to scientific data
collection. Art historian Frits Gierstberg draws parallels with
sociology, whereas photographer Martin Parr (see p.384) writes,
"Anthropologists often make use of photography in their research,
especially when gathering information about a society's strange and
fascinating habits. If I were an anthropologist, the first photographer
I would call upon is Eijkelboom." To create "Photo Notes," Eijkelboom
would return again and again to the same territory; in Amsterdam,
his favorite haunt became the busy shopping street of Kalverstraat.
He would dress so as not to attract attention and hiding his camera
against his chest, he did not even need to lift it to his eye to look
through the viewfinder; image capture was automatic, mechanistic.
Consequently, people rarely noticed him or that they were being
photographed. He would wait patiently and observe the crowd. Slowly,
a particular behavior would draw his attention and he would set
about recording it: women clutching the same handbag, men wearing
diamond-checkered sweaters, women wearing fur-lined parka hoods
(see image 1), or men wearing Che Guevara T-shirts (see image 2).

 Like a scientist amassing specimens, Eijkelboom positions all his
subjects in the same way: central and similarly sized within the frame.

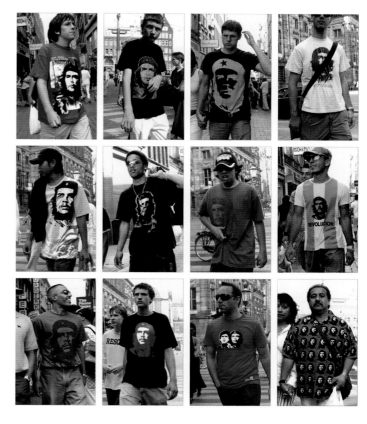

| 1 | | 2 | |

1 *Photo Note, December 31, 2004*, Amsterdam,
The Netherlands, 2005
2 *Photo Note, September 7, 2005*, Amsterdam,
The Netherlands, 2005

He titles each "Photo Note" with the date of collection; he then
arranges and presents these individual photographs in a grid. People
appear like pinned exotic butterflies. This repetitive, serial approach
calls to mind the objective aesthetic of the early twentieth-century
German photographer August Sander. His almost life-long yet
unfinished project "Menschen des 20. Jahrhunderts" (People of the
Twentieth Century) was to create a collective portrait of the German
people in which they were classified according to profession and social
position, and has since been interpreted as creating typologies. His
late twentieth-century successors Bernd and Hilla Becher (also from
Germany) cultivated a similar systematic photographic approach in
order to create typologies of industrial, utility, civic, and vernacular

3 *Photo Note, June 28, 2007*, Amsterdam,
The Netherlands, 2007
4 *Photo Note, September 19, 2002*, Amsterdam,
The Netherlands, 2002

architecture. Eijkelboom's practice and presentation similarly read as typologies; the grid format encourages the viewer to compare and contrast subjects, searching for the similarities and differences between them.

Eijkelboom's approach is rooted in conceptualism. In 1971, at the age od twenty-two, he was the youngest participant in the landmark Dutch exhibition "Sonsbeek 71: Sonsbeek buiten de parken." He was showcased alongside renowned names from the Conceptual art movement, such as Sol LeWitt, Joseph Beuys, Dan Graham, Douglas Huebler, Robert Smithson, and Ed Ruscha. His preference for creating small, inexpensive, often privately published books has also often drawn comparisons with Ed Ruscha. Furthermore, his various bodies of work are almost always underpinned with simple conceptual systems. For his early series "Identity" (1976) he made contact with ten people he knew as a teenager and asked them to predict his career; he then photographed himself dressed as these predictions, which

included a banker, a pilot, an electrician, and a gamekeeper. For "96 alternatives" (1978) he asked ninety-six people to dress him up, whereas for "People wearing my clothes" (1973) he did the dressing. All these series share an interest in issues of identity; they each investigate what clothing says about who we are, how we choose to present ourselves, and how we in turn perceive others.

"Photo Notes" continues Eijkelboom's interrogation of identity, but broadens his scope dramatically by situating the individual within an ever more globalized and urban society. Indeed, he photographed other cities beyond Amsterdam, and as the project drew to a close he published *Paris—New York—Shanghai* (2007). Readers are not only offered a comparative study of individuals within their own city, but between major contemporary megalopolises. The resounding message delivered by "Photo Notes" is the uniformity of our so-called individuality. "Identity seems to be a malleable concept," Eijkelboom explains. "This is becoming even clearer due to globalization. For instance, in every metropolis there suddenly appears to be a crying need for Louis Vuitton handbags. And the young couples featured come from different countries and although they perceive themselves as being very independent, they actually look very much alike." It would seem that every one of us, every individual, belongs to a group, or as curator Marcel Feil observes, "a market segment, for which products are specially devised and made." "Photo Notes" certainly comments on the forces at work within a global market, but it also reflects on deeper truths about human nature and fantasies of free will.

In his highly acclaimed book *The Selfish Gene* (1976), Richard Dawkins expounded on a hypothesis, developed by the evolutionary biologist William Hamilton, called "The Green Beard Effect." Dawkins wrote, "It is theoretically possible that a gene could arise which conferred an externally visible 'label,' say a pale skin, or a green beard, or anything conspicuous, and also a tendency to be specially nice to bearers of that conspicuous label." The Green Beard Effect is a way in which a would-be selectively altruistic gene can recognize copies of itself in other people, and thereby look after its own interests by preferentially treating those people. When asked "Could that mechanism later be programmed to say 'be good to someone who wears the same baseball cap, the same rugby colors, or whatever?'" Dawkins answered "I think that's possible." In other words, there are possibly forces at work within us that work in opposition to endless choice and freewill, and instead persuade us toward conformity and uniformity: as Hans Eijkelboom's visionary "Photo Notes" so eloquently reveal.

ROTTERDAM

BORN 1966, Rotterdam, The Netherlands **LIVES** Rotterdam **SERIES** "Rotterdam,"
1997–2009; "Why Not," 2009; "Fun!," 2001; "Europe," 2007–present **OTHER CITIES
WORKED** Copenhagen, Amsterdam, Athens, Reykjavik, Oslo

1 *Schouwburgplein*, Rotterdam, The Netherlands, 2001
2 *Eendrachtsplein*, Rotterdam, The Netherlands, 2001
3 *Kruisplein*, Rotterdam, The Netherlands, 2008
4 *Hoogstraat*, Rotterdam, The Netherlands, 2000

OTTO SNOEK

Take time to consider any image shown here by the Dutch artist
Otto Snoek. The arrangement of people and objects at first appears
awkward and angular; his compositions have previously been
described by critics as untidy, even bordering on incoherent. Frits
Gierstberg, curator of the Nederlands Fotomuseum also notes how
his "harsh colors create a sense of unrest." This unease is compounded
by the fact that the frame might be dense with detail but it seems to
lack a central focus. One's eye looks to the edges to get a visual hold
on the picture but in vain. In image 3 the main subject might be the
man with "Rotterdam" inscribed across his stomach, yet why is he
faceless? The words of French philosopher Jean-Luc Nancy and his
experience of the city have been applied to Snoek's work: "The city
does not have a face, but it has features. It does not have a gaze but
it has a way of being in your face. The city cannot be understood as
one identity." This quote has particular resonance with the confusing,
anonymity of many of Snoek's photographs.

The pictures come from various series that Snoek has made in
and around his hometown of Rotterdam. Viewed en masse, one soon
realizes that complicated and jarring urban compositions are Snoek's
signature style. Indeed, the Rotterdam imagery combines to

overwhelm and unnerve the viewer. Photographer Aline Smithson
muses, "He makes one wonder, is everyone medicated in this urban
world? Do we all need something extra to survive the chaos and
confusion?" Meanwhile, curator Sophie Howarth detects a more
threatening atmosphere and observes how in his "agitated,
boisterous pictures" that "aggression is never far from the surface."
Snoek's interest in "the street" stems from the notion that it is a
microcosm of society. The urban obscurity expressed by Nancy,
the near hallucinatory complexity hinted at by Smithson and
the undercurrents of violence detected by Howarth are all fitting
interpretations. Seen through Snoek's lens, Rotterdam simmers,
splinters, and shatters into a multifaceted city.

Snoek was born in Rotterdam. He claims his first experience
of street photography was when he was fifteen. "I actually didn't
have a camera with me at the time, but I would spend hours and
days exploring my town on public transport," he recalls. The period
was formative, he learned to look, but he did not actually start
photographically documenting what he saw for another twenty
years, not until he started to witness Rotterdam undergoing a radical
transformation. Over a relatively rapid time, he saw his beloved,
working-class, harbor town turn into one of the world's largest ports
and Holland's second largest city: an international commercial capital
that has since earned the moniker "Gateway to Europe." Snoek
describes his experience: "Fifteen years ago, floods of new immigrant
faces arrived, creating big changes in a town that was already in the
process of endless reconstruction. This altered the whole atmosphere.
I had become a stranger in my own hometown." At that moment,

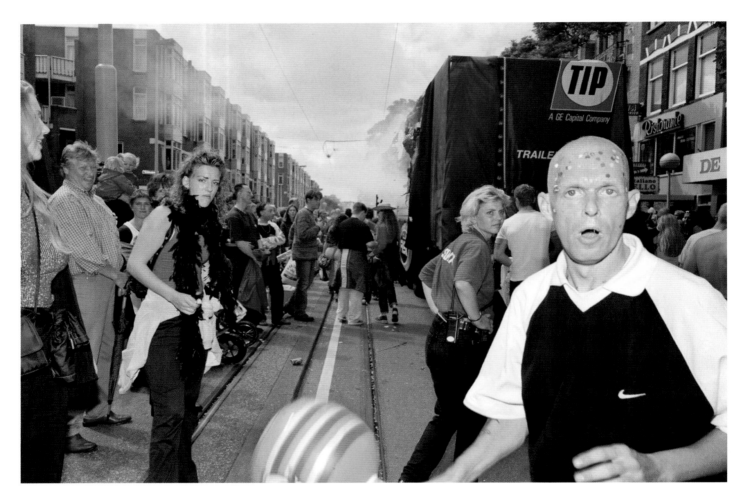

Snoek picked up his camera, concluding, "This new Rotterdam demanded a new photographic approach."

Ever since he has adhered to a tried and tested methodology. He always uses the same medium-format camera (a Fuji 690 GSW) and a flashgun. He walks the streets with this bulky gear, taking his pictures quickly and instinctively. He often positions himself at the center of a crowd to get a frontal, up-close view. People have no time to prepare or pose themselves; they only become aware after the flash has exploded, the shutter has clicked and their expressions have been exposed for posterity in the camera. "Occasionally I face verbal aggression," he admits, "but it seldom results in physical violence." Yet this tension translates itself onto the film. Snoek describes his

enterprise as a "city safari" and the people whom he captures actually resemble strange, somewhat startled creatures.

Snoek has been described as a traditional street photographer and critics have likened him to well-known masters of the genre, from Joel Meyerowitz (see p.18) to Joel Sternfeld (see p.382). Gierstberg also classifies him under the heading of 'slow journalism' because he has been working on the same project for a number of years. Snoek has also been working on another series that takes him beyond Rotterdam's confines. For the project "Millionaire" (2006–09), he traveled to five different European countries to photograph their increasingly popular millionaire conferences and to document their lavish yet grotesque excess. British photographer and curator, Aaron

5 *Nieuwe Binnenweg*, Rotterdam, The Netherlands, 2001
6 *De Kuip*, Rotterdam, The Netherlands, 2000

Schuman, finds echoes in this series with the work of photojournalist Erich Salomon. He explains how throughout the 1920s and 1930s, Salomon infiltrated international conferences and society events, and was one of the first to take candid images revealing "the rich and the powerful caught off-guard." However, as Schuman also realizes, there remains an overriding difference between the two approaches: Salomon presents his subjects in a flattering light.

Perhaps a more suitable comparison can be made with the contemporary British photographer Martin Parr (see p.384). There are resonances between Snoek's "Millionaire" series and Parr's series "Luxury" (2003–08), which also featured millionaire events in places such as Moscow and Dubai. Parr is renowned for his acerbic tone

and critics have deemed Snoek's approach "razor sharp and merciless," as well as bitter, barbed, and angry. However, the two photographers display a radically different aesthetic and moreover a very different focus. Snoek's target is what Gierstberg calls the "relationships between democracy and the sensationalist society." Howarth observes, "Women in hijab jostle in his frames with rave generation hedonists, grumpy senior citizens, and the finest European suntans and fake breasts"; the variety revels in "visual dissonance and culture clashes." He uses clever juxtapositions to contrast and thereby heighten the sense of the city as circus, a grotesquery, a freak show. Ultimately, Snoek's work provides a stinging social commentary at the expense of Rotterdam and its inhabitants.

COPENHAGEN

BORN 1972, Denmark LIVES Copenhagen, Denmark STUDIED Fatamorgana,
Danish School of Art Photography, Copenhagen SERIES "Now That You Are Mine,"
1997–2000; "Strude," 2007–10; "Interior," 2007–10 OTHER GENRES Landscape

1	2		5	6
3	4			

1–6 From "Now That You Are Mine," Copenhagen,
Denmark, 1997–2000

TRINE SØNDERGAARD

Skelbaekgade, Copenhagen: this small and unexceptional street
not far from the central railroad station in the neighborhood of
Vesterbro has become the capital's red-light district: the hub of street
prostitution. Daily, as early as the afternoon, women start gathering
on the pavements, waiting for customers opposite Kødbyen (which
aptly translates as "The Meat City," the meat-processing quarter).
Sometimes the transaction takes place in the client's car, at other
times, as writer and art critic Anthony Georgieff observes, they "take
their business up into some miniscule, dilapidated flat where beds are
covered with hand towels and the walls are so thin you can picture
what's going on in the next room by just listening." The women sell
their flesh for money to buy their next fix: a sniff of cocaine, a shot
of heroin, whatever it takes to keep them trapped in the seemingly
inescapable and vicious circle.

In 1997 Danish artist Trine Søndergaard lived in Skelbaekgade, in
a flat above a group of prostitutes. She had recently graduated from
Fatamorgana, the Danish School of Art Photography, and had enrolled
on a workshop led by renowned photographer Anders Petersen. He set
his students a challenge of creating a body of work that involved going
out to "take pictures of one's fears." Every day she would leave her
flat and see the prostitutes at work; as she returned in the evenings,
male customers would approach and harass her; she was continually
mistaken for one of them. "She realized she was not 'seen,'" observes
curator Finn Thrane, and "that she existed only as a projected fantasy
of a woman for the male customer." On the one hand, she was
outraged at being classed alongside these women, yet she also
felt empathy and loyalty toward them. It was at this point that
she knew she had found the subject for her photographic series.

Over the next three years, Søndergaard created a body of work that exposes the male fantasy of street prostitutes by revealing the harsh facts of their world: their needle wounds, their bruised skin and the cubicles in which they spend their days and nights. Her look is at times tender, at times respectful, yet always without remorse. When faced with ugly or heart-breaking realities, she does not turn away; she followed her subjects out on the street corners at dusk, then behind closed doors with paying customers. Søndergaard called the series "Now That You Are Mine." It received wide critical acclaim and was not only published (by Steidl) as her first monograph but also launched her career in the art world.

Søndergaard began her training as a painter. She recalls, "When I started out, I wanted to be a 'real artist.' One of those who had studied at the Academy of Fine Arts and who made real paintings." Yet, she was soon drawn to photography and began to understand that she could in essence create paintings with a camera. Much of her work from the outset demonstrates a painterly fascination with color and composition. For "Now That You Are Mine" she chose to shoot with a conspicuous flash to draw out various hues and shades from the lengthening shadows, but also to highlight and embolden the color range. Within a short space of time, photography became more important within her practice than painting. She talks about coming to view reality as a buffer, "as something that comes between me and the image," saying, "[I came to] feel that I could make pictures of the world—which were also about me, so that when you looked at them—you couldn't distinguish which was which."

These words resonate with the work that followed on from "Now That You Are Mine." In her recent portraiture series "Strude" she depicts girls wearing a traditional, Danish folk garment, a masklike hood called a "strude." Usually in portraiture, the viewer looks at someone's face to find meaning but the strudes act to block such a reading of Søndergaard's subjects. Moreover, she accentuated this effect by asking the girls to avert their gazes. "I'm interested in what lies beyond the direct gaze, in what happens when we can't look people in the eye," explains Søndergaard. "My focus is the introversion and mental space that lies beyond the image." In another series she was working on at the same time, "Interior", she again plays with the expectation of genre, but this time with landscapes. Turning to an old, abandoned Danish manor house, she photographed the interior landscapes of its derelict and empty rooms. Usually one might turn to props, furniture, or fabric to construe meaning, but these rooms were long ago stripped bare and all that remains is the shell. Once again, therefore, the viewer is prompted to go beyond what is seen. Like "Strude," and indeed like much of Søndergaard's work, "Interior" explores inner states of mind.

At first reading, "Now That You Are Mine" seems a direct contrast to her later work. It falls squarely within the realm of documentary photography. Yet despite this, Søndergaard feels omnipresent; the work feels highly subjective, more like a personal journey. She admits there was a crossover between her and the prostitutes, "I lived right in their neighborhood and we were the same age and so a lot of things overlapped." Furthermore, she had also been approached by some of their customers. One wonders at what point did she begin to ask questions such as what if I were to fall on hard times, what makes me different from these women? Thrane notes, "Søndergaard's work embodies and explores the dualities of her own role as an artist, but also as a woman." However, Georgieff takes this a step further and directly implicates her within the imagery, "After having asked the usual questions of . . . where would I find pride in my life if I were to fall out in Skelbaekgade, Søndergaard found out about some less empirical aspects of life in the street. The excitement. The exotic . . . You can see and feel for yourself the presence of a peculiar love triangle where the hypotenuse is the girl with the camera."

1 *Children Playing in Cihangir*, Istanbul, Turkey, 2004 2 *Outside the Blue Mosque during Ramadan*, Istanbul, Turkey, 2001 3 *Along the Bosporus*, Istanbul, Turkey, 2005 4 *Below the Blue Mosque near the Southern Entrance of the Bosporus*, Istanbul, Turkey, 2004

ISTANBUL

BORN 1952, San Francisco, USA LIVES New York, USA STUDIED Harvard
University and Carpenter Center for the Visual Arts, Cambridge, Massachusetts
OTHER GENRES Photojournalism OTHER CITIES WORKED New York, Mexico City

ALEX WEBB

Writer Geoff Dyer gave an insightful description of U.S. photographer
Alex Webb when he said: "Webb is addicted to testing the limit of the
load-bearing ability of his pictures." Webb himself explains, "It's not
just that that and that exists. It's that that, that, that, and that all exist
in the same frame. I'm always looking for something more. You take
in too much; perhaps it becomes total chaos. I'm always playing along
that line: adding something more, yet keeping it short of chaos." His
photographs are so complex and intricate that they led the Indian
photographer who was once taught by Webb, Dayanita Singh, to
refer to them as "migraine photographs." They require undivided
attention and deep concentration to unpick and unravel. Yet still

they resist simple understanding and trade instead in ambiguity
and mystery: to paraphrase Dyer, they are complicated pictures
about complicated places.

Istanbul fascinated Webb from the moment he arrived. He first
traveled there in 1998 on assignment. "I was intrigued," he recalls.
"This place that lies between Europe and Asia, the apparent
contradictions of a culture that is secular and Islamic, quite unique in
the world: a place with a deep sense of history and layer upon layer of
various empires." He did what he always does in new cities; he began
his walkabouts. His way of working is almost ritualistic. He rises early,
spends hours wandering the streets, watching people, getting the
measure of a place and then as the light brightens, he retires to his
hotel to rest and to eat. Then when the shadows deepen and the light
wanes, he returns with a plan and his camera. He describes himself as
a street photographer as opposed to a documentary photographer or

a photojournalist. "It's about wandering: wandering and wandering and re-wandering, and returning to places, and absorbing and just experiencing," he says. "For me, everything comes first and foremost from the street."

Webb was born into an artistic family in San Francisco. His mother is a sculptor and his father was a writer. "I actually learned photographic technique, at least black and white technique, when I was in fourth grade, from my father," he says. "When he was struggling with writer's block he did some photography." While he was growing up, two photographic books in particular influenced him: Henri Cartier-Bresson's *The Decisive Moment* (1952) and Robert Frank's *The Americans* (1958). However, he also cites other street photographers that have helped shape his maturing eye: from André Kertész, William Klein, and Garry Winogrand to Lee Friedlander. Webb, like each of these artistic forebears, uses the camera to offer a highly interpretative view of the

world. He says, "There is always a certain kind of tension that exists between the way I see, and what exists in front of me." His work presents a very specific view of the world: one that is recognizably his.

Echoes of these past masters do indeed exist within Webb's practice. Images such as *View from a Barbershop near Taksim Square* (see image 5) resonate with Friedlander's playful approach to the picture plane. Like Friedlander, Webb fractures the image with architectural frames and obstructs some views while multiplying others by presenting pictures within pictures and reflections within reflections. The various shards, splinters, and slices vie for attention: producing parallel pictorial universes. The words John Szarkowski, the famous photography curator of the Museum of Modern Art, used to describe Friedlander's work can be aptly applied to Webb's: "It would of course be possible to draw a diagram, with lines and arrows and shaded planes, to explain crudely what the picture itself explains

5 *View from a Barbershop near Taksim Square,* Istanbul, Turkey, 2001
6 *Street Scene in Ayvansary,* Istanbul, Turkey, 2001

precisely. But what conceivable purpose would this barbarism serve?" Similarly, Szarkowski's successor Peter Galassi said of Friedlander's pictures, "The viewer struggles to resolve the image. After all, it is only a photograph, and it ought to settle down, let us step back and have a look at things"; such words touch upon how one feels encountering Webb's *View from a Barbershop near Taksim Square.* However, a key difference between Friedlander (indeed with each of his photographic heroes) and Webb exists, a further and fundamental complication; whereas the past masters framed the world in the simpler, reduced palette of black and white, Webb captures it in its full, bewildering and confusing array of color.

"When I started working in photography I thought color was crass, commercial," Webb recalls. Art historians now generally agree that color photography did not gain institutional acceptance until 1976 with William Eggleston's landmark show at the Museum of Modern

Art (MoMA). Around this time, Webb talks of reaching a kind of dead end in his practice. He had been photographing the social landscape around New York and New England, using black and white, and he recalls, "I seemed to be exploring territory that other photographers had already discovered." However, a trip to Haiti offered welcome inspiration. "Searing light and intense color seemed somehow embedded in the cultures . . . so utterly different than the gray-brown reticence of my New England background." So he made a radical decision and in 1979, a mere three years after Eggleston's MoMA watershed, he decided to discard black and white forever, and to work exclusively in color. When asked to analyze what was behind this decision, and how it literally and metaphorically colors his work, he concludes, "Seeking out visual complexity may be tied to a belief in moral and political complexity. And color isn't just color. Color is emotion and psychology as well."

1–3 From "site specific_Istanbul 11,"
Istanbul, Turkey, 2011

ISTANBUL
BORN 1954, Carpi, Emilia-Romagna, Italy LIVES Modena, Italy STUDIED University of Bologna, Italy SERIES "site specific," 2003–13 OTHER CITIES WORKED Rome, Modena, Shanghai, Las Vegas, Milan, São Paulo, Tel Aviv, Los Angeles, Chicago

OLIVO BARBIERI

Istanbul is not only the largest city in Turkey—with a population of 13.9 million that is sprawled over 2,063 square miles—it is also the largest in Europe and one of the largest in the world. Moreover, it is rapidly expanding. The architectural historian Kenneth Frampton suggests that the modern city is currently undergoing an evolutionary transition from the age of the metropolis to that of the "megaform." As curator Christopher Phillips says, "This is Frampton's term for the city type produced by the contemporary urban explosion set off by the unleashed social forces and vast accumulations of capital in Asia, Latin America, and the Middle East, which have sent waves of newly built structures sweeping over entire regional landscapes." Istanbul is one such emerging megaform. Olivo Barbieri went there in 2011 on one of the last stops on a ten-year odyssey that took him to over 40 megacities around the world. The resulting series "site specific" explores the idea of the twenty-first-century city as a site-specific installation: one that is shifting, mutable, and constantly evolving.

Barbieri started the series in 2003, not long after the terrorist attacks on the Twin Towers in New York. "After 9/11 the world had become a bit blurred because things that seemed impossible happened," he recalls. Structures that had seemed fixed and permanent were reduced to dust. At the time, he was working on a series on the Italian highway system and had been photographing the routes around the town of Brescia in Lombardy from the air. He had experienced the power of aerial photography as a child, when he flew above his home town of Carpi: "The first time I flew in a light plane," he says, "I took a twin-lens reflex camera, which I had to turn upside-down to reach the airplane window. There were several black and white photos, and I still remember the amazed reaction of the neighborhood photographer who developed them when he saw the picture of the town square." Barbieri decided to shoot the "site specific" series from a low-flying helicopter and create a bird's-eye view of the planet's emerging cityscape. Yet, the imagery would not be the typical aerial survey; objectivity would be cast aside in favor of highly subjective visions.

From the outset, Barbieri wanted to push photography into uncharted territory. His interest in the medium was as a means to depict inner rather than outer worlds. "I've never been interested in

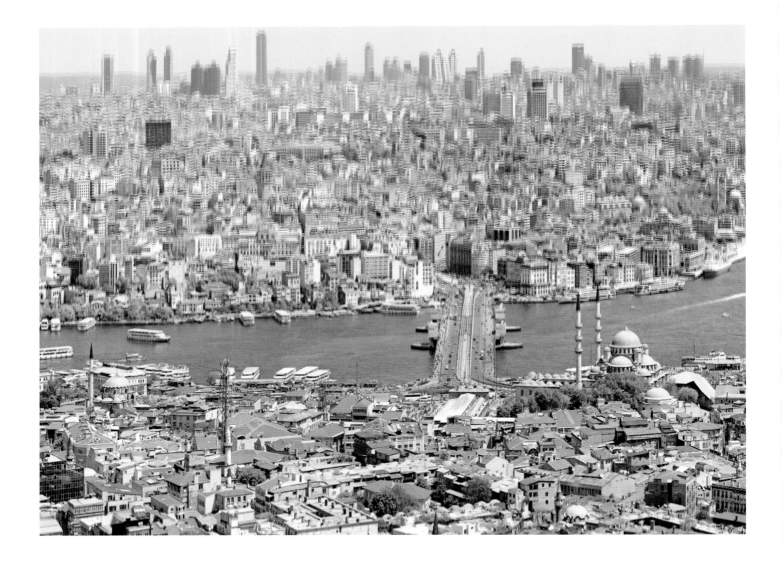

photography," he insists, "but in images. I believe my work starts when photography ends." In the 1970s he met and fell under the influence of renowned Italian photographer Luigi Ghirri, who introduced his new and willing student to esteemed names in the canon of the documentary genre: from Eugène Atget and August Sander to more recent figures, such as William Eggleston and Stephen Shore. Yet this rigorous training in the classical documentary mold failed to entice the budding artist. Barbieri recalls, "From an attempt to describe the world around me as objectively and aseptically as possible, it turned out the results of this approach showed a world which seemed absolutely phantasmagoric and unreal." In 1999 he came across a technique that would take his work in a completely new direction.

Barbieri had been commissioned to create a series on Italian sports stadiums. He decided to experiment with a highly specialized lens usually used by architectural photographers. The tilt-shift lens enables one to adjust perspective, for example, avoiding the distortive effect when towering lines of skyscrapers converge on one another within the camera. Barbieri discovered that it enabled him to separate and selectively focus the various planes of a three-dimensional space as it is compressed into a two-dimensional picture. Whereas previous photographers had used it to delineate precisely the clean surfaces and spatial dynamics of a scene, in Barbieri's hands, it became a tool for condensing space and confusing, or as he says "destroying," perspective. The resulting pictures radically and

 5

4–5 From "site specific_Istanbul 11,"
Istanbul, Turkey, 2011

uncannily skew the focus; some of the soccer players are thrown into sharp relief, others blur against the green canvas of the field. Moreover, by adjusting the exposure to lose the detail, he further transforms the scene. Ultimately, the men are reduced to tiny toy figurines and the stadium appears as a model from a miniature village; Barbieri morphs reality into illusion.

In 2003, Barbieri set about applying his tilt-shift technique to aerial photography and thus began his "site specific" exploration of the urban landscape. Putting the architectural lens on a large-format camera, he would frame city skylines from hundreds of feet above the ground in a helicopter. His first stop was the capital of his native Italy, Rome, then Amman, Jordan, soon followed by the United States

to destinations such as Las Vegas, then Shanghai. In 2007 he stopped using the tilt-shift lens and started digitally manipulating the color, tone, and even the structure of the individual pixels of his images in post-production. This is most notable with the "site specific Istanbul") imagery. The pastel-tinted palette panoramas appear to have been split, staggered then doubled. Landscapes stutter, then shift. The city seems to coexist with a replica on a parallel plane. "All my work is about perception," he says, "It's a deconstruction of the way of seeing." Barbieri has visualized the ideas that enticed him to the city in the first place; the idea that Istanbul is a city existing on the fault line between East and West. A place where two cultures live side-by-side, fused yet fractured.

MOSCOW

Although the face of Moscow has transformed dramatically over the last century, the city's role as the center of Russian artistic culture, and photography in particular, is unchanged. Considering the range of cultural diversity within Moscow's streets in the early 1900s, it is no wonder the city served as a backdrop for the most advantageous of photography-driven avant-garde movements. In the twenty-first century, the city's cultural character remains unparalleled and its vibrant streets continue to fuel groundbreaking photographers.

Leading up to World War I, Moscow was a center of international cultural exchange. As a result of rapidly advancing industrialization, the city attracted progressive artists and patrons from Western Europe, most notably, Paris. This free exchange of ideas provided an ideal foundation on which to build a revolutionary photographic ideology. Rapid urban expansion dominated the streets, and Russian photographers utilized the opportunity to document the construction of buildings and modern architecture. The desire to capture Moscow's future potential directly influenced the proceeding generation of avant-garde photographers.

Moscow became the capital of Russia in March 1918 after the Russian Revolution of 1917. The city soon became the center of cultural and political progress. Nowhere in Europe was the utopian spirit of the 1920s as vividly explored and expressed as in Moscow. Artistic schools such as Vkhutemas (Higher Artistic and Technical Workshops) produced students of Constructivism, while photography became the revolutionary medium of choice. In the aftermath of the revolution, art—and photography in particular—was considered capable of educating the masses about the Soviet state. Photographers in Moscow, motivated by the political environment, were responsible for teaching Russians to see their world anew through the only medium capable of documenting reality.

Based in Moscow, photographer Alexander Rodchenko accomplished this most successfully in the 1920s. Rodchenko and his contemporaries influenced the population to see in a revolutionary light by using radical angles in their street photography. His earliest example of this method is the series "Building on Miasnitskaia Street" (1925) , in which he depicts his apartment building in Moscow. The image *Balconies* (see image 1) showcases his approach of shooting from the ground up, while *Assembling for a Demonstration* (1928–30) contains his iconic diagonal lines and top-down views. These details of daily life in Moscow proved an ideal subject for the photographers who called the city home. As the epicenter of Soviet advancement, the streets of Moscow were a deeply familiar vision and a representation of the city's unknown, utopian future.

Rodchenko inspired countless photographers in Russia. Notable among them was Ukrainian Boris Ignatovich, who used dramatically

angled perspectives in his work during the late 1920s and early 1930s. Employed as a documentary journalist in Moscow for the state—as many photographers were at the time—Ignatovich photographed power plants, factories, and their workers for inclusion in illustrated publications that would be distributed throughout the West. Images such as *On Construction Site* (1929) use dynamic geometric angles to highlight an idolized construction worker.

At this point in the 1930s, the purpose of the medium for Soviet photographers shifted as promoting the success of the USSR was prioritized. Recognizing photography's ability to reach a mass audience, the state required photographers to illustrate the country's transformation into an industrial, modern power. Photographs were taken in the factories, construction sites, squares, and homes of Joseph Stalin's model communist city, Moscow. The illustrious reproductions in the magazine *USSR in Construction* are prominent examples of the images that dominated these publications that were distributed to an international audience. At the opposite end of the spectrum, the influential photography series "Twenty-Four Hours in the Life of the Filippov Family" (1931) focused on the prosperous life of one particular metalworker in a Moscow factory. These more intimate, relatable images highlight the positive effects of factory life on a particular "utopian" proletarian family. Both projects were instrumental in unveiling the progressive USSR society, via its Muscovite epicenter, to the outside world.

A new Soviet photography emerged in the late 1970s when political ideology began eroding, and expanded greatly in the 1980s when glasnost provided artists with greater freedom of expression. Many photographers took this opportunity to turn inwards to their personal lives, or to use photography for purely artistic purposes. Others chose to document previously forbidden subjects such as poverty, homelessness, and loneliness: the other side of Soviet life. Native Muscovite Alexander Lapin adopted a Henri Cartier-Bresson viewpoint of the "decisive moment" with perfectly constructed compositions. Conversely, Ukrainian photographer Boris Mikhailov (see p.230) moved to Moscow in the early 1980s and has devoted his career to exposing his interpretation of post-Soviet social disintegration, seen notably in his series "Case History" (see image 2).

Each utilizes different avenues to explore contemporary notions of Soviet reality and identity; neither methodology is less significant. They, along with their contemporaries, took advantage of the eruptive Moscow street life in the final years of the Soviet Union and used their newly acquired sense of artistic freedom to redefine the meaning of Russian photographic "truth."

In the twenty-first century, the ever-changing, electrifying city of Moscow provides a rich photographic history from which contemporary artists continue to draw inspiration. **AB**

MOSCOW
BORN 1948, Chernovtsy (now Chernivtsi), Ukraine LIVES Moscow, Russia
SERIES "31 Years," 1976–2006 OTHER GENRES Fine art OTHER CITIES
WORKED Madrid, Chernivtsi

BORIS SAVELEV

"Pictures can be taken wherever there is light," the artist quotes the man who was one of the first to take on the mantle of modernism in photography, Alfred Stieglitz. "I think that is a truism for every creative photographer," he continues. However, Muscovite Boris Savelev takes this notion to new levels. Hailed as one of Russia's most important living photographers, Savelev is a master of light, as well as color and form. His recurring subject is his much cherished home. Although born in the Ukrainian town of Chernovtsy, he moved to the Russian capital in 1966 and has lived there ever since. He observes, "Born and raised in a city myself, I have devoted my work as a photographer to an attempt to understand the nature of a city dweller, who spends his life surrounded by concrete, glass and iron."

He came to photography relatively late. After graduating from Moscow's Aviation Institute with a degree in aeronautics in 1972, he began a career as a rocket engineer. Photography was already becoming a passion, but it remained a pastime. It was not until 1983, when he had reached his mid thirties, that he turned to it as a profession. Arguably, his lucky break came when Thomas Neurath, then managing director of Thames & Hudson publishers, decided to travel to Russia in the wake of perestroika in search of new artists. Neurath met and was impressed by Savelev. Their resulting collaboration launched Savelev into the art world with the publication in 1988 of *Secret City: Photographs from the USSR*.

Since then, Savelev has almost solely concentrated on color photography and he moved to digital in 1995. He argues, "The photographer's work is with his camera." Well versed in camera technology, Savelev has relied on an array of cameras and lenses throughout his career. He adds, "I avoid wide-angle lenses, for their use seems to me to place method above meaning and so to lose the essential charm of a photograph." He relies on shadows and tends to shoot through layers: a foggy atmosphere, a cracked window, gauze curtains, or a wire mesh. He uses the reflections he spies in the polished and glassy surfaces of the city to add new facets to his imagery. He fragments and divides up the pictorial space with telephone pylons, signage poles, or window frames. He looks for frames within his picture frame—an open doorway or a window.

1 *Pravda Frost*, 1989 2 *Izmailovo*, 1988 3 *Taganka 003*, 1996 4 *Samotioka*, 2003 5 *Suckarevka*, 2008 6 *Cafe Ion*, 2009 7 *Taganka 002*, 2006

As art historian Ian Jeffrey notes, "In his more complicated vein, a view through a vehicle window, itself a moving frame, might be interrupted by a rear-view mirror holding a miniature of elsewhere all set alongside a windshield wiper, itself a sign of a provisional transparency." Savelev delights in adding new and unnoticed dimensions to the world he encounters as he walks his city. He concludes: "Everything depends on light, that great magician which in a second can transform the trivial into the extraordinary." Ultimately, his lens skillfully metamorphoses those fleeting, often overlooked moments of everyday Moscow into works of thought-provoking beauty.

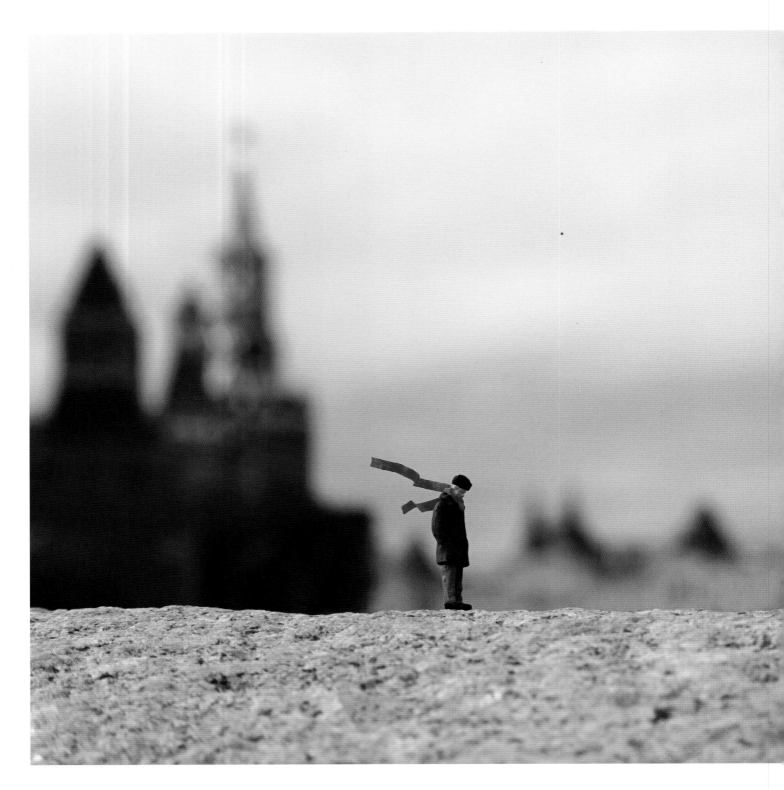

MOSCOW
BY SLINKACHU

I loved the contrast of architectural styles in Moscow, from Russian
Revivalist to Stalinist to modern. All seem designed to be imposing,
shrinking down the city inhabitants in a way that a city boasting
taller structures, such as New York, still doesn't quite manage to
do. This isn't just a physical shrinking, but a psychological one. The
inhabitants seem remote and lonely on the wide streets, as if they are
all just visiting for a day and don't really belong. I tried to capture this
in my installations and also in other photos I took while I was there.

It's only when you step out of the cold and in to a bar or
restaurant that you see Moscow truly come alive, as if everyone
is relieved to be among relatable scales again.

MELANIE MANCHOT

In the summer of 2004 Melanie Manchot set off for Moscow, taking with her a book of nineteenth-century photographs of Russia that includes classic topographical studies and group portraits of citizens standing in front of different sites. These images were taken to help Russian people appreciate what their enormous country and its inhabitants looked like. Manchot, who often uses photography to challenge ideas about portraiture, employed the same formal devices in staging a series of group portraits in twenty-first-century Russia, only she limited herself to Moscow. With no spoken Russian and the added constraint that, in the name of terrorism prevention, photography and public gatherings in Russia are often prohibited, the series "Groups + Locations (Moscow)" was going to be no easy task.

Once she had chosen her locations, including several notable historic sites around the city, Manchot then had to set about trying to explain her idea to large groups of ordinary Muscovites who happen to be passing by and persuade them to take part in this potentially illegal activity. Manchot's portraiture has often relied on persuading strangers to participate in her work. For each photograph she would set up her large-format camera and work with a small group of assistants to gather potential participants. Then, aware that it might only be a matter of minutes before she was stopped by the authorities, she would quickly approach members of the public, explain what she was doing and persuade them all to stand informally and look at the camera before anyone interrupted the process.

Born in Germany, Manchot has spent much of her time in London, where she studied photography at the Royal College of Art from 1990 to 1992. In her work she explores portraiture as a performative and participatory practice, and regularly sets up situations into which strangers are invited to inadvertently perform, to achieve the results. Her projects often propose constructed events or situations in public spaces and form engaging explorations into our individual and

1 *Pavilion, 2:29 p.m.,*
Moscow, Russia, 2004
2 *Aeroflot, 12:36 p.m.,*
Moscow, Russia, 2004

collective identities, at times comparing the past with the present. She claims, "Making work through photography, film, and video I consider my practice an ongoing investigation into extended notions of portraiture and into the relationship of performativity to representations of subjectivity as mediated by the camera." Indeed, Manchot's work sits on the border between documentary and conceptually driven, staged events.

The transience of the moment that she captures in each of the 12 striking color images in "Groups + Locations (Moscow)" is heightened by the knowledge that at any moment police might, as they sometimes did, turn up and interrupt the proceedings. While the work shares the same formal idea as the nineteenth-century prints upon which the idea is based, in a contemporary context and in a country where photography is still banned in many public spaces, the participation of the passers-by and the resulting pictures develop a political charge.

Throughout the series, the city of Moscow, with its complex political history, provides a powerful and evocative backdrop. Her images include *Manege, 3:15 p.m.* (2004) for which she gathered together one of her largest groups in Manege Square. Most of the figures are casually dressed, some carry shopping bags, while others have decided to put them down as the picture is taken. The work refers to the way in which photography may have been used in the past; it also takes the vernacular of historic group portraiture as a cue for structuring contemporary images that are similarly striking in their intensity. Many of the subjects gaze directly toward the camera in a somewhat disconcerting manner. Other locations include a display of Aeroflot jets and a space rocket, which dwarf the people Manchot places in front of them (see image 2); the garden of Gorky House; while an imposing university building provides the backdrop to *University 4:12 p.m.* (see image 3, p.220) and an exhibition center performs the same role in *Park of Economic Achievement, 1:44 p.m.* (see image 5, p.221).

The relationship of Manchot's images with Russian history lies not only in her choice of locations but also in the composition of the actual photographs, which again is specifically Russian. In both the historical and Manchot's images, there is an intensity in the composition that derives in part from the tension between the individual and the collective. These people stand as individuals, yet are gathered as a spontaneous group; they "share" the moment of the photograph and perform a temporary image of a group. For a country that spread from Eastern Europe through to Central Asia, figures were often positioned in prominent groups in the foreground as part-topographical, part-ethnographic representations of Imperial Russia. In Manchot's pictures as each group stares toward her camera, yet another transient moment is trapped forever as soon as the shutter clicks. The camera becomes an organizing principle that structures the event. The brevity of this spontaneous moment is highlighted by Manchot, who allocates the subtitle of each image a precise time. At first glance,

these are optimistic, expansive images, which provide a stark contrast to the type of images we are used to seeing from Russia. Indeed, the participants look happy to be taking part and seemingly unworried about the potential risks. As one critic said when the series was exhibited in London, "as political statements these photographs are very highly charged. Manchot is delving deep into the complexities of contemporary Russian society. Here her subjects are tasting the forbidden. They are engaging with their own political history as well as their current situation. Manchot's work defiantly links contemporary Russia with its history, engaging with the many waves of turbulence, repression, and anarchy that have affected all Russians." These powerful images demonstrate how contemporary Russia is still inextricably connected to its history. From their poses and expressions, and despite the possibility of being reprimanded for taking part in Manchot's venture, the subjects reveal a combination of confidence and defiance as they struggle to make sense of a troubled past.

MOSCOW

BORN 1960, Kharkov, Ukraine LIVES Moscow, Russia STUDIED Repin Art College,
Kharkov; Polytechnic Academy, Kharkov SERIES "Chapiteau Moscow," 2012
OTHER GENRES Performance, video, sculpture

SERGEY BRATKOV

Modern-day Moscow with all its contradictions provides a wealth of material for artist Sergey Bratkov. His photographs—which need to be considered in both the Soviet and post-Soviet contexts—capture and convey many of his bold ideas and opinions about contemporary urban Russia. Bratkov's brutal and often surreal reportage gives a very chilling, even nihilistic appraisal of post-Soviet society. In a recent body of work "Chapiteau Moscow," Bratkov's startling photographs highlight the inequalities and juxtapositions that exist today in Russia and specifically in his adopted city of Moscow where he has lived since 2000.

Born in 1960, Bratkov graduated from Repin Art College in Kharkov, Ukraine, in 1978. After the collapse of the Soviet Union, Russian and Ukrainian photography reconstructed itself according to the Western tradition. It managed, however, to maintain a unique identity due to its original form and content. This singularity is more than apparent in Bratkov's work. Bratkov is a disciple of one of the best-known contemporary Russian-Ukrainian artists, Boris Mikhailov (see p.230). Mikhailov founded the Kharkov School of Photography and Bratkov has been hailed as one of its most promising representatives. The balance of brutality and tenderness, comedy and tragedy that the photographer displays throughout

1–2 From "Chapiteau Moscow,"
Moscow, Russia, 2012

his body of work is characteristic of the Kharkov school and with it comes a distinctively southern Russian humor.

Bratkov likes to depict people of all ages and from all strata of society, often presenting the individual as a hero (a crude standardization that characterizes National Socialist Art). He achieved instant notoriety with his early series "Kids" (2000), in which aspiring child stars, their faces caked, Lolita-esque, in make-up, posed before his unforgiving lens. His choice of subjects also demonstrates an intense vitality and includes sailors, women serving in the Ukrainian army, hard-nosed Russian businessmen, and rowdy marines out drinking in Moscow's Gorky Park. While his work has matured, it has lost none of its bite as it tackles some of the anomalies of contemporary Russian society. Take, for example, his recent video installation, which earned him first prize at Russia's "Innovation" contemporary art awards; "Balaklavsky Drive"

(2009) depicts a group of vibrant but reckless young men diving into a bay that is known for its pollution by toxic waste.

A recurring theme within his practice is how post-Soviet Russia remains ill at ease with itself. While many remember the noughties for being full of change with fluctuating oil prices, the rise of the oligarchs, and a war in Chechnya, Bratkov's work seems to suggest that as the new millennium progresses post-Soviet Russia appears to be at an ideological standstill lacking in political and economic stability. In "Chapiteau Moscow" he turns to the circus as a metaphor for Moscow society. Unlike a theatrical production with its linear narrative, he opts for the structure of the circus, using a series of random scenes to create a whole rather than a narrative sequence. He describes the street sweepers near his house wearing orange municipal robes and worn out sneakers as they push around assorted

junk in carts: "This looks so comical that the first thing it brings to mind is the circus and its clowns with sad make-up on their faces. . . . Someone's gotten drunk early and now lays on the lawn, like a fallen trapeze artist smashed on the stage."

To present this vision of Moscow as a circus Bratkov uses two independent wall-length images that are paired to present a series of diptychs. An image of a line of riot police, ready for action, is set against a picture of a row of statues of Soviet heroes facing, almost challenging them. This photograph has a three-dimensional feel to it; as Bratkov suggests, "One could say that I want to make painting from the photography. But really I want to do rather a sculpture which has a shape, volume, mass. The sculpture is closer to the photo I think. I shoot really different[ly]. Traditionally photography is emotional, especially amateur shots. But I do not shoot emotionally and my composition is also different. For example, I almost don't use the central focus. In addition the light and shadow are very important for the traditional perception of the photography, but for me it doesn't matter." Another powerful pairing includes a photograph of a large poster of a heroic, idealized looking Russian soldier next to an empty stadium; next to it sits an image of another vast poster positioned next to an empty stadium only this time it features a performer with his face painted like a clown (see image 6). Other surreal combinations in this series, include an image of a man in swimming trunks squeezing the head of an inflatable doll with large breasts, while next to this is an image of a Stalinist skyscraper dwarfed by the ridiculous image beside it (see image 7).

Throughout "Chapiteau Moscow," Bratkov celebrates life but also shows that he has an exceptional talent for expressing serious ideas with easy humor, serving up ridicule with great aplomb. Yet, always the eccentricity of his characters and what they are doing is balanced by the highly organized way in which they are presented. As well as providing a structure the circus also provides a metaphor for Moscow. He says, "Moscow is a city in which risk and magic are incredibly concentrated. Thousands of people come to the Russian capital each year in hope of a miracle. This city is a myth in which you can get fabulously rich, marry a princess, and triumph over the three-headed dragon." If one puts the humor to one side, juxtaposing two contrasting, often unrelated images is genuinely thought-provoking, as one sees each image in the light of the other. Ultimately, Sergey Bratkov's work serves to remind its viewers of the shocking inequalities that exist in modern-day Russia between the rich and the poor.

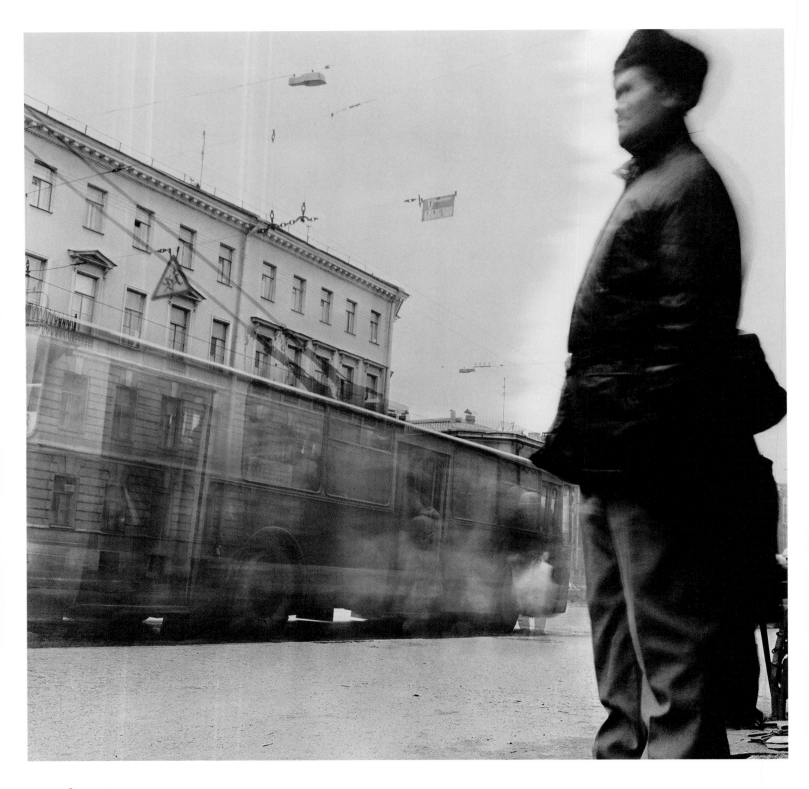

ST. PETERSBURG

BORN 1962, St. Petersburg, Russia **LIVES** New York, USA **STUDIED** Public University of Society-Related Professions, Leningrad; Leningrad Institute of Culture **SERIES** "City of Shadows," 1992–94 **OTHER CITIES WORKED** Venice, Havana, New York

ALEXEY TITARENKO

Born and bred in St. Petersburg, Alexey Titarenko claims "I've devoted my entire life's work to this city." He describes it as "a Russian city built by foreigners" with "more Italian architecture than Rome" and with a museum (the Hermitage) "bigger than the Louvre or the Metropolitan." Yet, he has witnessed his much-cherished home city being brought close to collapse. After the dissolution of the Soviet Union in 1991, he saw the old regime crumble and his fellow citizens suffer under the resulting economic crisis. The situation was so drastic that Germany sent humanitarian aid to avoid famine. He was so affected by the experience that he was inspired to create a deeply haunting body of work. Using St. Petersburg as a prism, he set about depicting "the changes, the catastrophes and the human tragedies that have swept this city and the people of this land." The result was "City of Shadows."

The idea came when he was out strolling around his neighborhood one winter's day at the end of 1991. After Mikhail Gorbachev's resignation the country spiraled further into economic collapse. Titarenko saw how streets that weeks previously had been bustling with people were now almost totally deserted. He recalls, "The depressing and strange quietness was interrupted by the sounds of banging grocery store and bakery doors, stores in which the shelves were absolutely empty." Yet, what affected him more were the few faces that he did encounter: "I could hardly recognize these people, seemingly astray men and women, soberly dressed, their eyes filled with fatigue and despair, breathlessly carrying out the daily sad search for some basic food to make a meal." Everyone seemed so undernourished and worn out that he experienced an overwhelming sensation: "The city had become for me a city of shadows."

Titarenko started photographing St. Petersburg when he was eight years old. His parents gave him an old Kosomolets camera and at his request enrolled him in a photography class. "I liked the class so much that I became its most avid participant. . . . No doubt, my first photographs were quite weak, but this fact did not bother me at all, since it was the process itself that fascinated me." At the age of eleven he read François Arago's announcement on January 7, 1839 declaring the invention of the daguerreotype. He became intrigued by Louis-Jacques-Mandé Daguerre's early depictions of street scenes. The

1 *Untitled (Man at Tram Stop)*, St. Petersburg, Russia, 1992
2 *Untitled (Crowd 2)*, St. Petersburg, Russia, 1993
3 *Untitled (Crowd 1)*, St. Petersburg, Russia, 1992

pioneering technology required long exposures, sometimes as much as sixty minutes, before light would imprint itself on the photosensitive surface. Consequently, most activity hardly registered. In Daguerre's *View of Boulevard du Temple* (1838–39) only one limb of one man was still long enough to indelibly etch itself on the image: "From the crowd, nothing was left in the image, only a leg of the person who put his shoes up to be cleaned!" The rest had blurred into oblivion.

Titarenko drew on these childhood discoveries for "City of Shadows." He set about experimenting with the method that he knew would dissipate form and dissolve reality: the use of long exposures. He set up his large-format, Hasselblad camera on a tripod outside the entrance to Vasileostrovskaya subway station and opened the shutter. He vividly remembers taking his first exposure; it lasted over a minute and he could sense the people around him melting away. He adds, "these people were like shadows from the underworld." When he came to develop the negative in his darkroom, he saw how his camera had visually realized his thoughts. Using tools such as solarization, toning, and bleaching, he eventually created his first successful image. *Untitled (Crowd 2)* (see image 2, p.227) was taken in 1991, although it is labeled 1993. As he had hoped, it rendered his fellow citizens—amid the permanence of the city's beautiful nineteenth-century façades—as fleeting, flickering specters. Occasionally, as with the single limb in Daguerre's image, details remain so still that they retain their coherence in the picture. In *Untitled (Crowd 2)* the occasional hand

rests for just long enough on the metal handrail that it emerges as a touch of solidity from the moving blurred bodies: likewise the pale face that stares out from behind a fog of figures in *Untitled (Boy at the "Black" Market)* (see image 6). Titarenko explains, "He doesn't see me. He looks to you, not to me"; the crowd draws his attention, otherwise he "would just walk away." Titarenko often uses crowds, which he knows will become hazy and translucent, as a screen. He used the same tactic to capture *Untitled (Three Women Selling Cigarettes*, 1992) where the three faces (aware of the illegality of their activity) appear more alert to policemen than the lone cameraman. Time affects the images in other ways. In *Untitled (Man at Tram Stop)* (see image 1, p.226), whereas the waiting pensioner stays still long enough to fix his image, the trolley passes in a smear. As Titarenko observes, "The trolley makes it possible to express the time that has lapsed. It has come to the station and gone on its way again and the man is left standing there."

Photography has long been associated with the instant, much-hailed decisive moment. By contrast Titarenko uses exposures that last as long as three minutes. When Arago announced the daguerreotype, Titarenko argues, he did not praise it as a new technique to duplicate reality, but as "a discovery of the notion of time." He hopes his work acts to remind us "that what we see is relative." Time moves strangely in Titarenko's photography; he creates images that seem atemporal, removed from the flow of time, as if revealing a parallel universe amid the architecture of St. Petersburg.

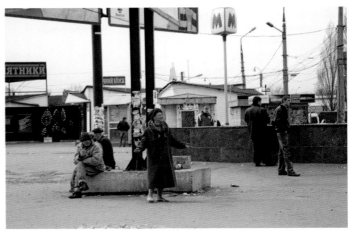

KHARKOV

BORN 1938, Kharkov, Ukraine **LIVES** Berlin, Germany **SERIES** "Tea Coffee Cappuccino," 2000–10 **OTHER GENRES** Conceptual, documentary **OTHER CITIES WORKED** Berlin

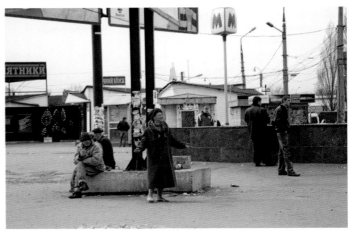

1	2	3	4
		5	

1–5 From 'Tea Coffee Cappuccino', Kharkov, Ukraine, 2000–10

BORIS MIKHAILOV

Boris Mikhailov has been hailed as the most important photographer to emerge from the former Soviet Union. For two and a half decades, he has focused on the Ukrainian city of Kharkov, where he was born and grew up. There he has documented the social collapse, poverty and oppression that transpired after the memorable events of 1991. "I was always a street photographer," he writes. "I always searched the streets for historical symbols of the present times. The streets reflect the social processes like a mirror." His photographs have attracted much controversy and have been equally praised and criticized for their harsh, unrelenting realism. Art critic Lupe Núñez-Fernández describes them as the "most frank documents of the human condition in times of desperation." Yet, as New York's Museum of Modern Art curator Eva Respini points out, they are also deeply personal and reveal "narratives of humor, lust, vulnerability, aging, and death."

"Tea Coffee Cappuccino" is the latest series set in Kharkov and possibly his darkest yet. It paints a bleak picture of this industrial city from the first to the last year of the noughties. Mikhailov declares, "A new age has come—the age of business." Advertising billboards and posters are ubiquitous. People are portrayed holding shopping

bags. Scantily clad women can be seen to sell themselves. Men look on wondering whether or not to buy. Mikhailov observes, "Everything can be bought and sold—even children," and he tells the tale of walking through Odessa in 2003 and being offered a child for the sum of $1,000. The title of the series is borrowed from the cry of the local street hawkers: old women call out these words as they wheel around trolleys packed with tempting goods. To Mikhailov, the cappuccino represents the "perambulatory product" of the age—"a veritable sign of the times"—proof of the advent of capitalism and globalization.

Mikhailov originally trained and worked as a technical engineer on the development of Soviet rockets and the Cosmos space program; photography was simply an interesting pastime. However, in 1965 an event occurred that prompted him to devote himself entirely to the medium. He recalls: "The KGB came and took away my negatives." They discovered nude photographs Mikhailov had taken of his wife Vita; he was fired from his factory job, but thankfully not sent to prison. Eventually he started the influential photography group Vremya (a word that translates as "time" and was also the title of the monthly magazine published by renowned, nineteenth-century author Fyodor Dostoyevsky). As he established himself, he inspired a future generation of photographers, such as Sergey Bratkov (see p.222). Photography became Mikhailov's life's pursuit and Kharkov his subject.

"Tea Coffee Cappuccino" follows on from three series that have been described as Mikhailov's three-part requiem to his hometown: "Am Boden" (By the Ground, 1991), "Dämmerung" (At Dusk, 1993), and, arguably the one that launched his career in the international art world, "Case History" (1997–98). Mikhailov introduced "By the Ground"

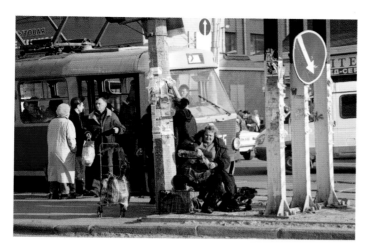

with the words: "I already notice the tendency toward a 'new' society, a deterioration in the quality of life for most people and the waning hope that some time everything will turn out fine." In the portraits Mikhailov took for the series, he deliberately altered his subject's gaze and body posture; by holding his camera at hip height, they were forced to look down into his lens, which lent the work a downcast demeanor. Furthermore, he suppressed all color in the imagery and depicted a timeless grayness. With "At Dusk" the impending doom gathers; Mikhailov equated what was happening to his city to a "natural catastrophe." The pictures are drained of color, but this time given a blue cast. Mikhailov explains, "The color blue is for me the color of the blockade, of hunger and war." However, it was "Case History" that proved to be Mikhailov's most controversial project.

"Case History" comprises over 400 images portraying a new social class in Kharkov. Mikhailov had been in Berlin; he recalls what he encountered on his return: "Devastation had stopped. The city had acquired an almost modern European center. Much had been restored. . . . But I was shocked by the big number of homeless [people], before they had not been there." A new name had been invented for this new class: the "bomzhes." It describes, as Mikhailov explains, people "living in the streets, wherever they can stretch their bones . . . creatures that were once humans, but now . . . degraded, ghastly, appalling." He chose the title of the series to hint at a "clinical file of a disease." The images are shocking. Respini says, "Once you see these pictures from 'Case History,' they are impossible to forget." Art critic Adrian Searle writes, "Part of me wished I had never looked at them."

6–7 From "Tea Coffee Cappuccino," Kharkov, Ukraine, 2000–10

There are numerous parallels between "Case History" and "Tea Coffee Cappuccino." For a start, Mikhailov shot both series in full color. "The color 'express-photo' became for me the thing which mostly correlated with the new time," he explains, with digital photo-centers, such as Agfa, Konica, and Fuji, opening on every street corner. "Both the rich and the poor wanted to have color photographs and there was only one distinction: the rich could afford them, the poor couldn't." He also deliberately shot the pictures like snapshots: faces are cropped off at the edge of the frame, verticals slant and skew, there is even red-eye caused by the camera flash. The aesthetic calls to mind amateur photography and lends both series a sense of directness and reality. However, this sense becomes complicated in "Case History"

once one learns that Mikhailov asked his homeless subjects to pose for him, sometimes suggesting they remove their clothes, and moreover that he then paid them. This intervention not only complicates a documentary reading of "Case History," but it also raises issues of ethics and exploitation. By contrast, in "Tea Coffee Cappuccino," Mikhailov returned to a straightforward street photography approach. For ten years, he wandered his home city and with an unflinching eye captured disturbing scenes as they unfolded in front of him. He hoped to create an epic, sweeping picture of the time, saying, "I feel that the documentation of reality in this series can be regarded as a document of this period." As such, "Tea Coffee Cappucino" presents a dismal and redemptive portrait of humanity in post-Soviet Russia.

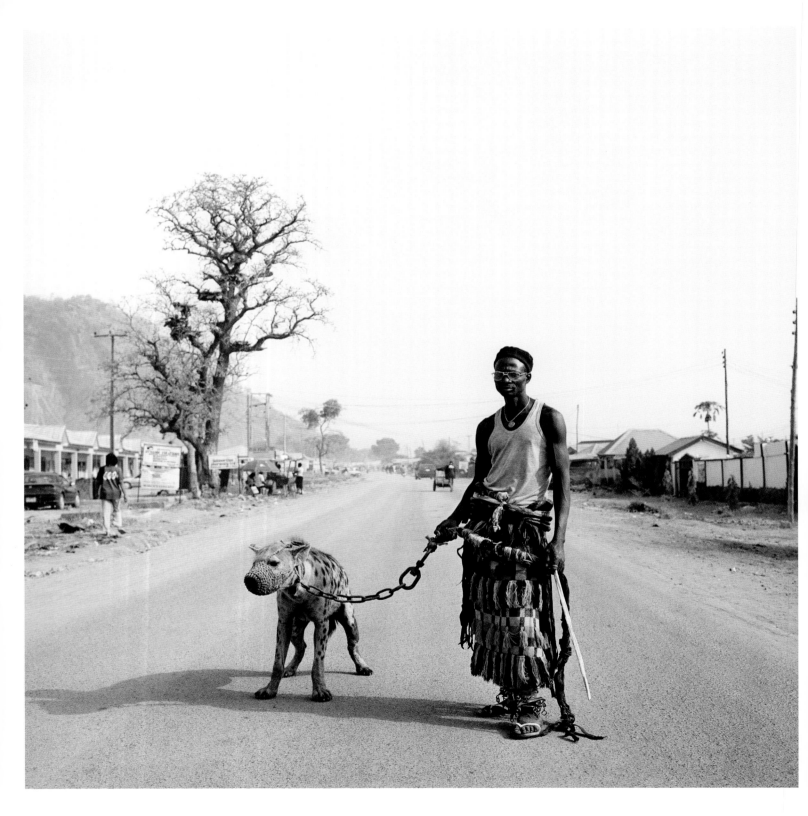

1 *Mallam Galadima Ahmadu with Jamis*, Pieter Hugo,
Lagos, Nigeria, 2005. Digital C-print

AFRICA

JOHANNESBURG CAPE TOWN DURBAN LIBREVILLE LAGOS MOSHI LUANDA DAKAR TANGIER

SABELO MLANGENI NONTSIKELELO VELEKO GRAEME WILLIAMS MIKHAEL SUBOTZKY
ESSOP TWINS DAVID GOLDBLATT JO RACTLIFFE GUY TILLIM PIETER HUGO
VIVIANE SASSEN EDSON CHAGAS RUT BLEES LUXEMBURG MIMI MOLLICA YTO BARRADA

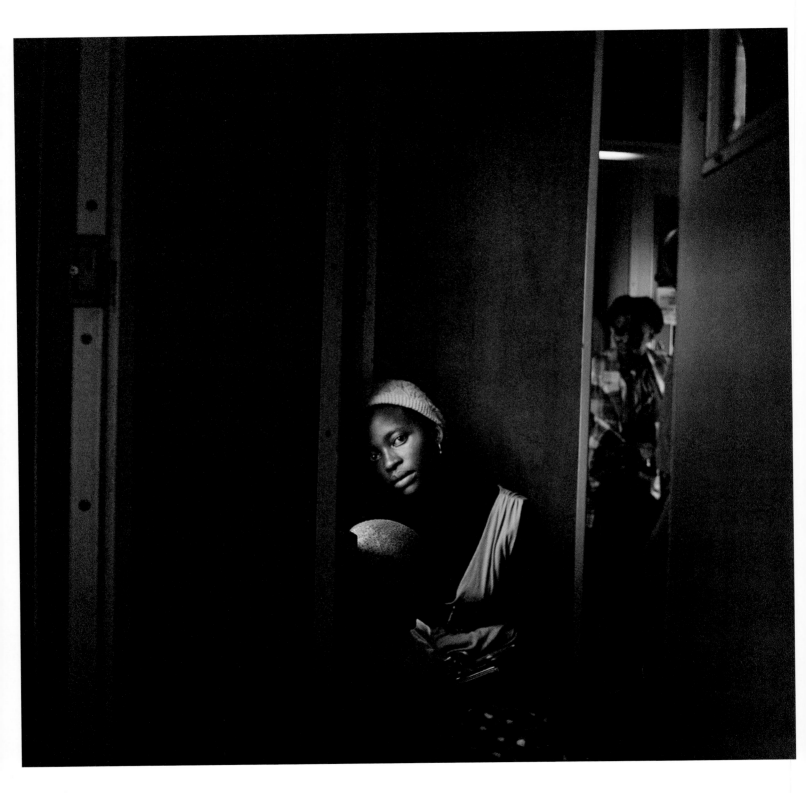

2 *Coming to Johannesburg I, January 2011*, Sabelo Mlangeni, Johannesburg, South Africa, 2011. Handprinted silver gelatin print, 10 ⅝ x 10 ⅝ in.

Within the confines of the city, residents are compelled to exist in relatively close proximity and therefore issues of inequality—between rich and poor, between different races, sexes, or social strata——can become strikingly apparent. Clearly this arises in cities throughout the world, however, the desire to document injustice is arguably particularly noticeable on the African continent. As this chapter journeys from south to north, from South Africa to Morocco, different artists repeatedly return to inequality, in all its guises, revealing it as a fundamentally shared concern.

Much of the photography that emerged from South Africa during the time of apartheid (from 1948 to 1994) focused on the difference between how black and white people were treated. Guy Tillim (see p.266) recalls working during that period: "What the foreign newspapers really wanted from us was an illustration of the injustice that was happening." Today, post apartheid, social inequalities still remain but their boundaries seem to have shifted. Johannesburg-based photographer Mikhael Subotzky, who firmly believes in the power of his work to "bear witness," identifies a new form of apartheid. "So much of the way crime is represented in the popular media polarizes victim and perpetrator, us and them," he explains, creating "a new kind of apartheid—between those that fear and those that are feared." Subotzky relentlessly ventures into urban no-man's lands. For his project "The Four Corners," he photographed inside Cape Town's Pollsmoor Maximum Security Prison, and for the "Ponte City" series (see p.250), he entered Johannesburg's notorious, gangster-ruled tower block. By framing "those that are feared," Subotzky hopes to expose stereotypes and neutralize public paranoia.

The project in this chapter by the renowned and influential photographer David Goldblatt takes a similar approach. Goldblatt, who has been documenting South African society over the last half century, arrived at the idea after an encounter not atypical for fellow residents of Johannesburg. "Having been the victim of armed robbers, muggers, and thieves I asked myself who are the people who are doing this to us?" he explains. "I wanted to burrow under the statistics . . . to meet some of the doers of

crime." The resulting series "Ex-Offenders" (2008–present) marks a radical shift within his photographic practice (see p.258) as Goldblatt succeeds in creating a body of work that unusually grants the perpetrators a voice.

The rising photographer Sabelo Mlangeni exposes a different face of inequality. "I look at those things that people shy away from in the world," he asserts. For his latest series "Invisible Women" (see p.240), he observes how in South Africa individual honour is "predicated not only along racial lines, but also within various racial groups, by gender." He became intrigued by the fact that no matter how dirty the streets of Johannesburg's business and commerce district became, by morning order and cleanliness would be restored. His investigations introduced him to an army of women who labor throughout the night: "These are the women who prepare the city at night for the men who come in the morning." He photographs these nocturnal workers with such dignity that he does not simply alert us to their plight, but also manages to celebrate these previously unsung heroines.

The Parisian and Tangier-based artist Yto Barrada widens the scope of focus beyond the shores of the African continent; she considers an inequality that exists between Africa and elsewhere, between the Orient and the Occident. Rare in her dual citizenship of both France and Morocco and therefore free to move unimpeded back and forth across the Strait of Gibraltar, she became acutely aware of how the Schengen Agreement has restricted African access to Europe. "Since fifteen European countries united their borders," she explains, "frontier states like Spain require Moroccans to present special visas which are almost impossible to obtain," creating in effect "a one-way Strait." The resulting series "A Life Full of Holes: The Strait Project" (see p.286) considers how this loss of liberty and this sense of paralysis inscribes itself on the people of Tangier. The philosopher Nadia Tazi adds, "The country's increasing poverty has made the Strait feel like a Berlin Wall. You feel the call of freedom and possibility—the allure of city lights." Ultimately, Barrada's work also reads as a visual eulogy to the thousands of people who have died in pursuit of better lives and in pursuit of equality.

JOHANNESBURG

Johannesburg's streets in the early twentieth century were home to two types of street photographers. There were those who hunted light and shadows for fleeting moments of human and architectural interaction. The others were workmanlike street photographers who created work in the prosaic genre of cards (portraits of the complete body) and half cuts (portraits showing the waist up). A photograph by Russian emigré Leon Levson of an African street photographer taking a picture of a migrant worker on the streets of Johannesburg encompasses the world of the documentary photographer and of the dapper, unidentified photographer making his living doing street portraits. Many important South African street photographers began as street portraitists, including Ernest Cole, Santu Mofokeng, and Juda Ngwenya. Some yearned to capture life on the fly. The introduction of smaller, faster cameras made this possible for those such as Bob Gosani and Peter Magubane who made their names at *Drum* magazine, which reported on life under apartheid in South Africa's townships during the 1950s and 1960s.

Gosani made some spectacular images, and in accordance with the nature of Johannesburg, not all of them in public streets, but in spaces generally closed off to the public. Among them is Gosani's famous photograph of the so-called "Tauza dance" taken in 1954. The dance refers to a ritual he captured on camera, whereby black inmates of the city's The Fort prison had to dance naked to show warders they had nothing hidden in their rectums. Gosani also shot remarkable photographs of bare-fist boxing contests between migrant workers in the mining compounds.

One of South Africa's first black photojournalists, Cole, also worked at *Drum*. The body of work he produced between 1958 and 1966, after which he was forced into exile, remains one of the most courageous of the early days of the apartheid experiment. His intense, impassioned eye captured the reality of life in Johannesburg during apartheid with revealing images such as that showing a black man arrested and handcuffed for entering the city without a pass (see image 1). Cole published his images in *House of Bondage* in 1967. The book became a seminal work and was banned in South Africa.

A contemporary of Cole, documentarist David Goldblatt (see p.258) practices a rigorous form of street photography. His image *On Eloff Street* (see image 2) captures a throng of people waiting

2

1

1 *Pass Raid*, Ernest Cole, from *House of Bondage*, 1967
2 *On Eloff Street*, David Goldblatt, 1967

for the lights to change; every face shows the diversity of South Africa, yet their expressions mirror the stress of racial separation. Another image also shot on Eloff Street in May 1966 has the high-contrast and claustrophobic feel of New York street photography, yet is filled with the menace in what is a chiaroscuro of racial antagonism. Other images from the streets and suburban sprawl reflecting on the nature of work and labor are found in his book *Intersections* (2005).

There is no shortage of contemporary street photography in Johannesburg, some of it interesting and arresting, yet much of it seems almost arbitrary. A lot of it is produced by talented photographers, but their work appears to show them treating the street as a project to dabble in and then move on. Some adopt a less generalist approach and have specific themes that they seek to depict on the streets. Other amateur photographers have created serious bodies of work in and around the city of gold. Perhaps it is the peculiarly Johannesburg suburban separation of street and dwelling

divided by impenetrable walls and electric fencing, and guarded by sentries and ferocious dogs that makes the city's suburbs such a daunting photographic venture. The city itself is gritty, unforgiving and menacing, making the street a place less photographed in the extensive way of other cities. Over the decades, it has grudgingly given itself to those wishing to capture its rough and tumble streets. One photographer who has ventured into Johannesburg's inner city is Graeme Williams (see p.246), who began making photographs in the 1980s. Williams's most eye-catching street work is in his book *The Inner City* (2000), consisting of images made between 1996 and 1998 that are as visually complex as the places in which he shoots.

Among the more youthful photographers capturing the city are Nontsikelelo "Lolo" Veleko (see p.242), who concentrates on eye-catching avant-garde urban street fashion, and Sabelo Mlangeni (see p.240), whose images of those living in the outer townships are characterized by the peculiar stasis of architecture in the post-apartheid world. **GM**

1 *Trolley Pushers in Wonderus Street*, from "Big City," 2009. 2 *A Space of Waiting*, from "Big City," 2012. 3 *A Schoolboy, Joubert Park*, from "Big City," 2012. 4 *Joubert Park Chess Team*, from "Big City," 2012. 5–6 *Invisible Woman I* and *Invisible Woman II*, from "Invisible Women," 2006. All silver gelatin prints

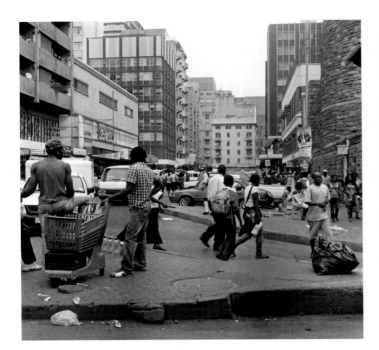

BORN 1980, Driefontein, South Africa LIVES Johannesburg, South Africa
STUDIED Market Photo Workshop, Johannesburg SERIES "Invisible Women," 2006;
"Big City," 2011–present OTHER GENRES Documentary

SABELO MLANGENI

Sabelo Mlangeni is not afraid to tackle tough subjects—if anything he seems drawn to them. The series "Invisible Women," which launched his career in 2007 when it constituted his first solo show, focuses on the women who work through the night cleaning the streets of his hometown of Johannesburg. The idea originated when he noticed how it never mattered how messy the city was at night, by the next morning it was always unfailingly clean. "Who are these ghosts who come while we all sleep?" he wondered. "These are the women who prepare the city at night for the men who come in the morning." In his most recent, and still ongoing project, "Big City" (2011–present) he confronts the inner city: a place that earned Johannesburg the unwelcome title of "most lawless metropolis outside a war zone." However, throughout these disparate projects, Mlangeni's work is united by a palpable sense of optimism. Indeed, it led the critic Anja Aronowsky Cronberg to write, "Mlangeni finds glamour and joy in places where onlookers only see hardship and strife."

Mlangeni was born in Driefontein, a small mining town in the South African veld in the province of Mpumalanga, which is a four-and-a-half hour drive from Johannesburg. He hardly knew his father and recalls, "I grew up thinking my mother's sister was my mother. I didn't know until I was about ten years old that the woman selling handmade brooms who would come to visit, and stayed with us sometimes, was actually my mother." In 2001 he moved into the city in search of employment; he worked as a gardener and as a bookkeeper. While walking to one of these jobs, he discovered the city's famous photography school, the Market Photo Workshop, started in 1989 by David Goldblatt (see p.258). His decision to enroll on a course and learn the art of documentary photography changed his life.

"When I work I'm always mindful of the stereotyping that South Africa—and Africa in general—is often subject to in art and the media," he says, mentioning images of ragged children smiling broadly through adversity, majestic landscapes, the misery of poverty and destitution. "I try to bring another aspect to my country and my continent," he adds. Giving a voice to those subcultures and communities that tend to be ignored. With his series "Invisible Women" he reminds us how South Africa is not simply rent by racism, but also sexism. He demonstrates how these women are still fighting for gender equality. Yet, he portrays them with great grace and dignity; as curator Sipho Mdanda observes, "They are shown standing tall as conquering heroines." In "Big City" he challenges previous stereotypes of his hometown, painting a portrait of Johannesburg that reads more like an homage. Gone are the bleak, war-torn, poverty-stricken street corners. Mlangeni reveals a city in the process of rejuvenation. "I have grown to love Johannesburg. It is a cosmopolitan world-class African city," he says, "These photographs are a labor of love; my ode to its many, ever-changing faces."

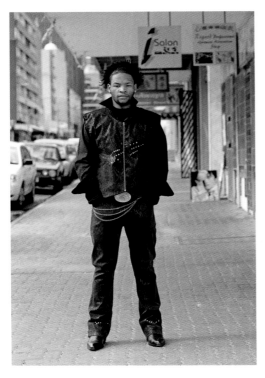

NONTSIKELELO VELEKO

In 2006, the Johannesburg-based photographer Nontsikelelo Veleko
won international recognition. Her ongoing series "Beauty Is in the Eye
of the Beholder" catapulted her into the public eye as part of the highly
acclaimed group exhibition "Snap Judgments: New Positions in
Contemporary African Photography" at New York's International
Center of Photography. In "Beauty Is in the Eye of the Beholder," Veleko
explores the contemporary, urban, and edgy fashion scene through
the lens of portraiture. She used the downtown backstreets and
alleyways of her home city as the backdrop. All Veleko's subjects pose
confidently; all are adorned in bold, stylish clothes. Most are framed
in the same way—face-on and full length head-to-toe—so there is the
sense of an anthropological study categorizing an array of bright and
colorful exotic creatures. The evident flair and flamboyance was one
of the first things critics noted when the work was unveiled; it offers
a welcome change from more usual, Afro-pessimistic views of the
continent. However, it would be a mistake to classify Veleko's work
simply as South African street fashion. She admits, fashion is "fun and
it's like play," but there are more serious motivations at work, or at play.

Veleko was born in Bodibe, North West Province and raised
in Cape Town. When she arrived in Johannesburg, already trained
in graphic design, she set about enrolling in the city's famous
photography school that had been founded by David Goldblatt
(see p.258): the Market Photo Workshop. The school's director, John
Fleetwood, recalls, "Lolo, as she is affectionately known, entered the
Market Photo Workshop in 1999 with an approach (fashion) [and] a
subject (Johannesburg)." The school trained young people in the
tradition of documentary photography, but as Fleetwood recalls, it
was clear from the outset that "Lolo's strength was to deconstruct
this dynamic." Her initial projects moved beyond the simple
documentary into more conceptual arenas. Series such as "www.
notblackenough.lolo" (2003) revelled in the variety of South Africa's
street style, but also started to question its purpose.

"My journey in photography arose from an interest in exploring
identity," claims Veleko. Fashion is her way in. "More than just
documenting fashion and style, I am interested in how we read
fashion," she explains, "and how my subjects use their clothes to
construct, and often deconstruct, their guises of identity." Throughout
her work, Veleko explores the shifting fashions, the myriad ways in
which people choose to express and define themselves and in doing
so, she visualizes the mercurial, liquid nature of identity. In South
Africa she has found an interesting case study; in the wake of
apartheid, the country struggled to construct a new identity. For
"Beauty Is in the Eye of the Beholder," Veleko chose to focus only on
those born after 1994, people who have been christened the "born
free" generation. The series not only reveals the creation of a radically
new black street identity, but also as Mark Sealy, the director of
Autograph ABP, points out "there is a latent sense of political urgency
and defiance about her work that wants to look forward into a place
of unhinged freedoms . . . a life without boundaries."

JOHANNESBURG

BY SUE WILLIAMSON

Somehow, their wry question "Who is Johannes?" expresses a lot about the chaotic, makeshift but open nature of South Africa's largest city. No one is really sure which "Johannes" Johannesburg was named after, which makes it a city with an unclear identity from the start—a city that is constantly reinventing itself.

The photo shoot took place on the street that links the city's central railroad station to the taxi rank. In incessant motion, this street is the point of entry for thousands of people from the rest of Africa, who come to Johannesburg to seek work and find their fortune, but sometimes disappear without a trace.

1 *Who is Johannes?*, from "Other Voices, Other Cities:
Johannesburg," 2009.
Pigment inks on archival paper.
Photographer: John Hodgkiss

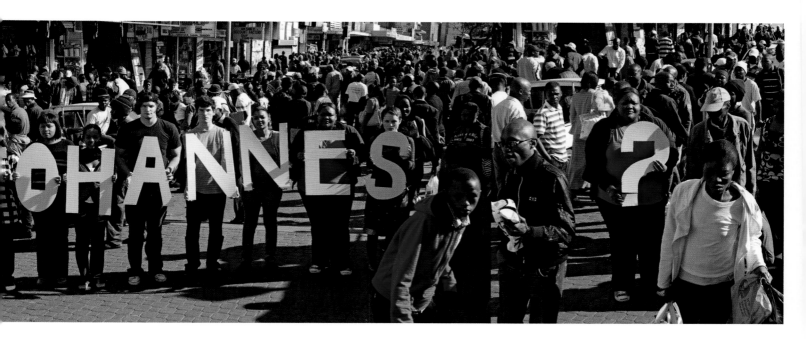

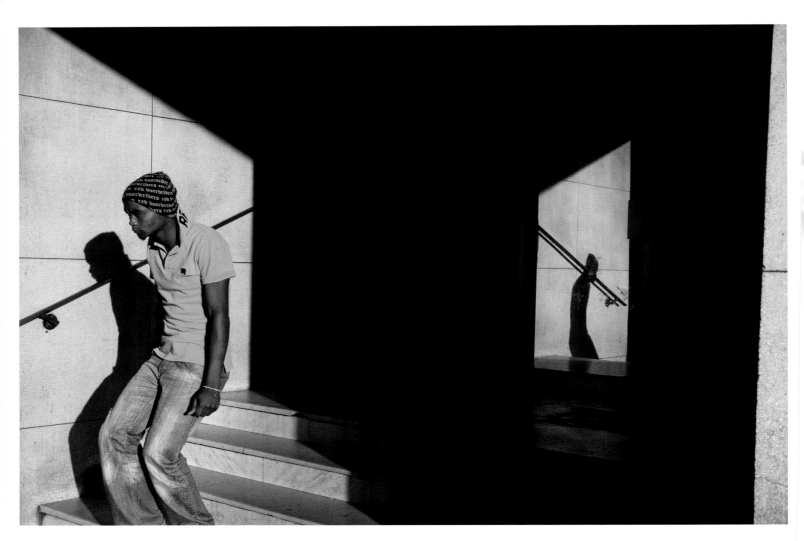

JOHANNESBURG
BORN 1961, Cape Town, South Africa LIVES Johannesburg, South Africa
STUDIED University of Cape Town SERIES "A City Refracted," 2012–14 OTHER
GENRES Documentary OTHER CITIES WORKED Cape Town, London, Singapore

GRAEME WILLIAMS

For two decades Graeme Williams's muse has been his much-loved hometown. "Johannesburg is a unique city," he says, "made up of separate communities that differ greatly in wealth, education, race, and cultural background." For his latest series, he trained his lens on its inner city. This once relatively wealthy, white-only neighborhood has changed dramatically since the end of apartheid. Williams recognizes how, since its formation as a mining town, it has always been the first stop for new arrivals, and that today it remains so; he observes, "Certain districts and apartment blocks are now dominated by Nigerians, Ghanaians, Somalis, and immigrants from all over Africa." White people have now more or less vacated the area, and many of those who live in the suburbs no longer dare venture in. Williams is keenly aware of how these changes "have resulted in me being an outsider in a neighborhood that is less than ten minutes drive from my home." Indeed, he had to hire three bodyguards to work there. The resulting series "A City Refracted" explores what it is like to feel like a foreigner in your hometown.

Williams came to the photographic medium as a photojournalist. In 1989 he was contacted by Reuters to cover South Africa's transition to ANC rule. He accepted the post, but did not anticipate how things would turn out. The violence began quite suddenly. "It started with a few deaths a day and rose rapidly to fifty deaths a day," he recalls. "I was thrust into this role of photographing violence: a sort of localized war. It was never my intention." Yet he felt a sense of responsibility to document what he was seeing. He would spend his mornings in the townships witnessing horrendous brutality, then return home to the city. "At the beginning you consider your life at home with friends normal and your life photographing as abnormal," he says, but "at some point it flipped over the edge and photographing violence became my real life." The tumultuous years of war engulfed him and it was not until the end of apartheid, when Nelson Mandela and the ANC won the democratic vote that he re-emerged. "Post 1994 it really changed," Williams remembers, "I had this strong sense of having to find a reason again why I was a photographer and what I wanted to photograph." Once more Johannesburg drew him in, although this time not in the capacity of war photographer.

1–4 From "A City Refracted," Johannesburg, South Africa, 2012–14

His first body of work to come out of the post-apartheid years was "Inner City" (1994–98). Still reeling from his experiences, he set about photographing the city in a loose fashion without any preconceived direction to see what might happen. A theme started to develop in the black and white images he was bringing home. "I began to realize that the content of my photographs appeared to be reflecting my state of mind at the time." He adds, "I felt very removed from the day-to-day realities of the world. I think it was this sense of isolation, and apartness, that drove this project and, for me, gave it a sense of cohesion, as well as meaning." Subjects are quite often cropped so that only parts of bodies are visible; faces are obscured or hidden

behind masks and costumes. Alternatively people are framed at the edge of the image so they appear staring out at a void. When more than one figure fills the image, they tend to be separated by structures, such as fences or bars, or have their backs to each other, lost in their own private worlds. Taken together the images evoke an overriding sense of alienation. Williams chose to use a few lines from T. S. Eliot's poem "The Hollow Men" to open the book of the series because it reflected his emotions. It reads: "Between the idea and the reality, Between the motion and the act, Falls the shadow."

Similar themes run through the "A City Refracted" series, yet they are more acutely developed. Frames picture people as fractured, split and divided; objects are shattered, torn and ripped apart. Faces once again appear masked, but sometimes also scratched out. However, there are radical differences with the earlier work. The most obvious change is Williams's move to color. "A City Refracted" reveals vibrant hues and, because much is shot at dusk, there are the strange shades that appear as the light leaves the sky. He opted for color because he wanted to evoke what he calls "an untutored snapshot quality." The skewed horizons and brutal crops accentuate the amateur snapshot aesthetic. Moreover, movement or limited field of focus blurs many of the images. Williams's aim was to evoke "the sense of disorientation tourists might experience when finding themselves

5–8 From "A City Refracted," Johannesburg, South Africa, 2012–14

5　6　7　8

surrounded by a foreign culture." This sense is heightened by his move toward abstraction. Reflections, shadows, silhouettes repeatedly create pictures that disorientate; the viewer loses his or her bearings on the world, and is simultaneously immersed in a beguiling yet threatening atmosphere.

"A City Refracted" and "Inner City" before it reveal a shift change in Williams's post-apartheid work; gone is the objective documentarian recording the present for posterity. He has developed the language of street photography to create highly subjective views of Johannesburg. They portray less about the outside world and more about his internal wars. He explains, "I felt [my work] needed to be about how I felt about my life, my country, my immediate surroundings." Yet these views are by turns dark and brooding. He admits, "In this country I think most of us live in this sort of post-traumatic stress situation." They reflect his feelings of isolation and alienation in his hometown. "The country is such a mess of positives and negatives, that if one really engaged with all the things that happened, it would drive you nuts. I want to get across that you can never really get a grip on what is happening." Yet "A City Refracted" is also perhaps a call to arms: a stark reminder of how the whole country has failed to socially integrate; Williams adds, "In many ways it refutes the dream of the rainbow nation."

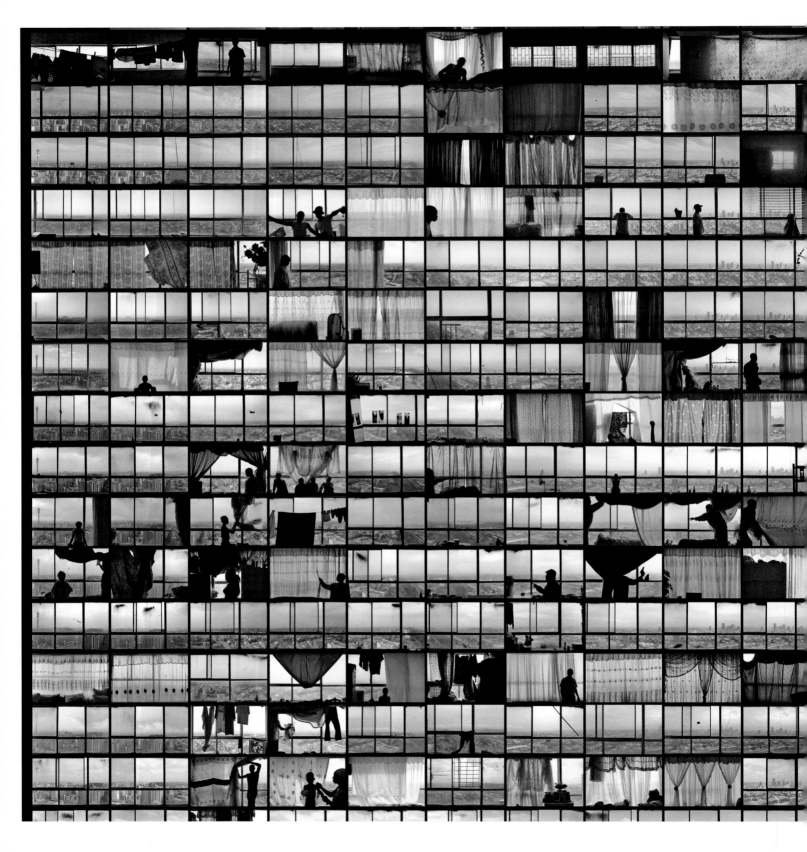

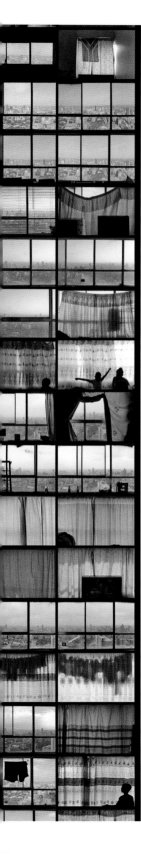

JOHANNESBURG

BORN 1981, Cape Town, South Africa LIVES Johannesburg, South Africa
STUDIED Michaelis School of Fine Art, Cape Town SERIES "Ponte City," 2008–14
OTHER GENRES Documentary, video OTHER CITIES WORKED Cape Town

MIKHAEL SUBOTZKY

"It is the ultimate in chic and sophistication. Join us on a guided tour of a building that brings Utopia to life and proves that South Africa has caught up with the world's urban centers." Thus reads a brochure, written in 1973, advertising the opening of Johannesburg's infamous tower block Ponte City. It was the first cylindrical skyscraper in South Africa, built around a hollow center that enabled sunlight to filter into its apartments. At 54 stories and 568 feet high, it dominates the city's skyline and is said to be the tallest residential building in the southern hemisphere. Yet, Ponte City was destined for a very different future than was originally hoped. While it remains a symbol of South Africa, it became a place where utopian dreams soured into dystopian realities.

When South African photographer Mikhael Subotzky and British artist Patrick Waterhouse arrived at Ponte City in 2008, the building bore the marks of three decades of abuse and decay. Since the fall of apartheid in 1994, the exodus of the white middle classes and the influx of unauthorized immigrants from nearby countries had turned Johannesburg's inner city into a gang-ruled, crime-ridden ghetto. Ponte City is situated in one of the worst hit neighborhoods of Hillbrow and it had become one of the most dangerous places to live in South Africa. Various attempts to restore it to its glory days had failed spectacularly. "Tales of brazen crack and prostitution rings operating from its parking lots, four stories of trash accumulating in its open core, snakes, ghosts, and frequent suicides have all added to the building's legend," write the artists. Subotzky and Waterhouse ventured into this no man's land to document it through various lenses—found objects, interviews, historical archives, and videos. However, it was through Subotzky's camera that the series "Ponte City" was realized.

Subotzky and Waterhouse gained access to every apartment on every floor of Ponte City. In each front room, they set up cameras at the same position to frame the same three-paneled window. This formula enabled them to rebuild the high-rise, window by window, 12 across and 54 floors high. The end result is an almost 12-foot-tall light box that displays 648 photographs. From a distance, the towering installation appears abstract; individual windows register as pixels of light. Up close, however, one can make out the separate window vistas from the foundations of the buildings opposite, past their pinnacles as Ponte

1 *Windows, Ponte City*
(detail), 2008–10

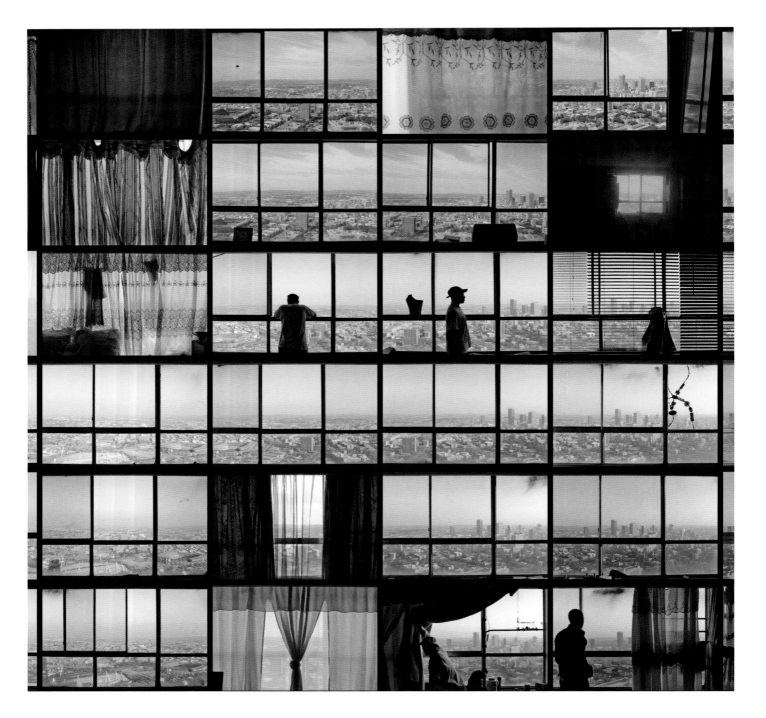

City passes them, to aerial panoramas of the Johannesburg skyline. Sometimes curtains obscure these views and one's gaze is diverted to scenes within, where silhouettes of occupants, their belongings and furniture jostle for room. Then one realizes, as the artists point out, that "floor by floor, and apartment by apartment, lives are lived stacked together, and on top of each other"; each of the 648 images represents the living space of individuals and families. Subotzky created two further light boxes; one detailing whom he saw when he rang the front door bells (or the door itself if no one answered), the other documenting what was showing on the television sets that seemed to continually run. These three typologies reveal the three separate worlds of Ponte City occupants: the interior, the exterior, and the imaginary. Together, they paint a fragmented, bleak, dystopian vision.

Subotzky's career has been brief but stellar. Born in Cape Town in 1981, he achieved the highest grades ever given for a final project at the city's prestigious Michaelis School of Fine Art. The series "Die Vier Hoeke" (The Four Corners, 2004) explored life inside the Pollsmoor Maximum Security Prison, famous for once holding Nelson Mandela. "I was scared a lot of the time," he recalls of his experience being locked up with some of South Africa's most dangerous felons. "I don't think it is on a par with war photography, but it was a difficult environment to work in." The project attracted international attention, and at the age of twenty-five, he became one of the youngest ever to be invited to join the ranks of the esteemed Magnum agency.

Subotzky cites various influences, but names one photographer above others: "I am greatly inspired by David Goldblatt's life project of photographing his surroundings in South Africa." Indeed, the series he worked on after "Die Vier Hoeke"—titled "Umjiegwana" (The Outside, 2005) looking at the lives of ex-prisoners—recalls Goldblatt's project "Ex-Offenders" (see p.258). Subotzky freely admits that his next project, "Beaufort West" (2006–08)—a portrait of a small town blighted by poverty, segregation, and violence—is indebted to Goldblatt's "In Boksburg" (published in 1982). Subotzky's various series continually revolve around the same themes and issues— prisons, policing, crime, and social marginalization. The opening shot of "Beaufort West" is an aerial view of the town showing how it revolves around the prison at its center. Talking of "Beaufort West," he describes an issue that reverberates throughout his practice: "The problem is that so much of the way crime is represented in the popular media polarizes victim and perpetrator, us and them, the law-abiding citizens and those who the law-abiding citizens have to fear. I almost see this as a new kind of apartheid—between those that fear and those that are feared."

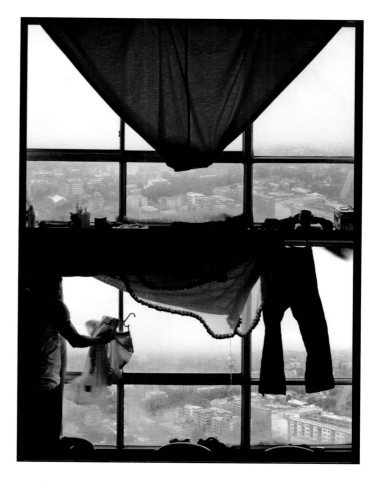

The series "Ponte City" investigates one side of Subotzky's new apartheid: those that are feared. For decades the building has overshadowed Johannesburg, looming over its residents: a concrete reminder of dreams dashed, a monument to the city's nefarious and criminal underbelly. Yet, after three years spent photographing the building and getting to know its inhabitants, Subotzky came away with a very different sense: "One is left with the feeling that even the building's notoriety is somewhat exaggerated," he concludes. "I believe in the power of bearing witness, but I see it more as responsibility to ourselves . . . to try and make ourselves as conscious as possible." Subotzky acts like our conscience—using his photographs to break down preconceptions and show us beauty where previously we were too scared to look.

ESSOP TWINS

At first glance, there is something about these colorful and dynamic scenes that feels odd, almost uncanny. On closer inspection, one realizes that the same outfits—whether traditional Islamic flowing robes, the latest in Western designs, or army camo uniforms—keep recurring both within and between the images. Furthermore, it soon becomes apparent that the protagonists look remarkably similar. In fact the work is entirely staged. The artists are fraternal twins, so not quite identical, and they photograph each other over and over, digitally superimposing these frames to clone and multiply themselves. Hasan and Husain Essop use the city in which they were born and bred as the backdrop to many of their performances; indeed they have been described as having "a youthful love affair with Cape

Town." Their playful constructions explore issues of identity and in particular what it means to be an Islamic youth living in a secular society. They argue, "This is our experience. We don't want to make an objective statement. We don't want to put words in other people's mouths. This is how we see the clash between east and west, which exists simultaneously in our bodies. It's our struggle."

Hasan and Husain grew up in a tough working-class suburb in the Cape Flats and were raised as devout Muslims. After school finished they were sent for after-hours religious education. "Every day," Husain explains, "we had history instilled in us, the way to read the Koran, all those things that every Muslim needs to be a good person." Pictures were not allowed on the walls of their childhood home because Islam forbids photographing the human form; it is deemed haram. Their mother constantly taught them, "If you have photos showing the person's eyes, you're chasing the angels away." Yet when they reached the capital's prestigious Michaelis School of Fine Art, they were

	2	
1		3

1 *Thornton Road*, Cape Town, South Africa, 2008
2 *Black River*, Cape Town, South Africa, 2007
3 *Azaan*, Cape Town, South Africa, 2008

determined to somehow embrace both Islam and some form of picture-making. Hasan had the idea of turning the camera on himself. Husain recalls, "When I saw what Hasan was doing immediately I thought . . . he's managed to find a loophole. Use yourself—any judgment that occurs is going to be only on yourself." Hasan adds, "This way, if we need to answer to anyone, we alone are judged," says Hasan. "It is still risky but we feel it's ethical."

Their experience at Michaelis School of Fine Art was far from easy. "People kind of pushed us away," remembers Husain. "I think they were afraid because we were Muslim" and they mocked "our god and our religion." Moreover, their initial projects failed because it was deemed "propagandist" by their professors. However, they received a further, in their eyes more damning, blow when they showed their work to their parents; they too were dissatisfied. "That's when we realized we are conforming to those people's ideas." Husain adds, we were "not making ourselves happy, not producing work that expresses

what we feel and are trying to say." At that point, they resolved to collaborate and set about experimenting with staged, digital composites. After graduating in 2006, via various brief diversions into press and wedding photography, they eventually got their first break. A local, highly reputable art gallery backed them and within a year their work, such as the iconic images *Black River* (see image 2, p.255) and *Pit Bull Fight* (2007), was hanging in their first show alongside established practitioners, such as Iranian-born Shirin Neshat.

All their images are meticulously pre-planned so that by the time they arrive on location they have a fairly defined and shared vision. Husain sets up the camera and locks it into position on the tripod, whereas Hasan is the first to pose. Husain is generally dressed in traditional robes, whereas Hasan wears casual Western clothing.

While Hasan performs, Husain directs: "I'll try to guide him to say like 'occupy this space, occupy that space,' remember not to occupy the same space with a different character, because you don't want them to overlap." Then they switch; Husain steps in front of the camera and Hasan turns director. The city backdrops they choose are often significant; for example, *Thornton Road* (see image 1, p.254) was the scene of the apartheid-era ambush that became known as the Trojan Horse Massacre. Locations are also scouted to decide on the best time and light to create atmosphere. *Sunrise Farm* (see image 4), which is set at an abattoir, was taken as the day dawned; whereas *The Night Before Eid* (see image 5) was exposed in near pitch-black darkness, three hours past midnight. Both mise en scènes were carefully stage-managed so that the sheep hung at the same sites as the pots. Husain explains,

4 *Sunrise Farm*, Cape Town, South Africa, 2009
5 *The Night Before Eid*, Cape Town, South Africa, 2009

"The two photographs work together where the sheep are slaughtered during the day and the food is cooked during the night."

Sunrise Farm and *The Night Before Eid* portray an important date in Muslim calendars worldwide (the feast of Eid al-Fitr marks the end of the month-long, dawn-to-sunset fasting of Ramadan). Other images embody various cultural aspects experienced by young Muslims living in Cape Town. Husain argues, "Today, the youth are going through this inner struggle." They explain: "We love dancing, we love movies, we love music . . . but then we have the strict teachings of Islam that forbid us to do certain things." The images are created to explore what it means to be a young Muslim negotiating this cultural divide. However, their work also touches upon broader issues: it interrogates tensions between East and West, Islam and secular societies, but also between narrative and documentary, staged and spontaneous, and between self and other. They talk of the self as mutable; how the different characters represent "different facets of one's self" and of "split personalities within ourselves." As art historian Jean-François Chevrier says: "Every self-portrait is inevitably, by its very nature, a doubling, an image of the other." Yet Hasan and Husain, create multiple portraits of each other that lead to a further fragmentation of self—other become others—and each of these is performed, so the selves are in effect imagined, fantasized, or fictionalized. The Essops, perhaps because they are twins, seem highly attuned to issues of identity. Ultimately, their work tears asunder any notion we have of a stable, coherent self and reveals that our sense of individuality is essentially and eternally shape-shifting.

1 *Blitz Maaneveld at the Terrace, Woodstock, Cape Town,*
where he murdered a man with whom he had been gambling,
October 7, 2008, 2008. Silver gelatin print on fiber-based paper

CAPE TOWN

BORN 1930, Randfontein, South Africa **LIVES** Johannesburg, South Africa
STUDIED University of the Witwatersrand, South Africa **SERIES** "Ex-Offenders,"
2008–present **OTHER GENRES** Landscape, portraits

DAVID GOLDBLATT

Throughout his long career David Goldblatt has become a guiding light to today's generation and many contemporary artists, such as Mikhael Subotzky (see p.250), cite him as an important influence. Goldblatt also founded the renowned Market Photo Workshop in 1989. Its aim was, in his words, to teach "visual literacy and photographic skills to young people . . . disadvantaged by apartheid." Up-and-coming names have passed through its doors, including Nontsikelelo Veleko (see p.242). It is therefore not surprising that David Goldblatt has been hailed as South Africa's most esteemed and respected photographer.

His series "Ex-Offenders" is in some respects a departure from form in that it uses both image and text. The idea began with a simple question: "Having been the victim of armed robbers, muggers, and thieves I asked myself who are the people who are doing this to us?" Not prepared to accept the crime statistics at face value, he decided to track down the actual people that made up the numbers. He made contact with convicted criminals recently out of jail who were then trying to go straight and invited them back to the scene of their crime with the sole purpose of taking their picture. He later interviewed them and exhibited their words and their stories next to these portraits. In the series, he returns to the place where Blitz Maaneveld murdered a gambling partner; Kapou Maaneveld robbed a passer-by of his wallet; and where Ellen Pakkies strangled her son. "I don't believe these people are inherently evil," Goldblatt offers. "They came to their crime for a whole lot of other reasons."

Blitz Maaneveld (see image 1)

"Blitz Maaneveld ('Blitz,' meaning lightning, because he was so fast with the knife) disappeared shortly after this photograph was taken and was murdered before I could interview him. 'H' became his girlfriend in 2007 when she was twenty-one. This is what she told me: 'He was born in Bonteheuwel in 1959. He had four brothers and two sisters. He was criminal since he was young. He was about nine when he stole from stores, then he started breaking into cars, then stealing cars, then more serious crimes like robbing people, then attempted murder, then murder. All his life he was in jail. All his life he was on drugs—dagga [cannabis], tik [crystal meth], cocaine, mandrax,

everything, and then he still drank on top of it. He had four children that I know of. . . . He didn't improve his life and he didn't want to improve his life. He was just satisfied with what he did. . . . Blitz and his younger brother, Kapou, were doing the same crimes, they looked after each other . . . and were in the same gang in jail, the 26s. Blitz was a general. . . . His father was also a gangster . . . abusive toward his mother. . . . Blitz believed a woman should be beaten to make her listen. He beat me. A lot. I got an interdict against him because he didn't want to stay away from me. I was afraid of him. Then he came here to my mother's house for one week and was hitting me every night. . . . Mommy called the cops and he disappeared. That was November 2008. Five months later the cops asked me to identify the body. But I couldn't, it was too decomposed. They had to show me a photograph of when he was brought into the morgue. . . . He was shot twice in the chest, once in the back. By gangsters. He robbed one of the merchants. Everybody had a reason to kill him. I wanted to kill him. Part of me was happy to see that he's dead and he can't hurt me anymore, but another part of me was very hurt because I loved him.'"

Kapou Maaneveld (see image 2, p.260)

"Kapou grew up in Bonteheuwel, one of six children. He was ten when he started smoking cannabis. He'd miss school and steal money from his family. At 13 he was living rough in Cape Town. His first judicial punishment was a caning for robbing a store, the second, two years at a reformatory for breaking into a bakery. For the mugging on Darling Street he was sentenced to four years imprisonment. He was twenty-three years old. He joined the 26 gang in jail, stabbed another prisoner for his initiation and for punishment served eighteen months' solitary confinement. Involved in a prison riot, other violence, theft of a warder's watch and sunglasses, sold for drug money, he served nineteen years in all. Kapou rose through the gang's ranks, becoming a captain. 'I am a big man. And I am a man who goes first out from his camp, and then I go look how deep is the waters.' He is wedded to the gang. 'The day when I finish with that, that is the day when I die.' Kapou remained close to his brother, Blitz. For a time they shared a cell and lived together after Kapou was released in 2004. Blitz was murdered in

2008. Every year, Kapou is given a new Carnival costume by a friend, Richard Stemmet, a gift in gratitude. When Richard's brother was in prison, Kapou saw to it that he was not robbed, beaten, or sodomized. Kapou has two children. He would like to get a place for his family. In 2010 while living under a bridge in District Six he was arrested for breaking into a car. In December 2010 he was back in prison."

Ellen Pakkies (see image 3)
"Here, Ellen Pakkies strangled her son to death. She was sentenced to three years in prison suspended and to sixty-two hours of community service. There were extenuating circumstances. Her son Abie, the youngest of three, had started using tik when he was thirteen. He robbed Ellen and her husband of everything: money,

clothes, bed linen, dishes, appliances, copper pipes, and faucets in their house. He smashed their home to pieces and terrorized them. Through it all, she cared for him. She wanted to make him feel that he belonged somewhere. She couldn't throw him out onto the streets, because she had come from the streets herself. Born in 1961, she was still an infant when her grandmother threw her mother out. They lived under a truck. Her mother got married when Ellen was two, and they moved into a backyard room in Kensington. Ellen was four when the neighbor's sons began molesting her, six when a neighbor, a known murderer, first raped her. Her parents drank heavily. Ellen cared for the children born to the marriage, but had no friends. She hid her pain with a smile on her face. By the time she was eleven she had been abducted twice by sexual predators. She was thirteen when

she shared a bed with a rapist because he brought liquor into the house. She ran away. She'd had four years of primary school. Ellen lived on the streets, eating out of garbage cans and selling her body. Rape remained a constant. Her first child, conceived in rape, was born when she was seventeen. She married at eighteen. The union lasted six months. Her second marriage lasted two years, and she had two sons, Abie and his brother. She married Ontil, her husband today, when she was twenty-eight. She worked at the Maas Memorial Home, where the children taught her new things, like how to swim and to play, and she could help them, because she knew where they came from. Today, she helps other women with addicted children. She thanks God everyday, for the peace and tranquility he has brought into her life."

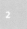 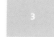

2 *Kapou Maaneveld where he robbed a man on Darling Street, Cape Town in 1987*, 2010.
Silver gelatin photograph
3 *Here, on his bed, in 2007, Ellen Pakkies strangled her son Abie. Lavender Hill, Cape Town*, 2010

DURBAN

BORN 1961, Cape Town, South Africa LIVES Johannesburg, South Africa
STUDIED University of Cape Town SERIES "Port of Entry," 2001 OTHER
GENRES Documentary, landscape OTHER CITIES WORKED Luanda, Johannesburg

JO RACTLIFFE

Durban is usually portrayed as a vacation destination where palm
trees and white beaches fringe turquoise, tropical seas. However, when
the Johannesburg-based artist Jo Ractliffe visited the city, she recalls,
"I was curious to discover that few of the usual stereotypical
representations manifested themselves during my stay there. Instead
it felt strangely full of extreme contradictions and juxtapositions . . .
an unstable place in complex ways." Her series "Port of Entry" (which
was originally produced as part of a collaboration with Argentine
visual artist Sebastian Diaz Morales) casts Durban in a radically
different light with crumbling bridges, derelict backs of apartment

blocks and dimly lit taxi stands. Critics claimed she had turned Durban
into a "post-apocalyptic nightmare," envisioning scenes that would
seamlessly merge with dystopian science fiction movie *Blade Runner*
(1982). Moreover, she created the series without the usual array of
professional camera gear; instead she used one of the current
mass-produced, low-tech, inexpensive plastic "toy cameras."

Ractliffe has been fascinated by toy cameras ever since a friend
sent her a Diana camera in the mid 1980s, and she slowly started to
amass a large and varied collection. It took a burglary to prompt her
to start using them within her photographic practice. She explains:
"In 1990, all my regular equipment was stolen and in order just to
keep photographing, I began experimenting with some of these
toy cameras." The experience would revolutionize her practice. She
started with the Diana camera, but found that its fixed focus, plastic

1 From "Port of Entry," Durban, South Africa,
2001

lens, light leaks, and lack of exposure controls save for the "sunny"
and "cloudy" dials, meant that it was far from easy to use. "My first
pictures were terrible," she remembers. "I had to rethink how I saw
the world and find a new approach to making images." The resulting
body of work was called "reShooting Diana" (1990–95); it earned her
both critical acclaim and her second solo exhibition.

Her toy camera collection continued to grow and soon boasted
Leaders, Envoys, Banners, Bull's-Eyes, Aces, Fiestas, Brownies and
Holgas; she used this last one to make "Port of Entry." The full body of
work is somewhat different from the discrete images displayed in this
publication; in a gallery it appears as a continuous strip of eighteen
rolls of film pasted together to create a 66-feet-long installation. While
experimenting with the Holga, Ractliffe found that the plastic framing
device could be removed. This had two interesting implications. First,

the edges of a frame became as important as their contents. She
recalls: "I developed a particular way of seeing, a kind of emptying out
the center of vision while paying attention to the peripheral." Second,
with the clear separation between frames removed, one image would
spill into another and Ractliffe realized, "I could shoot an entire roll of
film in one uninterrupted sequence and depending on how I framed
things and juxtaposed one image to the next, I could 'narrate space' in
various ways in the camera and even dissemble it."

The first city she photographed with her modified Holga—the
first to be "dissembled" – was her hometown. The result was the
series "Johannesburg: Inner City Works" (2000–04) in which the
capital was rendered as a continuous filmstrip that aesthetically
shares much with "Port of Entry." She refers to Johannesburg as "a
city of slippages," saying it "is not a place you can apprehend in any

fixed way. . . . Its buildings, its people and its streets catch you unaware and hover, half-blurred, on the edges of your vision when you're on your way to something else." The Holga's stream of images capture this sense of slippage, but they also act like a visual replay recounting her impressions as she traveled through the different cities of Johannesburg and then Durban. She explains: "I wanted images that, when you looked at them, pointed back to your experience of what it feels like to walk or drive through the city with its intense flood of buildings, space, and motion, information and phenomena." Like "Inner City Works," "Port of Entry" portrays the cityscape as a fluid, continually shifting experience.

Throughout her practice, Ractliffe has been drawn to landscapes. She wryly comments how her friend and colleague David Goldblatt (see p.258) says that she likes landscape because it doesn't talk back. She retorts, "I don't entirely agree; I find landscape very present and I have a strong sense of being in dialogue with it," and adds, "I'm a little hesitant to even call it landscape; it's more about space and the ways space speaks." In a more recent project, in 2007, Ractliffe ventured three times into the Angolan countryside. Her series "Terreno Ocupado" (2007) frames landscape that was once the site of the Border War, fought from 1966 to 1989 between South Africa and Angola; the images portray how the past has left its traces. In conversation with Ractliffe in 2011, critic Kathleen MacQueen suggested that the artist has come up with an addition to geographer Donald William Meinig's list of ten ways of seeing landscape. Ractliffe admits, "I like Meinig's ideas around landscape as history . . . also place and ideology." Her additional version is "landscape as conscience." Ultimately, the wild spaces of "Terreno Ocupado" are so successful at conjuring the past into the present that they seem haunted.

Like all her work, "Port of Entry" is preoccupied with the nature of photography and its particular way of framing and seeing the world. "For years I had been experimenting with ways to dislodge or resist the 'fixity,' or as David Goldblatt would say, the 'particularity' of the photograph. . . . I wanted my photographs to move beyond the specifics of a particular subject or event toward something more metaphoric, emblematic." She first found the answer to this conundrum in toy cameras. The imagery they produce seems to disturb reality to such a degree that it dislocates the viewer's perception and this, in her words, "opens up a space for other imaginings." Ractliffe's landscapes offer an evocation of ephemeral things not visible, yet present. In "Terreno Ocupado" it was landscape as history, perhaps also as conscience, and in "Port of Entry" it is landscape as experience, as a dynamic, near-filmic narrative of a journey.

LIBREVILLE

BORN 1962, Johannesburg, South Africa **LIVES** Cape Town, South Africa **SERIES** "Libreville," 2012 **OTHER GENRES** Photojournalism, landscape **OTHER CITIES WORKED** Johannesburg, Rome, São Paulo, Kinshasha, Cape Town

1 *Libreville*, Libreville, Gabon, 2012 2 *Independence Day Celebrations, Boulevard de l'Indépendance*, Libreville, Gabon, 2012 3 *Intercontinental Hotel*, Libreville, Gabon, 2012. All images: pigment ink on cotton paper, 42 ½ x 56 ¾ in.

GUY TILLIM

Since Gabon gained its independence from French colonial rule on August 17, 1960, it has been ruled more or less by one family. Apart from the first few years when Léon M'ba was president, Omar Bongo Ondimba held the office for over four decades, until 2009 when his son Ali Bongo Ondimba took charge. Consequently, the capital's name, Libreville (French for "Freetown"), rings somewhat with irony. Guy Tillim, one of South Africa's most influential photographers, arrived in Libreville in 2012. The series that he created there does not simply reveal urban topography, but also investigates various shifting ideas of landscape: he frames this contemporary African cityscape as history, as ideology and even also as conscience.

Tillim was born in Johannesburg in 1962, which means his lifespan is roughly congruent with postcolonialism in Africa, although the transition did not happen in his own country until much later. From 1986 he worked as a freelance photojournalist under apartheid for local and foreign media, including at various times Reuters and Agence France-Presse. "What the foreign newspapers really wanted from us was an illustration of the injustice that was happening in South Africa," he recalls. "This was very beneficial in some senses that it exposed that injustice, yet at the same time it went some way toward creating another orthodoxy because there was a certain formula for describing what was happening there." He gradually became bored by this formula but crucially it made him reflect on

alternative ways to approach representing photographic subjects. He became aware of the problems inherent in framing, saying: "We would desperately go in search of an iconographic moment, but the texture or the context of a place was often lost . . . because outside that frame was often the context." Thoughts about the nature and power of representation, and the language of photography began to preoccupy him; they would soon become his focus.

In the mid 1990s, Tillim (like Graeme Williams, see p.246) became fascinated by what was happening to Johannesburg in the wake of apartheid. There was a mass exodus of white people leaving the city for the suburbs as marginalized black communities moved into its center. Visiting his grandmother who lived in a concrete high-rise downtown, he saw how rapidly and radically this area was changing and decaying. "Windows were broken and not repaired. Elevators froze and their shafts became waste dumps." He adds, "The buildings started looking like fire hazards." He decided to move in and rent an apartment, wryly observing, "I was the only white guy on the block," and he set about documenting what was happening, creating a portrait of this failing city. However, weeks went by and he struggled. He seemed to have reached an impasse; the images were not working. He then had what he describes as a turning point. "I remember the moment so well, I was working on a rooftop," he says; he experienced this dawning realization that he had to refrain from looking for the journalistic drama in a scene but rather take a step back. "I didn't need to grab an image, I could really let it go," he explains. "It was only then that I could be in places and attempt to let the place speak for itself." The result was his renowned body of work "Jo'burg" (2004): a series

4 *Founding Residence of Léon M'ba, First President of Gabon,* Libreville, Gabon, 2012 5 *Boulevard Omar Bongo,* Libreville, Gabon, 2012 6 *Stade Omar Bongo,* Libreville, Gabon, 2012. All images: pigment ink on cotton paper, 42 ½ x 56 ¾ in.

that marked a transition in Tillim's way of working. "What has concerned me since then is to try to look beyond not just my notions of beauty, my notions of drama which is often a false drama—it is creating some dynamic in a frame that moves us, that makes it beautiful but does not necessarily convey context." Tillim's various subsequent series—from "Congo Democratic" (2006) to "Avenue Patrice Lumumba" (2007–08)—chart his increasing interest in widening context through his use of the genre of landscape photography. He started photographing landscape in Angola, claiming that he found it enormously challenging and difficult: "Mainly because I would look at something and isolate certain elements to the negation of others," and thereby creating what he refers to as a kind of iconography that the viewer knows immediately what is photographed and what is not becomes insignificant. "Yet I began to feel strongly that if there was a democracy of elements within a frame, it would be a place you could enter. It wouldn't be a place of projection. It wouldn't be a place that you knew." Inspiration came from the journals that Captain James Cook wrote on his voyages in the late eighteenth century. Tillim avidly read about the debates they had on board Cook's ship about how to portray landscapes, noting not only how similar they are to those that we have today, but also to the ones he had been having with himself: questions such as "how much do you give the landscape and how much do you let it speak for itself?" The result was his first series devoted solely to landscape "Second Nature," shot first in French Polynesia and then in São Paulo (2010–11).

"Libreville," Tillim's most recent series, further explores notions of landscape. The buildings and monuments he frames clearly reference history and ideology. The image *Stade Omar Bongo* (see image 6) portrays the sport stadium, a modern day temple of power, christened to honor the capital's main ruler. His name recurs in *Boulevard Omar Bongo* (see image 5) as does his predecessor's in *Founding Residence of Léon M'ba, First President of Gabon* (see image 4). South African critic Percy Zvomuya reminds us of Omar Bongo's extraordinary wealth and how he once reputedly said, "Don't speak to me about corruption. That is not an African word." He comments on how Tillim juxtaposes grand against poor, "inviting us to question some of these hierarchies." However, the series also draws on the aesthetic concerns developed in "Second Nature." Tillim's lens captures vistas that are both vast and detailed, still and sharp. His democratic eye refrains from giving any one thing predominance. This prompts direct engagement from the viewer, in which they are left to scour the landscapes in search of meaning. "What is photographed?" he asks. "Nothing, and everything, when you have no desire to leave the frame." "In making photographs of the landscape, I have to confront the difficulty of actually seeing the landscape. It's a space that changes its face with a glance or a ghost of a thought." Ultimately, Tillim's urban landscapes convey unknowability; instead they become sites of reverie in which we start to wonder whether what matters most is how we perceive them.

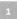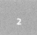

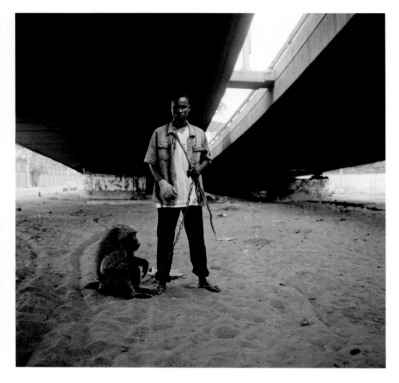

LAGOS
BORN 1976, Johannesburg, South Africa **LIVES** Cape Town, South Africa **SERIES**
"The Hyena and Other Men," 2005–07; "Nollywood," 2008–09 **OTHER GENRES**
Portraits, documentary **OTHER CITIES WORKED** Johannesburg, Cape Town

PIETER HUGO

Lagos is the largest, most populous city in Nigeria. It is also reportedly
the second fastest growing city in Africa and the seventh fastest in
the world. In 2005, the South African, Cape Town–based photographer
Pieter Hugo flew to Lagos in search of his next subject. The series he
created, "The Hyena and Other Men," catapulted him into the public
view. It arguably remains to this day his most famous body of work.
It portrays a band of men who capture and tame wild animals, from
hyenas and baboons to pythons, for sideshows. They are known in
the Hausa language as the *Gadawan Kura* (the "Hyena Men"). Hugo's
series is not simply striking for its content, however, but also for the
style in which it was shot. Elisabeth Biondi, influential curator and
former visuals editor of *The New Yorker* magazine, claims: "the images
just stop people in their tracks. You can't look away."

Hugo recalls how the project started, it "came about after a friend
emailed me an image taken on a cell phone through a car window

in Lagos." The hastily snapped picture revealed a group of men
walking down the street with a fully grown but muzzled hyena on
a leash. He then saw the same image reproduced in a South African
newspaper under the caption "The Streets of Lagos." The papers
variously reported the men as bank robbers, drug dealers, even debt
collectors. "Myths surrounded them. The image captivated me," says
Hugo. Mere days later, he had touched down in Lagos, met up with
a Nigerian reporter called Adetokundo Abiola, and together they
eventually managed, via various cities, to track down the peripatetic
gang and their menagerie.

Hugo initially spent two weeks traveling with the Hyena Men but
was not quite satisfied with the images he had made. "The project
felt unresolved," he says, and so in 2007 he returned. The second trip
was markedly different. Having kept in touch with the men over the
intervening years, their relationship had evolved a level of trust.
Consequently, the men were more eager to pose and have their picture
taken. Hugo peeled individuals off from the gang and framed their
"performances" in expansive urban locations with his Hasselblad
camera. The resulting large-format photographs – such as *Mallam
Mantari Lamal with Mainasara* (see image 2) – reveal such direct,
open gazes that they almost appear confrontational. Reading what he
wrote in his notebooks during the trip, Hugo has since been struck by
certain words he repeatedly used, such as dominance, codependence,
and submission. Such themes ripple through the images, and he
correctly attests, "These pictures depict much more than an exotic
group of traveling performers in West Africa." The South African
writer Bronwyn Law-Viljoen observes, "He directs an understated
drama that poses more questions than it answers." Biondi also notes,
"The urge is to not look away however much we want to."

Not all criticism has been welcome. Hugo has been accused of
exploiting the exotic "otherness," the "African spectacle" of the
Hyena Men: a charge to which he retorts, "I reject that view utterly."
The individual images in this series do not depict what he describes
as "some stolen romance." He points out that he always asks for his
subject's permission: "The photographs were taken on their
conditions, and you can see this. They have complete agency." He
counters that such criticism often smacks of condescension, the
implication being that the Hyena Men are incapable of deciding for
themselves whether they should, or should not, take part. "And, you
know, it always comes from white, liberal, European people, which
suggests to me that there is something essentially colonial about
the question itself." Ultimately, whatever responses Hugo's work
provokes, they are usually powerfully felt.

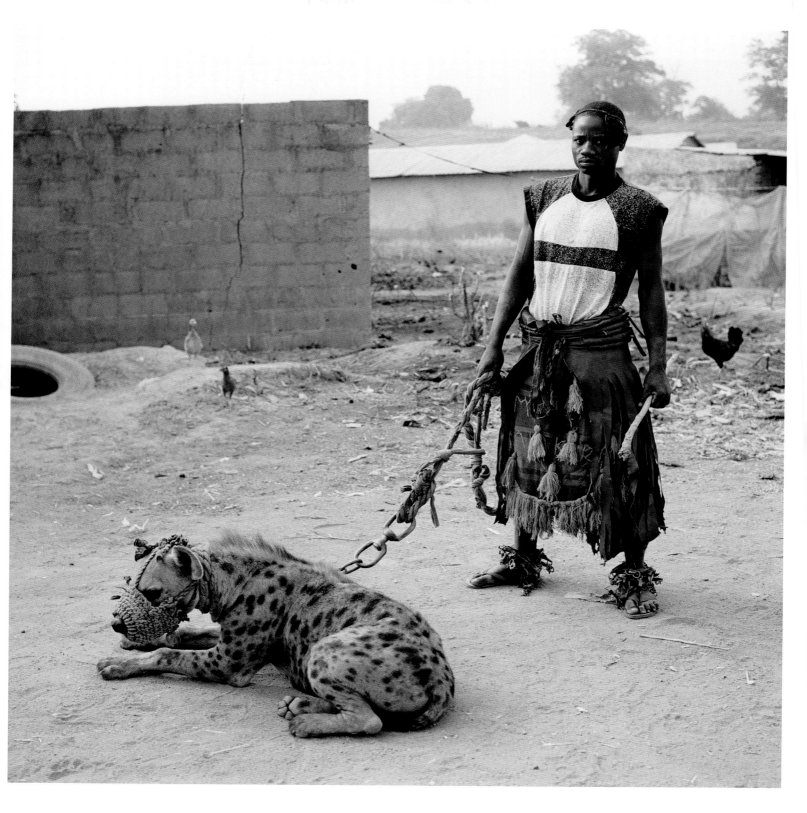

1 *Ivy*, 2010. C-print.
49 ¼ x 39 ⅜ in.
2 *Codex*, 2010.
C-print. 31 ½ x 25 ⅝ in.

MOSHI
BORN 1972, Amsterdam, The Netherlands LIVES Amsterdam
STUDIED Hogeschool voor de Utrecht and Ateliers Arnhem, The Netherlands
SERIES "Parasomnia," 2008–11 OTHER CITIES WORKED Nairobi

VIVIANE SASSEN

Two youths embrace, yet the banana leaf pressed between them refuses skin contact. A boy in a white tank top balances an open book across his upturned face. These compositions, often lit by the blinding African sun, reveal vivid colors and deep black shadows that interlock in such a bold, flat aesthetic that they appear as graphics, collage, even sculpture. They resist simple reading, as well as categorization; features that could offer clues, such as faces, tend to be either obscured or turned away. Indeed, the imagery by Dutch artist Viviane Sassen seems to revel in ambiguity and mystery. The series is titled "Parasomnia" after the term describing a range of disorders that occurs when the body hovers between sleep and wakefulness. "Photography is in some way about that for me. Putting one foot in an unconscious world," she contends. The art critic Ken Johnson similarly senses that her "pictures are like clear glimpses emerging from otherwise murky dreams." As with our dreams, Sassen creates places of uncertainty that evoke an atmosphere of foreboding. She adds, "I want to seduce the viewer with a beautiful formal approach and at the same time, leave something disturbing."

Sassen, who lives in Amsterdam, first studied fashion design at the academy in Arnhem and worked briefly as a model for Viktor & Rolf. However, she quickly became bored of being photographed in the same, clichéd poses. "I was sick and tired of the male gaze," she recalls. "I found that photographers would picture me and other women in a not-so-interesting, one dimensional way." Instead, she made a decision to step behind the camera, saying, "I wanted to be in control of the image: to create it." She transferred to study photography at Utrecht and within a few years of graduating she started taking commissions. By 2000 she was in high demand as a fashion photographer, working for a range of influential customers: from magazines such as *Wallpaper, Self Service, Purple,* and *Dazed & Confused,* to fashion brands such as Levi's and Stella McCartney. In 2002, however, prompted by a trip to Africa, her work took a very different direction. The result was an ever-growing body of fine art photography from various countries in East Africa. "Parasomnia" is the fourth series shot partly in the city of Moshi, Tanzania, but also

Nairobi, Kenya, preceded by "Die Son Sien Alles" (The Sun Sees Everything, 2002–04), "Ultra Violet" (2005–07), and "Flamboya" (2008). These personal projects have garnered glowing accolades; one critic even hailed them as "the most original, unexpected work to emerge from the continent by a Western photographer." Ultimately, they launched her career in the art world.

The trip to Africa was a return for Sassen. Between the ages of two and five, she lived in Kenya where her father worked in a polio clinic. "When I'm in Africa, I feel like I'm coming home, yet I also feel like I'm not one of them," she claims. She was the only white girl in the village and distinctly recalls her nanny Rispa Ogutu: "I remember the smell of her skin, the way she talked. She would wake me early and take me to a field to pick small white mushrooms." The list continues: "I remember the taste of sugar cane, orange Fanta, and bloody goat heads in the market in Kisumu." Coming back to her childhood home triggered many of these early memories and inspired her to explore them. "Working in Africa opens doors of my

3 *Belladonna*, 2010. C-print.
39 ⅜ x 49 ¼ in.
4 *Parasomnia*, 2010. C-print.
59 x 47 ¼ in.

subconscious," she notes. "Sometimes when I wake in the morning after very vivid dreams or if I just suddenly have an idea, I sketch." From there, she engages "friends, or friends of friends" as models, shows them the sketch and explains the idea. Together they embark on a quasi-collaboration in which Sassen coaxes a sort of performance from them to somehow recreate the original thought, memory, or dream for her medium-format Mamiya camera.

The work slips between various definitions and various genres. As already mentioned, it visually falls between photography, collage, and sculpture; Sassen adds, "In fact I see myself more as sculptor than a photographer." It also borrows heavily from her experience of the fashion world: trading in fantasy and make-believe to a certain degree. The collaborative performative aspect recalls the staging involved in the genre of constructed photography. She also cites magic realism and surrealism as influences. However, there is an undeniable element of documentary underlying the project. Critic Sean O'Hagan elaborates: "She seems to be moving away from fashion toward a kind of heightened documentary, where atmosphere and mystery are key elements."

The work has prompted heated debate. Photographer and writer Aaron Schuman comments that Sassen reduces her subjects to mere objects; he expands further by saying that the images "appear to ignore the individuals they portray and instead inherently possess— maybe even propagate—the problematic histories, legacies, and relationships between Africa and the West." O'Hagan deftly counters, "Perhaps more than any of her contemporaries, she has undercut the received image of Africa as a continent of conflict, suffering and poverty." Although Sassen herself admits, "I somehow like the idea of objectifying the human body and making it into a shape, or a sculpture," the enterprise is highly personal. Ultimately, Sassen's imagery is not about African people or places; it is more about her own self. By delving into her subconscious, her childhood memories, her fantasies and dreams, "Parasomnia" reads as a form of self-analysis, or perhaps an extended, serial exercise in self-portraiture. "I am trying to evoke that parallel universe I experienced as a child and that I could not find when I came back to Holland. All artists, to a degree, make self-portraits—that is what I am doing in my own instinctive way."

LUANDA

BORN 1977, Luanda, Angola **LIVES** Luanda **STUDIED** London College of
Communication; University of Wales, Newport **SERIES** "Found Not Taken,"
2010–present **OTHER CITIES WORKED** London, Newport

EDSON CHAGAS

A deflated, threadbare soccer ball lies at the foot of an Yves Klein blue
wall; a tattered, muddy sneaker stands on a dirt road; the upper half
of a mannequin is propped in a doorway. The series "Found Not Taken"
portrays objects that have been abandoned on the streets of Angola's
capital, Luanda. In fact, the items have been carefully placed against the
blank canvas of a building façade or wall, then framed through a camera
by artist Edson Chagas. He explains, "Sometimes I see the object in the
right place and I shoot it. Other times I move it: maybe five feet or
a mile." The exploration of the city adds a performative gesture to the
work and the photographs provide a record. Luandan curator Suzana
Sousa describes the result as "urban taxonomy" and "urban
cartography" that mix documentary precision with poetic
reconstruction. In 2013 "Found Not Taken" formed the centerpiece
of the Angolan pavilion at the 55th Venice Biennale, and it launched
Chagas's career when it earned him the prestigious Golden Lion award.

Chagas was born in Luanda but he studied for some years in Britain.
By the time he returned in 2008, his hometown was undergoing a
transformation. Angola was thriving and had become one of the
fastest growing economies in Africa. "While I was growing up in
Luanda, everything was reutilized," Chagas recalls. However, on
his return, he regularly found objects, such as sofas and washing
machines, that would previously rarely have been left on the streets.
"My city [was responding] with a sense of vibrancy and renewal. I was
struck by how consumerist habits were changing."

The discarded objects shown in "Found Not Taken" comment, in
various ways, on the society to which they belong. As Sousa aptly points
out "where on the one hand, they are merely utilitarian . . . on the other,
they occupy space and meaning in our homes and lives" and because
they cost something "they represent the daily bread of a lot of people."
Consequently, the work can be read as a critique on consumerism, lack
of recycling and capitalism. However, Chagas decontextualizes these
everyday household items by repositioning them in near-blank urban
spaces and creates aesthetic, almost sculptural arrangements. Chagas
has taken his ongoing series to London (as well as Newport, Wales),
adding "the project continues and will go wherever I go'.

1	2	3
4	5	6
7	8	9

1–9 From "Found Not Taken," Luanda, Angola, 2010–present

DAKAR

BORN 1967, Germany **LIVES** London, UK **STUDIED** London College of
Communication; University of Westminster, London **SERIES** "Phantom," 2003
OTHER GENRES Landscape **OTHER CITIES WORKED** London, New York

1 *Wourouss*, Dakar, Senegal, 2003
2 *El Mansour*, Dakar, Senegal, 2003

RUT BLEES LUXEMBURG

In the winter of 2002, the German-born but London-based artist
Rut Blees Luxemburg traveled south to Dakar. She had been
commissioned by Tate Liverpool to undertake a project on the
Senegalese capital. Each image in the ensuing series exhibits an
unearthly, eerie color cast: acid greens pitted against fluorescent
yellows, rich golds against sulfurous oranges. The photographer
admits, "The serious amateur would be horrified by certain results
I get, in terms of color balances." Yet these saturated hues are
deliberately created by her decision to make long nocturnal
exposures. She leaves the shutter open for as much as ten to fifteen
minutes so that the light from neon signs and street lamps slowly
etches itself on the negative. Blees Luxemburg uses her camera in

this way to allow for what she calls "a transformation." She explains,
"Something other than what you see in your mundane, everyday
experience of the city can emerge. Something which is there but
perhaps which can be sensed better than it can be seen." She chose
to name the Dakar series "Phantom," thereby emphasizing this sense
of the other, the supernatural.

Blees Luxemburg moved to London from Germany in 1990 to study
photography first at the London College of Communication and then at
the University of Westminster. From the outset, she trained her lens on
cities, always making slow exposures by the glow of street lamps in the
dead of night. Consequently, her imagery exhibits a signature style; it
appears strangely lit and deserted, conjuring up ideas of desolation,
abandonment and other-worldliness. She first came to prominence
with "London: A Modern Project" (1997), which focused on the City and
the East End. Two of the images made their way into mainstream
popular culture when English hip-hop group The Streets chose one for
the cover of their debut album *Original Pirate Material* (2002), and Bloc
Party used another for their second album *A Weekend in the City* (2007).
The series "Liebeslied" (1999–2000), which translates as "love song,"

soon followed and was again set on the highways and thoroughfares of her hometown. Yet her practice, despite its urban focus, is arguably the antithesis of street photography. She notes that her "5x4 camera is the opposite of what the street photographer would use. It requires slowness and concentration." Also, her lingering exposures are in stark contrast to street photography's more typical decisive moments. Instead, she argues, "It's another kind of street photography. Or maybe 'street' isn't even important." She wonders "perhaps 'public' photography is better."

Her practice has been compared more to painting than street photography. She often takes a picture of her subject with a 35mm camera before returning to the site with her large-format camera. Curator and critic David Campany suggests that the use of such preliminary studies "is quite a painterly activity." Blees Luxemburg explains, "I take a very deliberate number of photographs. . . . For me it is more interesting to concentrate on less, and perhaps in one image enough happens to keep you engaged for a longer period, instead of moving on to other images." Campany counters, "That means you have an output that parallels a painter more than a photographer." Indeed, this approach certainly implies more consideration and deliberation than the shoot-from-the-hip style of street photography. However, her aesthetic as well as her technique has been pronounced painterly; art critic Barry Schwabsky describes how her images exhibit "the downright Old-Masterish haziness that had seemed banished from photography along with the pictorialism of the late nineteenth century." Furthermore, she underscores this feeling by printing large-scale and creating tableaux.

Perhaps what aligns her most to street photography, however, is how her work revolves around walking. In a past series, she equated her process to the wanderings of a poet in search of an encounter, rather than the *flâneur* made famous by Baudelaire. "In a way the motion induces a certain state of mind," Blees Luxemburg comments. "It's not dreamlike but it is almost meditative." On arriving in Dakar, she took to its streets after all the daily events and activities had ceased. Images, such as *The Libertine Sofa* (see image 5) were taken on the Dakar Corniche, a coastal road that runs between the sea from the city and during the day rings with the cries of craftsmen and street hawkers selling handmade furniture. She hoped to find images that would portray a modern African metropolis in an atypical light. As she walked, she searched for how Dakar's unique history had inscribed itself on the buildings; how various architects from the French colonials to the Senegalese modernists had translated it into concrete reality. "When you enter a city for the first time, you tend to be more visually

sensitive," she recalls: "I immediately responded to the city's way of displaying itself, looking for signs to interpret and decode the place."

The result was works such as *Immobiliere* (see image 6), which depicts an advert for a local architectural practice; *El Mansour* (see image 2, p.279) reveals a quintessential example of African modernism, described by the artist as a building that "extends itself like the bellows of a camera." Yet, before she even noticed the buildings, she saw signs, specifically immense posters announcing the imminent wrestling match between Mohamed Ndao "Tyson" and Sérigne Dia "Bombardier." The resulting image *Tyson/Bombardier* (see image 4) presents one such vast billboard displaying these oiled,

near-naked wrestlers standing bicep to bicep. The event, scheduled for Christmas Day 2002, was so important that Senegal's world-famous musician Youssou N'Dour composed a song in its commemoration. Blees Luxemburg instantly saw how the wrestlers had been elevated to the status of mythological heroes. She asks us to "imagine the fight between Achilles and Hector being advertised in Troy!" *Tyson/Bombardier* is the only image showing human figures in the series. Eerily, the poster displays them standing in front of their negative image. This creates another dimension that works alongside Blees Luxemburg's trademark color casts to shift the picture into an ethereal, or as she says, "phantomlike" otherworld.

DAKAR
BORN 1975, Palermo, Sicily LIVES London, UK SERIES "En Route to Dakar,"
2007–08 OTHER GENRES Photojournalism, documentary OTHER CITIES
WORKED Rio de Janeiro, Athens, London, Peshawar, Palermo

MIMI MOLLICA

When Mimi Mollica visited Dakar for the first time in April 2007 it was a vast building site. A number of large-scale building projects were underway causing chaos throughout the city, the most ambitious of which was the creation of the country's first highway. Construction had started on the proposed 20-mile-long Dakar Diamniadio Toll Highway that promised to connect the capital to the rest of Senegal. Elena Baglioni, a specialist in development studies (and Mollica's wife) recalls the experience: "The air, saturated with sand and dust, was transformed into a dense barrier when the Harmattan blew. Pollution reigned." The new highway has since opened for business amid much pomp and ceremony. However, Mollica witnessed its formation—how it reshaped the city and how the locals inhabited and related to this emerging transitional space.

Mollica visited the Senegalese capital three times in total and, with advice from his mentor, artist, curator and writer Martin Parr (see p.384), he created the series "En Route to Dakar." Curator Sophie Howarth describes how the resulting images "vividly convey the stench of new tarmac being laid in oppressive heat, the stink of fetid water and the diesel fumes billowing down this black ribbon of road." Yet they are also bustling with people: shepherds selling sheep, street sellers hawking food, flowers and all manner of wares, and drivers pulling up to buy. Baglioni adds, "All around people bargain, build, chat, cook, do the laundry, even pray." "En Route to Dakar" captures the human face of a city experiencing successive waves of destruction and construction.

Mollica grew up in Palermo, Sicily, the son of a dedicated amateur photographer. "That is when my love of the visual poetry started," he says. At the tender age of nine, he started to take his own pictures, and his mother, recognizing her son's enthusiasm, bought him a book of Magnum photographs. It was a turning point, he recalls: "The illustrations revealed to me a beautiful reality so there was no going back, I was hooked. In fact little has changed, for me, Magnum is still the temple." At twenty, he moved to London and found work assisting the architectural photographer, Hélène Binet, used by well-known architects such as Zaha Hadid and Daniel Libeskind. Little more than a year later, in 1998, he embarked on his lifelong dream of becoming a reportage photographer. Today he works for magazines and nongovernmental organizations covering paid (as well as personal) assignments throughout the world.

He is somewhat unusual for a reportage photographer; in place of a traditional, lightweight 35mm camera, he occasionally opts for a heavier, medium-format Hasselblad. He says, "I like the way that this camera forces me to slow my pace." He believes it focuses his mind when composing images; the framings do appear structured and considered. "Hélène Binet once described the square format that struck home," he recalls. "It is a very democratic format in that each side is equal to the other, creating a composition without a hierarchy imposed by the frame, but only set following your choices as a photographer." Mollica also feels that it spurs the viewer to spend more time reading each image.

On his first visit to Senegal, what struck him most about the road's construction site was its palpable three-dimensionality. A network of bridges, overpasses, exit ramps, and vast heaps of variously hued sand, soil, and rubble created a strange and surprising visual world. "I was attracted by a landscape in the middle of a drastic transformation but what was really interesting is that I immediately felt immersed within it. It was a surreal place with strange perspectives between different planes of view." This is also one's first impression on viewing the imagery. Strong diagonals, verticals, and horizontals zigzag across the frame, bisecting each other; the viewer is prompted to recall his earlier work with Binet as the pictures appear highly architectural. Two directly opposing aesthetic strategies seem to be at play; at times the lines of these various paths crisscross into a dead end, otherwise they might recede and lead the eye away. The images are by turns either confined, almost claustrophobic, or spacious, almost infinite.

Mollica asserts, "My first impression was very instinctive; the place looked very photographic and it was love at first sight. However, I then started to digest what I had seen, to research and look for something to motivate my story. Little did I realize but this autoroute was the current buzz word in Dakar." His wife was studying development in the city for her Ph.D. and she recalls, "The expectations for this road were high. Once completed it was widely thought that the port would prosper again, buses would speed up their journey in and out, commuters would reach work more easily, trade would blossom, construction would flourish, and in familiar jargon wealth would 'trickle down.'" There was an overriding sense that the autoroute held much promise and in Mollica's eyes suddenly it became a narrative framework for wider sociopolitical, economic, local, and international issues. Yet Mollica's daily experiences, walking the site from dawn to dusk, told a very different story. In between taking photographs, he would talk to whoever he could strike up conversation with and he discovered that nearly every single person—workers, businessmen, poor, rich, women, men, old, young—more than anything, wanted to emigrate to Europe. He recalls, "So in my mind the autoroute became not only a physical place, a symbol of change and engineering progress, but also a metaphor for a way out from something, for escape." These hopes and aspirations make sense of the alternating architectures; "En Route to Dakar" ultimately reads as a series hinting at entrapment and release, imprisonment and freedom.

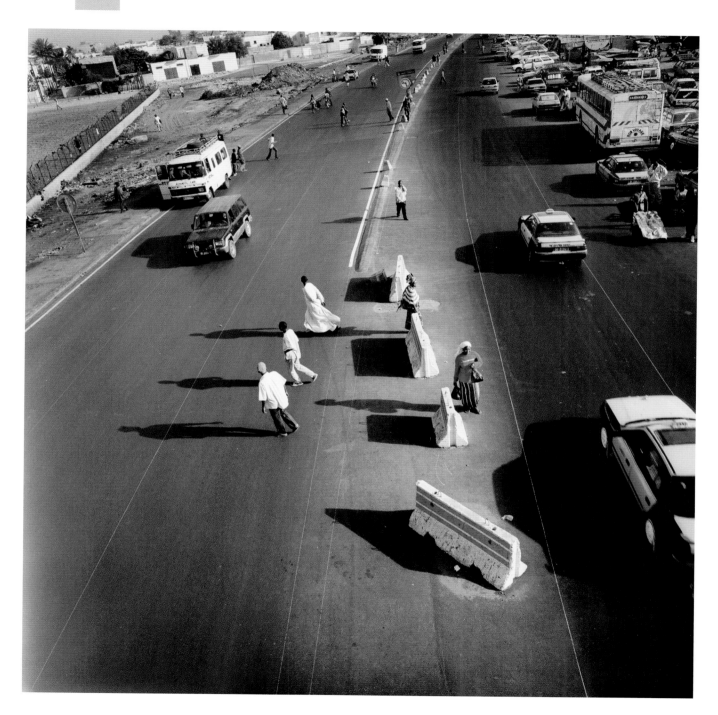

YTO BARRADA

TANGIER
BORN 1971, Paris, France **LIVES** Tangier, Morocco, and Paris **STUDIED** Sorbonne University, Paris; International Center of Photography, New York **SERIES** "A Life Full of Holes: The Strait Project," 1999–2003 **OTHER GENRES** Conceptual, documentary

"I thought: people say it's better to have no life at all than a life full of holes. But then they say: better an empty sack than no sack. I don't know." Moroccan artist Yto Barrada introduces her work with this quote from the book *A Life Full of Holes* (1964) by the illiterate Tangier servant Driss ben Hamed Charhadi that U.S. author and translator Paul Bowles recorded and then translated. She also borrows the title for her photographic series. "A Life Full of Holes: The Strait Project" considers the impact on her Moroccan hometown of Tangier of the creation of the Schengen Area in 1995 that restricts African access to Europe. The philosopher Nadia Tazi argues that the Strait of Gibraltar became a Berlin Wall, suggesting it "is seen not so much as a place but a state of being. . . . A kind of doctrine of the afterlife that sees exile, an impossible exile, as its ultimate horizon." The Strait now lures people with the promise of a better life; every year thousands of people cross the border, or die trying. Tangier has become the gateway to the Strait, and in Barrada's words, "the jumping off point of a thousand hopes."

Barrada was born in Paris, but grew up and was educated in Tangier. She is one of the rare privileged dual citizens who has unimpeded access back and forth across the border. This freedom of movement prompted her to consider those less fortunate. Curator Alona Pardo recognizes that "Her work is informed by living both within and between these two parallel geopolitical realities: between the Occident and the Orient, between hope and despair." Barrada herself argues that this was the point of departure for her work. "What is the condition of a country whose people are all leaving, or trying to leave?" she asked. "I came to realize that this fatal drive to leave . . . is today inscribed in a whole people."

The series moves beyond traditional documentary by presenting snapshots of quotidian street scenes that resonate with symbolic significance. Barrada's photographs show dividing lines, ditches, walls or barriers; in the overhead shot *Le Détroit, Avenue d'Espagne* (see image 1) the empty expanse of tarmac facing the model ship hints at the expanse of sea that separates Morocco from Europe, the Strait. The images depict figures on the move. "We see people from behind, turned away from the camera as if they're departing,"

1 *Le Détroit, Avenue d'Espagne*, Tangier, Morocco, 2000. C-print. 23 ⅝ x 23 ⅝ in.
2 *Container 1. Rust Holes in the Top of a Shipping Container*, Tangier, Morocco, 2003. C-print. 23 ⅝ x 23 ⅝ in.

suggests art historian and critic T. J. Demos thereby revealing their thwarted desire to be elsewhere. Art historian Anthony Downey adds that another image in the series, *On Ferris Wheel, M'Diq* (2001), serves as "a metonymic reminder of a people who are constantly in motion but apparently not going anywhere." However, perhaps the most haunting image is *Container 1. Rust Holes in the Top of a Shipping Container* (see image 2). At first this reads as some strange map, yet the title reveals that the view is actually of sky seen through the rust holes in a shipping container; the sense of freedom and exploration suggested by the image suddenly twists into confinement and claustrophobia. Moreover, the image reminds us of how people have tried to escape these shores, as Downey observes, "This rusting shell becomes a mausoleum of sorts, a veritable death-trap for the unfortunate emigrant forced to make the often perilous journey across the Strait of Gibraltar."

1–2 From "Watercolors," Narelle Autio, Sydney, Australia, 2001–04

AUSTRALIA
SYDNEY MELBOURNE

TRENT PARKE NARELLE AUTIO BEAT STREULI BILL HENSON JESSE MARLOW

3 *Woodsmen*, Jesse
Marlow, Melbourne,
Australia, 2007

"I like chance," claims Trent Parke. "If I know exactly what is going to be on the film then I can't be bothered processing it." The beauty of the serendipitous event or the spontaneous encounter appeals to many of the featured Australian artists: so too does a desire to explore the strange in the everyday, and an interest in the subconscious and dreams. Many of these elements once delighted the Surrealists and fueled their fascination with the medium of photography almost a century ago. Today a recurring theme emerging from the Australian continent is how the urban environment continues to inspire and foster a sense of the surreal.

Melbourne-based photographer Jesse Marlow wanders the streets of Melbourne looking for images that are so absurd that they almost beggar belief. He explains, "For me it's all about searching for the extraordinary in the ordinary." This Surrealist sentiment resonates with street photographers on the other side of the world; Londoner Matt Stuart (see p.144) describes his best street photograph as one in which "there is no way you can stage or even think it up." Yet, Marlow's series "Don't Just Tell Them, Show Them" (see p.308) can be read as a highly concerted attempt to seek out the surreal in the real. He employs the harsh Australian sunlight to create deep and dislocating shadows. His eye is finely attuned to search for surprising viewpoints. Marlow explains, "I deliberately want to challenge the viewer to ask: 'Am I seeing things?'" With images such as the head-scarfed lady with laser vision, the Mondrian-esque composition missing a rectangle and the three headless bodies draped over a Dumpster, Marlow achieves precisely that.

A trademark feature of Narelle Autio's work is her proclivity toward the surreal perspective (see p.296). "The Seventh Wave" series, created in collaboration with her partner Trent Parke, explores the Australian preoccupation with the beach. Not content to look at it through the eyes of regular beachgoers, Autio and Parke traded habitats; they submerged themselves beneath the waves and framed the entire series from an aquatic animal's point of view. By contrast Autio next headed skyward for her "Not of this Earth" project (see p.302). She scaled the heights of Sydney's Harbour Bridge in search of dizzying, vertiginous views peering down at the city's inhabitants enjoying summer in the parks. Sydneysiders are rendered antlike and from such unexpected angles that the viewer struggles to ascertain exactly what they are looking at. Sun-worshippers appear unmoored and floating free on a sea of green, dog-walkers seem towed by their companions and overall people give the impression of being less substantial than the shadows they cast.

The Surrealists believed in the omnipotence of the subconscious and the importance of dreams. One Australian series, arguably more than any other, acts to engage with these themes: Trent Parke's tellingly titled project "Dream/Life and Beyond" (see p.292). "For me it is very personal—it's about what is inside me. . . . The camera helps me see things," he elaborates and adds that with "Dream/Life and Beyond," "I wanted to suggest a dream world." Curator and ex-director of the Australian Centre for Photography, Alasdair Foster describes the series as "a vision of Sydney quite unlike any other." Sometimes the city appears as randomly snatched fragments from dreams; figures cloaked entirely in light shimmer like strange and marvelous apparitions, and solar shafts pierce gloomy street corners with celestial effect. "I am forever chasing light," he observes, "light turns the ordinary into the magical." Indeed, he is so smitten with the sharp, strong and crisp qualities of the Australian light that he claims to find working elsewhere in the world difficult. Ultimately, what Parke excels at is chiaroscuro; he treats his photographic frames like canvases using the presence of light as much as its absence. He renders Sydney as darkness falls, inky black and brooding. At these times, Parke's lens succeeds in recasting a city known for its color and vibrancy as an ethereal and foreboding shadowland.

Motifs of the magical and mythical can be found through much of the work coming from this continent. Whether primed for chance events, strange encounters, or disorientating perspectives, many of the ensuing artists seem to exhibit a preternatural ability to conjure up the uncanny in the everyday and the surreal in the real. Ultimately, the world appears transformed and the shifting facets of the Australian urban experience—its streets, its parks, and its beaches—are rendered as shifting and as surreal as dreams.

1 2

3 4

1–4 From "Dream/Life and Beyond," Sydney,
Australia, 2001–02

SYDNEY

BORN 1971, Newcastle, New South Wales, Australia **LIVES** Adelaide, Australia
SERIES "Dream/Life and Beyond," 2001–02; "Minutes to Midnight," 2003–04
OTHER GENRES Photojournalism **OTHER CITIES WORKED** Canberra, Cairns

TRENT PARKE

Sydney appears through a lens darkly. Buildings are rendered indistinct, blurred as if in the process of dematerializing. People flit through frames as dim spectral flickers and where occasional shafts of light pierce the gloom, they burn bright, almost incandescent. "I am forever chasing light. I rely on it," claims photographer Trent Parke. "Light turns the ordinary into the magical." He set out to present a dreamier, darker vision of Australia's biggest city, not the typical picture postcard clichés. He claims this was only made possible by the unique quality of light one finds there: a searing, unpolluted light that "just rattles down the streets." He wields it to mesmerizing effect in his two series "Dream/Life and Beyond" and "Minutes to Midnight" and transforms Sydney into an ethereal and brooding shadowland. Indeed, these two bodies of work earned him the first ever invitation for an Australian to join the respected ranks of Magnum, and he has been fairly praised as "one of the most innovative and original contemporary photographers," with "one of the most vivid visual signatures in Australian photojournalism."

Parke grew up on the outskirts of the town of Newcastle in New South Wales, where, in his words, "the suburbs meet the bush." His interest in photography started when he borrowed his mother's Pentax Spotmatic 35mm and persuaded his parents to convert a corner of their laundry room into a darkroom. Later in 1992, he left home to live in Sydney in the hope of finding work as a photographer.

It was not long before he was offered a job at the city's tabloid newspaper, the *Daily Telegraph*, to photograph the Australian cricket team and the next ten years were spent honing the skills of sport photography. Part of his artistry as a street photographer was learned during that period: his instinct for anticipating movement. He explains, it "really gave me that extra edge when I was shooting on the streets because I could sense all the elements of a picture while they were still forming around me." However, perhaps the experience that most shapes his practice happened many years previously.

When Parke was twelve, his mother died one night from an asthma attack. It was so sudden and unexpected that it left a great impression on her son. "It was this turning point," he explains, it was "the thing that changed my life forever because it made me question everything around me, every tiny little thing that I was looking at and still do. Why has this happened? What is this all about? What is this world I'm living in? Why am I here?" These concerns remain important to him today; they inform and inspire the way he looks at the world. When he describes his practice he frames it in words that suggest some sort of existential quest: "My photographs are more questions than answers. I use photography as a way to help me understand why I am here. The camera helps me see. It's my journey: an exploration of my life." Indeed, it is this highly personal approach that elevates the work beyond simple documentary.

"Dream/Life and Beyond" was started the year that Parke arrived in Sydney. Having left his family, friends, and everything familiar, he decided to immerse himself in photography. "So I did what I always

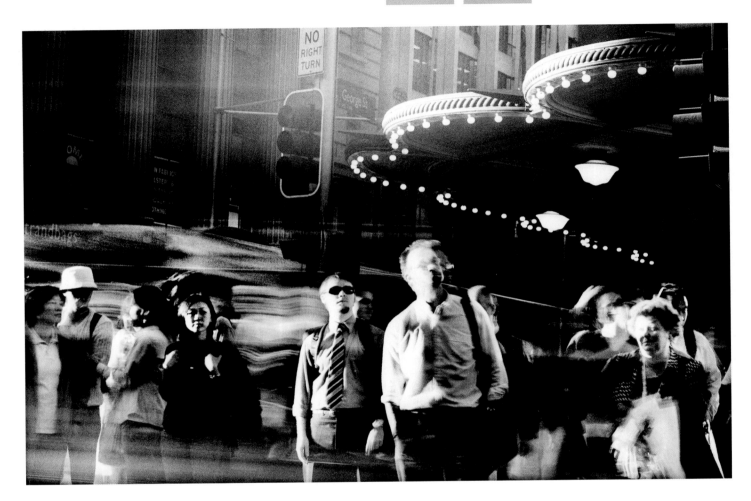

do: I went out onto the street and used my Leica to shoot how I felt at the time," he recalls. "I went out every day; it became like a drug for me." Yet these days and months spent walking the Sydney streets enabled Parke to perfect his technique; it is when and where he learned to work with light. "Trouble was the city was actually quite ugly," he recalls. However, he soon discovered the harsh Australian sunlight could come to his aid. He started to use it to create deep shadows that would obliterate advertising posters, billboards, and other unnecessary clutter. They also had the added effect, as he points out, of making "the scenes blacker and more dramatic."

Roaming around with his wide-angle lens and high-contrast black-and-white film, Parke quickly learned which parts of the city offered rich pickings. He homed in on the activity and opportunity of the city's business center. Due to its relatively small size, he found himself repeatedly circling the same streets, over and over. However, this restriction imposed a new and interesting dynamic on the work; it forced him to invent novel ways of seeing the same place. He adds, "This in turn led to constant experimentation, especially with light, and a concern with how photographic technique relates to the conceptual and emotional content of a picture." Indeed, one could argue that it instigated the single, most important dictate evident in Parke's practice: the rule that demands that there are no rules.

Critics often praise Parke's photography for its technical prowess and near relentless innovation. Curator Sophie Howarth proposes,

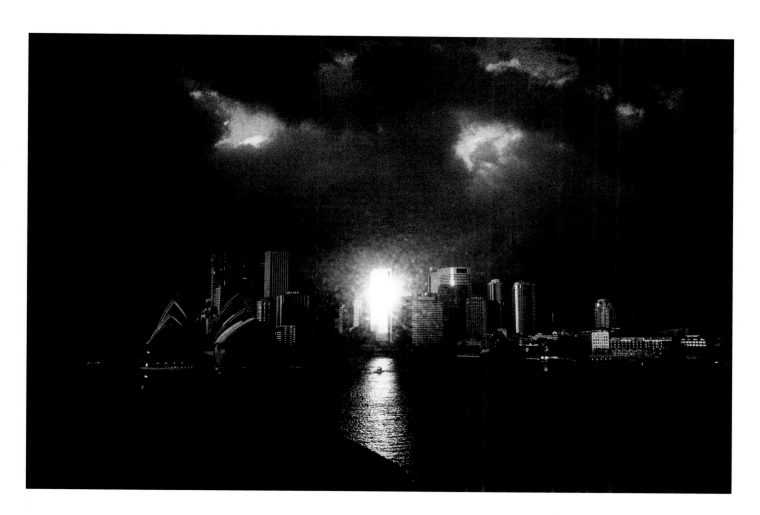

"Among contemporary street photographers, Trent Parke stands apart because of his restless urge to experiment with the . . . limits of the medium." When it comes to the photography manual, he defies all manner of usual instructions; in fact, he commits a whole litany of what could be termed "photographic errors." He ignores the conventional limits for shutter speeds, allowing people and traffic to smear their image across the film; he ignores the conventional limits for exposure times, voiding elements of the frame in darkness or brilliance. He throws the central characters within the frame out of focus, yet renders the smaller, seemingly insignificant dramas with pinpoint lucidity. He also revels in chance, quipping, "If I know exactly what's going to be on a film then I can't be bothered processing it. . . .

I like it when I see something unexpected on the negative. I think: 'How did that happen? I'm going to go back and work on that.' I will go out with that effect in mind for the next three to four weeks . . . just working away until I get it just right and come up with the image that best represents that little moment." Parke's radically expressive approach means that series such as "Dream/Life and Beyond" and "Minutes to Midnight" can be read both as fact and as fiction: as fragments of dreams or perhaps nightmares. Yet, consequently, they also read as a rigorous interrogation of his chosen medium. He concludes, "It's not enough for me just to be out on the street and shooting people—I need to be trying to push the medium of photography as well."

BORN 1969, Adelaide, Australia LIVES Adelaide STUDIED University of South Australia, Adelaide SERIES "The Seventh Wave,"1999–2000; "Watercolors," 2001–04; "The Summer of Us," 2009 OTHER CITIES WORKED London, Los Angeles

1–5 From "Watercolors," Sydney, Australia, 2001–04

NARELLE AUTIO

Australian artist Narelle Autio has an unusual take on street photography. Whenever she finds herself in an ocean-side city, she has a tendency to gravitate toward its stretch of coastline. When living in Sydney, she had the pick of some of the most famous beaches in the world: Bondi, Bronte, Clovelly, and Coogee are all within walking distance of the city center. "The beaches are where I always found myself walking to when photographing on the streets," she recalls. "I think of the work I do there as a type of street photography." Indeed, despite the swap from street to beach, asphalt to sand, suits to swimsuits, the practice remains much the same. Autio wanders camera in hand, up and down beaches, in and out of waves, ever ready for that fraction of a second when chance intervenes to create a moment that peaks her interest. She elaborates: "Most of the photography I do is found, rarely do I set out with a plan in mind. I am usually looking for the candid moment out in the public domain, that there is really no way to preconceive."

From an early age, Autio loved to paint. "On graduating from school I went to an art college with the vision of becoming a painter. Yet somehow I ended up with a camera, instead of a paintbrush, in my hand." She left Australia in 1995 and traveled extensively through Europe working as a photojournalist. On returning home in 1998, she continued in this career supplying photographs to an array of national and international newspapers, but also began investing time in personal artistic ventures. "Arriving back in Australia proved to be an awakening for me," she claims. "I realized there was so much here to photograph. Things I had grown up with, that I knew about and loved: all things that I had taken for granted. The only inspiration I needed was this country and the ability to see it with new eyes."

Her first photographic series, which earned critical acclaim, was perhaps inevitably ocean-drawn. "The Seventh Wave" (made in collaboration with her partner Trent Parke, see p.292) portrays people frolicking in the surf, shot in black and white and from beneath the waves. Submerged, one leaves the sun-drenched, seashore optimism and enters a surreal world of frantically paddling limbs and reflected impressions of colliding waves; the imagery ripples with a dark and menacing undertow. By contrast, and as the title might suggest,

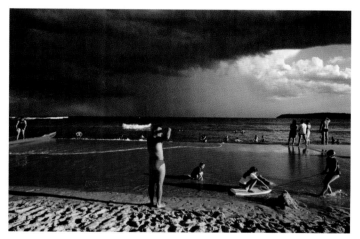

"Watercolors" stays at the beach but introduces color; the compositions are awash with various pigments, tints, and hues. Critic Virginia Baxter wrote of "Watercolors" that it offers "an almost painterly feel of place on the one hand and a suggestion of unconscious drama on the other." Although many of the pictures are framed above water, one still feels immersed and buoyed along by their atmosphere and energy. "I spend a lot of the day running up and down the water's edge trying to capture this particular sensation," declares Autio. "The kids playing in the shadows, scream and laugh . . . I get in among them. . . . I'm swamped by the wave and feel their energy soaking into me."

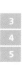

1–5 From "Sydney 98,"
Sydney, Australia, 1998

SYDNEY

BORN 1957, Altdorf, Switzerland **LIVES** Zurich, Switzerland **SERIES** "Sydney 98," 1998, "Sydney 02," 2002 **OTHER GENRES** Video **OTHER CITIES WORKED** New York, Tokyo, Düsseldorf, Zürich, Brussels

BEAT STREULI

"I would not wish to be too grand for streets. To be removed from them is to lose the blessing of the multitude." Critic Trevor Smith used these words from Jim Crace's novel *Arcadia* (1992) to illuminate the work of the Swiss-born, Zurich-based artist Beat Streuli. He adds, "Streuli's photographs and installations are among the clearest expressions today of how it is that we inhabit our cities." He has dedicated the last twenty years to photographing faces in the urban crowd, focusing on anonymous individuals in the heaving metropolitan mass. In doing so, he has now amassed hundreds of thousands of portraits from far-flung corners of the earth: New York to Ghangzhou, Tokyo to São Paulo, Cape Town to Jerusalem, London to Sydney. And it continues, for despite the accruing air miles, resolution remains tantalizingly out of reach. The project is essentially without end. Streuli describes it as an ever-expanding archive of global dimensions. Others describe it as a "street-wise version of the United Nations" and "a monument to contemporary humanity." What remains clear is that through no small amount of tireless obsession, Streuli has embarked on what might be the most epic endeavor in street portraiture ever conceived.

The way Streuli chooses to present the work reminds us that each image is part of a greater whole. Often he prints each portrait to monumental proportions then juxtaposes these large-format color photographs so that they play out horizontally like a filmstrip. He also creates slide shows or runs them together as films. These various tactics enable him to hint at the incessant movement of people and human restlessness within urban environments. In addition, from the outset Streuli decided to exhibit his installations in the public realm: on the streets and in the cities that gave rise to them. They appear as billboards (such as the vast one that ran the length of a Sydney street for the 1998 Biennale), as large posters in airports, as projections on vast screens and as gigantic translucent figures on the windows of banks and various corporations. The glossy appearance of these installations hints at cinema and television. They read as fashion and advertising images, yet viewers are confused when they cannot trace the logo or the commercial message. Streuli asserts, "I want to have installations that are big and beautiful just as the movies are, or great billboards, and without selling stupid products." Ultimately, they exist in the realm of mass media and consequently raise fundamental questions about the proper place of art.

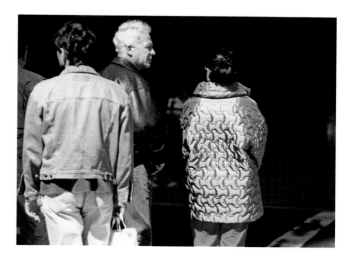

All Streuli's subjects are photographed in much the same way, which creates a sense of uniformity and therefore brings a sense of objectivity to the enterprise. "There are different ways of using our eyes: you can fix something or just take it in," he points out. "In the first case, one is much more focused, selective and intentional, in the second, one is more neutral, you could almost say 'democratic.' My way of taking pictures corresponds more to the second case." He sets up his camera on a tripod, across the road from a busy junction or street and frames passing faces from a distance through his telephoto lens. "I think it is easier to look at things against a neutral background, and this is why I hardly ever take pictures in poor suburbs where the social problems are obvious." Instead, he homes in on recreational areas such as shopping centers; the two series from Sydney were taken in 1998 and 2002. He avoids the dramatic in favor of mundane, inconsequential moments. Consequently, he has been said to "dismantle the decisive moment," and his work manifests an unspectacular way of seeing. Critic Katerina Gregos suggests, "The street society he photographs is the society of the 'unspectacle,' a vision of ordinariness which in its entirety alludes to the quotidian human condition."

The telephoto lens affords Streuli anonymity and his subjects rarely know they are being photographed. As a result, their faces are caught unaware; one wonders what can be seen in a face that does not know it is being watched; what is revealed, when we are unguarded and unposed? Walker Evans posed similar questions with the series he took on the New York subway between 1938 and 1940, when he surreptitiously photographed fellow commuters. Evans's monochrome imagery reveals passengers with almost vacant expressions, seemingly lost in thought and endeavoring to avoid the gaze of others. When the images were finally published as *Many Are Called* in 1966, he said, "As it happens, you don't see among them the face of a judge or a senator or a bank president. What you do see is at once sobering, startling, and obvious: these are the ladies and gentlemen of the jury." Yet, Evans's faces, like Streuli's more contemporary ones, remain impenetrable; little can be gleaned other than perhaps a sense of disengagement.

What can we learn from Streuli's imagery? Gregos suggests it reveals that "the reality surrounding us has become more fractured and complex." She adds "that contemporary life in the public arena has become less engaged and more autistic; that we all conduct ourselves less as part of a social whole and more as individual 'monads,' cut off from what happens around us." She also invokes the work of twentieth-century German sociologist Georg Simmel who explored the relationship of "the metropolis and mental life." Simmel developed the notion that a defining experience of living within a city is that we are forced to live among people who remain forever strangers. These thoughts paint a bleak scene, although perhaps there is something to be gained by living among strangers. Streuli's photos expound on the uniformity of the contemporary urban experience; the pictures of Sydney replay around the world. Yet, recalling Crace's words at the outset of this essay, they reveal the pleasure, or "the blessing" of getting swept away in the crowd.

6–8 From "Sydney 02," Sydney, Australia, 2002

8

6 7

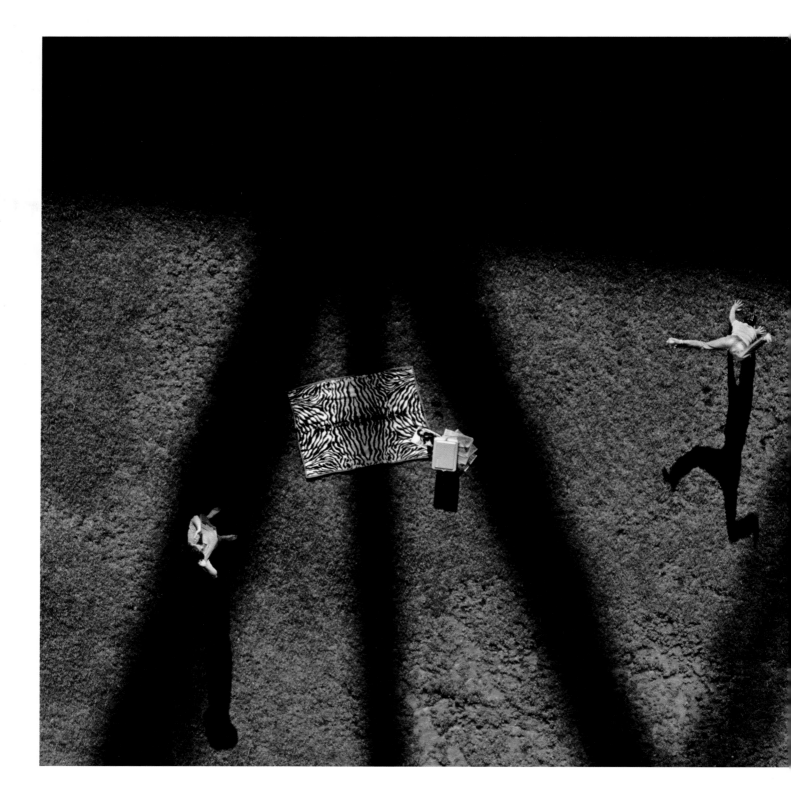

SYDNEY
BY NARELLE AUTIO

While living in Sydney many years ago I would walk to and from
work, across the iconic Sydney Harbour Bridge. The towering bridge
is a mecca for locals and visitors alike and as I wandered over it
I would photograph the freedom that was happening far below me.
In comparison to the deafening, rumbling of the vehicles crossing
with me, these quiet figures observed from high above felt as though
they were of another world.

MELBOURNE

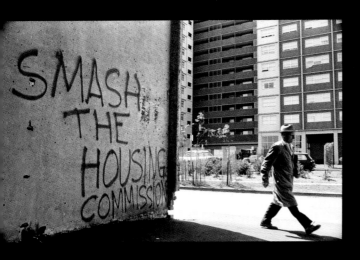

The approach to Sydney's Kingsford Smith Airport offers one of the world's most spectacular coastal vistas—the city's innumerable bodies of water, lush undulating landscape, Opera House, and Harbour Bridge flank the blue expanse of the Pacific. Landing at Melbourne's Tullamarine Airport—the flat, brown monotony of the city's semi-arid northern fringe spanning out as far as the eye dares to wander—couldn't be more disparate. The same could be said for the visual culture of the two cities. The vantage one garners from the air serves as an apt allegory for the way each city sees itself and each other. The geographic and cultural schism that extends between Australia's largest metropolises has been a prominent and long-running subject of cultural discourse. Sydney has forever been the beautiful, somewhat brash, older sibling. It is the Australia that the Northern Hemisphere is attuned to imagining: its climatic warmth, stunning bays and beaches, lush, flowering foliage, and comparatively fit, tanned, outgoing populace fit an entrenched portrait of the modern Antipodes. Melbourne tends to be understood as the more restrained of the two cities; its climate is colder, its landscape flat, its streets gridded and its fashion less about the skin. The color is found in the unlikely and uncanny—the suburban grit, subcultural and critical undercurrent.

Photographer Rennie Ellis is known for his depictions of Melbourne during the 1970s and 1980s, a period of great social, class, and cultural change in Australia. He is one of Australia's most prolific and influential social documentary photographers, and his images of Melbourne set a tone and a precedent for the many who have followed. His monochrome images of political graffiti on the rundown streets of inner Melbourne from the mid 1970s are both humorous and poignant—at once a celebration of youthful rebellion and wit, and a telling document of a city in the grip of social upheaval and the first stages of gentrification. People don't govern the images, but rather act as punctuation; the streets and their scrawled vernacular forge a playful undercurrent of tension and energy (see image 1).

While Ellis's work fits several social documentary archetypes, much street photography from Melbourne sidesteps and subverts as many conventions as it embraces. Bill Henson's early street photographs are also some of Melbourne's most iconoclastic. Known for his formally and texturally rich, unsettlingly sensuous images of the youthful body (see p.306), Henson took photographs of Melbourne schoolgirls that adopted a kind of shadowy, nonetheless lush palette more often attributed to seventeenth-century Dutch classicism than street photography. His monochromes of bustling pedestrian crossings around Flinders Street Station in the early 1980s assume a gripping air of surveillance.

A younger generation of photographers from Melbourne have further
expanded and complicated the street milieu. Ian Tippett's work uses a
particular, fragmentary vantage point of his young protagonists as an
allegory in exploring the psychology of personal space and exhibitionism
among the "selfie generation." His photographs pulse with color and
energy, expounding and abstracting its subjects in the one breath with
high flash. His "I Want You Back" series (see image 4) captures an intimate
view of young revellers and their dazzling T-shirt prints, fashions, and
abundance of bare skin. Standing within arm's reach of his subjects,
Tippett positions his camera just above eye level with the lens tilted down
their torso, creating a perspective usually reserved for those most intimate.

Jesse Marlow (see p.308)—perhaps the best known of Melbourne's
younger generation of street photographers—has been a constant on
the international scene for the best part of decade. Although adhering to
many conventions of classic street photography, his eye for formal oddity,
humor and happenstance is what has long set him apart. In Marlow's
world, street furniture, advertising slogans, workers, and passers-by are
all part of a dynamic, vibrant taxonomy. His work embraces the play of
unlikely visual cues, signifiers, and happenings, be it a discarded cardboard
box, crushed in such a way as to make the shape of a cartoonish face, or a
group of men in gorilla costumes sitting down on a park bench for some
lunch. While one wouldn't describe his work as poignant, it is certainly
astute and incisive. His is a vision of the street turned on its head.

The practices of both Louis Porter and Glenn Sloggett are entwined in
the vernacular of the street. Porter's suburban images operate within the
bounds of the conceptual archive and the collection. Although color-rich,
formally striking, and often humorous, the work is cumulative in teasing
out undercurrents of tension, prejudice and minor conflict via categorized
images of found notes, decapitated teddy bears, emergency assembly
points, racist graffiti, and the evidence of bad driving (see image 3). Sloggett,
meanwhile, paints a wry, somewhat dire picture of suburbia via its detritus,
overgrowth and unlikely turns of phrase (see image 2). Trashed, burned-
out houses, overgrown, garbage-strewn yards, decrepit storefronts, and
scrawled lingua franca define his works, forever empty of the human
subject. It's a quality that speaks to both Rennie Ellis's legacy and a new
taxonomy of the street in Melbourne. Public space—its people, moods,
and detritus—is forever a signifier of our sense of place and self. Whether
political graffiti or collected and categorized street stuffs, these seemingly
off-the-cuff photographs are indicative of something far greater. **DR**

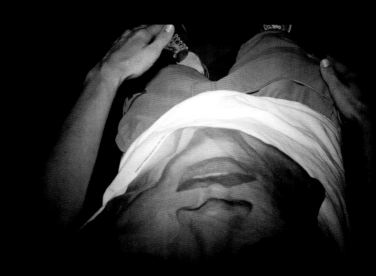

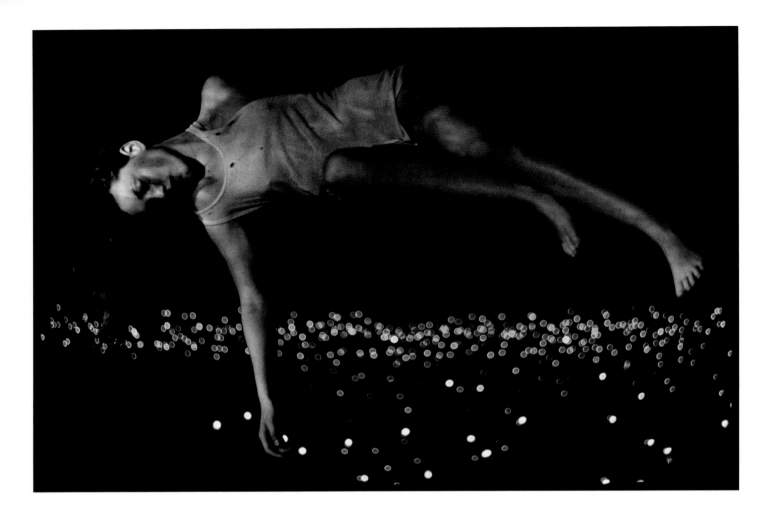

MELBOURNE
BORN 1955, Melbourne, Australia LIVES Melbourne STUDIED Prahan College
of Advanced Education, Melbourne; Royal Melbourne Institute of Technology
SERIES "Untitled 2000–2003," 2000–03 OTHER GENRES Staged

BILL HENSON

Hints of buildings, street lamps, roads, and figures slowly emerge
from these pitch-black canvases. The compositions, so cloaked
by darkness, hide more than they reveal. Australian artist Bill Henson
shoots these scenes in the outskirts of Melbourne at the end of
the day as the light wanes. He suggests his interest in urban edges
is fueled by "the feeling of being on the brink . . . of something." The
same could be said of his attraction to the hours of twilight—the
brink between night and day—when just enough illumination
remains to suggest muted shapes and shades. Henson adds that

he is drawn to "the way in which things go missing in the shadows,"
claiming that it is "what you don't see in the photograph that has the
greatest potential to transmit information." By presenting less, he
encourages the viewer to search for more, to let their mind wander
and to think creatively. Writer Dennis Cooper envisions the spectral
subjects exude blackness like "a paranormal manifestation of some
feeling too intense and guarded to register in any other fashion,"
whereas curator Susan Bright imagines, "In the darkness they can
indulge in what would seem forbidden in daylight."

 Henson is interested in photography for unusual reasons. He
certainly does not want the fact the work is photographic to override
one's first impression. He argues, "In every form of art, you really
want the experience of the images to transcend the medium. When

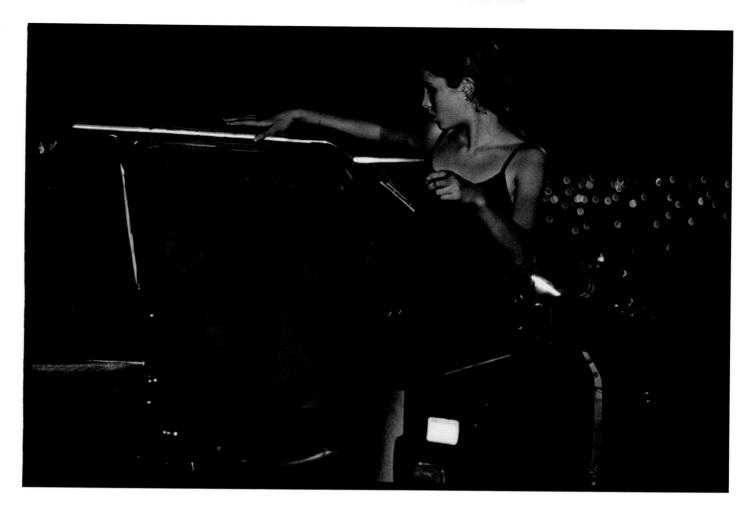

1 *Untitled #20*, Melbourne, Australia, 2000–01
2 *Untitled #25*, Melbourne, Australia, 2000

he was happy with a painting, Mark Rothko would say 'its not a painting.'" If anything, Henson tries to escape certain assumptions made about aspects of the medium. "Photography does have this conditioning presence," he explains, "it comes with this ringing proof . . . you have to try to get around it in some way." His solution is to set certain parameters that beget ambiguity rather than evidence; his proclivity for darkness is simply one of many tactics.

The urban settings Henson selects are generic; they tend to be littered with the detritus of everyday life, but proffer few details. His choice of subjects also fosters mystery. For a start, we are given no clues as to who they are and as curator Isobel Crombie points out, "Their anonymity is an important aspect of his work." He always uses adolescents, who in his words, "have this all pervading sense

of uncertainty . . . [a] sweet, dark, tumultuous sense of who they might be." This notion returns once again to his interest in "being on the edge of something," of almost knowing, of imagining. Furthermore, he reveals very little about how he works with his subjects. Crombie adds: "Although logic tells us they have been brought together for the purpose of being photographed, they do not look as if they have been directed to act in a certain manner." These ambiguities of what is "real" and what is staged, of what you see and what you don't, of what is and what might be, ultimately combine to create imagery that poses more questions than it answers, and therein lies its power. Henson concludes, "We find often in the most interesting art (as in life) that we can have an acute sense of something . . . and yet it is not fully understood. . . . These things naturally animate our speculative capacity."

MELBOURNE

BORN 1978, Melbourne, Australia **LIVES** Melbourne **STUDIED** Photographic Imaging College, Melbourne **INFLUENCES** Garry Winogrand, Joel Meyerowitz, Alex Webb **OTHER CITIES WORKED** Milan, London, Bologna, Treviso, Geneva, Sienna

| 1 | 2 | 5 | 6 |
| 3 | 4 | 7 | 8 |

1–8 From "Don't Just Tell Them, Show Them," 2004–13

JESSE MARLOW

"When shooting on the street I try to keep my mind free of expectation and let things come naturally. The second I go out hunting for things, I come home with nothing." Jesse Marlow's series "Don't Just Tell Them, Show Them" (2004–13) depicts his haul from these walkabouts in his hometown of Melbourne. Like Charles Baudelaire's *flâneur*, he roams with a mind open and alert to the chance encounter, to what the nineteenth-century French poet described as "the transitory, the fugitive, the contingent, which make up one half of art." Marlow's images are various, spontaneous and diverse, yet they are drawn together with a common theme. They all explore a dialogue between simple graphical imagery and complex content; they revel in ambiguity and are not easily interpreted. "Under all that solar-flaring technicolor a sense of implausibility radiates from these scenes," comments curator Sophie Howarth; people behave "in ways that can only be described as suspicious." Marlow adds, "I deliberately want to challenge the viewer to ask: 'Am I seeing things?' I want these photos to raise more questions than they answer."

Marlow's interest in street photography started at the tender age of eight. His uncle gave him a book called *Subway Art* (1984) that chronicles the explosion of street art and graffiti in New York City in the 1970s and 1980s. He recalls, "This book triggered something in me." He borrowed his mother's Minolta SLR camera and she would drive him around town. Whenever they saw any brightly colored graffiti, he would jump out of the car and take a photograph. Looking back, he realizes, "This was the beginning of my relationship with photography and the streets."

His first series evolved out of a soccer accident, which left him with a broken arm. He became attuned to seeing others with similar injuries and was surprised by how many there were, having never noticed them before. Once fully mended, he headed back out onto the streets in search of the same quarry and photographed them in black and white to create the series "Wounded" (2002–05). With "Don't Just Tell Them, Show Them," he switched to color film and

used the harsh Australian sunlight to create graphically sculpted scenes with deep shadows and saturated hues. However, he also made a fundamental change to how he worked; he stepped away from the busy street scenes where he had been targeting a pre-determined subject and instead embarked upon looser walks making a concerted effort to remain open to more elusive, hard-to-decipher subjects and scenes. His frames often reveal tricks of perspective. He points out, for example that in *White Horse* (see image 8), "you would never know that in between the horse and the tram barrier there are two lanes of traffic." The works depict all manner of surreal everyday moments, from peculiar behaviors to absurd juxtapositions. In keeping with his philosophy of open-mindedness, he came up with the title of this series after spotting it inscribed on one of his photographs; in *Keep Clear #1* (see image 6), "There's a piece of text at the top of the frame, which was on a tram that was going through Melbourne and the words just sang out to me."

ASIA

JERUSALEM SHANGHAI BEIJING SHENZHEN TOKYO DELHI MUMBAI MANILA DUBAI SEOUL HANOI

SOHEI NISHINO BIRDHEAD YING TANG SZE TSUNG LEONG JIANG PENGYI ZHANG DALI WENG FEN
YANG YONG DAIDO MORIYAMA NOBUYOSHI ARAKI NAOYA HATAKEYAMA TOKIHIRO SATO
OSAMU KANEMURA RAGHU RAI SUNIL GUPTA MACIEJ DAKOWICZ MAX PINCKERS
PETER BIALOBRZESKI JOEL STERNFELD MARTIN PARR AHN JUN MICHAEL ITKOFF

The twentieth century gave rise to a new urban phenomenon: the megacity is a sprawling, hyper-urbanized area broadly defined by the fact it houses in excess of ten million people. Today, in the twenty-first century, we are witnessing its continuing proliferation. The megacity now appears throughout the world in places as far flung as Lagos, Nigeria and São Paulo, Brazil. Yet its rise in Asia has been more meteoric than on any other continent. For years, Japan has boasted the most "mega" of the megacities in Tokyo, whereas China, with four, can now lay claim to more than any other country; and still the Asian list grows: Seoul in Korea, Jakarta in Indonesia, Bangkok in Thailand, Manila in the Philippines, Mumbai, Calcutta, and Delhi in India. Experts predict that by 2025, seven of the world's top ten megacities will be in Asia. Artists throughout this vast and varied continent seem united in interrogating the experience of what it means to construct and live in these contemporary urban juggernauts.

In the last decade Shenzhen has grown faster than nearly any other city globally. In 1979 it was a relatively small fishing village of approximately 30,000 inhabitants; now that number has surged to a staggering 12 million and counting. The process was so rapid that it led Hong Kong professor of architecture Juan Du to claim, "The scope, speed and scale of transformation . . . is quite unprecedented in human history." The tumultuous changes prompted Weng Fen to create the series "Sitting on the Wall" (see p.336), in which staged, sweeping tableaux portray a young girl astride a wall surveying the rapidly expanding city beyond. By casting the witness an adolescent on the threshold of adulthood, Weng effectively hints at the irreversible transformation being wrought on the urban skyline.

In Beijing two artists independently converge on the same theme. Both Jiang Pengyi and Sze Tsung Leong consider how destruction must inevitably prefigure architectural reconstruction, yet with radically different approaches. In "Unregistered City" (see p.328), Jiang synthesizes digital tapestries of fantasy cities and situates them within the crumbling demolition sites that increasingly litter China's megacities. By contrast, in "History Images" (see p.324) Leong composes vast photographic landscapes to reveal how the historic

past is being sacrificed in pursuit of rampant urbanization. He claims China is on the brink of unparalleled cultural erasure. "Nothing that I have seen or read conveys more vividly the enormous change that China is undergoing," notes critic David Frankel; adding, "The images are grandly disturbing, arguing for the new society as a place of inhuman scale . . . and enforced, anonymous uniformity."

Elsewhere artists are using the camera to explore and enact the personal experiences of living in the megacity. Editor at the Foam Photography Museum Marcel Feil notes, "For decades there has been a massive migration from the country to the city. In the West this movement has for some time now come to a standstill but it continues in the megacities that are currently mushrooming in Asia." In his series "Cruel Diary of Youth" (see p.342), Yang Yong collaborates with girls whom he meets on the streets of Shenzhen; having fled the rural interior of China in search of a better life, they often end their journeys in prostitution. His work explores their sense of isolation, anxiety, and, ultimately also, their resignation. On different shores, South Korean–born artist Ahn Jun focuses the camera on herself in a series that pushes self-portraiture to the edge (see p.386). Balancing precariously from the edges of some of the tallest skyscrapers in Seoul, she confronts the overwhelming scale of the city from a bird's-eye perspective, as well as the fear that many feel on the precipice of a vertiginous void.

Tales of urban Asia have long fascinated German photographer Peter Bialobrzeski and the Manila work in his latest series "The Raw and The Cooked" reads as a fitting endnote (see p.378). The sequence of images combines to convey an unsettling view of the contemporary phenomenon of the megacity. His vast celluloid canvases reveal hard-edged, thrusting skyscrapers radiating neon light and divided by chasmlike concrete canyons. Their dense detail and incomprehensible scale overload, overpower, and oppress the viewer and by ensuring most compositions are devoid of people, Bialobrzeski hints at what can only be described as the megacity's de-humanizing effect. "The series is essentially a provocation," urges Bialobrzeski; it questions if the megacity is really the civilized place to reside.

1 *Diorama of Jerusalem,* 2013

JERUSALEM
BORN 1982, Hyogo, Japan LIVES Tokyo, Japan STUDIED Osaka University
of Arts, Japan SERIES "Diorama Map Project," 2003–present OTHER CITIES
WORKED London, Istanbul, Rio de Janeiro, Osaka, Shanghai, New York, Paris

SOHEI NISHINO

"Maps organize information about a landscape in a profoundly influential way. They carry out a triage of its aspects, selecting and ranking those aspects in order of importance." In his book *The Wild Places* (2007), Robert Macfarlane writes persuasively about how maps create biases in the way landscapes are perceived and treated. He adds, "Few maps exercise a more distortive pressure upon the imagination than the road atlas. . . . [It] makes it easy to forget the physical presence of terrain." Artist Sohei Nishino likewise laments the predominance of contemporary maps, from road atlases to Google Maps, and notes how "in old maps, there are more elements of culture, history, religion." He has dedicated himself to remapping the greatest metropolises of the world through experiencing them. In the name of his ongoing "Diorama Map Project," which he describes as his life's work, he has traveled from Shanghai to Istanbul, Hiroshima to Hong Kong, Berlin to Bern, and most recently to Jerusalem.

One might easily mistake this diorama, like every other in the project, for a hand-drawn, nineteenth-century, panoramic map. Yet, under closer scrutiny, the seeming soft sketches resolve into a patchwork of haphazardly arranged, miniature, monochrome squares. The image is entirely photographic: a monumental photograph made from thousands that have been intricately collaged together. With his 35mm camera in hand, Nishino wandered the sprawling, historic city of Jerusalem for over a month, letting the streets guide him. "I don't plan how I walk in advance," he says, "I simply go in the direction that interests me," and "spontaneously shoot what catches my eye." He photographed the architecture, scenes, and people that he encountered, and when he could he climbed tall buildings in the hope of capturing bird's-eye perspectives. Before returning to Japan, he had exposed around 200 rolls of film. Back in his studio, he began the painstaking process of cutting the 7,000 odd photographs from their contact sheets. He used nearly every image, slowly assembling and pasting them onto a vast canvas, as he rebuilt Jerusalem from memory. The whole undertaking from start to finish lasted nearly six months. The end came when he immortalized the final collage with a medium-format camera to create *Diorama of Jerusalem* (see image 1).

Nishino began his "Diorama Map Project" while studying at Osaka University of Arts; however, his obsession with photographing while walking started the summer before he arrived at college. In Japan, the island of Shikoko is famed for its pilgrimage; the route is approximately 750 miles long and visits eighty-eight temples. Embarking on this pilgrimage with only a tent, a sleeping bag, and a camera borrowed from his mother, Nishino experienced what can only be described as a Damascene moment, working in favor of art, rather than religion, however. Until this point, he had shown little interest in photography. "It was a great turning point for me," he recalls. "During this journey, I started to take photographs while I walked and I realized that this act felt very natural." He adds, "I felt like my vision was suddenly broadened." So keen was this experience that he ultimately decided to switch his university studies to photography.

Nishino is influenced by Tadataka Ino, the man who made the first modern map of Japan. "By measuring the whole land on foot, he spent fifteen years surveying nearly 35,000 miles," elaborates Nishino: "I am amazed by the curiosity and courage he must have had to stand before something no one has ever experienced." Nishino is the first to recognize that his maps are a far cry from the objective survey a cartographer might undertake. By contrast they are highly subjective accounts: infused with so many personal memories, encounters, and stories that they arguably have more in common with the maps of yore. Nishino adds, "Through the eyes of an outsider, [my maps] are the embodiment of how I remember the city: a diary of the streets I walk." In this way, *Diorama of Jerusalem* is as much a map of one man's mind as of the city it portrays: a form of self-portraiture. "It may be true that I try to find myself within each city," he muses; indeed, such thoughts have led him to reshoot *Diorama of Tokyo* (2004) ten years later; as he says, "I would like to see how I have changed within the map."

Critics have noted a performative aspect to Nishino's work. Curator Daniel Campbell Bright calls it "a kind of theater of reconstruction where the artist performs out a new envisaging on the city." The first step of the performance is the act of walking his chosen subject. He claims, "Every time I visit a new city, I try to make myself empty and open to absorbing whatever I experience"; he suggests, "I walk to feel the city with my body." Such rhetoric recalls the words of land artist Richard Long: "My intention was to make a new art which was also a new way of walking: walking as art. . . . These walks are recorded in my work in the most appropriate way for each different idea: a photograph, a map or a text work." Similarly, Nishino admits, "the camera witnesses me"; then he uses photographs to construct a collaged map. The echoes are clear. Nishino did not know about Long when he started the project, but he empathizes with Long's ambitions and adds, "I think walking is the best way to know the world and to measure its size with my body. . . . I think of ["Diorama Map Project"] as an homage to the act of walking."

SHANGHAI

BORN 1979 (Song Tao); 1980 (Ji Weiyu), Shanghai, China LIVES Shanghai
STUDIED Shanghai Academy of Art and Design, China OTHER CITIES
WORKED London

BIRDHEAD

"Our Shanghai grows in their wandering and repeated stare.
The dark-green scaffolds are removed and mounted; the cement
columns of the viaducts silently form shade over our heads;
large landscape across the old houses that have witnessed our birth.
. . .
No time for questions and hesitation.
There's a voice pushing us . . .
wandering aggressively and aimlessly
to witness what shadow our Shanghai will create."
Birdhead, 2002

"Born 2004, lives and works in Shanghai" reads the biographical note
that is often used to introduce Birdhead. However, this is the fictional
collective identity of two Shanghai-born and -based artists, Song Tao
and Ji Weiyu. They use their cameras to chronicle their everyday lives:
themselves and their friends, in parks or at clubs, eating, drinking,
sleeping, or laughing. We are accustomed to seeing images that
reveal contemporary Shanghai as a sleek and sophisticated global
city. Yet Birdhead sketch only snatched fragments and fleeting
moments of the metropolis, training their lenses instead on its
hinterland and its underbelly. They claim, "Shanghai is very important
to us." Art historian Paul Gladstone observes how "it is almost a daily
epiphany for them" and that their images explore "how it feels to live
within it—an immersive bodily experience." Song and Ji talk about
how their photographs digest and reconfigure this sprawling
conurbation as part of their own world, as a continual "process of
moving from the city of Shanghai to the world of Birdhead." This
collaborative, highly subjective view of Shanghai scans like an ode
to what is perhaps China's main metropolis.

Song and Ji met in 1998 as students at the Shanghai Academy of
Art and Design. Ji first picked up a camera when he was fourteen and
with his persuasion Song did the same. When Ji traveled to London to
do a postgraduate course at Central Saint Martins College of Arts and
Design, he left Song in Shanghai experimenting with a camera he had
lent him. Over the ensuing two years, between 2002 and 2004, Song

<table>
<tr><td>1</td><td>2</td></tr>
<tr><td>3</td><td>4</td></tr>
</table>

1–4 Shanghai, China, 2006–11

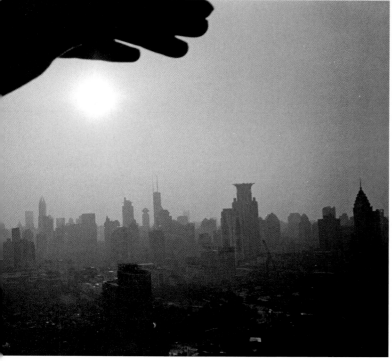

recalls, "Ji took a lot of photos of London, and I took a lot of photos of Shanghai" and we exchanged "our photos online to see how each other was getting on." On June 1, 2004, Ji returned and "we began to take photos together, just for fun." They spent the following two weeks relentlessly photographing together and then a further two weeks developing and editing their exploits. This led to the creation of their first album, "The Beginning of Summer" (2004), which exhibited not only their signature subject but also their signature style. Moreover, as they were saving a file of photographs on their computer, they conceived their nom de plume. "We typed randomly and two Chinese characters came up, which were 'Bird' and 'Head,'" recalls Ji. "The sound of the two characters when spoken together in Shanghai dialect sounds special."

Birdhead use a variety of cameras and lenses, but almost always resort to black-and-white film. Like traditional street photographers, they roam the streets. They have been described variously from "neo-punk *flâneurs*" to "latter-day drop-outs" who "thrive on simply lazing around and wandering the streets." Their images frame subjects off-kilter, with uneven flashlight or solar glare; faces are often obscured and backs are turned. Their approach seems the antithesis of Henri Cartier-Bresson's hunt for the "decisive moment"; their quarry is the partial view, the missed opportunity, and they immortalize these non-decisive, snatched glimpses that make up life. No subject is too banal: flowers wilting in a vase, a foot dangling from a window, a plastic dinosaur, a cat in the undergrowth, someone drinking a cup of coffee, someone else asleep. Their images are rarely about anything; they flow like a stream of consciousness, where one moment is no more important than another. They explain: "These trivial moments of everyday life we shoot are, for us, mirrors in which we can comprehend ourselves; examine ourselves."

Their approach appears obsessive; since June 2004, they continue to shoot voraciously, creating thousands upon thousands of images. They occasionally return home to take stock and edit their haul. "This is a cycle that we continually repeat," they add. It is "a constant [process] of seeking confirmation and ongoing accumulation and addition." This relentless, almost frenzied pursuit of self-cataloguing reads as a form of self-definition. Eva Respini, curator at New York's Museum of Modern Art, suggests "Birdhead's compulsive picture making mirrors contemporary culture's saturation with images and the current fascination with self-documentation via online platforms." Their work reflects not only how China's new generation sees itself, but also beyond; ultimately, they are very much the product of the Facebook generation.

SHANGHAI
BORN 1972, Shanghai, China LIVES Cologne, Germany STUDIED Washington
State University, USA; New York Institute of Photography, USA; City College of San
Francisco, USA OTHER CITIES WORKED San Francisco, Cologne, New York

YING TANG

In 2007 when Ying Tang returned to the city of her birth she was
shocked by its transformation and by the ferocious pace at which
it was changing. When Tang realized that construction was the
inevitable result of destruction, she began to photograph places in
Shanghai likely to be erased. Much of her imagery is set in the city's
winding alleyways, its *nongtangs*, where tumbledown buildings
tower three stories high and create tightly packed mazes that pulse
with local life. "I feel a responsibility as a photographer to witness
these changes and document them with my camera," claims Tang.
Yet, her photographs are far from dry, objective records; they are
highly subjective and captivating pictures. From the chaos and
confusion of *nongtang* life, she distils clarity of line and form to
capture the decisive moment. Curator Sophie Howarth writes,
"Her photographs are unsentimental but full of feeling, offering an
affirmative outlook on an often harsh reality." Tang admits, "It's a
personal journey out there on the street. I'm trying to catch a
moment that means something to me."

Tang became interested in photography while living in San
Francisco. Having left Shanghai to go to university in Japan, she went to
the United States where she earned a Master's degree. "At first when I
started shooting on the street it was just for fun and it was the cheapest
way to practice. I didn't have the money for studios or models," she
recalls. "However, it was not until I started uploading images of my
neighborhood onto Flickr that I seriously started taking street
photographs." The image-sharing website, Flickr, was Tang's catalyst
and to this day it still motivates her practice. She cites various influences:
"I admire Alex Webb, Trent Parke, and Elliot Erwitt, all of whom I got to
know just by clicking and searching online." Each artist belongs to the
Magnum agency and each provides different inspiration. From Erwitt,
she borrows humor. From Parke, her use of chiaroscuro; her enveloping,
velvety shadows transfigure real street scenes into visions snatched
while sleeping, echoing his "Dream/Life and Beyond" series (see p.292).
Yet, it is to Webb (see p.204) that she perhaps owes the biggest debt.
Like him, she revels in complicating the pictorial plane. She uses
alleyways to fracture the frame and windows or mirrors to multiply it,
creating intricate and mysterious images. Webb describes his practice
as playing along that fine line between method and mayhem, saying,
"I'm always . . . adding something more, yet keeping it short of chaos."
Such words reverberate with Tang's Shanghai *nongtangs*.

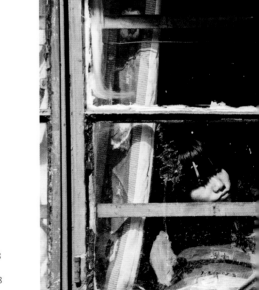

1	2
3	4

1 Shanghai, China, October 2008
2 Shanghai, China, April 2010
3 Shanghai, China, October 2008
4 Shanghai, China, March 2011

BEIJING

In the twentieth century, images of Beijing were dominated by the Tiananmen monument at the front of the Forbidden City, where a portrait of Chairman Mao still hangs today. Even though countless photographic images have been taken over more than 100 years in and around the city, this site remains a key symbol of central power, as well as of those contesting that power, and it is one to which photographers and artists repeatedly return. Photography in China developed along with the political and cultural events that determined its path toward becoming a modern nation. Street photography as such was never a genre in China until recent times, but it is possible to trace photographs taken at street level back to the late nineteenth century. Photography of Beijing often combines elements of its imposing architectural grandeur with the resilient nature of its inhabitants, while retaining a sense of its political importance, northern sensibility, and arid climate. Many early photographs were taken by foreigners traveling or working in China, such as the one by Scottish photographer Donald Mennie depicting a group of men at a street food stall near the city gate (see image 1). Mennie was a businessman who lived in China and died in 1944 in the infamous Lunghua Japanese internment camp in Shanghai described in J. G. Ballard's novel *Empire of the Sun* (1984).

Photography played a crucial part in forming an image of the Chinese Revolution in 1949. Images of Mao and his colleagues at the Communist base of Yan'an formed a visual narrative of the struggle for ideological supremacy that was part and parcel of a landscape that came to fruition with the founding of the People's Republic of China. As modern documentary photography in China was structured through official media, it was therefore inevitably bound up with creating socialist realist images aimed at fostering a revolutionary spirit.

In the late 1970s, photography emerged with other artistic forms, tracing China's cultural and economic rise after decades of political isolation from the Western world. Events in Beijing that trace political developments at street level can be seen in photographs during this period. Popular movements for freedom of speech and political reform played out in public demonstrations around the site of "Democracy Wall" near the Forbidden City, where "Big Character Posters" were pasted to vent criticism and air views. Photographs of members of the Stars Painting Group (Xingxing Huahui), China's first influential independent art group, show scenes of one of its leading

1 *Street Food Kitchen Near Gate, Peking,* Donald Mennie, c. 1915–20 2 *East Village, 1994 No. 1*, Rong Rong, 1994 3 *The Real Thing Comes to China*, Liu Heung Shing, 1979

artists, Ma Desheng, addressing large crowds of people as they called for freedom of expression. Hong Kong photographer Liu Heung Shing spent some of his early childhood in China and later returned as a photojournalist to cover Mao's funeral in 1976. He helped set up *Time* magazine's office in Beijing in 1978. A photograph by Liu shows a man in the Forbidden City joyfully waving a bottle of Coca-Cola, shortly after the drink had started being sold in China (see image 3). Liu's photographs from this time encapsulate the joy of such newfound pleasures and the (literal) thirst for capitalism. Liu has described his experience of photographing China over several decades as seeing "the transformation of China from a very backward, self-isolated country to the China that we know today . . . a journey [of China] moving from collectivism to individualism."

A photograph taken a decade later by artist Ai Weiwei shows his girlfriend, Lu Qing, lifting her skirt in a fleeting moment of irreverence in front of Tiananmen on the fifth anniversary of the student-led mass protests that took place in June 1989. A self-conscious movement of image-making through artistic circles was underway in China by the mid 1990s, with artists such as Rong Rong, who played a key role in documenting emergent performance art through black-and-white photographs. Together with other artists, he formed an avant-garde artists' "village" that was inspired by the East Village of Manhattan in the outskirts of Beijing, fixing at the entrance a handwritten sign (see image 2).

Art and documentary photography often merged in projects such as Zhang Dali's "Dialogue and Demolition" series of the 1990s (see p.332). For this street-based project the artist drew a large outline of his own head on numerous buildings in Beijing that had been marked for demolition, which he cut through leaving a series of head-shaped spaces on the walls of abandoned buildings. The photographs bear witness to the contemporary urban environment in China, in which huge swathes of major cities have been demolished to make way for new development. Demolition became an ongoing subject of photography for many years as it underpinned China's bid to "change its face" to the world, which involved the old being replaced with the new in a drastic, often brutal and fast-moving drive to modernize.

Many photographers chose to engage in the dizzying experience of the rapidly changing horizon, literally and metaphorically, including artist Weng Fen (see p.336), whose poignant images of schoolgirls perched on walls, poised between present and future, movingly portray a young generation facing a rapidly changing skyline rising up before their eyes. Artists such as the duo Birdhead (see p.316)—Song Tao and Ji Weiyu—have actively engaged in street photography, taking images of everyday scenes in Shanghai that refuse any kind of framing and pay homage to the black-and-white aesthetic of the early twentieth century. The work of Birdhead plays with the interaction of the street as a historical site along with the ongoing minutiae of its localized social activity. **KH**

1 *Tiantong Xiyuan Third District (North), Changping District*, Beijing, China, 2004. Chromogenic color print
2 *Suzhou Jie, Daoxiang Yuan, Haidian District*, Beijing, China, 2004. Chromogenic color print

BEIJING
BORN 1970, Mexico City, Mexico LIVES New York, USA STUDIED Art Center
College of Design, Pasadena; Harvard University, Cambridge SERIES "History
Images," 2002–05 OTHER CITIES WORKED Shanghai, Nanjing, Xiamen, Pingyao

SZE TSUNG LEONG

"Who controls the past controls the future: who controls the present controls the past," ran the Party slogan in George Orwell's dystopian novel *Nineteen Eighty-Four* (1949). These words find new resonance with Sze Tsung Leong's series "History Images." Between 2002 and 2005, Leong visited various cities in the People's Republic of China: from the capital Beijing in the far north to Pingyao farther south and Xiamen farther south still, from Shanghai and Nanjing in the east to Chongqing in the center. At every stop, he trained his lens on scenes of unprecedented urban expansion, architectural destruction and reconstruction. The photographs he took are beautiful, but intensely disconcerting; they led one critic to write: "nothing that I have seen or read conveys more vividly the enormous change that China is undergoing. And the news is bad—the images are grandly disturbing."

Nearly all of Leong's imagery is taken from distant, elevated viewpoints that enable vast vistas. Yet, his large-format camera renders miniscule details with crystalline clarity; these smaller,

mundane objects—lamp posts, phone pylons, fencing—underscore the enormity and almost inhuman scale of the architecture. The muted colors appear cheerless and unwelcoming; the panoramic white-gray skies are bright but bleak. Hard-edged surfaces of concrete, steel, glass, and tarmac abut and rise up in rigid, monotonous order. Columns and rows of regularly spaced, identical windows and balconies look more like gargantuan grids than apartment blocks. Critic Peter Frankel reminds us that each of the different "boxes" in the grid acts as a "container for a family," whereas philosopher Nigel Warburton observes how the architectural repetition "suggests a regime that values the collective above the individual." The buildings are clearly being made to house a growing population, yet Leong (by making his exposures in the early hours) has ensured that nearly every frame is vacant of people. The effect is haunting, indeed, almost apocalyptic.

Leong now lives in New York but he was born in Mexico, to English and Malaysian parents with Chinese ancestry. He first visited China in 1984 and moved to Beijing to live in 2002. It was while he was there that he conceived the idea behind "History Images," At first, like all visitors cannot fail to be, he was struck by the scale and relentless pace of the city's growth. Tower blocks—housing luxury offices, apartments, shopping centers, supermarkets—seemed to sprout up in mere months. Large areas would be bulldozed to make way for parking lots, sports complexes, widened roads. As he walked the streets day after day, he would see developers with names such as "New World" (Xin Shijie) and building projects prefixed by phrases such as "New City" (Zincheng) and "Century City" (Shijicheng). The implications of such intense construction slowly dawned on him. Clearly the architects and urban planners had the power not only to demolish and raze to the ground any buildings that stood in their way, but also to reroute streets and eradicate circulation systems. What he was actually witnessing was a systematic annihilation, in fact, a wholesale erasure of what had gone before.

Leong claims, "History is composed as much with the buildings of a city as it is with the words on a page." He describes the transformation of urban skylines in geological terms: as a "complex sedimentation of time resulting from a slow, dense accumulation of construction." Like a geologist or paleontologist looks to rocks, so we can look to bricks to read our past. "A culture's development can be read through the layers of previous buildings that together form a geological summary of history." The photograph of *Chunshu, Xuanwu District* (2004) speaks of that history; it reveals a neighborhood in Beijing that, according to Leong, dates from the thirteenth-century

3 *New Street, Shijicheng, Landianchang, Haidian District*, Beijing, China, 2004. Chromogenic color print
4 *Xihuashi Nanli Dongqu, Chongwen District*, Beijing, China, 2003. Chromogenic color print

Yuan Dynasty and was not completed until the last Imperial Qing Dynasty. However, at the time of taking the photograph, these buildings had been condemned and were awaiting obliteration. Today, a towering, pristine construction of metal and glass housing luxury apartments stands on this site. Leong highlights another image of the capital, *Xihuashi Nanli Dongqu, Chongwen District* (see image 4): it "depicts an area that had been entirely cleared of structures and streets." The single traditional building remaining appears stranded among the tracts of commercial housing blocks. Effectively, the mass destruction of the old fabric of Beijing (and elsewhere) equates to a whitewash across swathes of cultural heritage.

The situation starkly contrasts with other world capitals. When London was bombed, modern houses and factories were built to fill the voids, but they were juxtaposed against Georgian or Victorian façades. When firebombing almost entirely destroyed Tokyo, city planners turned to historic plans for its reconstruction. U.S. artist Stephen Shore cites New York as a comparison, whose eclectic buildings mark a variety of eras: "They tell a story of evolution. In Leong's photographs of contemporary cities in China, a very different story is told. The underlying dynamic is not one of evolution, but one of radical fracture." Unlike Beijing, these cities read as "a

compendium of histories," as Leong adds, where "modernization continues the writing of what preceded it."

In the past, whenever cultures have erased their heritage, the motivation has often been one that George Orwell would have understood—who controls (erases/rewrites) the past, controls the future. China has a long history of cultural erasure. In Imperial China, successive dynastic emperors shaped cities to enforce order. In 1966 the Cultural Revolution advocated "Smash the Four Olds": old ideas, old culture, old customs, and old habits. As Leong observes, "In the urban realm, this was first realized by Mao Zedong's destruction of Beijing's Ming-era city gates and walls." Thankfully, he did not get to fulfill his wish of destroying the capital's Forbidden City. However, today history is not so much an enemy, as an inconvenience to urbanization. The combination of unprecedented economic vitality and a government with near total authority means that China's current erasure of its history is swift and sweeping; indeed, Leong argues the destruction of historic urban areas is "on a scale and suddenness equal to warfare." It makes one look to China with a sense of unease; indeed, it led critic Frankel to argue that it "makes you worry for the world . . . for its ability to tolerate the accelerated rates of consumption and waste in the global economy that is coming into being."

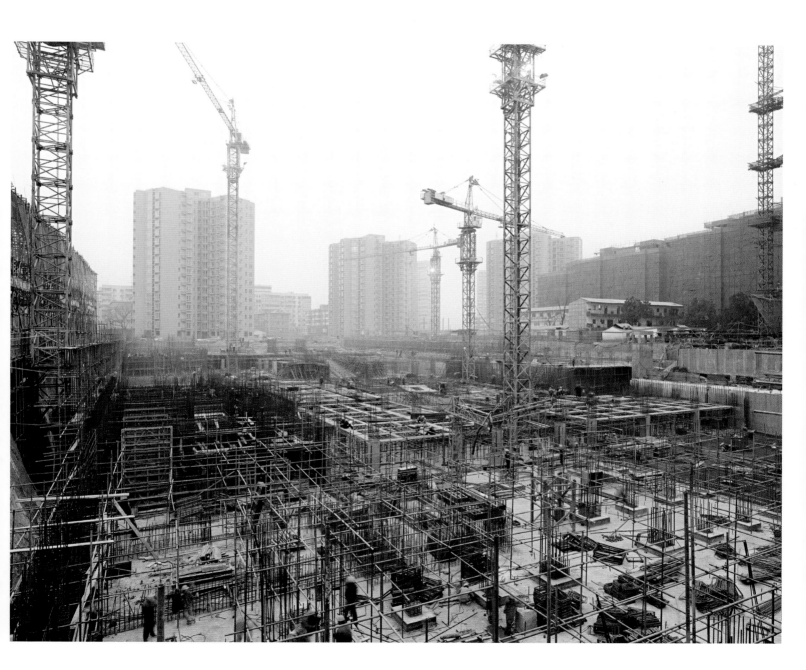

BEIJING

BORN 1975, Yuanjiang, Hunan Province, China LIVES Beijing, China
STUDIED Beijing Institute of Art and Design SERIES "Unregistered City," 2008–10
OTHER GENRES Staged

JIANG PENGYI

Jiang Pengyi's series of photographs "Unregistered City" can be viewed within the context of both urban art and social commentary because it seeks to mark a particular moment in China's history. Like other Chinese artists in this chapter, Jiang is endlessly fascinated by the tumultuous changes in his country's urban environments, and his work is clearly informed and inspired by the culture collision he experienced growing up. He is described by Chinese artist Yang Fudong, who curated an exhibition of his work in 2009, as a "quiet

and gentle man" who "is immersed in the 'real imagery' he creates. The one of a kind, sensitive and slightly lonely nature of his works only emerges in the prolonged gaze of the audience."

Born in rural China, in Yuanjiang, Hunan Province, he went to art school in 1995 in Beijing, where he experienced a profound culture shock. He witnessed an ancient city in the throes of rapid urbanization; as modernization drove the traditionally civic societies in the direction of a homogenous urban culture there was a simultaneous eradication of their origins and histories. Like many of his generation, Jiang was left with a deep sense of displacement and alienation. His series of photographs "Unregistered City" directly confronts these emotions; the disquieting scenes in these sometimes breathtakingly magical

1 *Unregistered City No. 1*, Beijing, China, 2008
2 *Unregistered City No. 8*, Beijing, China, 2008

photographs allow him to, in his words, "experience the anticipation of fear" as he directly critiques the excessive demolition and urbanization of China's capital city.

Digital manipulation is key to the conception of this series and Jiang is drawn to its capacity for breathing life into the fantasy visions of his imagination. The advent of digital media and its use by art photographers further complicates photography's relationship with truth, making its correlation with fiction ever more complex. Jiang's practice engages directly with these expanding parameters within photography; in the earlier series "All Back to Dust" (2006) he started to explore ways of constructing fictions by digitally synthesizing images together while remaining conscious of the material heritage of art photography. In this sequence of images he starts with a traditional shot of a landscape and then uses Photoshop to splice images of urban architecture onto random piles of junk to create mini cityscapes. He then collapses them literally back into the ground. In this way, Jiang fulfills the metaphor implied in the title, which echoes his prophetic view on human civilization and the inevitability of its eventual downfall and return to dust.

These themes are further developed in Jiang's "Unregistered City" where he similarly uses digital manipulation to create micro cities by patchworking together images of urban landscapes. However, in this series Jiang montages them into interior shots of abandoned buildings. The geneses for these exquisitely crafted digital tapestries

are the inner recesses of the demolition sites throughout China's cities. Traditional houses, civic buildings, and imperial monuments—the last remnants of China's historic past—have been sacrificed in the pursuit of rampant urbanization. Jiang roams the streets of Beijing looking for potential sites. Using a large-format camera, he photographs these partly destroyed spaces, honing his lens on details, such as a bathtub, a shelf, piles of detritus, or a shattered floor. Jiang takes his time photographing these locations; his primary concerns are to master the light changes and to harness their dramatic qualities. Later, in the studio, he uses photo editing to knit together images—either from his own photographs taken in the city or from found images pulled from the internet of any city or country—to construct

fantasy micro cities that appear to emerge out of the ruins, phantomlike in form, Lilliputian in scale, and which recall the apocryphal scenes from movies such as *Blade Runner* (1982) and *Brazil* (1985).

Jiang's work morphs out of the tradition of staged or constructed photography. His meticulously constructed tableaux bring to mind the work of artists such as Thomas Demand and James Casebere, who use physical and architectural space, void of human presence, to generate drama and allegory. U.S. photographer Casebere handcrafts tabletop-scale models of institutional spaces using materials such as styrofoam, plaster, and museum board. Then, mimicking conventions drawn from cinema, he lights these staged scenes in such a way as to produce a disquieting and eerie effect that exacerbates the prevailing

3 *Unregistered City No. 4*, Beijing, China, 2008
4 *Unregistered City No. 5*, Beijing, China, 2008

mood of tension and anxiety. Jiang uses lighting to similar ends and, like Casabere, is interested in drawing on its dramatic qualities to charge his space with mood and meaning. In *Unregistered City No. 1*, (see image 1, p.328) the beam of light enters from the upper window, cutting through the waning light and illuminating the micro cityscape below. The viewer becomes aware of the miniature ghost city emerging from the crumbling wasteland of peeling paint and dust. Jiang picks out particular buildings within the tableaux, lighting them from the inside to enhance the surreal and psychologically charged atmosphere that dominates this mise en scène. The scene is dark and dusty; the city appears at the end of its life, exhausted, annihilated, devoid of people and energy.

Jiang's fascination with notions of truth is at play here. Critic Gu Ziang observes how Jiang "creates an image of the city that has never existed and merges it with ruins that come from reality"; ultimately, it is the effect of reality in the image that makes the fantastical elements both credible and disturbing. Jiang's use of an aerial perspective further encourages the viewer to scour the landscape for meaning and to reflect on the great urban questions confronting contemporary society, while the inverted scale is "almost a psychological attempt to reverse the power position between culture and expansion." As such, he engenders in his audience the deep-seated trepidation that he senses when faced with the rapidly changing cityscape of Bejing: recalling once more that "experience of the anticipation of fear."

BORN 1963, Harbin, China LIVES Beijing, China STUDIED Central Academy
of Fine Arts, Beijing SERIES "Dialogue and Demolition," 1993–2006
OTHER GENRES Graffiti, sculpture OTHER CITIES WORKED Bologna

ZHANG DALI

After the events of Tiananmen Square in 1989, Chinese artist Zhang
Dali fled to Europe for a six-year period of self-imposed exile. On his
return to Beijing in 1995, he was confronted by a city transformed into
a sprawling, chaotic demolition site. The People's Republic was engaged
in a headlong dash toward capitalist-driven modernity; the traditional
vernacular of city walls, courtyard houses and tiny alleyways was in
the process of being torn down to make way for shiny new hotels,
shopping centers, and skyscrapers. Zhang was prompted into a series
of anonymous, guerrilla-art actions in which he spray-painted a giant
image (sometimes as tall as 6 feet) of his own head onto the walls
of buildings awaiting demolition and marked "chai" (the Chinese
character meaning "demolish"). The tumultuous structural
metamorphosis of the city of Beijing forms the backdrop to
Zhang's iconic photographic series "Dialogue and Demolition."

 Zhang originally trained as a painter at China's prestigious Central
Academy of Fine Arts in Beijing but the move into spray-painting
transformed him into one of China's first graffiti artists. Between
1995 and 1998, he adorned more than 4,000 condemned buildings
throughout Beijing with his own image. From the center of the city
to the Third Ring Road, an area spanning about 30 square miles, he
used the fabric of the city as his own canvas and transformed derelict
urban ruins into sites of public art. Then, echoing the practice of U.S.
Conceptual performance artists of the 1960s and 1970s, he recorded
these gestures with his camera. However, the series did not develop
in the way Zhang originally conceived; it is the artist's subsequent
evolving use of and attitude to the camera that mark out this now
iconic body of work.

 In a sense "Dialogue and Demolition" began in Europe a few years
before Zhang returned to China. While living in Bologna, Italy, he was
introduced to graffiti and was instantly attracted to this art form that
did not exist in the People's Republic. He recalls, "After my graduation
it was very difficult for me financially so I couldn't hide in my studio
dreaming about things. I wanted to change reality into art, the things
near me into art . . . as an artist I thought I should create something
outside the studio, and graffiti was fast and powerful." Influenced by
this anonymous street art as well as by Western artists, such as Keith
Haring, he started painting on the city walls of Bologna. At the time
he was mainly concerned with anti-war protests focused on the Gulf
and sprayed these affirmations in Chinese characters, occasionally

accompanied with a self-image of a bald head. Local artists responded by spray-painting over these images, mistaking his spartan profile for a neo-Nazi symbol and the Chinese characters as socialist propaganda. Zhang was struck by the speed of the response as well as by the misunderstandings and he took photographs to document these retorts as they occurred.

On his return to China he was stunned by the changing urban landscape of Beijing and was impatient to see how local artists might react to his spray-painted profile on old buildings and derelict sites. He firmly believed in the visual image's ability to "incite discourse" and looked forward to generating the kind of interactions he had experienced in Europe. His artist statement reads: "This image is a condensation of my own likeness as an individual. It stands in my place to communicate with this city. I want to know everything about this city—its state of being, its transformation, its structure. I call this project 'Dialogue.' Of course, there are many ways for the artist to communicate with a city. I use this method because, for one thing, it allows me to places my work at every corner of this city in a short period." Zhang was about to be surprised, however; strikingly his interventions met with silence. People reacted with suspicion, indifference, outrage, and confusion, but the city did not actively respond, apart from sending workers with buckets of cement to repeatedly cover up the images. Zhang had failed to ignite the "graffiti war" he had hoped for. Art historian Wu Hung recalls,

4 *Fuhua Mansion*, Beijing, China, 1999
5 *Xidan Xiulong Futong*, Beijing, China, 1999
6 *Shanghai Jinmao Tower*, Beijing, China, 2000

"Partly because of the city's irresponsiveness . . . Zhang the artist (not Zhang the social critic) had to explore other possibilities to realize the theme of his project—dialogue. The result was a subtle but crucial change in the meaning of this theme: he was increasingly preoccupied with an ongoing visual dialogue internal to the city (rather than expecting an interaction with the city that could never materialize)."

Zhang turned to the camera to explore his central conceit of a dialogue; he started to document and archive people's reactions to his interventions. In one of these photographs, a young boy walks past the image, seemingly unconscious of the image on the wall behind him, he stares directly into the camera with a cool, unresponsive gaze, the spray-painted head seemingly following the boy and his friend entreating their acknowledgment (see image 5). Wu Hung writes, "This photograph is one of the earliest such snapshots in Beijing, [and it] never fails to chill me with a feeling of inability to communicate." By recording such reactions, the camera enabled him to transform his work, as he says, "from a monologue into a dialogue."

Zhang began to design his interventions primarily to be photographed; he also started to create dialogue between different elements within the composition—framing the spray-painted, demolished, traditional buildings against a backdrop of rising modern construction. He explains, "I think this concept is very important for this project; at the beginning I wanted to document graffiti, to document the place where I painted the graffiti, but at the end the artwork to be exhibited was not the graffiti but the photo. With time the audience got to see a photo artwork, and the photo became the main character on stage." The series evolved into one in which he increased the architectural dialogue by juxtaposing demolished old houses and preserved ancient monuments; he then further complicated the gesture by hiring migrant construction workers to hollow out the space inside his silhouetted profile, to create an open wound through which he frames the shimmering modern skyscrapers or preserved ancient monuments (see image 4). The viewer sees "the old" through the prism of the destroyed. The project itself is still open to debate but what is indisputable is that this body of work has come to symbolize, as Wu Hung states, "a new image of this city." Zhang concludes, "Many things are happening in this city: demolition, construction, car accidents, sex, drunkenness and violence infiltrate every hole. . . . I choose these walls. They are the screens onto which the city is projected." Zhang immortalizes these "screens" of bricks and mortar, on which the historical trauma of this age has played out, by framing them through his viewfinder, onto another—this time celluloid—screen.

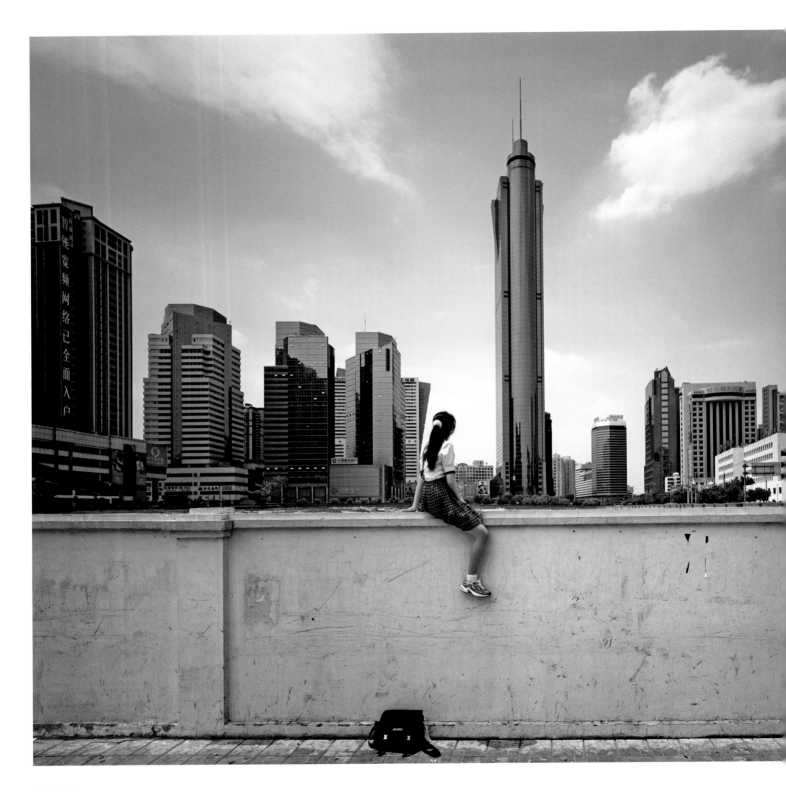

1 *Sitting on the Wall—Shenzhen 1*, Shenzhen, China, 2002

SHENZHEN
BORN 1961, Hainan Island, China LIVES Beijing and Haikou, China
STUDIED Guangzhou Academy of Fine Arts, China SERIES "Sitting on the Wall,"
1998–2003 OTHER CITIES WORKED Haikou, Shanghai, Guangzhou

WENG FEN

"The girl on the wall, that's me," enthuses artist Weng Fen (also known as Weng Peijun). "I live in a lonely place, Hainan Island. I'm alone like her facing the world." The author of these now iconic images was born in 1961 on Hainan Island in the extreme southeast of China, close to Macau. Known as China's "Hawaii," it is a lush, tropical mountainous island, where the pace of life is slow. However, life changed dramatically for Weng when he went to art school in Guangzhou, one of the southern cities on China's mainland. Like many of his generation, he witnessed China's momentous shift from military to economic superpower as he was growing into adulthood. He saw his world morph from peripheral agricultural region to China's largest "special economic zone" in response to Deng Xiaoping's experiment with "free market economics." It resulted in the cities of the south exploding into China's first vast sprawling megalopolises.

Weng's monumental photographs in the series "Sitting on the Wall" are meditations on this phenomenon and encapsulate this moment in time. He works within the tradition of narrative photographic tableaux to explore these notions and, like a director of cinema, meticulously crafts a mise en scène, masterminding every detail with carefully conceived precision. The sequence of photographs largely features a solitary schoolgirl (sometimes accompanied by a friend) with her back to the camera; perched astride a wall, she stares out at the urban cityscape rolling out in the background. *Sitting on the Wall—Shenzhen 1* (see image 1) is archetypical of this series. The stark realism of the scuffed white wall in the foreground contrasts with the glistening cityscape background with its ultramodern superstructures punching the horizon. On the wall at mid-distance sits a young girl dressed in school uniform, her beaten-up school bag tossed casually on the ground. Her face is hidden and the viewer is unable to read her expression. She exists as a silent witness—an adolescent on the threshold of a personal transition into adulthood, who mirrors a culture at an equally transformational moment.

Weng started to explore the metaphor of the schoolgirl in an earlier series titled "Great Family Aspirations" (2000). This body of photographs recalls the typical family snapshot taken during the Cultural Revolution. Weng depicts families after the introduction of the one-child policy. Each image portrays a typical family—a mother, a father and their single child—standing to attention, bolt upright,

2 *Sitting on the Wall—Shenzhen 2,*
Shenzhen, China, 2002

blank facial expressions, facing the lens. In some of the images the little girl perches on a stool, the top of her head exactly aligned with that of her parents. "There is an enormous pressure on children to grow up quickly—too quickly," Weng observes. "Chinese parents tend to unload their worries onto the shoulders of their children."

In "Sitting on the Wall," the girl becomes Weng's signature vantage point. It is an effective compositional trope to lead the viewer into the image, echoing the work of other contemporary "tableaux" photographers interested in allegorical storytelling. It also invites comparison with German Romantic painter Caspar David Friedrich, who often shows his main character from behind, setting up a tension between the viewer and the view. Historian John Lewis Gaddis describes the figure in Friedrich's painting *Wanderer above the Sea of Fog* (1818) as leaving a contradictory impression, "suggesting at once mastery over a landscape and the insignificance of the individual within it. We see no face, so it's impossible to know whether the prospect facing the young man is exhilarating, or terrifying, or both." This work was known in China and inspired *Chairman Mao goes to Anyuan* (1967), a painting by Liu Chunhua that Weng would have been familiar with from his childhood. Weng adds, "When I was young, I loved going for long walks in the mountains and looking down on things from above. Like my photos."

Weng's choice of large-format camera further aids this thoughtful and precise analysis of the world. He uses it to maximize scale and clarity, and then later employs digital manipulation to create a seamless fluidity between background and foreground. This practice recalls the work of Düsseldorf School photographers such as Thomas Ruff (see p.190) and Andreas Gursky, who were among the first to absorb the digital techniques of commercial advertising photography into art photography. Like them, Weng also uses repetition—the compositional elements of girl, wall, and cityscape—as a means of negotiating the sociocultural issues that he wants to explore through his work. Weng's high viewpoint references in particular the work of Gursky, who employs this device to create distance between viewer and subject, thus enabling the narrative to unfurl with greater impartiality.

In "Sitting on the Wall," Weng explores a specific moment in China's history; the rapid urbanization of the world he grew up in with its shifting skylines and cacophony of urban hyperarchitecture. He creates a tableau in which the narrative of this moment can be distilled into a single image. Weng questions what this new metropolis offers and yet refrains from judging. As the girl in the picture encourages thought and contemplation, these photographs encourage reflection on the possibility of a true urban Chinese utopia.

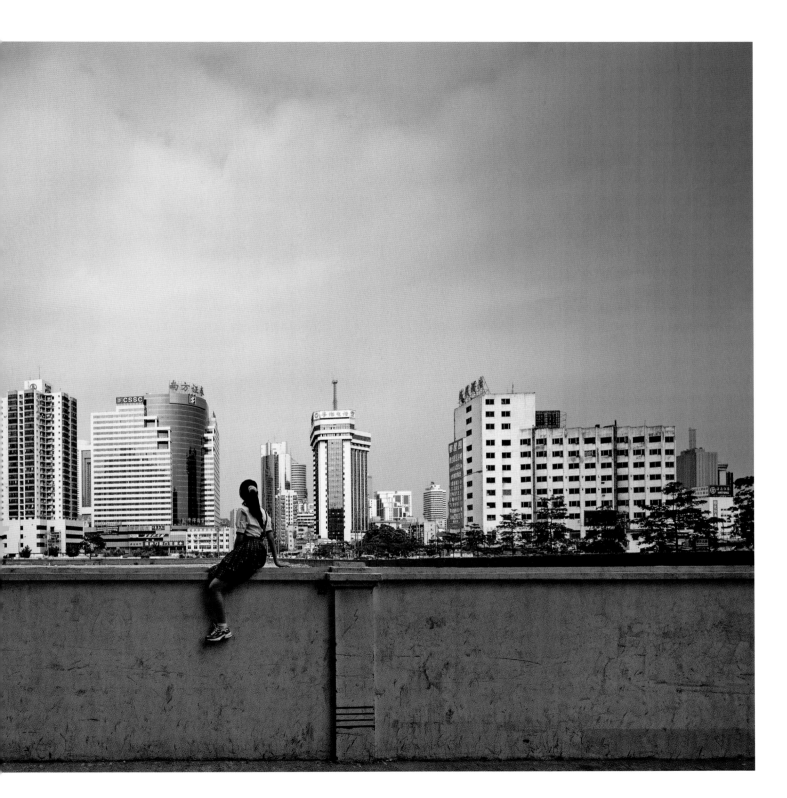

SHENZHEN
BY POLLY BRADEN

Shenzhen, in Guangdong Province, was China's first Special Economic
Zone. In 2007 I was on assignment for *Icon* magazine but also
shooting for my book *China Between* (2010). This was not an unusual
back street but the conjunction of elements was pleasing. New
construction, one last old wall, children playing, a woman posting
flyers and a doctor (or is he a factory worker?) passing through.

1 *The Dusk of Gods*,
Shenzhen, China, 2000

SHENZHEN

BORN 1975, Sichuan, China LIVES Shenzhen and Beijing, China STUDIED Sichuan Fine Arts Institute, Chongqing, China SERIES "The Cruel Diary of Youth," 1999–2001 OTHER GENRES Staged

YANG YONG

"Rather than directing the main characters, I play a game with them; we improvise scenes. The rule of this game is that there are no rules. The main character is cast as a complex simulation of the new millennium; capable of assuming many roles. . . . These photographs are like film stills." Yang Yong has been hailed as a pioneer of a new southern Chinese avant-garde. His series "The Cruel Diary of Youth" captures a pivotal moment in China's recent history. Born in 1975, Yang is one of the first generation of Chinese artists to have no recollection of the Cultural Revolution. For this cohort the concept is, according to critic Richard Vine, "as abstract as World War II is to the baby boomers in the west." They are quite unlike any Chinese generation before or after. They lack the resolute beliefs of their parents/grandparents and the defiant cynicism of the generation that came of age after 1976 and Mao's death. They are also distinct from the generation of singletons that followed—the products of the single child policy described as "little emperors." Yang's work taps into what has been called the "in between" generation.

Most of the images are taken at night on the streets and are staged in collaboration with his subjects. The subjects are Yang's friends, the girls he met when he moved to the city, and hence the work has drawn comparison to the intimate, diary approach used by artists such as Nan Goldin. Indeed, he cites Goldin as one of his heroes. Yang elaborates, "My focus is on my friends around me, their interior changes and exterior reaction to the changing world, whether real or virtual. . . . They (my works) express people's feeling of being at a loose end under the tension of contemporary city life, as the society itself is a series of life drama, from one act to another." However, unlike Goldin, Yang does not appear in his own imagery; he keeps to his role of observer/documentarian, imposing a clear delineation between himself as director and the tableaux he fastidiously stages.

Melancholic and haunting, Yang's stylized and self-conscious images are of women posing in anonymous urban settings; they are mainly girls who have come from rural China to try their luck in the sparkling new cities of the Pearl River Delta. Yet for many the dream rapidly disintegrates and the bright lights fail to deliver; for some the reality becomes prostitution. Yang is fascinated by this lifestyle, the particular border of urban life the girls inhabit and the sense of disenfranchisement and resignation they feel. His camera becomes the tool through which he can immortalize these ephemeral

experiences. Cool, distracted, filled with ennui, his photographs portray the girls sitting on the edge of beds smoking, pointing a gun while posing in a subway, looking at themselves in a mirror, lying on a sofa, or speaking on the phone. The locations are generally places of passage where they leave no trace—hotel rooms, subway tunnels, construction sites. Yang directs his subjects loosely, giving them stories to interpret; they are encouraged to play with the poses and gestures appropriated from lifestyle and fashion magazines rather than reproduce them exactly. As critic Karen Smith observes "in what is almost a cinematic sequence they pretend to be the models they dream of becoming."

Such narratives recall the practice of Zheng Guogu, whose series "The Life of the Youth in Yangjiang" (begun in 1995) was influential in introducing staged photography to Chinese photography. However, there are differences. Yang is not as interested in the linear narratives that defined Zheng's storylines; instead he constructs visual fictions to anthropological and allegorical ends. His images are used as theaters to explore the possibilities of expressing a state of mind; to convey a specific taste, style, and mood associated with a particular generation and so they are often deliberately insignificant and ambiguous. Some of his work consists of multiple frames that can be read as a narrative unfolding in time, such as *Can't Find Way Home* (see image 2). This interest in seriality and storytelling has been seen as linking more to contemporary Chinese cinema than photography, especially the "urban generation" films of the late 1990s and early 2000s.

Initially, Yang's fictions appear to revolve around issues of identity and the internal emotional worlds of their protagonists, but a closer look connects the work to its wider context: the "model" city of Shenzhen. Throughout Yang's work the city appears as a recurring character; the work is located in a range of urban settings, from apartments and bathrooms to passageways, tunnels, public toilets, bus stops, shopping malls, airports, and construction sites. Yang is captivated by this complex and multifaceted futuristic city that has risen out of the marshland; the insignificant fishing village turned into one of the most dynamic cities in Asia. Yang, along with millions of others of the "in between" generation, came to Shenzhen intoxicated by the promise of an imported, unrestricted Western-style capitalist culture. He explains, "I wanted to see reality, to learn about those things you can't learn about in school." The tableaux in Yang's contemplative and poetic work explore the superficiality of this burgeoning consumer culture and reflect the isolation and fragmentation of a wandering generation, adrift from history, torn between the two worlds of China's past and its present.

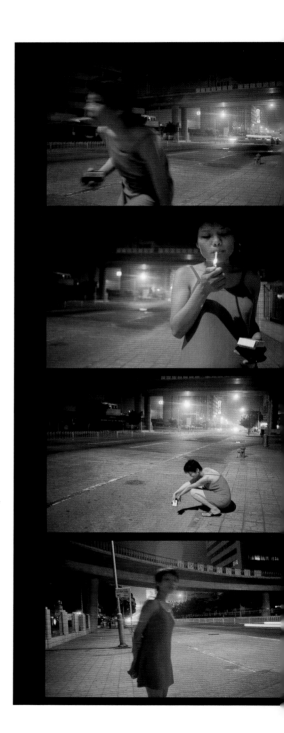

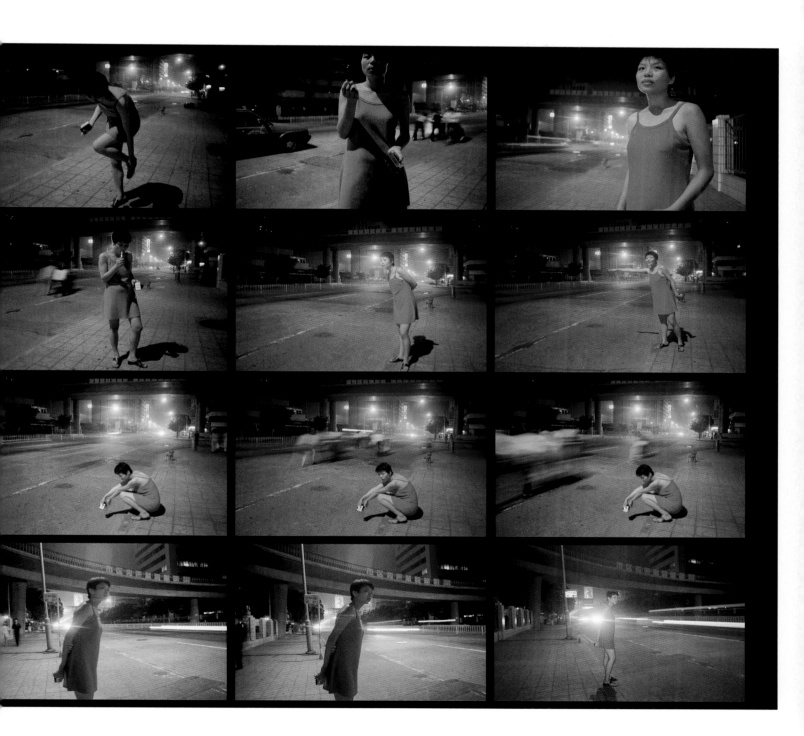

TOKYO

Over the past half-century, Tokyo has established itself as one of the global capitals of street photography. Yet, unlike other cities, the Japanese capital does not boast many easily recognizable landmarks or the distinctive, coherent architecture of Manhattan Island and Haussmannian Paris. Rather, the visual chaos of Tokyo's overlapping architectural styles and periods led to a gritty, high-contrast aesthetic emerging in the late 1960s that has become iconic for Japanese street photography.

The emergence of street photography in Japan began in the 1930s with the introduction of smaller, portable rangefinder cameras on the Japanese market. Hiroshi Hamaya and Kineo Kuwabara began taking pictures in Tokyo during this period, and both went on to have a major impact on the development of postwar Japanese photography. Kuwabara was an extraordinary prolific photographer, endlessly pacing the alleyways of the *shitamachi*, the Edo-era areas of downtown Tokyo. Contrary to the prevalent *shinko shashin* (new photography) style at the time, his photographs were not driven by artistic aspirations, relying instead on his keen eye for detail and the telling moment. Although Hamaya was Kuwabara's junior, his photographic style was more developed, and his photographs of 1930s Tokyo are deeply atmospheric (see image 1), revelling in the vibrancy of his favorite entertainment district of Ginza with its night markets, cafes, and bars.

While the street photography of the 1930s was swallowed up by the propaganda imagery of the wartime years, it resurfaced rapidly in the wake of defeat, at a time when photography played a crucial role in bearing witness to the devastation of the capital. Many of the major photographers of the prewar years were able to begin working in Tokyo again, thanks to the publishing boom that occurred after wartime censorship was lifted. Ihee Kimura and Shunkichi Kikuchi published *Tokyo, Fall of 1945* as early as 1946, a book that showed how life was beginning to sprout up again among the rubble. Tadahiko Hayashi also photographed the reconstruction, developing a body of work entitled *Kasutori Jidai* (Days in the Dregs, 1980), a fascinating portrait of life in postwar Tokyo with its decommissioned soldiers, GIs, street urchins shining shoes and puffing cigarettes, rickety dive bars, and young lovers strolling through the streets of Ginza. His photographs capture the duality of this period: the relief of newfound freedom amid great hardship and devastation.

During the early 1950s, many photographers returned to the *shitamachi* that they had photographed before the war, neighborhoods where life took place in the street. Children became a major photographic subject, a symbol for the reconstruction of

Japanese society. Kimura, Ken Domon, Yasuhiro Ishimoto, and many others photographed them at play in the streets, in images both tinged with nostalgia and with a sense of hope for the future.

The postwar years were turbulent ones for Japan. In response to the radical changes taking place, a new generation of photographers began to experiment with novel forms of photographic expression. They had not been active during the prewar years and sought to distance themselves from the traditional photographic approaches of the past. In 1959, six young photographers—Shomei Tomatsu, Eikoh Hosoe, Kikuji Kawada, Ikko Narahara, Akira Sato, and Akira Tanno—came together to form the Vivo cooperative: a group that encompassed a wide variety of photographic styles, but which shared a fascination with the growing Western influence in Japan and an expressive "subjective documentary" approach. The streets of the city remained their primary subject, but instead of seeking to "objectively" document this world, these photographers sought to engage actively with their subject and thereby to question the nature of the Japan that was emerging, as in Tomatsu's photographs of the student street protests in 1969 (see image 2). Although they were not members of Vivo, both Ishimoto and Shigeichi Nagano produced some of the most interesting images of early 1960s Tokyo, capturing the emergence of a modern, corporate city that was unsettlingly faceless and impersonal.

Steadily, photographers had shifted their focus away from the *hitamachi* to Shinjuku, the city's underbelly and its most densely populated area. When political and social tension reached fever pitch in 1968, a small group of critics, poets, and photographers came

together to form *Provoke*, a magazine that would shake Japanese photography to the core. In its first issue the group laid out its manifesto: "Today, when words have lost their material base—in other words, their reality—and seem suspended midair, a photographer's eye can capture fragments of reality that cannot be expressed in language as it is. He can submit those images as documents to be considered alongside language and ideology. This is why, brash as it may seem, *Provoke* has the subtitle 'provocative documents for the pursuit of ideas.'"

Rather than documenting the world around them, the *Provoke* photographers sought to push the medium of photography to its limits. While the streets of Shinjuku remained their photographic raw material, their photographs pushed the city to the edge of the recognizable, reducing it to a series of flashes, blurs, scratches, and fragments.

The intensity of *Provoke* remains influential and emblematic of Japanese street photography, particularly as many photographers of the period—Daido Moriyama (see p.348), Nobuyoshi Araki (see p.352), and Yutaka Takanashi—are still active. Yet, just as Tokyo has added further layers of complexity over time, Japanese photographers have continued to develop fresh approaches to their capital city, from Takashi Homma's deadpan portrait of Tokyo's suburban sprawl (see image 3) to Naoya Hatakeyama's studies of the hidden facets of the city's structure (see p.354). Like the city of Tokyo itself, Japanese street photography remains in constant flux. **MF**

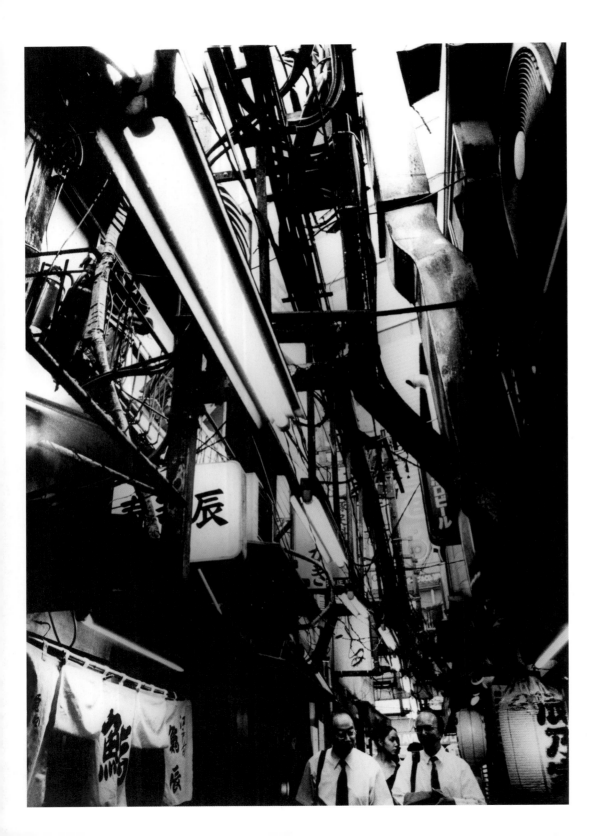

1–2 From "Shinjuku," Tokyo,
Japan, 2000–04. Gelatin
silver prints

TOKYO
BORN 1938, Ikeda City, Osaka, Japan LIVES Tokyo, Japan
STUDIED In the studios of Takeji Iwamiya and Eikoh Hosoe
OTHER CITIES WORKED New York, Buenos Aires

DAIDO MORIYAMA

On an unusually sweltering summer's day in 2004, two of Japan's
most influential and renowned photographers met in a ward of
Tokyo called Shinjuku. It is arguably the pulsing and throbbing heart
of the capital: it boasts the city's largest railroad terminal, vast
shopping complexes, skyscrapers stacked with offices, and the
thriving red-light district of Kabukicho. Futuristic glass, concrete, and
metal architecture butts up against old, tumbledown buildings and
winding alleyways. It is a place of contrast and contradiction, of
vibrancy and vulgarity, a melting pot of different classes and different
races. It is therefore not surprising that it proved an irresistible lure
to photographers Daido Moriyama and Nobuyoshi Araki (see p.352).
Curator Hiromi Kitazawa vividly recalls the occasion on August 16,
2004: "they started from the east exit of Shinjuku Station and walked
through Gold-Gai. At times, they were as aware of each other's
presence as a jam session. Then, in the next moment, each entered
his own unique space. . . . Their relationship was neither hostile nor
entirely harmonious. It was obvious, however, that they provoked
each other." They spent the whole day walking and photographing.
The memory remains fresh to Araki: it "didn't matter where [we
walked]. Keep the sun at our backs, and go from one end to the other,
clicking every five seconds." Much of what they shot was featured in
their celebrated book, *Moriyama–Shinjuku–Araki* (2005). However,
this visit to Shinjuku was not their first; it was more like a return.

Shinjuku is Moriyama and Araki's shared territory; they have both
spent the last five decades photographing it. "I've been shooting
here since the 1960s," claims Araki. "The streets, the women. I just
unconsciously kept coming back to Shinjuku. . . . Maybe that's how
I got my 'Shinjuku eye.'" He equates photographing there to "taking
pictures of yourself, your life and how you live." Moriyama views
Shinjuku as a place he can wander forever, saying, "All buzzing and
scrunched up together, flowing out everywhere, then regathering,
only to rinse out over and over." This one area, less than 7 square miles
in size, has provided endless inspiration for these iconic practitioners.
"With one day's shooting in Shinjuku, I've got me a book," quips Araki
prompting Moriyama to counter, "With just one street, I got a book."
The most fascinating aspect of the *Moriyama–Shinjuku–Araki* project

is that it reveals how radically different the two artists' approaches
are to the same subject. Kitazawa describes this eloquently by
reminding us that Kabukicho, one of their favorite haunts, was
named after kabuki theater and that this ancient Japanese tradition
has been interpreted in two ways that aptly apply to the
photographers. Whereas *aragoto* (rough style) refers to the
masculine, heroic and violent dramas characteristic of Edo kabuki,
wagoto (gentle style) refers to the dramas of love affairs one finds
in the kabuki of west Japan. Kitazawa concludes, "The world
composed of lights and darks in Moriyama's photography has the
roughness of *aragoto*," and, "the scenes that Araki has chosen to
shoot . . . can certainly be seen as *wagoto*."

Since 1964 Daido Moriyama has taken tens of thousands of photographs and published over 100 photo-essays and photobooks. His recurring theme is the city. He admits, "I can't photograph anything without a city. . . . For me cities are enormous bodies of people's desires and as I search for my own desires within them, I slice into time, seeing the moment." Moriyama is celebrated for his monochrome images and their distinctive style, which has been labeled "blurry, grainy, and out of focus." His exposures tend to be roughly skewed with a pronounced, almost harsh chiaroscuro. Simon Baker, curator of photography at Tate, observes, "Despite a resolute commitment to the everyday, to photographing the world as it is, often out in the street, he has made some of the most challenging and willfully abstract photographs of the twentieth century." Curator and photographer Gerry Badger adds, "Moriyama gives us the lone outsider, speeding through the streets of a Blade Runner-type Tokyo." Hervé Chandès, director of the Fondation Cartier pour l'art contemporain in Paris, says, Moriyama's "is a dark vision. Very dark, very sullen . . . I like the aggressiveness." Overall, the imagery exhibits a raw and powerful aesthetic that readily calls to mind kabuki's *aragoto* style.

Moriyama left Osaka, the city of his birth, for Tokyo in 1961 when he was twenty-two and he soon ended up in Shinjuku. He found a job as assistant to the photographer and film-maker Eikoh Hosoe, but accommodation was more difficult to come by. He recalls, "I had no close friends or acquaintances and could not stay that long with relatives. I carried a Canon 4Sb and everything I owned in a dark blue Boston bag. . . . I made the rounds of Shinjuku with very little money and I was forced to sleep in one of the flop-houses near Shin-Okubo." By 1962 Hosoe had opened a new studio at Yotsuya, a neighborhood in Shinjuku, and Moriyama was able to move in there to both work and live. However, those early experiences left an indelible stain that colored how he viewed his adopted city and from that point onward Shinjuku almost became an obsession. He confesses it is "a place that I cannot overlook, that I cannot leave alone as long as I am a photographer." He adds, it is "a place of excessive stimulation and searing pain that goes straight to the heart." Shinjuku has since appeared repeatedly in his work. There is a photograph of Shinjuku Station taken in 1965 in his first published book, *Nippon Gekijo Shashin-cho* (Japan: A Photo Theater, 1968) and his photographs of Shinjuku characters later appeared on the cover of Shuji Terayama's novel, *Aa, Koya* (Ah, a Wilderness, 2005). Eventually, he published one of his most comprehensive photobooks tellingly titled *Shinjuku* (2002). The *Moriyama–Shinjuku–Araki* project followed swiftly after.

Moriyama's practice is very instinctive; he rarely stops to frame an exposure. He explains, "I basically walk quite fast; I like taking snapshots in the movement of both myself and the outside world." His images appear so skewed and blurred that one can sense this movement and these gestures. He says, "What interests me most is what's before my eyes this very moment. Everything else is over and done with." With absolute focus he peers through the cross hairs of his camera, as a sniper might a rifle. Indeed, he calls himself a "hunter with a camera" and Kitazawa describes him as a "hunter of the light." Kitazawa has seen Moriyama in action and recalls, "He is relaxed but never wastes motion. He passed through the streets like wind, leaving nothing behind but an elusive sense of presence." Critic and philosopher Koji Taki adds, "I don't think he stares and composes an image, but rather passes by, glancing. . . . Each of his glances is reflected, like a flash of light, in each of his slightly different representations of the city."

There is another dimension to Moriyama's imagery, beyond its evident vitality and violence. Arguably, this reached its apogee in his best-known book, *Shashin yo Sayounara* (Farewell Photography, 1972). Within its pages one encounters a litany of photographic "errors": damaged images, figures looming out of the gloom lit only by a glaring flash, others cropped so oddly they appear not to have been framed. "Farewell Photography" reads more like a negation: a deliberate and careful rejection of all the standards of conventional and "tasteful" photography. Over half of the images in the publication are so out of focus that one is hard pressed to decipher what they depict. When it was first published, it received much criticism, however, Araki was one of its earliest defenders. Moriyama remembers, "When I made 'Farewell Photography,' I felt like the world was fragmenting." He kept returning to the same questions: What is photography and why am I taking photographs? He even decided to include negatives that he had discarded on his studio floor, believing that they were just as valid a representation of the world as those he had first selected. This last gesture acts to eliminate the artist's choice. The result, as Baker observes, is that "they 'emerge' showing some kind of alternate reality." Moriyama wonders what it is about Shinjuku that keeps drawing him back: maybe it is its promise of alternate realities, its connection to theater where the real and unreal collide. He writes, "At night when I pick up my camera and walk from Kabukicho to Kuyakusho Street, and then from Okubo Street to Shinokubo Station, I sometimes feel cold shivers running down my spine. Although nothing unusual has happened, I have a sense of myself existing somewhere. In the darkness of the back streets illuminated with neon signs and other lights, people become shadowy entities."

NOBUYOSHI ARAKI

TOKYO
BORN 1940, Tokyo, Japan LIVES Tokyo STUDIED Chiba University,
Tokyo SERIES *Sentimental Journey*, published 1971; *Pseudo-Reportage*, published
1980; *Tokyo Lucky Hole*, published 1990 OTHER GENRES Video

Pornographer, pervert, and monster are just a few of the names
Nobuyoshi Araki has been called, but he has also been hailed as a
genius. He seems to enjoy causing controversy and often fuels it with
the odd remark. He famously quipped, "My sex drive is weaker than
most. However, my camera lens has a permanent erection." Imagery
of sexualized women is Araki's art form; he has photographed them
suggestively sucking on fruit, naked, masturbating, suspended in ropes,
and bound in the traditional Japanese method of *kinbaku*.

Araki was born and bred in a traditional quarter of downtown Tokyo,
Shitamachi, where his father made wooden clogs. As curator Hiromi
Kitazawa points out, whereas "Moriyama approached Shinjuku from
the position of an outsider," Araki "was able to drop by Shinjuku as if
visiting a neighbor." His first solo exhibition, "Satchin and Mabo," was
held there in 1965 at the Shinjuku Station Gallery. However, it was
women who proved the ultimate lure, especially those who worked
Shinjuku's red-light district, Kabukicho. His most notorious book, *Tokyo
Lucky Hole*, documents Kabukicho's sex shops. The title refers to rooms
where there would be sheets of plywood with holes through which
clients and prostitutes could interact. From 1983 to 1985, Araki visited
and fully participated in the activities of one club in particular.

It is perhaps Araki's personal perspective that most distinguishes
his work. Jérôme Sans, co-director of Paris's Palais de Tokyo, says, "Araki
smells, thinks, acts, lives photography. . . . He has a compulsive need to
shoot photographs, to exist." Photography is about proximity and
connecting. This comes across in *Moriyama–Shinjuku–Araki* (2005); as
Kitazawa observes, Araki "inserts himself into the city and establishes
a relationship with everything in it." His method of photographing is
radically different from Moriyama's. Using a medium-format camera
on a tripod means that his approach is slower, more considered. Central
to Araki's work are the opposing themes of Eros and Thanatos. Freud
described Eros as the drive for love, creativity, sex, and life, whereas
Thanatos is the drive for violence, aggression, sadism, and death. Sans
explains, "For Araki, photography is not storytelling or aesthetics—its
life and death." Araki elaborates, "In the act of love, as in photography,
there is a form of life and a kind of slow death." Ultimately, Shinjuku
is the place where Araki's obsessions of Eros and Thanatos collide.

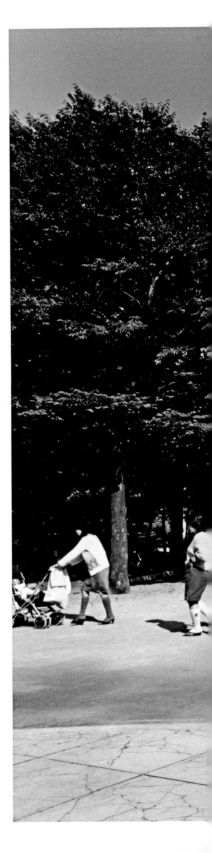

1 *Tokyo Story*,
Tokyo, Japan, 1989

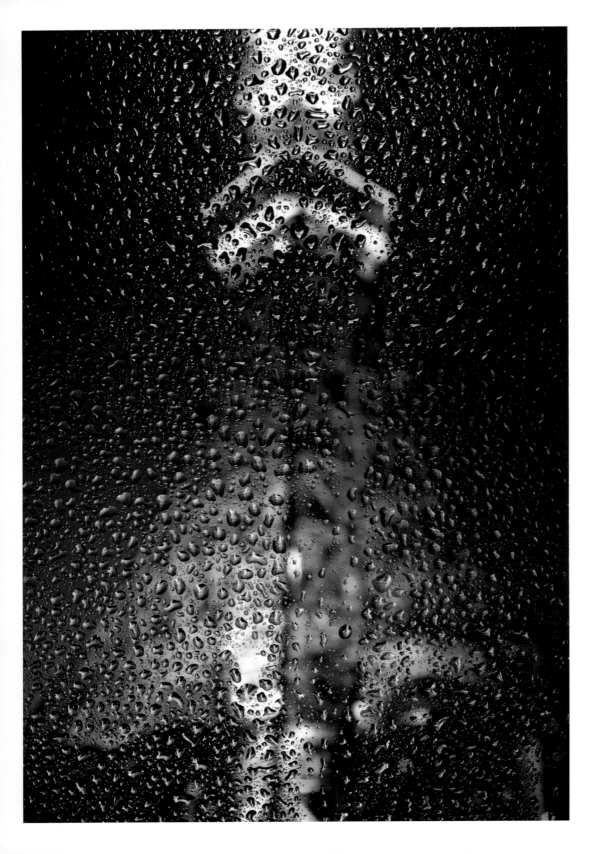

TOKYO
BORN 1958, Rikuzentakata, Japan LIVES Tokyo, Japan STUDIED University of
Tsukuba, Ibaraki Prefecture, Japan SERIES "Slow Glass," 2001–present OTHER
GENRES Landscape OTHER CITIES WORKED Paris

NAOYA HATAKEYAMA

Naoya Hatakeyama is masterful at finding unusual perspectives that reveal the unexpected beauty of cities. His ongoing series "Slow Glass" frames the Tokyo skyline and its streets as if through a rain-flecked car windshield. He specially constructed a camera box with an inbuilt glass plate so that he could focus his camera on the rain that fell against the plate. The individual water droplets fracture, fragment, and transform the urban landscape beyond. The title comes from a short story by Irish science fiction writer Bob Shaw. The story, "Light of Other Days" (1966), is built around the concept of "slow glass" that acts as a kind of time portal; light passes through it more slowly enabling the viewer to see scenes from the past. Shaw tells of how this slow glass is used to construct "scenedows"—windows that portray the memory of a beautiful landscape. People buy scenedows for their homes, but after a few years they expire and instead simply show the real world outside. When this happens, owners buy a new scenedow and throw the other out. Hatakeyama says, "I had begun collecting such discarded Slow Glasses within Tokyo. I find pleasure in imagining the lives of inhabitants who resided in the rooms endowed with Slow Glasses [and] the scenery previously reflected." His collection forms the "Slow Glass" series; however, in place of harsh urban reality, each image reveals scenes that stir the sublime.

Hatakeyama was born in a small town in the Iwate Prefecture. He says, "The door [of my home] opened onto a panoramic view of the riverbanks beyond. Growing up in the wide open visual field had a huge impact on me." When he moved to Tokyo, he felt surrounded by walls and the sky seemed suddenly narrow. In his photography he homed in on the city's few forgotten, people-less places. His "River Series" (1993–94) traces the passage of a river as it flows through cement canals beneath the Shibuya District. He captured these waterways at dusk so that they appear like dark mirrors reflecting the city; their liquid surfaces bisect each frame into lit tower blocks above and river below. For his next series, "Underground/River (Tunnel Series)" (1999), he traveled into the pitch-black labyrinth of Tokyo's tunneled sewage system. The camera becomes more than a simple recording device in Hatakeyama's expert hands. He claims he was guided by the surrealist sensibility of his teacher Kiyoji Otsuji.

According to Hatakeyama, Otsuji showed that the camera should "be used as an instrument that 'reveals' something." Yet, British curator Mark Haworth-Booth senses other influences at work. He identifies six elements in the imagery. The first five are clearly visible: the water droplets (one), the car windshield (two), the dark sky of twilight (three), the urban landscape beyond (four), lit by the glow of artificial lights (five). The sixth element requires a closer inspection, sadly not permitted with a reproduction image in a book. However, when faced with the actual artwork, one can make out that each raindrop acts like a miniature lens reflecting an inverted representation of the city beyond. Haworth-Booth asks whether the myriad perspectives and the decentered view is Hatakeyama's way of seeing.

Much of Hatakeyama's practice can be read as a meditation on the nature of photography. In "River Series/Shadow" (2004) he refers to

the reflected urban landscapes as "shadows," invoking a phrase used by William Henry Fox Talbot to describe his invention of the negative/positive photographic process: "the art of fixing a shadow." Like Talbot, he has made drawings with the camera obscura and in "Slow Glass" his use of the window recalls Talbot's first photographic negative of a latticed window taken in 1835. As curator Martin Barnes notes, Talbot's choice of subject is "an appropriate motif to herald a new medium" as photographs have often since been regarded as windows on the world. Consider the words of Joan Fontcuberta, Spanish photographer and writer: "Photography is a window and what is interesting is viewed beyond the window"; reiterated by U.S. photographer and curator John Szarkowski when he wrote that photography can be a "window through which one might better know the world." Yet the window in "Slow Glass" seems to subvert this notion.

Hatakeyama's rain-splattered window acts instead to interrupt and frustrate a glimpse of the world beyond. The individual droplets of rain blur and break up the cityscape. Yet perhaps this provides a better metaphor for what photography is. Critic Pedro J. Vicente Mullor points out, "What is truly intriguing about Hatakeyama's 'Slow Glass' is . . . it presents what is visibly palpable but also what is potentially imaginable." He explains, "Beyond that (slow) glass, there are views, which one has to imagine in their mind [and] it will always be uncertain, unclear and enigmatic; always open, hypothetical and promising. Always waiting 'to be.'" "Slow Glass" is as much pictures of the places they depict as they are about the visions and dreams they once held. Hatakeyama transforms the city into an abstract meditative space; the window becomes a screen onto which we project our thoughts and our imagination.

3 4 5

TOKYO

BORN 1957, Sakata, Yamagata Prefecture, Japan LIVES Tokyo, Japan
STUDIED Tokyo University of the Arts SERIES "Photo Respirations," 1989–97
OTHER GENRES Landscape OTHER CITIES WORKED New York

TOKIHIRO
SATO

The streets of Tokyo appear dimly lit and deserted apart from a host
of strange spectral lights that either float orblike above the ground or
weave a tangle of trails. The scenes look undeniably eerie and invite
myriad interpretations. As curator Mark Scala asserts, "To the spiritual-
minded, the lights may be the souls of the dead; to the child, they
may be will-o'-wisps or fairies; to the fan of science fiction, they may
be flecks of disembodied consciousness descending from a higher
plane." Yet the imagery has not been fabricated through either digital
or darkroom manipulation. In fact, each of these bewitching
landscapes is made with simply a camera and a flashlight or mirror.

Tokihiro Sato's series "Photo Respirations" is taken on a large-format,
8x10 camera mounted on a tripod and programmed to create exposures
that last up to three hours. The artist then moves into and through the
space framed by the camera. In daylight, such as the scene shown in
#87 (see image 3), he carries a mirror and at separate intervals uses it
to reflect the sunlight into the lens burning discrete globes on the
negative. At night, as in #267 (see image 1), he shines a flashlight at the
lens to draw fine lines of light across the negative. His method recalls
the Greek origins of the word "photography"—from "phos" (light) and
"graphic" (writing); the results are quite literally "writings in light."

It is very difficult to classify Sato's urban imagery. On one level you
could view these works as a form of self-portraiture. Yet because Sato
is in constant motion the film cannot register his image; instead he
exists more as a fugitive presence atomized within the photographic
emulsion. The use of long exposures, similar to Russian artist Alexey
Titarenko and his Moscow series "City of Shadows" (see p.226),
repeats elements of one of the earliest photographic experiments.
In Louis-Jacques-Mandé Daguerre's pioneering daguerreotype View
of Boulevard du Temple (1838–39) the long exposure ghosted the
bustling crowds so that this famous Parisian street scene seemed
derelict. Similarly in "Photo Respirations," Sato is not the only person
dematerialized; for example, #87 depicts one of Tokyo's busiest
shopping districts and countless figures doubtless walked through
this particular exposure.

Sato originally trained as a sculptor and his work is still concerned
with sculptural themes even though his tools have changed; now
he uses light and photosensitive paper to explore and define space.
There is also a performative aspect to his practice; critics have
commented that his repetitive and choreographed gestures for the
camera exhibit a meditative quality. He admits, "There is a direct
connection between my breath and the act of tracing out of light";
he even refers to the pieces as "breath-graphs." Moreover, as with
the work of Sohei Nishino (see p.314), there are echoes of land art.
Sato confesses to being inspired by Robert Smithson and his vast
earthwork Spiral Jetty (1970). Ultimately, Sato's unusual artworks of
time and space remind us of the inconsequentiality of human actions:
as fleeting and transient as a breath of air.

OSAMU KANEMURA

These cityscapes portraying the backstreets and alleyways of Tokyo are so graphically dense that they are almost difficult to look at, let alone understand. The compositions appear like convoluted jigsaws where concrete façades intersect with billboards, advertisements, posters, and pylons. The space depicted in image 2 is crisscrossed by horizontal wires, vertical poles, and skewed scaffolding to such a degree that it fragments and fractures into chaos. Whereas the store signage that crowds and clamors in image 3 is reflected and refracted in what appears like a store window, adding yet another layer that heightens the sense of confusion. The viewer is presented with information overload; one's eyes dart around the frame in an attempt to find purchase, but in vain. As Yozo Yamaguchi, curator of the Fukuoka City Museum, observes, "Eventually all the efforts of our gaze . . . only end in failure." Japanese architect Arata Isozaki has applied the metaphor of the spider's web to this imagery, although that implies a sense of pattern and order. Curator Sophie Howarth suggests it explores "the problem of 'knowing' a city that was half-destroyed in a world war, then in the headlong rush to rebuild, became the largest metropolis in the world." Yet what does the imagery tell us? "Is Tokyo an architectural entity," she continues, "or something much more complex?"

The work is by the Tokyo-born and -bred artist Osamu Kanemura and is taken from his series "Hindenburg Omen." Kanemura has operated in much the same way and produced much the same aesthetic for near on two decades. Employed as a newspaper deliverer, he works the morning shift supplying railroad station kiosks. He is rarely without his camera; in between jobs he takes pictures and then hops on the train to various parts of Tokyo to take more pictures. He always uses the same equipment: a medium-format rangefinder, the Plaubel Makina 67, attached to an 80mm lens and loaded with black-and-white film. Despite Tokyo being a city of towering vertical skyscrapers, he only shoots in horizontal format. He uses a small aperture and sets the camera to infinity to ensure that nearly everything within the viewfinder is rendered in crisp detail. He quips, "I want my pictures to be shown in merciless focus." "The various aspects of the city, which normally would be prioritized due to aesthetic and personal regard, are all considered of equal value here," commented one critic, who adds, "In other words, everything is regarded as being equally worthless." He operates quickly and instinctively, requiring only an instant to decide on the subject and composition. Indeed, according to his diary he often burns through twenty rolls of film in an hour. He says that his photographs are much like parachutes; one never knows quite where they might land.

1–3 From "Hindenburg Omen," Tokyo, Japan, 2013

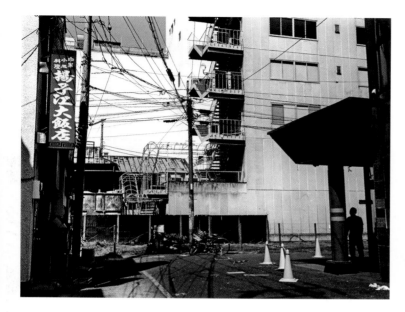

However, as author Donald Richie points out, "The presentational process is so strong in these pictures that one feels that this parachutist landed very near where he intended."

Critics have found many art historical parallels to Kanemura's oeuvre. Photographer Martin Parr (see p.384) and curator Gerry Badger have invoked the name of a master of Abstract Expressionism, stating that "Kanemura's exuberant imagery describes a spatial complexity to rival the best of Jackson Pollock." Certainly, there is a debt to Pollock's pioneering "all-over" style that did away with much traditional composition: like Pollock, Kanemura avoids any points of emphasis. Yamaguchi has also made comparisons with the abstract paintings and Minimal art of Frank Stella and Donald Judd, noting how Kanemura operates like both contemporary artists to produce work that attracts, indeed, almost traps the gaze: "In works of [all] artists, the viewer is forbidden to allow his/her gaze and attention to wander away from the surface of the work itself. That is because nothing exists outside of the work itself." Yet despite these illustrious international references, one can actually site Kanemura's practice more locally, within the tradition of Japanese photography.

John Szarkowski, famous former curator of the Museum of Modern Art in New York, was one of the first influential curators to show an interest in Japanese photography. In 1974 he described a "new spirit" in Japanese documentary photography that was less interested in objectively recording or reporting realism than in translating it subjectively. Szarkowski deemed that artists such as Daido Moriyama (see p.348) were intent on (as paraphrased by Frits Gierstberg) "the rendering of the experience of reality, to a degree that the photograph could become a substitute for this experience." In this way, Kanemura can be seen as following in the footsteps of Moriyama and his contemporaries. Kanemura himself writes, "I believe that photography is a world made up of many stages"; he lists the choice of camera equipment and film type, the nature of the photographer and subject, the act of shooting and finally presenting the imagery. His practice utilizes all these elements to create highly personal interpretations of his home city. His following words echo those of Szarkowski: "Photography does not copy an actual world that exists prior to the photograph but constructs a world that, in a sense, exists in itself."

Kanemura's aesthetic, highly developed in the "Hindenburg Omen" series, serves a clear psychological purpose. The imagery has been intentionally created to engender a specific experience—to reflect the sense of bewilderment and alienation experienced by the everyday urban pedestrian. Shino Kuraishi, curator at Yokohama Museum of Art, states: "He exposes the true face of the city ignored and forgotten by the people who inhabit it, through a foreigner's eye or a *jamais-vu*—the visual experience in which a familiar landscape takes on a completely different appearance." Yet there is also a brooding darkness underlying Kanemura's Tokyo, as Parr and Badger point out, "We do not know whether we are a dream or a nightmare, exhilaration or despair—or both, at the same time." Yet perhaps we are far from asleep. Kuraishi instead suggests that he reveals contemporary civilization for what it really is. He argues that Kanemura dispels any illusion and that "we already live in ruins devoid of emotion"; we are already living the nightmare.

DELHI

Photography reached India within a year of its invention. It did not take long for the British Empire to realize the significance of photographic records to legitimize imperial domination. The earliest reported photographs of Delhi were taken in the aftermath of the Indian Rebellion of 1857. Italian-born British photographer Felice Beato's photographs of the ruins of the battered city document the Indian uprising. By then, amateur photographic societies in India were producing impressive work, including views of Delhi's streets around the great mosque of Jama Masjid opposite the Red Fort. *Chandni Chowk or Silver Street, from the Palace, Delhi*, a print taken *c.* 1857–58 shows a broad avenue neatly lined by trees and houses.

The centrality of polity and governance has influenced the documentation of Delhi continually. Among the finest photographs of the early twentieth century is a series showing the grand entourage of the Viceroy of India, George Curzon, and his wife, Lady Mary Curzon, passing through the streets of Old Delhi to the Red Fort in 1902. The "Delhi Durbar" photographs that form part of the Curzon Collection housed in the British Library have been credited to different photographers, including Thomas A. Rust, S. H. Dagg and the Madras-based German photographic studio Wiele & Klein run by E. F. H. Wiele and Theodor Klein. They provide a visual record of the Coronation Durbar held in Delhi between December 29, 1902 and January 10, 1903, with parading jeweled elephants, crowds, and bustle.

The city of Delhi was defined by the area in and around the Red Fort until the British built their imperial capital, New Delhi—south of the old city—between 1911 and 1931. As the avenues were being laid out in the new city, protests against British rule spilled into the streets as a full-blown movement for civil disobedience. While photojournalists such as Homai Vyarawalla were documenting these significant political and social events in Delhi, the flexibility of the portable camera was changing the genre of street photography in the West. Henri Cartier-Bresson's "decisive moment" inspired a new generation of photographers to find their own definition of India

1 *Street Photographer in the Old City, Delhi*, Henri Cartier-Bresson, 1966 2 From "Street Dreams," Vicky Roy, 2007 3 *Boy at Bus Stop, New Delhi*, Raghubir Singh, 1982

on the streets, moving away from the architectural grandeur of an ancient capital into the fomenting chaos of a population in transition. Cartier-Bresson's record of Mahatma Gandhi's funeral in 1948 is reminiscent of the "stylized decisive tableaux" of his early photography. However, he made six extended visits over a twenty-year period to India, capturing its quintessence in images such as his informal view of a local street photographer napping between customers (see image 1) taken in 1966.

Two brothers working as photojournalists in Delhi in the mid twentieth century took to the street in their own ways. In S. Paul's black-and-white photograph of Chandni Chowk in the mid 1960s, the street became an arena for a large-scale significant event: Muslims offering prayers at Eid. His younger brother, Raghu Rai (see p.366), became a photographer for Magnum. Rai developed a more "vernacular idiom," interpreting layers of meaning in his work at a time when many street photographers were still taking pictures in the old city.

The mid 1970s saw this paradigm shift with the work of Raghubir Singh. Born in Jaipur, Singh lived outside India most of his life in Paris, London, and New York. A self-taught photographer, he met and observed Cartier-Bresson at work in India and was influenced by him. However, Singh became a pioneer of color photography. His pictures

of Delhi are "engaged, immediate, and subjective," and bursting with color (see image 3). Singh shared this platform with artist and activist Ram Rahman, who studied in the United States, before working on the streets of Delhi, "formulating a balance between comment and criticism, description and inscription."

The twenty-first century has brought a careful construction of the portrait into the street. In Gauri Gill's "Nizamuddin at Night" (2007) series there is a classical framing of the street as subject. Sunil Gupta's series "Mr. Malhotra's Party" (2007–11) shows people within a deceptively casual frame against the streets of a modern city (see p.368). In response to the demand for legitimizing gay relationships in India, Sunil has constructed documentary portraits of people who are willing to identify themselves as queer, lesbian, or gay.

Born to a poor family in West Bengal, Vicky Roy ran away from home to Delhi, where he lived first as a street kid and later, as a photographer. His series "Street Dreams" (2007) is evocative of the "fleeting glance" while being a powerful documentation of the lives of Delhi's street children (see image 2). His pictures remain a testimony to the postmodern generation that views their diurnal round without discrimination, creating a new genre of photography for the digital world. **RS**

1 *Cinema Hoarding Painters, Old City*, Delhi, India, 1976
2 *Makeshift Studio Outside Chandni Chowk*, Delhi, India, 1980
3 *Reflections in lajapat Nagar Market*, Delhi, India, 2005
4 *Celebrating Holi, a Festival of Colors*, Delhi, India, 1987

DELHI
BORN 1942, Jhhang, India (now Pakistan) LIVES Delhi, India STUDIED Punjabi
University, Patiala OTHER GENRES Photojournalism OTHER CITIES
WORKED Bangladesh, Mumbai, Calcutta

RAGHU RAI

Indian photographer Raghu Rai has lived in the city of Delhi for almost five decades. He finds his hometown an endless source of inspiration—in fact, it has been the sole focus of three of his books—and he has witnessed its transformation into one of the world's fastest growing megacities. Rai observes, "Today we find ourselves in a Delhi that, in parts, melds with a Hong Kong or a mini New York." Moreover, Delhi is like a microcosm of the wider country and, for him, India is the world. He describes it as "an ocean of life, churning day in, day out . . . crowded with cross-currents of many religions, beliefs, cultures, and practices that may appear incongruous." Rai mirrors his native land's complexity within his photographic practice. Curator Sophie Howarth notes how his images refuse to illustrate simple messages: "Intricate and often irresolvable visual constructions are his way of portraying a country where pizza parlors and cell phones butt up against beggars and religious rituals."

The tale goes that a donkey introduced Rai to photography. He was training to become a civil engineer but hated it. His elder brother made his living taking photographs, and he suggested Rai join a friend of his on a shoot to take photographs of the children in a nearby village. When he arrived, he saw that he could amuse his intended subjects by trying to take a photograph of their donkey. "I tried to get closer but when I was about ten feet away the donkey started running and the children started laughing," he recalls. Eventually, the donkey tired and even though the light had started to fade, Rai persevered and made his exposure. On a whim, his brother sent the donkey image off to London, to *The Times* newspaper's weekly photography competition. Rai won and he was so surprised with the prize money—"[It] was enough to live on for a month"—that he abandoned engineering and took up photography. Fifty years later, having worked for many high-profile New Delhi publications and having been invited by none other than one of the founders of Magnum Photos, Henri Cartier-Bresson, to join their esteemed ranks, Rai continues to work as a photojournalist, and in India he has almost achieved celebrity status.

Rai is a master of creating a complicated image. Throughout his photographic practice, he playfully experiments with myriad ways to convolute the picture plane. His use of color exudes vibrancy and vitality. He fractures the photographic canvas with devices such as telephone poles or pylons, or car window frames as in *Reflections in lajapat Nagar Market* (see image 3). Sometimes, as with *Cinema Hoarding Painters, Old City* (see image 1), separate characters play out their separate stories in opposing corners. Rai multiplies and layers his frame by including reflective surfaces, such as windows, polished metal counters, and mirrors. He also obscures it with darkness, with rain or with flying flecks of paint, as in *Celebrating Holi, a Festival of Colors* (see image 4). "India is, for me, the whole world," he concludes, "I stand amid this human deluge trying to untangle the merging and emerging of various colors, the myriad hues of every emotion, set in motion by each charge and recharge."

BORN 1953, Delhi, India LIVES London, UK and Delhi
STUDIED New School for Social Research, New York; Royal College of Art,
London OTHER GENRES Portraits OTHER CITIES WORKED London, New York

SUNIL GUPTA

"What I like about India is that the street is like a theater," claims
Delhi-born artist Sunil Gupta. Telling words given that his ongoing
series of street portraits started in 2007 called "Mr. Malhotra's Party"
is choreographed and uses Delhi's ever-changing thoroughfares as its
stage. He frames his subjects as "the guests of an imaginary party,"
choosing the name Malhotra, he says, "after the ubiquitous Punjabi
refugee who arrived post partition and contributed to the development
of the city." Each guest has been invited for the same reason; they all
describe themselves as "queer." The idea of the party alludes to the
lengths one has to go to in New Delhi (the southern part of the
capital) if this is the case. As Gupta wrote when he started this series,
"Gay nights at local clubs in Delhi are always signposted as private
parties in a fictitious person's name to get around the law: Section
377, a British colonial law, which still criminalizes homosexuality in
India." Each of Gupta's subjects is essentially making a stand for their
rights and, as the artist says, "performing themselves for posterity."

Although born in Delhi, Gupta emigrated with his family to
Montreal in 1969. In the 1970s, he moved again: this time to New
York. There he met Lisette Model, the photographer famed for her
work at *Harper's Bazaar* and for being the mentor to Diane Arbus.
Gupta had been passionate about photography since his childhood.
When he showed Model his work, she was intrigued. At the time he
was studying for a postgraduate degree in business studies, but she
advised him to take up photography as a career. "Lisette how am I
going to live?" he recalls asking. "Middle-class Indian boys can only
do medicine, engineering, or MBAs" Yet she persuaded him, and he
enrolled at the New School for Social Research under her tutelage.

Gupta's first photographic series was named after a street in
Greenwich Village: "Christopher Street, New York" (1976). It was
renowned for being the location of the Stonewall Inn and the ensuing
Stonewall riots in which gay men fought the police during a raid on
June 28, 1969—an event that is widely considered to have given rise
to the gay liberation movement in the United States. Gupta's series
uses traditional, black-and-white street photographs to portray young
gay men striding proudly around what was, at the time, the center
of New York's gay rights scene. "It was 1976," Gupta recalls, "post-
Stonewall and before AIDS. Everything was about hedonism . . . the
whole liberationist sexual politics had come to life." The images
in the series reflect this confidence and optimism.

1 *Kaushiki, Alaknanda Market*, Delhi, India, 2007
2 *Pavitr, South Extension Part 1*, Delhi, India, 2007
3 *Diepiriye, Malviya Nagar*, Delhi, India, 2007

|5|6|7|

4

4 *Shubham, Krishna Park*, Delhi, India, 2012
5 *Sonal, Yusuf Sarai*, Delhi, India, 2012
6 *Charan, Najafgarh*, Delhi, India, 2012
7 *Arti, M-Block Market, Greater Kailash-1*, Delhi, India, 2011

In 1980, eleven years after last stepping foot in India, Gupta returned to the city of his birth. His experiences in New York (and subsequently in London) starkly contrasted with the gay scene in New Delhi, where homosexuality remained illegal. "People living under such extreme conditions start behaving in extreme ways," says Gupta, "we have the spectacle of furtive, fleeting meetings." As to the hope of openly sharing your life with your partner, he adds, "that seems beyond the realm of possibility." His groundbreaking series "Exiles" (1986–87) was born from this frustration; it reads as part document, part theater and part protest. "It would have been relatively easy to shoot reportage pictures," but instead "I decided to do constructed images, which would involve getting to know a small group of people . . . and they become the cast." Gupta collaborated with his gay friends to create portraits in various iconic sites in the capital—from Humayun's Tomb to Hauz Khas—however, each sitter retained his anonymity by turning his back to the camera. This simple gesture eloquently visualizes the marked disparity between gay life in Delhi and New York: the men's refusal to reveal their identity could not be more different to the open, exuberance of the "Christopher Street" series.

"Mr. Malhotra's Party" is Gupta's way of revisiting "Exiles" in the present day. Gupta has seen how life for gay, lesbian, bisexual, or transgender Indians has been transformed. He adds, "Today there is a younger generation that is much more impatient and wants the laws to be changed. They want to have their freedom and they want it now. They are much more upfront about being queer or being lesbian or gay." "Mr. Malhotra's Party" expresses this radical shift. As in "Exiles,"

Gupta trained his lens once more on his friends and acquaintances. He says, "I prefer to photograph people who I know personally, not use models and not use strangers because I feel there is a relationship between me as the photographer and them as the subject, which carries over into the picture." However, unlike "Exiles," this time he also included women. Whereas "Exiles" uses public spaces as the backdrop, the locations chosen for the new series are all personal to the sitter and reveal the streets where they live or work. Furthermore, again in direct contrast to "Exiles," this time subjects face the camera, striking poses that tend to read like open declarations of identity; indeed, their names give the works their titles.

Vidya Shivadas, a curator and art critic based in New Delhi, believes that "Sunil Gupta is a vital catalyst in the contemporary Indian landscape; where marginalized groups are beginning to speak up, seek collective identities and build alternative support structures." Indeed, during the making of "Mr. Malhotra's Party," on July 2, 2009 the Delhi High Court made an historic decision to reverse the archaic Section 377 that criminalizes same-sex behavior. Although this has since been challenged in the Supreme Court, at the time of writing, while people await the final judgment that of the Delhi High Court prevails. Shivadas concludes, "Today we have the queer community celebrating its newfound 'freedom.'" Who knows what exact role the production, publication, and subsequent exhibition of this series played in this outcome. However, it is clear that the series not only considers the documentary and theater inherent in portraiture, but also reveals how Gupta successfully wields photography as a weapon for resistance and revolution.

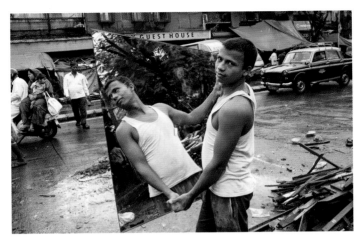

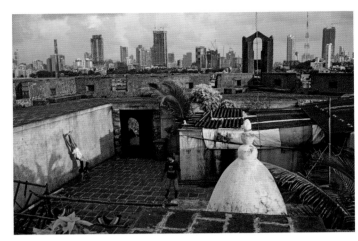

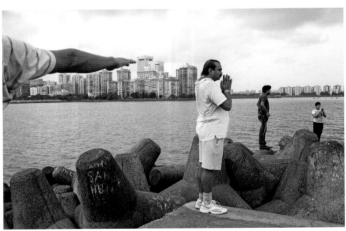

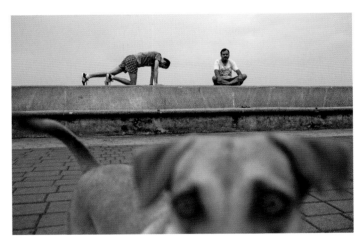

MUMBAI

BORN 1976, Bialystok, Poland LIVES Mumbai, India STUDIED University of Glamorgan, Wales SERIES "Cardiff After Dark," 2005–11 OTHER GENRES Photojournalism OTHER CITIES WORKED Cardiff

| 1 | 2 | | 7 | 8 |

| 3 | 4 |

| 5 | 6 |

1–8 Mumbai, India, 2007–13

MACIEJ DAKOWICZ

Maciej Dakowicz subscribes to the traditional practice of street photography. He spends hour after hour walking his chosen city, combing its busiest quarters, with a camera at the ready for that rare instant when something unexpected and fortuitous happens. He defines what he searches for as the "twist"—"something clever, funny, surprising, or ambiguous." Dakowicz is currently living in and looking for such moments in a city to which he has repeatedly returned, Mumbai. The ongoing body of work he is creating conjures up a strange, almost fantastical world in which people appear as tall as tower blocks and four-eyed taxi drivers stare at you from their rear-view mirrors. "I love India for its vibrancy, there is so much life there, so many people, so much happening all the time," declares Dakowicz. His words echo those of the genre's past master, Henri Cartier-Bresson, who said, "Photography is nothing. . . . It's life that interests me."

Dakowicz came to prominence with his critically acclaimed series "Cardiff After Dark" (published in 2012), which reveals what takes place on the Welsh capital's streets after the pubs close. Curator Sophie Howarth wrote an apposite description of the work, saying "Dakowicz's Cardiff is a dystopian carnival where closed-circuit cameras patrol

street-corner trouble spots, trash cans are used as toilets, phone boxes become stripping booths, and alcohol-flushed faces are illuminated by a multitude of flashing electronic oracles." Critic Sean O'Hagan adds, "He has an outsider's eye for telling detail, a way of showing us, in often dramatic fashion and with a degree of humor, what is right under our noses." Dakowicz was indeed an outsider to Cardiff; he had arrived there from Hong Kong in 2004 to study for a Ph.D. and before that he grew up in Poland. Following the success of "Cardiff After Dark," he quit his university job to focus on photography and to travel further.

The Mumbai work is different from that set in Cardiff. For a start, Dakowicz shoots during the day when the sun casts velvet black shadows and creates saturated colors. He only stops at midday for a break to avoid the harsh, overhead light. He rarely photographs after dark; he quips, "I am simply too tired by the end of the day to carry on." Also, in contrast to the drunken Welsh crowd (he admitted to drinking a pint or two to fit in with the revelers), the Indians are acutely aware of his presence. "I don't blend with the crowd," he jokes. Moreover, "People love being photographed. They tend to start smiling or posing the moment they see the camera so getting natural pictures can be difficult. You either need to be quick and shoot before being noticed or try getting a photo while interacting with people." Also, he explains, "I am not a one shot person. I work the scene, moving around, changing angles until I get the shot." Despite these differences, the Mumbai and Cardiff series are united by their sense of humor and their delight in the absurd. Wherever he goes Dakowicz's razor-sharp eye is able to extract from the ordinary, everyday world, something surreal and extraordinary.

MUMBAI
BORN 1988, Brussels, Belgium LIVES Brussels STUDIED School of Arts (KASK),
Ghent, Belgium SERIES "The Fourth Wall," 2012 OTHER GENRES Staged,
portraits OTHER CITIES WORKED Bangkok

MAX PINCKERS

Three boys peer into an illuminated hole in the ground; a man sits on the pavement and proclaims to an unseen audience while an elderly man appears to be directing a group of feral cats. There is something faintly unnerving about this collection of Mumbai street scenes; they do not appear quite real. A clue reveals itself on considering how these images are usually displayed. In a gallery or museum setting, the artist exhibits them as large, unique, free-standing light boxes, whereas in the book *The Fourth Wall* (2012) the artist chooses to print them on cheap, low-quality newspaper. These presentations may seem to contradict each other but they actually hint at different aspects of the same medium. The light box installations ensure that the scenes emanate light in much the same way as they would on a cinema screen, whereas the newsprint is selected to evoke the low-quality production values of local cinema. For the series "The Fourth Wall," Belgian artist Max Pinckers took his inspiration from the Hindi movie industry that is based in Mumbai, known fondly at home and abroad as Bollywood. Photographer and writer Colin Pantall astutely notes, "Pinckers takes us to a Bollywood Mumbai that is half-imagined, half-nostalgic and half-real, a masala mix that conforms to the rich history of representation that the city has experienced over the years."

Pinckers started the project during his final year at the School of Arts in Ghent, Belgium, while studying for a Master's in fine art. He traveled to Mumbai with Victoria Gonzales-Figueras, who acted as his lighting assistant and researcher. The trip was not his first; he had been there a few years before and one particular event had left a memorable impression upon him. Out on the streets one day, he had been scouted to take part in a Bollywood movie as an extra and the experience made him understand the extent of the local cinema industry's influence. He suddenly realized, as he says, "nowhere else is there such devotion to cinema as in India"; indeed, "Bollywood strongly defines the [local] culture." Furthermore, "this fictional world seeps into reality and influences everyday life, dictating the perception and imagination of its audience." This crossover between fact and fiction was exactly what Pinckers hoped to explore in the photographic venture he was planning with Gonzales-Figueras.

On arriving back in Mumbai, he started by taking photographs of real actors at work on real film sets. However, these images seemed not to achieve what he was looking for so he put this approach aside

1 *Emphasis Applied Over a Single Line of Interest*,
Mumbai, India, 2012
2 *The Dominant Performer*, Mumbai, India, 2012
3 *The Mask Dance*, Mumbai, India, 2012

4 *A Progressively Diminishing Shot-length Prior to the Visual Climax*, Mumbai, India, 2012 5 *An Action Broken in Two is Stretched in Time*, Mumbai, India, 2012 6 *When Pivoting Performers Have a Passive Role*, Mumbai, India, 2012

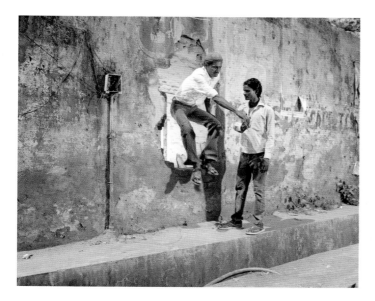

and changed direction. After much thought, he came up with the idea of turning the Mumbai streets into his very own set and their residents into his actors. First he searched for locations that seemed to evoke an atmosphere of anonymity: places free from the clamor of competing advertising posters and billboards. He selected tumbledown buildings whose surfaces, faded and weathered, created a sense of timelessness. He then invited policemen, security guards, store salesmen, street hawkers, whoever happened to be passing by and asked them if they might act out scenes from their favorite Bollywood movies for his camera, beneath the full glare of dramatic lighting. "The people in these images become actors by choosing their own roles, which they perform for the camera and its western operator," he explains. "Conscious of the power of images, they give it their all, reflecting on their silver screen dreams by embracing their collective visual world and creating their own brief moments of suspension of disbelief." Indeed, their performances captivate; as Pantall observes, the viewer enters "the world of long-lost brothers and separated lovers. Smoke bombs explode, lovers weep, and wannabe bad guys put on their best Gabbar Singh (the bad guy from the ultimate masala Western, *Sholay*, 1975) faces for Pinckers's camera."

Yet despite the staging, choreography and lights, in other words the theatricality, these scenes are embedded in the urban everyday. Sometimes scenes might be based on real spontaneous moments. He elaborates, "A photograph of two men in uniform climbing over a fence, escaping," for example, is "a re-enactment of a moment that just passed. They do it over again with great pride and pleasure." At other times inspiration comes from real news stories; again Pinckers

explains, "I read an article in the newspaper: two men use sleep-inducing gas to rob a struggling actress in her home, the same gas used in a 1972 hit film in which a cook robs his landlord." Cue the image title, in which he released a smoke bomb in a bedroom film set. The series is ultimately a mix between the language of documentary fact and fiction: what Pinckers describes as a "very fine balance" between the cinematic and the real.

Curator Charlotte Cotton suggests that this tactic, "can tell a story of magical realist power, of unexplained wonders and drama that are rendered from actual lives and experiences." Ultimately, as Simon Bainbridge is quick to point out, "The Fourth Wall" questions widely held assumptions about the documentary genre. A clue is found in the title, which refers to a different kind of rupture between reality and the celluloid world: "On a theater stage that consists of three walls—left, right, and back—the fourth wall forms the imaginary screen through which the audience sees the scene unfold. The actors, conscious of this barrier, tend to break through it now and then by hinting at their own fiction, acknowledging the camera and the act." However, Pinckers applies this concept to documentary photography by way of commenting on the paradoxes of his chosen medium; he says, "The documentary photographer who captures reality as 'a fly on the wall' can't deny his directive and manipulative role any longer. His anonymity, his seeming absence, is merely a pose. He is the one with all the power and he chooses 'the decisive moment.'" The tableaux that he captures are not lies, but enfold themselves within the studio that he creates from reality. As such "The Fourth Wall" can be read as a comment on the whole genre of documentary photography.

MANILA

BORN 1961, Wolfsburg, Germany LIVES Hamburg, Germany STUDIED Folkwang University of the Arts, Essen; London College of Communication OTHER CITIES WORKED Bangkok, Shanghai, Calcutta, Kuala Lumpur, Hong Kong, Shenzhen, Jakarta

PETER BIALOBRZESKI

Peter Bialobrzeski's latest series takes the viewer on a journey through the contemporary megacity, starting at its outer edges and moving ever deeper into its massive, superdense core. He visited many capital cities for this project, but perhaps of all of them, Manila reveals the most interesting progression. We begin at its periphery with images of slum huts (see image 3). Critic Peter Lindhorst elegantly describes this housing as "built from the refuse of civilization" so primitively cobbled together that it seems to mock "any sort of physical laws, with lines and hooks strung across their fronts, where clothing and other possessions hang." As we continue, we encounter images such as image 2, where the scenes become more built-up, more sophisticated and the buildings start to shoot skyward. Finally, we reach Manila's center; image 4 reveals the glittering, glass and metal façades, the steep walls and concrete canyons of the high-rise blocks.

Bialobrzeski has called the series and book *The Raw and the Cooked* (2011). The term is borrowed from French ethnologist, Claude Lévi-Strauss, who used it as the title to one of the volumes from his famous treatise *Mythologiques* (1964–71). Lévi-Strauss suggests that the invention of cooking denotes a transition from nature to culture, from primitiveness to civilization. As Lindhorst explains, "Cuisine becomes a metaphor through which one can read the progress of civilization." Bialobrzeski has adopted this notion and applied it to the various stages of urban infrastructure found within a city. He proposes, "The huts made from scrap mark the beginning of the idea of habitation, they stand for the 'Raw.' Whereas the multistoried, air-conditioned skyscrapers portray the 'Cooked.'" The series takes us on a photographic odyssey from the "Raw" to the "Cooked." the primitive to the civilized way of life.

Urban Asia has long fascinated the German photographer. For one of his earlier renowned series and subsequent book *Neon Tigers* (2004), he traveled to seven of Asia's major cities: Hong Kong, Bangkok, Kuala Lumpur, Jakarta, Singapore, Shanghai, and Shenzhen. He photographed the seven separate cityscapes as night fell and they lit up the dark skies. He then merged the imagery to construct one virtual city; in *Neon Tigers* densely packed verticals soar sky high, flare and flicker to create one

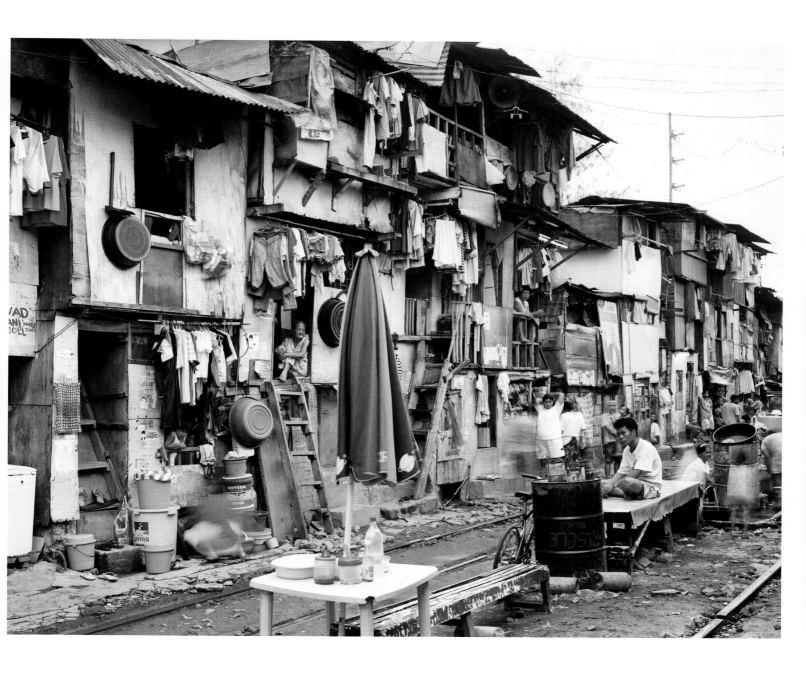

1—4

1—4 From "The Raw and the Cooked," Manila, Philippines, 2008

4

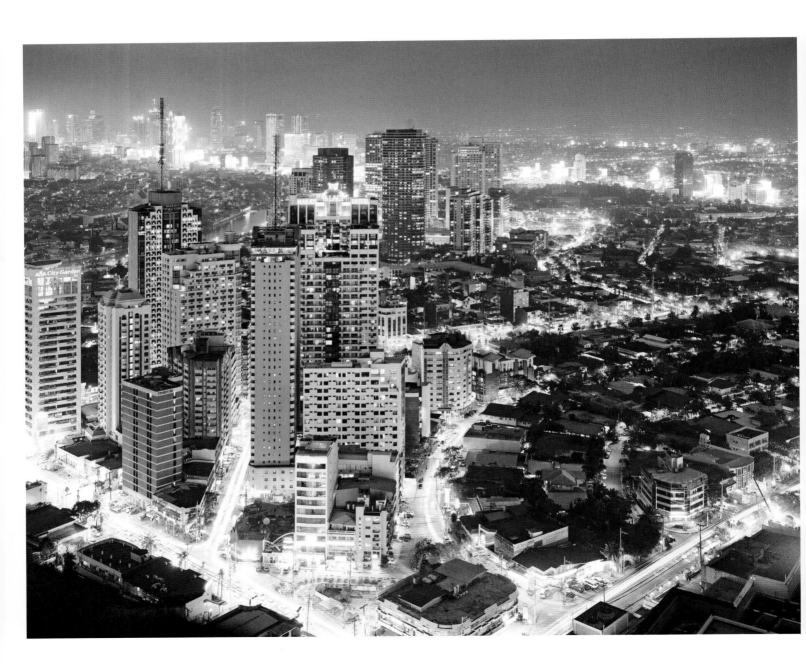

sprawling, gargantuan, glowing "megatropolis." "My intention is not to show how it is," he claims, "I want to show how it could be." The same applies to "The Raw and the Cooked" series; the images of different cities coalesce and the end result is one seemingly seamless fantasy metropolis. Lindhorst writes: "Bialobrzeski's photos unfold a world drenched in artificiality. . . . We have to take care not to get immediately lost in the vast urban juggernaut, with its oppressive complexity and relentless sensory overload."

Much of Bialobrzeski's imagery is made in the same way. After he arrives in a city and checks into a downtown hotel, he walks in concentric circles outward looking for scenes to photograph. High vantage points are particularly useful in the city center and he ascends office blocks, apartments, or parking structures to find views down to the labyrinthine streets and through the narrow man-made ravines. His tools of choice are an old-fashioned, large-format camera and a tripod. The academic Christoph Ribbat wryly notes, "Bialobrzeski likes to present himself as the absurd figure from the nineteenth century who moves through the metropolises of the future." He adopts the role of the *flâneur*; he heaves his cumbersome kit through the city, sets it up, watches and waits, waits and watches. He tends toward long exposures and after he has framed his picture, he will leave the shutter open for up to eight minutes. Just like in one of the earliest photographic images, Louis-Jacques-Mandé Daguerre's long exposure *View of the Boulevard du Temple* taken in Paris in 1838–39, fast-moving throngs of pedestrians and traffic blur into oblivion. Consequently, Bialobrzeski's are devoid of people, one could say that they appear dehumanized.

Ultimately, "The Raw and the Cooked" contains a disturbing message about today's megacities. Bialobrzeski elaborates, "The

project charts a progression from the simplest hut to the complicated dense tower block arrangements, but in these later images we see so many repeated individual apartments that one struggles to say how many people live there. The series is essentially a provocation; it asks whether this is the civilized way to live." The images of the thrusting, hard-edged skyscrapers make the huts in the ghettos look almost cosy, and suddenly the "Raw" scenes begin to look more appealing than the "Cooked." Among the diverse influences cited by Bialobrzeski, perhaps unsurprisingly, is Ridley Scott's movie *Blade Runner* (1982), William Gibson's book *Neuromancer* (1984), and the city-building computer game SimCity. The "Cooked" scenarios swiftly take on the appearance of an urban dystopia.

"The new face of the city . . . is clothed in a kind of decor that speaks of the coarse chill of economic ascendency," argues Lindhorst, "The paradigm of technological progress, and rapidly growing economic power, leads the inhabitants of a city to simultaneously lose their sense of identity, and tend toward a feeling of alienation." Bialobrzeski's series provokes feelings of isolation and loneliness, and promotes the idea that the modern metropolis is not so much civilized as dehumanized. It is perhaps to be expected, therefore, that the work has previously drawn critics to quote French cultural theorist Jean Baudrillard and his notion of the simulacrum. Baudrillard once wrote, "The city is no longer the political-industrial polygon it was in the nineteenth century—today, it is a polygon made of signs, media, and codes." Arguably, in no series more than "The Raw and the Cooked," the urban skyline is fractured, fragmented, reassembled and layered to create a simulated space, where as Baudrillard says, "signs of the real replace the real" and reality is derealized: the city as simulacrum.

DUBAI
BORN 1944, New York, USA **LIVES** New York **STUDIED** Dartmouth College, New Hampshire **SERIES** "iDubai," 2008–09 **OTHER GENRES** Documentary, fine art
OTHER CITIES WORKED New York, Chicago, Los Angeles

JOEL STERNFELD

Dubai looms out of the vast, flat expanse of desert like a mirage, boasting (when this book went to press) the world's most colossal skyline: the tallest building (the 2,716-feet high Burj Khalifa), the tallest residential skyscraper (the 1,356-feet high Princess Tower), and the tallest hotel (the 1,165-feet high JW Marriott Marquis Dubai Hotel). It is a playground of underwater hotels and man-made island archipelagos, where the world's largest flower garden blooms. One could say that Dubai represents the latest leap in urban evolution: the twenty-first century's fantasy of a metropolis, but native New Yorker Joel Sternfeld has a very different take.

Sternfeld views Dubai as a "symbolic site for a consuming world." He came to the city in 2008 specifically to photograph its huge system of shopping and entertainment malls, training his lens on people passing through the acres of highly polished, air-conditioned retail space. The resulting series and book *iDubai* (2010) reveals the lavish excess of these mega-malls. Art historian Jonathan Crary notes how the imagery exposes "an extreme form of what the political theorist Guy Debord called 'the suppression of the street' and all its potential unruliness and spontaneity." He labels these malls "non-places," adding, "What Sternfeld shows us then, with all the nuance of his art, are people negotiating and subsisting in these profoundly alienating surroundings."

| 1 | 2 | 3 | 4 |

1–2 *Ski Dubai, Mall of the Emirates*, Dubai, United Arab Emirates, 2008–09
3 *11 p.m., Festival Center*, Dubai, United Arab Emirates, 2008–09

4 *Amusement Park, Deira City Center Mall*, Dubai, United Arab Emirates, 2008–09
All images: Pigment print. From an edition of 5 and 2 artist's proofs. Image size: 5 ⅓ x 4 in. Paper size: 11 x 8 ½ in.

Sternfeld is one of a small number of artists who legitimized the use of color in the medium of photography in the 1970s and 1980s. He is renowned for using a nineteenth-century style, large view camera, complete with tripod and black focusing cloth, but in lieu of glass plates, he applies sheets of film, which he then scans to make digital prints. He has used this approach for the last three decades to create images that are dense with detail and depth. However, this latest series marks a radical departure. He cast aside his usual tools, in favor of the simple, inbuilt camera on his iPhone. Although he admits to admiring its color palette and its pinhole lens, saying that it creates "little chromatic jewels," the decision was perhaps made for conceptual rather than aesthetic reasons: "It was about the marriage of form and content; using one of the most visible contemporary fetish objects to create an image of global consumption."

iDubai is easily situated within Sternfeld's wider practice. It is the final addition to what could be called a four-book cycle: following on from *Sweet Earth* (2006), *When It Changed* (2008), and *Oxbow Archive* (2008). Together these bodies of work present utopian and dystopic views of humanity's effect on our planet. However, these concerns date back to the book that launched Sternfeld's career, *American Prospects* (1987), and one of its most iconic images. *McLean, Virginia, December 1978* depicts a fireman carefully choosing a plump pumpkin from a farm stall as a house burns in the background. Curator Lisa Le Feuvre notes, "This unlikely scene takes on an allegorical position, symbolizing a society where individual pleasure is prioritized over human responsibility." Her words echo eerily through the labyrinthine mall halls, the conspicuous consumerism and ostentatious opulence on display in "iDubai."

DUBAI
BORN 1952, Epsom, UK LIVES Bristol, UK STUDIED Manchester Polytechnic,
UK SERIES "The Last Resort," 1986; "The Cost of Living," 1989; "Luxury," 2003–08
OTHER GENRES Documentary OTHER CITIES WORKED London, New Brighton

MARTIN PARR

"Luxury is the new poverty," claims Surrey-born photographer Martin Parr. "For years, the subject of social documentary photography has been poverty, whereas I think that the new front line is luxury." During the noughties, Parr traveled the globe in search of the most ostentatious displays of wealth—from Fashion Week in Paris to the Beijing Motor Show. In 2007, he touched down in Dubai, with a packed schedule that took him to the Gulf Art Fair and its whirl of lavish parties, as well as to the Cartier International Dubai Polo Challenge. The trip was such a success that he returned again the next year for the World Cup Races.

Dubai was one of the last locations photographed for "Luxury"; Parr decided that 2008, the year of the global economic crisis, aptly signaled the end to the series and published the book *Luxury* as an epitaph to the decade of aspirational living. Throughout, even while the champagne flowed and the jewels dazzled, Parr's shrewd eye was rarely distracted. "Luxury" exposes the vagaries and vanities of each culture, how some flaunt their wealth more than others and, as Parr points out, none better than the newer economies such as Dubai.

Parr has been described as a "chronicler of our age." He shot to fame in 1986 with "The Last Resort," which pictured vacationers in the coastal resort of New Brighton in Merseyside, UK. At the time, the work divided critics; some accused Parr of exploiting and sneering at the working class. He admits to waiting for vacation times when there would be more people, more babies, and more garbage; as he says, "My job as a photographer is to exaggerate . . . you have to make your case very clear." His next series, "The Cost of Living," which portrayed the middle classes at the height of Thatcherism, also caused commotion; one subject even claimed she felt "photo-raped." The controversy continued in 1994 when Parr was up for election at Magnum and Philip Jones Griffiths led the opposition claiming, "Let me state I have a great respect for him as the dedicated enemy of everything I believe in, and I trust, Magnum still believes in." Parr eventually got the 66.6 percent required to become a member.

Parr's uncompromisingly direct photographic approach has become his unique, signature way of seeing. Photographer Gerry Badger points out how this has in the past been translated "as aggressive, which is then conflated in many people's minds with cynicism." However, Parr's images are often humorous and always illuminating. As curator Thomas Weski aptly observes, "They show us in a penetrating way how we live, how we present ourselves to others and what we value."

1–4 From "Luxury," Dubai, United Arab Emirates, 2007–08

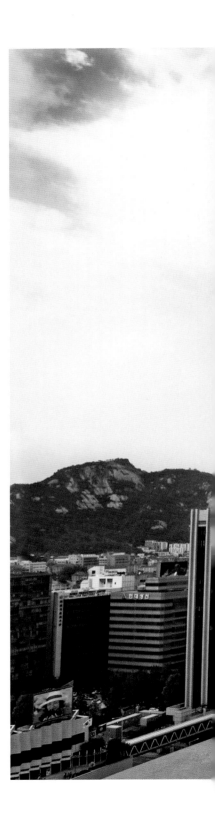

SEOUL

BORN 1981, Seoul, South Korea LIVES Seoul STUDIED University of Southern California, Los Angeles; Pratt Institute, New York; Parsons The New School for Design, New York OTHER GENRES Performance OTHER CITIES WORKED New York

AHN JUN

South Korean artist Ahn Jun refers to her series "Self-Portrait" (2008–13) as "a kind of performance without an audience." These intense, psychologically charged images depict the artist balanced precariously, sometimes sitting, sometimes standing, on edges of roofs atop various skyscrapers in her hometown of Seoul. Ahn creates a birds-eye view of the city from above by pointing her lens downward, capturing her dangling feet and the vertiginous drop that plummets to the pavements far below. There is a powerful experiential element to viewing her work as she succeeds in conveying the physical response of placing her body in such a perilous position. Ahn pushes the viewer to directly sense the heady mix of thrill, fear, and anxiety that such a moment engenders.

Ahn first conceived of the idea for her series in 2008 when she was studying photography at the Pratt Institute in New York; she has since played with the idea farther afield in the metropolises of Seoul and Hong Kong. In New York she was living alone in an apartment on the corner of 27th Street and 6th Avenue (see p.32). Ahn recounts, "There was a day I recalled my time in adolescent years . . . I was sitting on the edge of my apartment in New York and looking over the cityscape. I had thought that suddenly my youth was coming to an end and I could not figure out the future. I sat on the edge and looked down. Then I saw the empty space, the void. There was a sudden change in my perspective on life and death, present and future. What I was actually standing on was the empty space. It was the present for me. So I took a picture of my feet. That was the start."

Her methodology for photographing the cities in this series is always the same. She selects the building she wishes to shoot—she looks for landmark architecture but with a personal significance—and makes her way to the top, sometimes having waited months for permission. She positions herself on the edge of the building and then sets her camera (either the Canon 5D Mark II, selected for its fast shutter speed and lightness to handle, or the heavier Nikon D800 if it is not too windy) on drive mode and shoots as many images per second as possible until the memory card is full. Ahn refrains from using safety equipment when her whole body is in the frame, but when she is required to lean

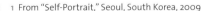
1 From "Self-Portrait," Seoul, South Korea, 2009

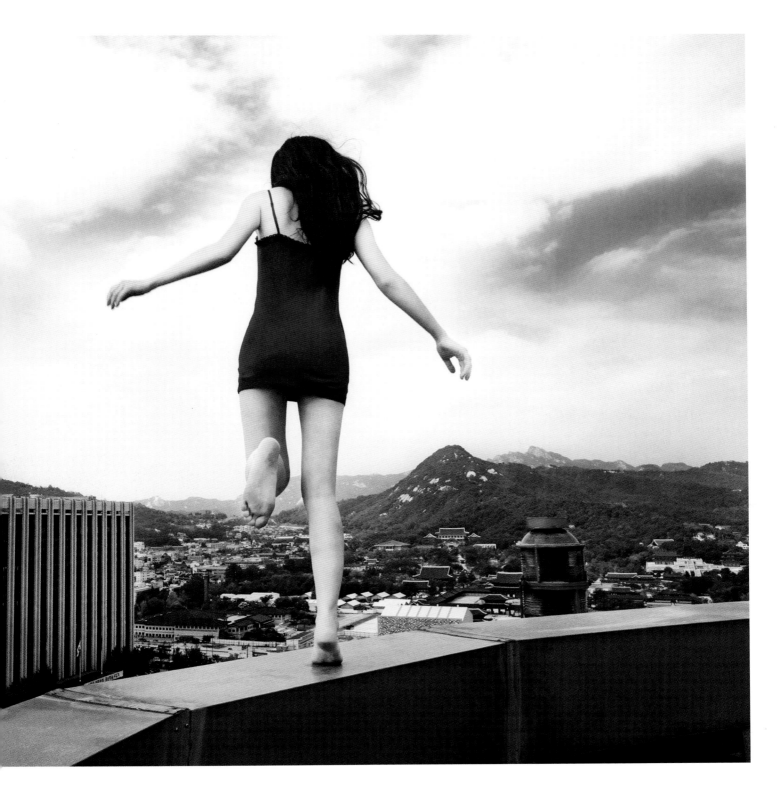

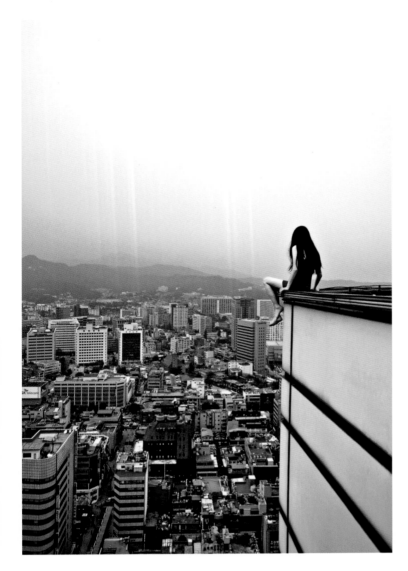

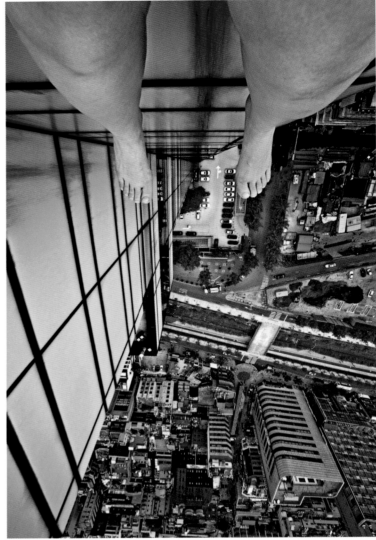

forward to take a photograph of her hanging feet, then she wears the kind of harness used by mountain climbers so that she can get a more dramatic angle, safely. She then painstakingly reviews each thumbnail image, potentially thousands in a sequence, and searches for what she describes as "the one frame that subverts the context and erases the rest." She explains, "I am interested in capturing the invisible moment. It's the very short moment that cannot be perceived by the naked eye. That is the moment we cannot really reveal within context. . . . For example, images in which my body looks peaceful or aggressive, rather than fearful. It is a certain moment of time that did exist, but which we couldn't perceive with the naked eye because it happened too fast." Friends who have

accompanied Ahn on her rooftop missions bear testament to this, recalling how conditions are often windy and fraught with tension and yet the photographs exude a certain serenity and quietude.

Ahn cites scientist and photographer Dr. Harold Edgerton as her greatest influence and inspiration. The pioneer of the electronic flash in fast-moving photography, he used a stroboscopic flash to archive 1/1,000,000 images a second. One of his most iconic photographic works depicts an apple being pierced by a bullet. For Ahn this reveals an important aesthetic: "It was a moment that the human eye cannot perceive, but for a very short instant it was there. . . . I consider the most fascinating aspect of a photographic image to be the elimination of context. It means that the image is

isolated from the five senses of human perception and has the possibility to create its own context inside the isolation of space and time. Hence, for me, photography is reality and fantasy, the truth and fake at the same time." Ahn's adoption and development of this notion simultaneously subverts and expands the traditional relationship between photography and performance, where the camera is used to document the performance thereby making the ephemeral moment eternal and recording an action that would otherwise be lost. She questions, counters, and confronts this notion of truth in performance photography and photography in general, widening the context of the work into a more philosophical realm. Ahn explains, "I believe in an instant of life, our reality meets with dream or fantasy which we cannot perceive since it is so short and vulnerable. And I believe photography can capture this dreamlike moment just like the moment was everything we saw." She calls this the "directed decisive moment," referencing the celebrated maxim of Henri Cartier-Bresson.

Ahn's practice can be seen as developing out of the genre of self-portraiture pioneered by female photographers such as Cindy Sherman and Francesca Woodman in the 1970s. Indeed, one can draw parallels with Woodman's series "Self-Deceit" (1978). Ahn, like Woodman, slowly reveals herself and her psychology to the camera lens as the series progresses using a performative approach; at first the audience only sees her feet, then her dangling legs, a full-body shot from behind until eventually glimpses of her face are permitted as she steps out of a window, balances on a roof edge or sits perched, gargoylelike, atop a skyscraper: part goddess, part superwoman, part vulnerable child.

However, there is always an ambiguity to Ahn's motivation. Immediate reading suggests some form of death wish, an allusion to the suicidal fantasies she was exposed to in her teens and has openly discussed, or perhaps to the wider issue of increasing rates of suicide in Asia where Seoul, the artist's place of birth, has one of the highest. Yet a purely metaphorical reading of these images falls short of appreciating a more profound psychological and philosophical interpretation. Ahn explains, "We think the city is in front of us but actually it is very far away. What is actually in front of us is a void. . . . The edge is a psychological symbol for me. When I look at the skyline, I can see it, but I cannot capture it. It is like a fantasy of the future. So I think the present is one very short instant between the future and the past. The present is the void. So basically all of us are living on the edge of something, between life and death and between the ideal and the reality."

2–3 From "Self-Portrait," Seoul, South Korea, 2009
4 From "Self-Portrait," Seoul, South Korea, 2008

HANOI

BORN 1981, Philadelphia, USA LIVES New York, USA STUDIED Slade School
of Fine Art, London; Sarah Lawrence College, Bronxville; International Center of
Photography, New York OTHER CITIES WORKED New York, Sydney, London, Bangkok

MICHAEL ITKOFF

Over the past decade, New Yorker Michael Itkoff has traveled to London, Sydney, Bangkok, New York, and Hanoi in pursuit of faces for his ongoing project "Street Portraits." His method is always the same; in each city he picks up a local assistant. "In Hanoi, a friendly fellow named Zong drove me around the city on the back of his scooter," he recalls, and served "as a translator and board holder." The assistant

holds up a small white board behind the subject's head. Itkoff makes little effort to conceal him and Zong often appears; hands clasping the board's edges, flip-flopped feet between the subject's legs and, in the image of a child, even face staring at the camera with a blank expression that refuses engagement. The resulting images have been described as street portraits with a passport photograph pasted on top. Each image merges the long-standing photographic traditions of the street photograph and the studio portrait. As critic Aaron Schuman recognizes, "The amalgamation of these two approaches within one frame somehow persuades us—the experienced, if not exhausted viewers of such photographs—to look harder, to investigate further and, ultimately, to care more." Itkoff's "Street Portraits" call to mind two very different bodies of work: first that

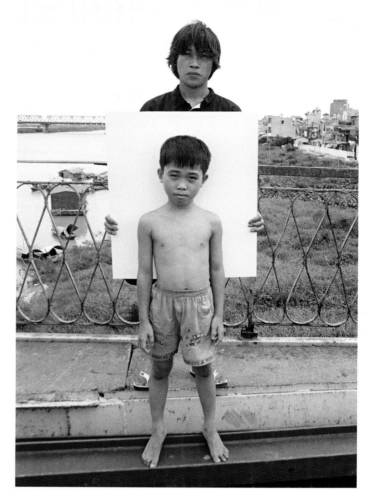

1 *#2*, Hanoi, Vietnam, 2003 3 *#12*, Hanoi, Vietnam, 2003
2 *#16*, Hanoi, Vietnam, 2003 4 *#9*, Hanoi, Vietnam, 2003

1	2	3	4

of the legendary photographer of people, August Sander, who worked in Germany during the 1920s and 1930s. Sander hoped to create a typology of the German people; he pictured his subjects in their homes or at work, providing meaningful context, and their profession or social class lent the images their titles, such as "Pastry Chef," "Coal Carrier," or "Bohemian." He took thousands of images for his collective portrait; some he exhibited as "Menschen des 20. Jahrunderts" (People of the 20th Century) in 1927, and a mere sixty were selected for the book *Anlitz der Zeit* (*Face of Our Time*) published in 1929. Many contemporary photographers, from Bernd and Hilla Becher to Andreas Gursky, claim that his straightforward approach influenced their objective, deadpan imagery, and there is certainly an echo of this within Itkoff's work. The subject of each "Street Portrait" faces the

camera straight on, with little facial expression, and Itkoff frames every one similarly so that when seen together, whole bodies from head-to-toe seem to stand in formation with repetitive regularity.

Furthermore, the use of the small white board invokes the history of studio portraiture and perhaps the master of the white backdrop, Richard Avedon. For his landmark series "In the American West" (1979–84), he framed his subjects outdoors against vast, seamless sheets of white paper; by using narrow depths of field, they appear like scientific specimens skewered in a void, completely removed from context. Avedon eliminates what he calls "distracting backgrounds" so that the viewer will more readily engage with the subject's face. He is often quoted saying, "The point is you can't get at the thing itself, the real nature of the sitter, by stripping away the surface. The surface is

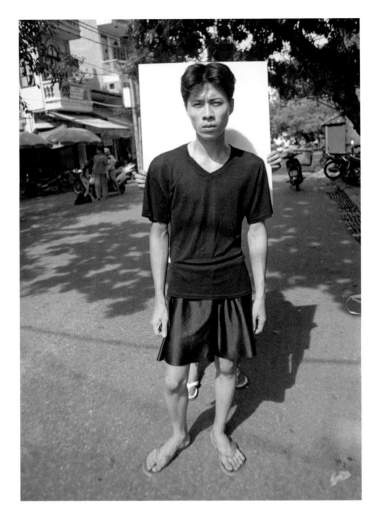

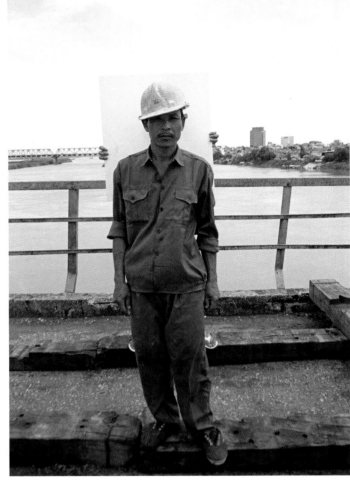

all you've got." However, he also suggested, "The discipline is to do as truthful and as deep a portrait as is possible to make. For me it's been a lifetime of digging deeper, into myself and the people who have posed for me." When "In the American West" was shown in Texas, one sitter was reported as saying that he had "finally found himself in the museum" in his Avedon portrait.

Much has been written about how we should be sceptical about what the studio portrait and the street photograph actually reveal about their subjects. Aaron Schuman argues that both tell us very little, "One simply strips the image as bare as possible in order to allow for the most basic levels of facial recognition, while the other attempts to cast its subjects, usually based on their physical appearance or attire, as conventional stock characters or 'types'

within the theater of the street." Yet, Itkoff in one fell swoop, with just a small piece of board, artfully reveals the artifice involved in the approaches of Sander and Avedon, and their respective traditions of street and studio portraiture. He explains, "The white board allows the viewer to take a look at the subject within and without the confines of the city. They are at once removed and contextualized within their surroundings." This duality simultaneously lays bare the artifices of both photographic approaches. By not allowing the white board to extend throughout the frame and by revealing the various assistants' hands, feet, and faces, Itkoff makes explicitly visible the subterfuge behind Avedon's seamless technique. Likewise, by allowing the white board to interrupt the background, he makes visible the design behind Sander's seamless settings. As writer

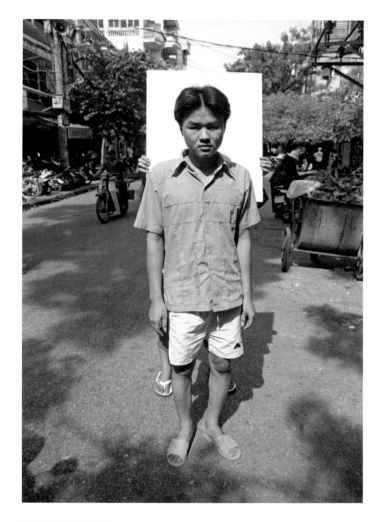

				5 *#17*, Hanoi, Vietnam, 2003	7 *#15*, Hanoi, Vietnam, 2003
5	6	7	8	6 *#4*, Hanoi, Vietnam, 2003	8 *#3*, Hanoi, Vietnam, 2003

Bill Kouwenhoven summarizes, "He critically transforms his work by subverting both the pretenses of white backdrop and the unadorned, yet equally stylized, contemporary street portrait."

Itkoff has repeated his "Street Portraits" in various cities around the world, five so far and growing. He has talked of the body of work in relation to the epic humanist exhibition curated by Edward Steichen in 1955, "The Family of Man." The exhibition, featuring 508 photographs, taken by 273 photographers from 68 countries, opened in New York's Museum of Modern Art and traveled the world, espousing ideals of universal brotherhood. Itkoff was surprised by the commonalities he discovered in the different cities. He observes, "Not only do the buildings look similar but the clothes, suits, T-shirts, and sneakers could be worn by anyone anywhere." As Kouwenhoven notes, "With the advent of mass marketing and global brands—Ikea, Nike, Uniqlo, Levi's—made popular through advertising throughout the world, a sort of aspirational homogeneity has seemingly taken over the world." Like Steichen, Itkoff seems to be presenting a contemporary, globalized "family." Yet, despite the similar cityscapes and similar fashions, the series is about the individual, "It is only the unique faces, which I strove to separate and elevate in the viewer's mind, that differentiate the subjects from their surroundings." Schuman says Itkoff's portraits "suggest that character may still faintly linger within the city" and "confirms that given the opportunity we still find ourselves captivated, comforted, and defined by [the] remarkable uniqueness of each other." As Avedon eloquently described his own photographic encounters, "There is nothing between us except what happens as we observe one another."

INDEX

CONTRIBUTORS

(AB) Anne Bracegirdle is a specialist at an auction house in New York City. She has a Master's degree in the history of photography at Sotheby's Institute of Art, London.

(SC) Sean Corcoran has been curator of prints and photographs at the Museum of the City of New York since 2006. He previously served as assistant curator of photography at George Eastman House, Rochester, New York, and as adjunct faculty of Ryerson University's Master's Program in Photographic Preservation and Collections Management (Toronto, Ontario). He has organized a wide range of photographic and media exhibitions, including "Police Work: Photographs by Leonard Freed, 1972–79," "Legacy: The Preservation of Wilderness in New York City Parks," "Photographs by Joel Meyerowitz" and "City as Canvas: Graffiti Art from the Martin Wong Collection."

(CF) Chantal Fabres is a specialist in Latin American photography. She advises private clients, and works with galleries and curators to introduce the work of Latin American artists to an international audience. She has contributed to various publications, including *Photography: The Whole Story* (Thames & Hudson, 2012). Her expertise focuses on the Chilean artistic production known as "la Escena de Avanzada" during the Pinochet dictatorship.

(MF) Marc Feustel has curated a number of photographic exhibitions and edited both photographic and fine art publications, including an anthology of postwar Japanese photography, *Japan: A Self-Portrait, Photographs 1945–1964* (Flammarion, 2004). Based in Paris, he also writes the photography blog, eyecurious.

(SG) Sophia Greiff is an author and photography curator. Her writing has been published in a number of renowned international books and magazines. She is co-curator of the FotoDoks Festival for Contemporary Documentary Photography in Munich, Germany, and has worked on exhibitions and publications for Münchner Stadtmuseum, Museum Folkwang in Essen, Staatliche Kunstsammlungen Dresden, and the Victoria and Albert Museum in London.

(JH) Jackie Higgins is a writer, journalist, and film-maker. She has produced films for the BBC, National Geographic, and the Discovery Channel. She is the author of *Look: David Bailey* (Phaidon, 2010) and *Why It Does Not Have to Be in Focus: Modern Photography Explained* (Thames & Hudson, 2013).

(KH) Katie Hill is a lecturer, curator, and writer. She runs the Office of Contemporary Chinese Art, a consultancy dealing with artists from China and the Chinese diaspora. She is co-author of *The Chinese Art Book* (Phaidon, 2013). She lectures in modern and contemporary Chinese art at Sotheby's Institute of Art, London.

(SH) Sophie Howarth is a writer, curator, and social entrepreneur. She is co-author of *Street Photography Now* (Thames & Hudson, 2010).

(GM) Greg Marinovich is a South African Pulitzer Prize-winning photographer, writer, and film-maker. He is co-author of *The Bang-Bang Club: Snapshots from a Hidden War* (Arrow Books, 2000).

(CN) Carole Naggar is a poet, writer, and photography historian. Her books include *George Rodger: An Adventure in Photography* (Syracuse University Press, 2003), *Werner Bischof* (Delpire, 2008), *David Seymour Chim* (2011), and *David Seymour: Vies de Chim*, which is due to be published in 2014.

(DR) Dan Rule is a writer, critic, editor, and publisher from Melbourne. He is a visual art critic and design columnist for *The Age*, editor of *Vault* magazine, and co-editor of *Composite Journal*. He has written on art, design, music, and culture for publications throughout the world, including *The Sydney Morning Herald*, *Dazed & Confused*, *i-D*, *Oyster*, and *TOO MUCH*. He is co-director of Perimeter Books, Perimeter Editions, and Perimeter Distribution.

(RS) Radhika Singh is a photo editor and curator. In 1987 she founded Delhi's first photography agency, Fotomedia, which represents over 100 photographers. She is the author of *The Fabric of our Lives: The Story of Fabindia* (Penguin, 2010).

PICTURE CREDITS

Unless indicated, all images featured in the book are courtesy of the artists. Every effort has been made to credit the copyright holders of the images. We apologize in advance for any unintentional omission or errors and will insert the appropriate acknowledgment to any companies or individuals in subsequent editions of the work.

2 Graeme Williams **6** © Max Kozloff **8** © Yasmine Chatila, courtesy of the artist **10–11** © Maciej Dakowicz **12** © Joel Meyerowitz, courtesy of Howard Greenberg Gallery **14** © Mirko Martin **16** image 1: Jacob A. (Jacob August) Riis (1849–1914)/Museum of the City of New York; image 2: Berenice Abbott (1898–1991)/Museum of the City of New York; **17** image 3: © William Klein; image 4: © The Estate of Garry Winogrand, courtesy of Fraenkel Gallery, San Francisco **18–19** © Joel Meyerowitz, courtesy of Howard Greenberg Gallery **20–3** © Yasmine Chatila, courtesy of the artist **24–7** © 2014 by Gus Powell **28–31** © Vera Lutter, courtesy of the artist **32–3** © Ahn Jun **34–7** © Matthew Baum **38–41** © Peter Funch **42–5** © Nikki S. Lee, courtesy of Sikkema Jenkins & Co., New York **46–7** Courtesy the artist and David Zwirner, New York/London **48–9** Bruce Gilden/Magnum Photos **50** image 1: ©

1939 Los Angeles Times. Reprinted with permission; image 2: © Lee Friedlander, courtesy Fraenkel Gallery, San Francisco; **51** image 3: Courtesy Stephen Shore and 303 Gallery, New York **52–5** © Mirko Martin **56–9** Courtesy the artist; Tanya Bonakdar Gallery, New York, 1301PE, Los Angeles **60–1** Olivo Barbieri, courtesy Yancey Richardson Gallery, New York **62–3** © Andrew Bush, courtesy of Yossi Milo Gallery, New York **64–7** © Katy Grannan, courtesy Fraenkel Gallery, San Francisco **68** © The Estate of Harry Callahan, courtesy Pace/MacGill Gallery, New York **69** image 2: Wayne F. Miller/Magnum Photos; image 3: Photography © The Art Institute of Chicago **70–3** © Michael Wolf, courtesy m97 Gallery, Shanghai **74–5** Photographs Copyright © Dawoud Bey, courtesy Stephen Daiter Gallery, Chicago **76–9** © Doug Rickard, courtesy Yossi Milo Gallery, New York **80–3** © Paul Graham, courtesy of Pace Gallery and Pace/MacGill Gallery, New York **84–5** © Wim Wenders, Berlin/Verlag der Autoren, D-Frankfurt am Main **86–7** Courtesy of the artist **88** Julio Bittencourt **90** Oscar Fernando Gómez **92** image 1: © ADAGP, Paris and DACS, London 2014; image 2: © Pedro Meyer, 1968; **93** image 3: © Graciela Iturbide, courtesy of the artist; image 4: © Pablo Ortiz Monasterio, courtesy the Rose Gallery, Santa Monica **94–7** Courtesy David Zwirner, New York/London **98–9** Alex Webb/Magnum Photos **100** Oscar Fernando Gómez **102–3** Edi Hirose **104–5** Claudia Jaguaribe **106–9** Julio Bittencourt **110–11** Ana Carolina Fernandes **112–13** Julio Bittencourt **114–15** Cássio Vasconcellos **116–17** © Luis Molina-Pantin, courtesy of the artist and Henrique Faria Fine Art, New York **118** © Johnnie Shand Kydd **120** Nils Jorgensen **122** image 1: © Bill Brandt Archive; image 2: Marketa Luskačová **123** image 3: Paul Trevor **124–5** © the artist, courtesy Maureen Paley London **126–9** © Slinkachu **131** © Richard Wentworth, courtesy the artist and Lisson Gallery **132–3** © Rut Blees Luxemburg **134–5** Shizuka Yokomizo **136–9** © the artist, courtesy Maureen Paley, London **140–1** © the artist, courtesy Maureen Paley, London **142–3** Polly Braden **144–5** Matt Stuart **146–7** Nils Jorgensen **148–9** Adam Broomberg and Oliver Chanarin, courtesy of Paradise Row **150** image 1: Henri Cartier-Bresson/Magnum Photos **151** image 2: Gamma-Rapho via Getty Images; image 3: © Michael Wolf, courtesy m97 Gallery, Shanghai **152–5** JH Engström **156–9** Luc Delahaye/Galerie Nathalie Obadia **160–3** © Mohamed Bourouissa, courtesy the artist and kamel mennour, Paris **164–7** 'Suite Vénitienne' (detail) 1980. Set of 81 elements, made in this form from 1996 onwards. 55 b/w photographs, 23 texts, 3 maps. 6 ¾ x 9 ¼ in. (each b/w photograph), 11 ⅞ x 8 ½ in. (each text) © ADAGP, Paris and DACS, London 2014, courtesy Galerie Perrotin **168–9** Courtesy of the artist **170–3** © the artist/White Cube **174–5** © Johnnie Shand Kydd **176–7** © Cristóbal Hara **178–81** Txema Salvans **182** image 1: Photo © Rheinisches Bildarchiv, Otto Umbehr: rba_c012033; image 2: © Arno Fischer Estate, courtesy Berlinische Galerie, Landesmuseum für Moderne Kunst, Fotografie und Architektur **183** image 3: bpk/Friedrich Seidenstücker; image 4: Göran Gnaudschun **184–5** Alisa Resnik **186–7** Courtesy of the artist and Goodman Gallery (Photographer: Abrie Fourie) **188–9** © Vera Lutter, courtesy of the artist **190–1** © DACS 2014 Courtesy David Zwirner, New York/London **192–5** Hans Eijkelboom **196–9** Otto Snoek **200–3** Courtesy of Martin Asbaek Gallery, Copenhagen and Bruce Silverstein Gallery, New York **204–7** Alex Webb/Magnum Photos **208–11** Olivo Barbieri, Courtesy Yancey Richardson Gallery, New York **212** image 1: © Rodchenko & Stepanova Archive, DACS, RAO, 2014 **213** image 2: Courtesy the artist and Galerie Barbara Weiss, Berlin **214–15** © Boris Savelev, courtesy Michael Hoppen Gallery, London **216–17** © Slinkachu **218–21** © Melanie Manchot, courtesy Galerie m, Germany **222–5** © Sergey Bratkov, courtesy Regina Gallery, Moscow **226–9** © Alexey Titarenko, courtesy of Nailya Alexander Gallery, New York City, NY, USA **230–3** Courtesy the artist and Galerie Barbara Weiss, Berlin **234** © Pieter Hugo, courtesy of Yossi Milo Gallery, New York **236** © Sabelo Mlangeni, courtesy of the artist and Stevenson, Cape Town and Johannesburg **238** image 1: © Ernest Cole Family Trust **239** image 2: © David Goldblatt, courtesy of Goodman Gallery, Johannesburg and Cape Town **240–1** © Sabelo Mlangeni, courtesy of the artist and Stevenson, Cape Town and Johannesburg **242–3** Courtesy of the artist and Goodman Gallery, Johannesburg and Cape Town **244–5** Courtesy of Goodman Gallery, Johannesburg and Cape Town (Photographer: John Hodgkiss) **246–9** Graeme Williams **250–3** Courtesy of the artist and Goodman Gallery, Johannesburg and Cape Town **254–7** Courtesy of the artists and Goodman Gallery, Johannesburg and Cape Town **258–61** Courtesy of the artist and Goodman Gallery, Johannesburg and Cape Town **262–5** © Jo Ractliffe, courtesy of the artist and Stevenson, Cape Town and Johannesburg **266–9** © Guy Tillim, courtesy of the artist and Stevenson, Cape Town and Johannesburg **270–1** © Pieter Hugo, courtesy of Yossi Milo Gallery, New York **272–5** © Viviane Sassen, courtesy of the artist and Stevenson, Cape Town and Johannesburg **276–7** © Edson Chagas **278–81** Rut Blees Luxemburg **282–5** Mimi Mollica **286–7** Courtesy of the artist and Sfeir-Semler Gallery, Beirut/Hamburg **288** © Narelle Autio, courtesy of Agence VU', Paris **290** © Jesse Marlow, courtesy of the artist and M.33, Melbourne **292–5** Trent Parke/Magnum Photos **296–7** © Narelle Autio, courtesy of Agence VU', Paris **298–301** courtesy the artist **302–3** © Narelle Autio, courtesy of Agence VU', Paris **304** image 1: © Rennie Ellis Photographic Archive; image 2: © Glenn Sloggett, courtesy Stills Gallery, New South Wales, Australia **305** image 3: © Louis Porter; image 4: © Ian Tippett 2013 **306–7** Courtesy of the artist and Roslyn Oxley9 Gallery, Sydney **308–9** © Jesse Marlow, courtesy of the artist and M.33, Melbourne **310** © Peter Bialobrzeski, courtesy L.A. Galerie–Lothar Albrecht, Frankfurt, Germany **312** © Jiang Pengyi **314** © Sohei Nishino, courtesy of Michael Hoppen Contemporary **316–19** © Birdhead, courtesy of Paradise Row **320–1** © Ying Tang **322** image 1: Donald Mennie; image 2: Courtesy of Rong Rong **323** image 3: photograph by Liu Heung Shing, all rights reserved **324–7** © Sze Tsung Leong, courtesy Yossi Milo Gallery, New York **328–31** © Jiang Pengyi **332–5** © Zhang Dali **336–9** © Weng Fen **340–1** Polly Braden **342–5** © Yang Yong **346** image 1: © Hiroshi Hamaya Estate/Courtesy of Studio Equis **347** image 2: © Interface/Courtesy of Studio Equis; image 3: © Takashi Homma **348–51** © Daido Moriyama, courtesy of Taka Ishii Gallery, Tokyo and Daido Moriyama Photo Foundation, Tokyo **352–3** © Nobuyoshi Araki, courtesy of Taka Ishii Gallery, Tokyo **354–7** © Naoya Hatakeyama, courtesy of Taka Ishii Gallery, Tokyo **358–9** © Tokihiro Sato, courtesy Leslie Tonkorow Artworks + Projects, New York **360–3** © 2013 Osamu Kanemura, courtesy of Osiris **364** image 1: Henri Cartier-Bresson/Magnum Photos; image 2: © Vicky Roy **365** image 3: Photograph © 2014 Succession Raghubir Singh **366–7** Raghu Rai/Magnum Photos **368–71** © Sunil Gupta **372–3** Maciej Dakowicz **374–7** Max Pinckers **378–81** © Peter Bialobrzeski, courtesy L.A. Galerie—Lothar Albrecht, Frankfurt, Germany **382–3** © Joel Sternfeld; images courtesy of the artist and Luhring Augustine, New York **384–5** Martin Parr/Magnum Photos **386–9** © Ahn Jun **390–3** Michael Itkoff, www.michaelitkoff.com

Published in association with
Yale University Press
302 Temple Street
P.O. Box 209040
New Haven, CT 06520-9040
yalebooks.com/art

This book was designed and produced by
Quintessence Editions Ltd
The Old Brewery
6 Blundell Street
London N7 9BH

Project Editor	Fiona Plowman
Editors	Jodie Gaudet, Becky Gee, Carol King
Designer	Dean Martin
Production Manager	Anna Pauletti
Editorial Director	Jane Laing
Publisher	Mark Fletcher

Jacket front: Jesse Marlow, *Stop*, 2011
© Jesse Marlow, Courtesy of the artist and M.33 Gallery, Melbourne.
Jacket back: Peter Funch, *Memory Lane*, 2008
Courtesy the artist and V1 Gallery, Copenhagen.

Printed in China

ISBN 978-0-300-20716-3

Library of Congress Control Number: 2014940105

10 9 8 7 6 5 4 3 2 1